ANIMATION
FROM PENCILS TO PIXELS

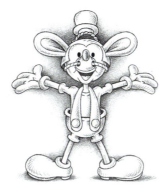

DATE DUE

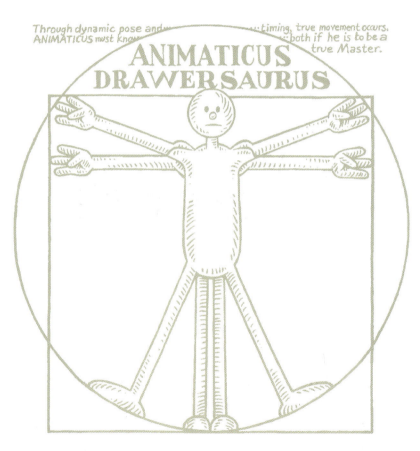

Through dynamic pose and ~~~~~~~~~~ timing, true movement occurs.
ANIMATICUS must know ~~~~~~ both if he is to be a
true Master.

ANIMATICUS
DRAWERSAURUS

TONY WHITE

ANIMATION

FROM PENCILS TO PIXELS

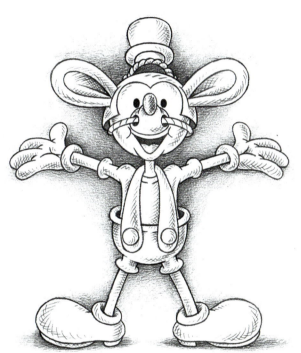

CLASSICAL TECHNIQUES
FOR DIGITAL ANIMATORS

ELSEVIER

Focal Press

Focal Press is an imprint of Elsevier

Amsterdam · Boston · Heidelberg · London · New York · Oxford
Paris · San Diego · San Francisco · Singapore · Sydney · Tokyo

Acquisitions Editor: Amy Jollymore
Project Manager: Brandy Lilly
Assistant Editor: Doug Shults
Marketing Manager: Christine Degon Veroulis
Cover Design: Tony White, Eric Decicco
Interior Design: Lisa Devenish and Detta Penna

Focal Press is an imprint of Elsevier
30 Corporate Drive, Suite 400, Burlington, MA 01803, USA
Linacre House, Jordan Hill, Oxford OX2 8DP, UK

Library of Congress Cataloging-in-Publication Data
Application submitted

British Library Cataloguing-in-Publication Data
A catalogue record for this book is available from the British Library.

ISBN 13: 978-0-240-80670-9

ISBN 10: 0-240-80670-0

For information on all Focal Press publications
visit our website at www.books.elsevier.com

06 07 08 09 10 10 9 8 7 6 5 4 3 2 1

Printed in China

DEDICATION

This book is dedicated to
all those selfless pencils
who sacrificed everything
in the pursuit of the
animated dream!

Contents

7 Digital Desktop Production

8 Principles of Animation

Acknowledgments

This entire project has been a long, hard haul. Indeed, there have been times when I felt I just could not go on any longer, believing during the darkest of days that I had bitten off more than I could chew. What kept me going was the fact that I needed to exorcise myself of a demon that demanded I share with others everything I have learned and achieved. No project as challenging and as extensive as this could possibly have been achieved without the genuine understanding and encouragement I received from innumerable people, especially those near and dear to me, each of whom has enabled me to take that one extra step I never thought I could take. It is quite impossible for me to thank every one of you who blessed me with your love, strength and encouragement over the past three years or so. Yet I am, without a shadow of a doubt, indebted to ALL of you—whoever you are and wherever you are—for the tremendous help and encouragement you provided me. If forced to name names, I would single out those of you that I am able to recall with what brain cells I have remaining at the end of this mind-chilling marathon of effort. If I have missed you out of this list quite unintentionally, then please forgive me as I still do value you, even in my omission.

First I have to thank, without reservation, my wonderful contacts at Focal Press, Amy Jollymore and Cara Anderson. You have been an absolute dream to work with and I value the constructive and amusing e-mails we have shared together. Without your infinite encouragement, patience and understanding, this book would never have come into existence. I will be forever grateful to you both for your support and your confidence in me, even when others have caused me to doubt. I thank you too for the wonderful flowers you sent on receipt of my manuscript; they were indeed a very pleasant surprise and a wonderful inspiration to travel further and faster! You have both given me back my faith in publishers and publishing houses!

I need to thank too my wonderful editor, Beth Millett, whose job it was to make sense of all my infinite and animated meanderings. Thank you, Beth, for your sensitivity, your sound advice and your patience. You somehow made me look more like a teacher than a preacher in all this and for that I will be forever grateful to you!

It goes without saying that but for the support of my family, friends and loved ones on both sides of the Atlantic, I would never have been able to do anything. It is with such valued ones in our lives that we find richness and reward and although I have been absent from many of you in my mind, body and soul from time to time, I thank you unreservedly for your constant love and sacrifice throughout it all. Words just cannot express enough my gratitude to those of you who have enabled me to tread this singular path without rant or recrimination. I especially thank my beloved silver-winged Saille for dragging me from that dark abyss I found myself in and for showing me how to walk freely and confidently in the sunlight once more.

Next, in writing such an exhaustive account on the ways and wherefores of this wonderful world of animation, I must not fail to thank the great teachers and pioneers of the work who have both inspired me and taught me all they knew. Thank you Frank,

Ollie, Ken, Art and Dick, all of whom have been and inspiration and provided me with a solid path to walk upon. I especially thank Walt for kick-starting this whole thing in the first place and for setting incredible standards that even today have not been surpassed. I thank also Walt's "young" nephew Roy, who has been of significant encouragement to me, for generously writing the foreword to this book and for equally generously donating his voice to the cause, so that his uncle's great spirit could momentarily live again within my film!

I thank too the Henry Cogswell College in Everett, Washington, especially my friend and valued colleague there, Ken Rowe. Ken and Cogswell have shown me such support and encouragement over the years. I sincerely believe their collective generosity has been instrumental to the completion of the book and film. Special acknowledgements also go to colleagues Dave Benton and Bob Abrams at Cogswell; their friendship, experience and unbending professionalism were a great inspiration to me. I thank the students of Cogswell too for their enthusiastic support in helping me with "Endangered Species," and especially those (Dani, Saille, Patrick, Todd and Warren) who agreed to be photographed for the illustrations in this book. I thank also my new colleagues the DigiPen Institute of Technology in Redmond, and specifically the irreplaceable Dean Abbott Smith for both encouraging my work and inviting me to teach at the only current establishment I know that truly understands the meaning of education in all of its expression. At DigiPen, I have met great friends and colleagues who have not only supported my objectives but have also materially contributed to them. I specifically thank Raymond Yan, Monte Michaelis, Charles Wood and Royal Winchester for their generous donations in encouragement and artwork, as well as Alecia, Geraldine, the remarkable BJ, and Jazno for their great support and understanding.

Realistically, I cannot complete this picture of gratitude if I did not say a sincere thanks to all those companies and corporations that have kindly donated materials and software for me to evaluate. I specifically thank the gods of technology for the following software (in alphabetical order, not preference): After Effects, Animation Master, Flash, Flipbook, Gif Animator, Magpie Pro, Mirage, Photoshop, Premiere, QuickTime, Snagit, Sound Forge, Storyboard Artist, ToonBoom Studio, Wacom, XSI and of course for my pet video iPod, which has entertained me and so wonderfully enabled me to share my work with others along the way. (Thank you, Claude "Mr. DigiPen" Comair, for making this the most perfect Christmas gift ever!).

Lastly, I have to offer huge and heartfelt thanks to Dr. Jodi Berg and Dr. Chris Rivera for keeping me physically going throughout this entire marathon. Without your generous hearts and healing wisdom I don't think my body would ever have survived the journey. I am sure you secretly recognized the practical folly of my mission but your non-judgmental support and insightful counseling kept me steadfastly focused on the straight and narrow path ahead of me. You are both indeed one in a million.

THANKS... ...FOR GETTING ME THROUGH A TOUGH TIME, JODI & CHRIS !!!

Foreword

Mickey Mouse is only a little more than one year older than me, so I guess I have grown up and (hopefully) matured alongside the art of animation—Disney animation, that is—virtually from its very beginnings. Whether that makes me an expert on the subject is another question, but certainly I have been a long-time observer of the evolution of both the art and the business of animation for a good deal of its history.

In the last twenty years, the so-called "digital revolution" has brought sweeping changes to animation, or at least that is the perceived wisdom as we hear it from the outside world. You will hear that "everything has changed," that "pencils are no longer required," and most demeaning of all, "2D is dead!!"

Before we all go out and hang ourselves in despair, let me recommend that you sit down and watch "Endangered Species," so you can see that animation has been in a state of evolution from its very inception, that it continues to evolve, and most of all, that there is nothing to fear.

What you will see, instead, both in "Endangered Species" and in this wonderful book, is a world of possibilities. The animator, whether young and full of aspirations, or mature and looking for new worlds, will find his or her answers here. This new world the computer has opened up to all of us is nothing more than the biggest, most diverse paint box yet available to artists. It has most certainly not—nor will it ever—replace the pencil.

Tony sees these truths clearly, and with his background as both a successful animator and a successful teacher, he has brought to the world a comprehensive—and eminently practical—guide to every aspect of the art.

My only words of advice to the reader would be: take this complete set of tools, go out and tell us a great story!!

Thank you, Tony.

Roy Disney

Introduction

The film "Endangered Species" was created especially so this book could be written. It may seem a quite extraordinary statement for an author to make—that they created an entire film simply to write a book—yet this is basically what I have done. Without the film, this book could never have been written. But then again, without an amazing, magical, diversely enchanting world of animation which has existed for almost 100 years now, the film could never have been made in the first place!

Throughout my own 30-plus years within that magnificent century of animation, I have always dreamt of finding one, single, authoritative book that would deal with every conceivable aspect of animated film creation. Not just the pure principles of movement, as some very good books already do, but EVERYTHING that an animator could possibly ever need to know to practice animated filmmaking comprehensively, from the principles of production to development and distribution, from screen ratios and other technicalities to animation's illustrious history. In short, I wanted a "one-stop-shop" book that has everything that any animator could ever want to know about life, the universe and of course animation too. Since, I could never seem to find one, I decided to sit right down and write it myself!

Ultimately, all animation teaching is about learning "tricks." Over the years I have learned a few more tricks than the raw beginner is likely to know, hence my presenting them here. It must never be forgotten that animation is all about illusion too; it is not real filmmaking, about real characters, but the audience has to believe it is so. Consequently, the more tricks you know to create this illusion, the easier it will be for you to do so. This book attempts to lay out all my tricks to help you in this process.

I recently reviewed the body of all my life's work as a director/animator and calculated that if everything were edited together and shown as one complete non-stop presentation, it would actually amount to the equivalent of two or three full-length animated movies! This was a terrifying thought, and an especially frustrating one for an animator/director who still dreams of crediting just one full-length movie to his name before he goes on to that "great lightbox in the sky."

 My work has always been consistently mercurial and aesthetic in its nature. I have tended to shun the more predictable cartoon route of animation for the simple reason that, for me, this is ground well-trodden and I prefer to travel along new paths of discovery. The first significant award I ever won was a British Academy Award for the first personal, short film I made, "HOKUSAI—An Animated Sketchbook." Upon reflection, I set up shop from the very beginning, in pursuit of the more innovative, aesthetic and original (albeit less lucrative) work that I have subsequently preferred to do.

 Along my career path, I have studied with some of the greatest names in animation: the late Ken Harris (master "Bugs Bunny" and "Roadrunner" animator from the Warner Brothers studio) and Art Babbitt (animator on films such as "Pinocchio" and "Fantasia" during the golden age of Disney). I served (and survived) as Richard Williams' (three-

time Academy Award winner and author of the exceptional "Animator's Survival Kit") own personal assistant for two years. This wonderful exposure to the very best talents the industry can offer enabled me to absorb the finer secrets of all the great traditions at a very early age.

Bringing this great circle to a close, my latest work, "Endangered Species," pays homage to some of the fine and classic moments of animation's defining moments, moments that have brought the industry to the point where it stands today. In essence, the making of this film has been a bridging of both of my worlds: the irreplaceable past and the unendingly exciting present. Although relatively short in length, "Endangered Species" nevertheless proved an enormously challenging undertaking for me. Yet in at first researching it and then ultimately creating it, the entire experience of re-enacting the work of some of the greatest animation masters of all time, did effectively enable me to "sit at the feet" of the great maestros from the past. As I worked on the film, I realized it was a wonderful opportunity to teach all these discoveries, so that both the old tradition and the new can be taught side-by-side and appreciated as one. Consequently, in addition to the huge filmmaking assignment I had already set myself, I proceeded to write this book as I made the film—and make the film as I wrote this book!

Within these pages I do believe you will find just about everything you should ever need to conceive, produce, direct, animate, assemble, publish and distribute your own animated film, whether that film is 2D, 3D, vector or raster format. But hopefully this book and its companion CD-ROM are even more than that. The CD-ROM also contains a unique record, scene-by-scene, of how and why "Endangered Species" was made. I comprehensively explain why I chose the sequences I did and how they were probably created in the first place. I also share with the reader how I subsequently re-created them in a digital environment and how I actually animated some of the special actions of note that have not been previously covered in other instructive sections of the book. Everything, quite literally from "pencils to pixels" is there. I hope that any animator or student of animation will find this book to be the very best resource publication he or she could ever wish for.

Like the current industry it reflects, the process of "passing down the pencil" from master to student has significantly changed in recent times. Once upon a time, there was a thriving apprenticeship system. But now it is gone. Today, education for the animators of the future needs to occur through schools, colleges, and textbooks like this one. If a continuity of knowledge is to remain, then this education, at the highest and most accomplished level, has to occur without further loss to traditional values. It is so easy for the young student of animation or those who teach the young students of animation to be seduced by the glamour and the immediacy of the new technologies.

Digital tools and techniques have so much to offer the contemporary animator and can effectively eliminate much of the tedium associated with frame-by-frame filmmaking. Teaching software, and not the fundamental principles of animation, ultimately breeds a generation of technicians rather than artists. I therefore earnestly encourage every student who is intent on becoming an accomplished animator (yes, even those of a 3D, or other, persuasion) to invest time in the pursuit of studying the great tradition that heralded this current era. This way is the way of true animated mastery. It is extremely important to me that this book will enable young animators from all over the world, of all cultures and social classes to animate, and to animate very well. Hopefully all that will need to be added is a humble pencil, a reliable computer and a dedicated soul afire with desire and imagination for the great art form we all know and love. If even the slightest and yet most significant progress is made in this wonderful, magical world we call animation, then I will have passed on my pencil with a satisfied mind and a jubilant heart.

Tony White

Spring 2006

Development

Dare to look through the keyhole—
anything's possible!

Everything begins with an idea, and a film project succeeds or fails in direct proportion to how well that idea is developed. I have always advised students that what you get out of a project at the end is in direct proportion to what you put into it at the beginning. Therefore, if you want your project to achieve everything you hope for, you should ensure that its development stage is approached meticulously and conscientiously.

Everything begins with an idea.

Development is taking a basic idea—a thought, a line of text, even a piece of music—and expanding it to its maximum filmic expression. The most formal development process possible is implemented for a movie or a TV series, but the development stage should be applied to all kinds of projects, whether they are large or small, commercial or personal. The stages of an animated film development will include anything that will enable a viable project to be understood, funded, and produced, including:

- idea creation
- evolving the storyline
- creating a script
- character design or modeling
- background/environmental design
- storyboarding
- scheduling and budgeting

Each one of these stages is extremely important to the success of the whole project, but some are more important than others. On the assumption you are reading this book because you not only want to animate but equally wish to produce your own projects too, let us examine each aspect of the development stage in more detail.

Idea Creation

Ideas can arrive in an untold number of ways. They can come from a phrase uttered by someone in a conversation, from a line read in a book, newspaper, or magazine, from a picture or illustration you happen to glance at one day, or from an event or moment you experience in your daily life. Perhaps the latest novel you read or the magazine article you recently finished inspires you. You may have sketched a curious character who suggests a storyline to you, or maybe you just have a thought buzzing through your head that won't go away no matter how hard you try.

You can even be inspired by another artist's work, or a technique you saw in the last movie you watched, or a dream you had one night. Or the idea just popped into your head when you were using the restroom! Ideas can come from everywhere and anywhere. Life speaks to us constantly. We just have to have our eyes and ears open to it when it does so.

Through dynamic pose andtiming, true movement occurs.
ANIMATICUS must kno... ...both if he is to be a
true Master.

ANIMATICUS DRAWERSAURUS

Storylines can come from characters, and characters can come from storylines.

Intellectual Property and Copyrights

Idea block is the hardest thing to cope with. We desperately want to make something. We have the energy and we have the talent, but we just can't seem to get a good idea. This is the most frustrating thing on Earth. But it is also not a time to panic. Ideas abound and we just have to find a way of coaxing them out of their hiding place. The one thing that the inexperienced person can find himself doing in this circumstance is take someone else's idea and run with it. Don't! Now this is not to imply that you are a blatant plagiarist and will steal someone else's concept and claim it as your own. It is more usually a case of seeing something in a magazine, on TV, or in a book somewhere and naively wanting to animate it. Apart from the genuine satisfaction of actually creating your own idea and bringing to the world something that no one else has thought of before, there are significant legal implications in using something you have seen elsewhere.

Make sure that what you have is your own.

Intellectual property—something that you or someone else has created or originated—is so powerfully protected these days that if you so much as draw a recognizable character someone else owns for anything beyond your own personal amusement, you will have the lawyers of that object's owners bearing down on you like a ton of bricks! Can you imagine, therefore, taking years to animate your pet project, only to find you cannot show it anywhere as its original idea infringes someone else's copyright? Plus the fact that, if you actually make money from it (and, trust me, it is virtually impossible to make money with a short, animated film), then you will have to pay back all of your earnings to the owner of the property, in addition to a daunting fine and all the legal costs!

There are gray areas connected with intellectual property that can have the lawyers delightfully wrangling with each other for year after profitable year. It is possible to copyright anything that is tangible, such as a line of text, a drawing, even a doodle on a piece of paper. Indeed, anything you create is automatically copyrighted, simply because you created it. This is recognized and acknowledged. However, you cannot copyright an "idea," that is, something in abstract form such as a thought or concept. If an idea is not specifically defined, if it is not written down in black and white, or seen and heard in any other way, then it is not protected by copyright. For example, if you hear somebody say, "I'm going to make a film about a mermaid who marries an alien," you can actually proceed to make a film about that idea yourself. However, if they produce a drawing and say, "I'm going to make a film about this particular mermaid and this particular alien," you cannot make a film with a similar mermaid or a similar alien. Now, if you are persistent in your aquatic ambitions, you can still make a film about another mermaid and another alien, just not the ones that have been defined already.

That acknowledged however, if you decide to make a film about a mermaid and an alien from a story that you just read and proceeded to create your own characters to go with that story, you will still end up in court if you follow the precise plot line that the story contained. Written ideas, regardless of visual content, are most definitely defined by the printed word. However, you can still make a film about a different mermaid and a different alien, using an entirely different plot line if you like, even if the other mermaid and alien story is a major hit, as long as your plot line and your design elements are nothing like the other. There are even more gray areas when it comes to idea origination and usage, so it is clearly always most advisable to come up with something that is entirely original and owes nothing to anyone else. That way sanity, and possibly a healthier bank balance, lies!

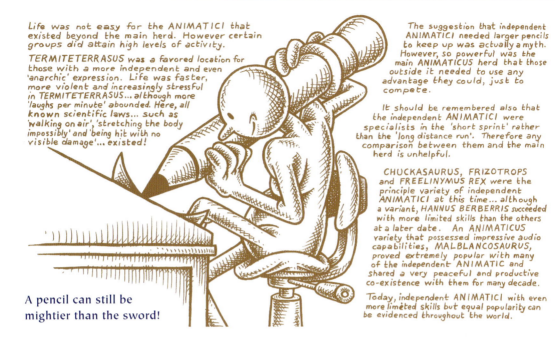

Life was not easy for the ANIMATICI that existed beyond the main herd. However certain groups did attain high levels of activity.

TERMITETERRASUS was a favored location for those with a more independent and even 'anarchic' expression. Life was faster, more violent and increasingly stressful in TERMITETERRASUS... although more 'laughs per minute' abounded. Here, all known scientific laws... such as 'walking on air', 'stretching the body impossibly' and 'being hit with no visible damage'... existed!

A pencil can still be mightier than the sword!

The suggestion that independent ANIMATICI needed larger pencils to keep up was actually a myth. However, so powerful was the main ANIMATICUS herd that those outside it needed to use any advantage they could, just to compete.

It should be remembered also that the independent ANIMATICI were specialists in the 'short sprint' rather than the 'long distance run'. Therefore any comparison between them and the main herd is unhelpful.

CHUCKASAURUS, FRIZOTROPS and FREELINYMUS REX were the principle variety of independent ANIMATICI at this time... although a variant, HANNUS BERBERRIS succeeded with more limited skills than the others at a later date. An ANIMATICUS variety that possessed impressive audio capabilities, MALBLANCOSAURUS, proved extremely popular with many of the independent ANIMATIC and shared a very peaceful and productive co-existence with them for many decade.

Today, independent ANIMATICI with even more limited skills but equal popularity can be evidenced throughout the world.

Purchasing or Optioning the Rights

That said, if you absolutely love someone else's idea (or book, or comic character, or toy, or whatever) and want to animate it as a film, or a game, or whatever, you will need to consider purchasing the rights (in film terms, often known as the "underlying rights") to this intellectual property.

Alternatively, if you want to see if you can raise the money to make your film of this property, before buying the rights outright, then you could option the material instead. An option is a legal document that states you have formal permission to work with the intellectual property in question through a pre-defined development stage, so you can endeavor to bring the project to the attention of potential financiers or distributors. Options are usually only granted over a specific period of time at a set amount of dollars per year. If you fail to finance your project idea in this time, you either lose the right to do so thereafter or pay for an additional option period that may be granted to you by the property owner.

Full rights are where you purchase the privilege to use someone else's intellectual property outright, for all time (in perpetuity) and in all specified media (dependent on the terms of the contract) for a single (usually large) fee. Purchasing full rights for a property is clearly a very risky thing to do at the development stage, when you have absolutely no certainty that the project is going to be financed. If your project is never financed, any money spent on full rights is pretty much money down the drain, hence the attraction of optioning the rights at the development stage.

The best approach to take is to build into the option agreement a clause which guarantees you the full rights on acquiring full production funding. For example, you might option the rights to a book for two years, develop it and even find the production finance to make your project. You then simply pay the owner of the property a

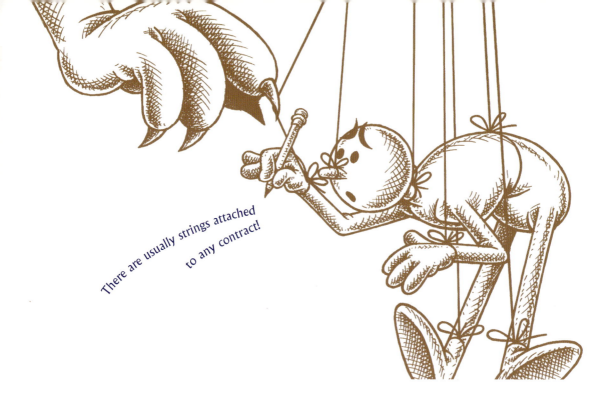

There are usually strings attached to any contract!

pre-agreed fee for the full film rights, and the rights are automatically yours. This clause ensures that, after all your hard work during the development stage, the property will indeed be yours. On occasions, some unscrupulous property owners have taken an option fee from an unsuspecting filmmaker, waited until that filmmaker has finally secured their financing, and then upped the full rights price unacceptably or even sold the property on to someone else who offers them more money. This is especially a danger if the property proves to be a hot one, with many competitors seeking it. Avoid this scenario by building a full rights clause into the option agreement.

Needless to say, whatever approach you take, it will require a significant amount of money for you to obtain even an option agreement for a major intellectual property. It is more likely that you will choose a low-profile or undiscovered property. If so, the owners of this property could well give you a real option break, with perhaps no money passing hands or, at the very least, only a token amount. If the property owner has no expectations of any other offers, he or she might take a chance with you, on the basis that half a loaf is better than none. Even in these generous circumstances, however, it is wise to pre-agree the full rights aspect of the acquisition, however generously you are treated at the outset! Just remember though—the higher the public profile (and there-

The temptation for many animators is to simply bury their heads in the sand and draw away regardless of practical realities!

fore commercial value) the property is, the more hoops you will have to jump through and the more money you will have to raise to pay to acquire that property. Yet pay for it you must, because if you attempt to proceed without such an agreement on something that is not your own, then you are setting into a dark and troublesome abyss!

Public Domain Material

Copyright laws have changed recently so extended rights to a particular property are protected for its originator (or the family or Trust that represents the interests of that originator, in the case of such long term rights). Copyrights are now secured for 50 years after the creator/owner's death (75 years if that creator/owner is an employee of a company or corporation). After this period, the material is considered public domain and is free for all to use. This means that even familiar works that might have been assumed to be out of copyright are quite possibly still in copyright at the present time. (For example, the song known worldwide as "Happy Birthday to You" is still subject to copyright and will continue to be so until about 2030!) The good side to this law is that if you are the owner of an idea that succeeds and attracts significant commercial success, then that copyright remains yours (or that of your descendants) for a significant amount of time.

Protecting Your Own Ideas

The best and safest route is to create your own original idea in the first place. But here lies dangers too. If you create an entirely new project with a colleague, friend, or partner who contributes to the development of your idea, character, project, etc., then technically that person also has a copyright interest in your project, especially if they gave you the seed idea in the first place.

Unless you create your new project entirely on your own, you do need to have a written agreement in place with whomever you have collaborated with, giving you access to the full copyright and, usually, indicating some kind of remuneration to the collaborators for their contributions, all before you progress further. The reality of life is that friends, partners, and lovers tend to fall out from time to time, sometimes terminally so, and many a creative project has found itself grounded until an often painful and expensive legal dispute over the mutual property rights is resolved.

Always carry an umbrella in the form of clear and legally accurate copyright agreements!

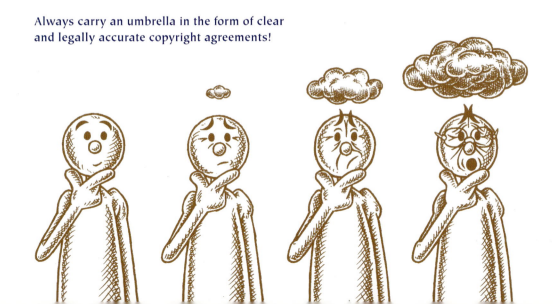

If you think that your concepts might have a high profile or commercial value, and sometimes even if not (for it is surprising how something rejected at one moment in time becomes a valuable property at another!), it is essential to protect the copyright. Protection of copyright is essential if you intend to develop a project idea and then show it around to others in the search for production support or funding. Many people are honest, but you would not be the first to have a valuable idea stolen by others while it is still at the development stage. Consequently, be cautious about who you show it to, the circumstances in which you show it and, of course, have proof that you have ownership to the rights.

Ideally, you should have an agent, manager, or entertainment lawyer represent you in all these matters, as they will have a far greater experience in negotiating, and understanding, the complex nature of the contracts involved. You can even protect your idea in some cases by having the other party sign a confidentiality agreement before you show it to them, effectively stopping them from showing it or talking about it to others.

Proof of Ownership

Unfortunately, the harsh reality of production life is that even if you do have an original property to develop, or perhaps have formally obtained the rights to someone else's property, then you will certainly still be required to show all that necessary paperwork to any potential investor or distributor. No one will take the risk of committing his or her valuable time or (more importantly) money to something that might attract a lawsuit later. So evidence of ownership is essential, if it means you are proving that you own your own property!

Proof of ownership can be an expensive process to undertake, especially since you should employ an experienced entertainment or property lawyer to tie up all these loose ends for you. As part of the process, the project idea has to be clearly and specifically defined and the date of its creation (or rights acquisition) has to be shown. The simplest way of doing this is for the originating creator to seal a copy of the idea, design, or presentation material in an envelope and deposit this with a lawyer. Or if it is a script, with the Library of Congress or with WGA (Writers Guild of America) if you are a member. This ensures a recognizable date of its existence.

A typical animation property package might include such things as a script, character designs, logo designs, and business plans—everything that defines the idea. (Note: The package needs to contain only tangible items such as these as you can't copyright an idea!) Once this material is safely in the hands of a lawyer, or appropriate safe place, your project will be safe to show around without too much threat of theft.

Confidentiality Agreements

As mentioned earlier, there is one other useful way of protecting yourself when showing your ideas around to potential backers. Confidentiality agreements are legal agreements between you and whoever you plan to show your material to. So, if you have the hottest movie concept in the world, with an entirely original and yet "Why didn't I think of that" idea, and you don't want to risk the stranger you're showing it to using it first, you can hand them a confidentiality agreement first. A confidentiality agreement

In his declining years, ANIMATICUS was to go blind. He was unable to see the technological advances that were approaching to threaten his world. He also was blind to the possibility of creative change within his world... and, in his greatest arena, the reality that tried and tested 'formulas' were no longer satisfying to those who sought change and maturity in their entertainment subject-matter.

A permanent crease in the forehead was a sign of a mature and aging ANIMATICUS... the product of a lifetime of compromise and restriction by the gathering forces all around him.

NOTE: The development of a twisted neck... where ANIMATICUS had been forced for years to look over his shoulder, to avoid predators such as CORPORATUS EXECUTUS from sneaking up behind them!

The existence of a prominent abdomen was yet another indication of a maturing ANIMATICUS. This is a clear indication of this creature's inability to fight the forces of gravity that bore down throughout his sedentary and often hard-to-stomach existence during his latter years in the herd.

Animators have always tended to blind themselves to the predatory influences that surround them— I include myself in this painfully earned observation!

states that if someone looks at your project, they will not show it, speak of it, or share it in any way with a third party without your prior permission. Confidentiality agreements can be threatening documents to some people, studios, and organizations, and some may not agree to sign them. This does not necessarily mean that they are going to cheat you out of your millions if they don't. It's often more a case that a company or corporation may wish to protect itself from future legal action, just in case they are already investing in a project that is very similar to yours and therefore may open them to a potentially compromising position. At this point, you have to decide whether or not the exposure of your idea to a particular person is worth the risk. It's actually then all down to that old-fashioned quality of being a good judge of character.

Quite often, a large studio or distribution organization might have their own form of confidentiality agreement which you are asked to sign before you show them your project. This agreement might state that although they will keep the confidentiality of your project paramount, it could well be that they are already developing a project along the same lines and you cannot sue them if they ultimately release it to the detriment of your idea. On the surface, this is a reasonable request, but in the hands of the rare unscrupulous entity, it in theory gives them a license to steal your idea without you having any hope of coming back at them through the courts.

Needless to say, the protection of ideas can be a nightmare on occasions in an industry that flourishes on the sharing and promoting of such ideas. But, in general, the entertainment industry does on the whole tend to respect the spirit of these agreements and therefore everything is usually done honestly and above board. The only real truth attached to being offered some kind of agreement is that if you don't sign it, the studio or distribution organization won't even open your project package.

If the opposite party is not prepared to sign any form of confidentiality agreement, there could be a stalemate and you won't even get an opportunity to show what you have. To circumnavigate this, you might just venture a broad overview of your idea to the prospective interested party, without going into specific details. If they show sufficient interest in the overview, then you could raise the idea of a confidentiality agreement before going any further. If their appetite is sufficiently whetted to want to learn more about your idea, then they will be more inclined to sign your agreement, or at the very least offer you a handshake as a gentleman's agreement on their confidentiality. (However, make sure there are witnesses to the handshake, incidentally, just in case!) Alternatively, if they are still not interested enough to sign your agreement or give any assurances of confidentiality, then nothing is lost, as you haven't told them your idea and therefore your confidentiality is protected anyway.

Works Created for Your Employer

If you are working for a studio or organization and you create a concept or a character that relates to the project you are being paid to work on, then the ownership of that material is owned by whomever is paying your salary. In some cases, your employment contract may include a commitment to the company that says if you create your own idea, character, sketch, or whatever within that company's time, even if it is nothing to do with the job you are working on, then that company can claim ownership of your creation too. Therefore, be vigilant. If this clause is included in a contract of employment that is offered you, you will either have to negotiate it out of the contract before you sign, or if this is declined, simply accept the notion that from that moment on, you and your ideas are effectively owned by that company for as long as you work with them!

Remember, there is no going back once you have signed an agreement, so scrutiny of contracts is always to be encouraged.

There's a claws in every contract!

PREDATORS ABOUNDED IN THE ANIMATICUS/DRAWASSIC AGE: Although most predator did not possess the real claws, as illustrated, they were indeed able to snag the unsuspecting ANIMATICUS with a clause or two that would be concealed in most contracts they issued! It was essentially a 'right brain/left brain thing... where ANIMATICUS lived in the creative, imaginative realms but CORPORATUS EXECUTUS live in the very real, MATERIAL WORLD!

(ANIMATICUS SOON LEARNED TO LOOK OVER THEIR SHOULDERS AT ALL TIMES!)

NOTE: ANIMATICUS EXECUTIVES, MANAGERS & PRODUCERS of ALL KINDS TEND TO BECOME PREDATORS OF, AND ASSUME CONTROL OVER, OTHER PEOPLE'S WORK IF GIVEN HALF A CHANCE!

An unwise decision made today will invariably come back and nip you in the butt tomorrow!

"Endangered Species"

"Endangered Species" actually began with two separate ideas in mind. The first was that I felt the need to pay homage to the classic, signpost moments in popular animation's history. The second was that, frustrated by the failures of the 2D industry to evolve and perpetuate itself, I wanted to record the rise and fall of traditional 2D animation, one of the greatest art forms ever created. I also hoped that the film (as well as this companion book) would inspire and enable others to pick up the pencil and move animation on to new horizons of excellence. In all honesty, even though I had an extensive (and rewarding) experience of over 30 years of practical filmmaking, I actually knew very little of the true history of animation myself. I knew of the Fleischer, Disney, and Warner Brothers studios, of course, as well as a number of the other, less brilliant lights in animation's firmament, but a detailed history of the industry I love so dearly had somehow eluded me throughout my career. Things changed when I was asked to offer an extended course on the history of animation for my digital arts students. In preparing the course, I developed a huge appreciation of some of the lesser (but nevertheless great) pioneers of the animated history. My more mainstream teaching duties encouraged me to study, analyze, and teach the actual principles of movement involved in some of the greatest moments from animation's chronological past. In all honesty, there was no sudden "Eureka!" moment that I had to do this film; it was more a slowly developing realization that this was an idea that I needed to bring to fruition.

Ultimately a third reason for embarking on the film began to press itself upon my consciousness. Although I love teaching animation and had been doing so full-time with absolutely no regrets, I desperately missed the process of production. In maturing an idea into a short film, I could kill three birds with one stone. Inspiration was achieved. Now perspiration would need to follow!

The Buzz Lightyear look-alike character I designed for "Endangered Species."

It should be noted that with "Endangered Species," I was facing a potential intellectual property nightmare! The entire film is an animated tribute to some of the greatest, classic animated moments of all time, so everything I did was in danger of offending just about every major cartoon intellectual property vehicle! The ideal solution would have been for me to write to all the owners of each of the characters and ask for their permission to use them. This would almost certainly be impossible to do. Even if agreements could be struck in principle, which I doubt would happen in reality anyway, the collective fees for these animated icons would be beyond the means of even the most affluent of Hollywood studios. A humble teacher's salary would just not cut it!

I had to take another route. I still acknowledged and re-created the moments from animation's history that have so inspired me. However, instead of using the original, intellectual-property-bound characters, I created alternative characters and new settings and scenarios that were not the same as the originals but those of a parallel universe I conceived around an animator's desktop.

This way, animation became the star of my film, not the original characters or settings that first established it. Even the actual animated movements from the past were effectively parody and tribute, which, in legal copyright terms, can be acceptable in specific circumstances. Artists can use an existing copyright in situations such as honoring, lampooning, and caricaturing, as long as the reputation, or the sales, associated with that copyright material are not damaged in the process. "Endangered Species" in no way seeks to do harm to any of the material portrayed. Instead, it not only documents an industry's historic achievements but it also defines the art of that movement for educational purposes. For all these reasons, and simply for the fact that I hope viewing the film will inspire audiences to go out and buy or rent the original movies to experience the magic for themselves, I do believe, hand on heart, that I have taken an honorable and legally acceptable approach to the project.

Evolving a Storyline

Ok, so let's say you've navigated the potentially treacherous and turbulent waters of intellectual copyright and its inherent dangers of plagiarism and you're ready to move on. The next stage is storyline. Whether you are making a film, a TV program, a computer game, or even a Web site movie, you will now need to progress your basic idea into a storyline that an audience or player can identify with. The very best storylines tend to contain three essential elements: set-up, conflict, and resolution.

In the set-up stage, you introduce your audience to the setting, characters, and circumstances of your story. Unless the opening of your storyline is deliberately conceived to shock, deceive, or confuse, the audience needs to be introduced to the world you are about to take them into. All the parameters of your storyline are set at this stage.

The conflict stage in your storyline is often the point where things start to go wrong for the characters. Characters might behave out of keeping with what we believed them to be, or our hero character may suddenly be threatened by unexpected, or out of control, events around him or her. Perhaps a new character or another form of disruptive element is introduced to the plot, which turns the entire status quo of the story upside down. Whatever the cause, a definite conflict materializes, something significant enough to turn our cozy, established world, or its way of being, entirely upside down.

As implied by its name, the resolution stage is the point of the movie (invariably the end of the movie but not always so) when the conflict we have introduced comes to a climax and is resolved in one way or another. This can give us a happy ending, a sad ending, or an ending that leaves audiences wondering. But it does need to resolve the storyline we have established in the first two stages so the audience feels some kind of satisfaction that the outcome is as it should be. The only exception to this would be in a series, where you deliberately leave the audience hanging, wanting more.

In "Endangered Species," the conflict in the storyline was symbolized by the spirit of Walt Disney leaving the dying ape's body.

The Hero's Journey: Story Structure

There are almost as many theories of storytelling structure as there are scripts in Hollywood. Some are helpful and some are very misleading. None of them should so entirely dominate your story outline that it inhibits you from expressing your idea. Occasionally films come along that baffle and contradict all theories of story structure, such as the disturbing "Memento," which is totally unique in its mind-twisting format and storyline. Most successful films, especially animated films, follow a more traditional "beginning to end" structure. One example of a successful and popular storyline structure approach that is used a lot today is outlined in "The Writer's Journey" by Christopher Vogler. (Michael Wiese Productions, ISBN 0-941188-3-2) Based on Joseph Campbell's notion detailed in his book "The Hero with a Thousand Faces," it is suggested that a specific sequence of archetypal events, known as the "hero's journey," can occur in your storyline, offering a solid story template upon which characters and events can evolve. The stages of the hero's journey are as follows:

ORDINARY WORLD

CALL TO ADVENTURE

REFUSAL OF THE CALL

MENTOR

FIRST THRESHOLD

TESTS

ALLIES

ENEMIES

APPROACH TO THE INNERMOST CAVE

SUPREME ORDEAL

REWARD (SEIZING THE SWORD)

THE ROAD BACK

RESURRECTION

RETURN WITH THE ELIXIR

Although these stages sound mythic in character, they can be applied to all stories, in all genres, in all times and locations. The book better explains the process and its stages along the way, so I will not go into that here and now. Suffice it to say that it is one of the better structure systems and many great stories can be applied to it, whether or not they were originally written with this structure in mind or not.

Nothing is infallible or essential to the story building process – sometimes none of the traditional structures are the right structure for a story. Yet, many writers do find inspiration by crafting their storyline around frameworks such as the hero's journey. In truth, the importance of any framework is relative to that writer's ability to work within such a framework, and not be limited by it, as can happen if a formulated approach is taken slavishly. Ultimately therefore, it is for each writer to ascertain what system works best for them in the final analysis.

When developing a storyline, it is important that you have a clear overview of your objectives at all times. A writer can be so enthused or inspired by an idea that he or she begins writing the storyline with no idea of how it is going to end up. You can create a great set-up in your mind, a perfect concept for conflict, but then fail in the resolution. This I have done more than once and it is extremely frustrating to approach the end of a good yarn and not know how to end it! Over the years, I have discovered that, before being carried away by the inevitable enthusiasm of an idea, you must initially sit down and outline your story in as few sentences as possible.

You don't have to be
Shakespeare to write for
animation . . .

. . . but it helps if you
want to be original!

Summarizing the Storyline

The film industry has a concept called the logline, a device used by many scriptwriters and production companies to give a prospective investor or distributor an immediate understanding of what their project is about. They attempt, in just a few sentences, to sell the entire film storyline in a way that is more like a TV commercial than a serious piece of prose. The logline is made up of juicy verbs and adjectives, all conceived to grab the interest of those who read them. These days, powerful, influential people have very little time to read an entire script or project profile document, so the simple logline is the answer to their prayer. Often whole projects can succeed or fail on the logline. Similarly, success at a complete and viable storyline for your idea can depend on you formulating a successful logline also.

It is often said that if writers can't explain their scripts in three sentences, they don't know what their scripts are about! By distilling your idea into this kind of brief statement, you ensure that you already have a strong grasp of your storyline. A patient reflection of just where your storyline is going, and where its twists and turns will take you, is effort well-rewarded. So many ideas start with great passion and turn into a whimper of failure because the bigger picture was never understood by its writer in the first place. A well-authored logline will go a long way towards clarifying, within your own mind, just what kind of story you are telling.

"Endangered Species"

Here's my logline for "Endangered Species": A young baby approaches an animation desk, picks up a pencil and draws. As he draws, we see the animated creations projected onto a cinema screen as moving film images. The child grows as he draws, from youth, to a young man, then a mature man. The films he creates on the screen evolve significantly as he ages, from sound, to color, to devastating imagery and performance. Eventually, with old age and feebleness now upon our hero, a new challenger emerges which effectively heralds the end of the old man's journey.

Okay, so it's not quite a three-sentence logline, but it is a suitably brief, descriptive, in a nutshell logline of what "Endangered Species" is about.

The storyline of "Endangered Species" did not actually come to me as easily as it sounds. As with a great many things that seem uncomplicated when they are done, there was a great deal of deep thought and soul searching to arrive at this concept, as well as a lot of detailed writing and ultimate concept rejections. Even then, the ultimate story ending was changed subsequently to provide a small twist to the logline ending, and then even a newer twist was added to this new end during the eleventh hour of production.

Dedicated to the Truly Dedicated

As I researched the history of animation and learned more and more about the true Walt Disney, I became even more in awe of the great man and his dedication to the evolution of animation standard. As a result of this eye-opening revelation, I dedicated the entire film to his philosophy and his memory. Although not in any way suggesting that I channeled Walt's thoughts and opinions here, I would nevertheless regularly allow my imagination to roam during the story creation aspects of the film and conducted an imaginary conversation with him in my mind. I would ask what he thought about this scene or that scene, or this movement or that movement, and try to anticipate his responses, in view of what I knew of him. I never did receive a direct answer from him, of course, but I do sincerely feel that he would approve of what I have done in this tribute to his name. At least, I hope so!

"Endangered Species" recognizes Walt Disney as the founder of all great animated storytelling.

Scriptwriting

The first thing you may need to decide, as you sit down to write your script, is what genre (horror, detective, sci-fi, etc.) it may fall into. It is not essential for you to hang your script on any of the genre pegs at all. But, if it does conform to any one of them, it is useful to study the style and techniques such genre movies embrace, as it can be extremely helpful in writing a story that follows the accepted motifs of that approach.

Animation is said to be a genre all of its own, but I do not hold this as absolutely true. Animation has too many possible themes, styles, and approaches to assign it to any one genre. I suspect popular opinion on this would suggest that the cartoon film IS the animation genre. Yet I strongly feel that animation is worth far more than that single viewpoint and believe even more that its full potential has been hardly exploited, even now.

One fundamental thing to remember, especially for animators who tend to think visually and in movement first and foremost, is that action alone does not make a good script. Other aspects of the storytelling process have to be finely tuned too. Characterization and dialogue are central to an accomplished screenplay, and unfortunately animators often struggle in this area. They tend to make their characters stereotypically cartoonish and the dialogue simplistic and without depth. In my storyboarding classes, I often spend half of each class showing films that the average student may not see on TV or at the cinema complex in their area, such as independent films from other parts of the world, in different genres with different cultural and dialogue approaches. I don't expect the students to remember or critique the films as they see them, but I do expect the experience of the film to sink deep into their subconscious to rise again, at some other time and some other place, and maybe influence the way they create and the way they write in a more un-stereotypical way. These students may not ultimately create the next animated masterpiece, but they will at least have a greater feeling for a better and broader form of storytelling, with perhaps improved staging and dialogue approaches. Films I've shown recently have been as diverse as "Spirited Away," "Tampopo," "Strictly Ballroom," "Brassed Off," "Amadeus," "Amelie," "Like Water for Chocolate," "The Waking of Ned Devine," "Memento," "Moulin Rouge" (the Baz Luhrmann version), "Rabbit-Proof Fence," "Grave of the Fireflies," "The Triplets of Belleville" and "Behind the Sun," all of which are exceptionally well-written pieces exercising entirely different sensibilities. Of course, this list is by no means exhaustive or exclusive, and the list of outstanding films grows significantly every year. Nevertheless, it is certainly a safe and wide-ranging starting point of experience, a less than mainstream cross-section of influences that would benefit any diligent student to be exposed to.

In Hollywood, it has long been said that there are only three things that make a great film: the script, the script, and the script! This is no less true for animated films, and any script for animation (whether long or short form) must be disciplined, entertaining, and well thought-out. Anyone who has experienced the endless agonies of an international short film festival, sitting through usually bad short film after bad short film, for days and days, will know the relentless suffering inflicted on the audience by the majority of inexperienced animated filmmakers! Rarely do animated films genuinely touch, inspire, surprise or simply instruct. But when one does finally come along, it appears like an oasis to a thirsting man in the desert.

All too often, many animated films (shorts films, especially) are universally criticized as being too self-indulgent, poorly conceived, or devoid of any real human content or structure. The same is said of many game scenarios. Action heroes, high-tech machines, space adventurers, comic book stereotypes, and vampire variants do seem to dominate the student film and games culture. Hollywood tends to churn out endless formula pictures that are essentially family-oriented cartoon films. However, significant variations to this once inviolate rule have emerged in more recent times which give audiences cause for hope, films such as "Spirited Away," "Grave of the Fireflies," and even "The Triplets of Belleville." Could the recognition and respect of these kinds of film mean that there is finally a new departure into more positive, mature, uplifting, and accessibly surreal films? One can only hope so.

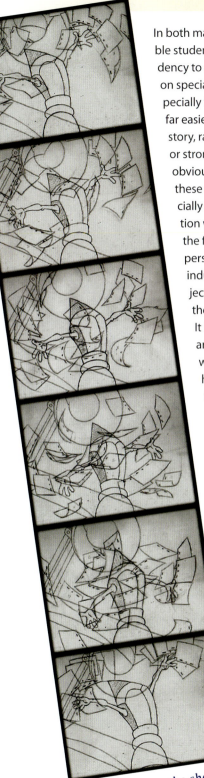

In both mainstream Hollywood movies and humble student films, there is an exaggerated tendency to concentrate less on storyline and more on special effects and digital trickery. This is especially true in 3D animated action, where it is far easier to let the visual wizardry dictate the story, rather than good character movement or strong story content. (The Pixar studio is an obvious exception to this!) However, many of these films can be profoundly boring, especially once the novelty of the visual innovation wears off. There can be little doubt that the filmmaker has derived a great deal of personal pleasure and satisfaction from their indulgence in visual trickery, but sadly, objective audiences of such films may find them story-sterile and emotionally remote. It is very rare that first-time student films are story-driven and character-evolved, which is a huge pity, considering the huge amounts of tireless, dedicated effort that is often otherwise poured into the projects!

On the tip of a pencil there are still huge new universes to explore!

I tried to capture the sheer exuberance of inspired animated filmmaking when I paid this tribute to Disney's "Fantasia."

The real attraction of the animated film, as opposed to more prevalent live-action variety, is the fact that there is literally no limit to the bounds of the writer's imagination, whether the film is to be produced in 2D or 3D. If you can think it, you can draw it. If you can draw it, you can animate it. No hard and fast rules can therefore be laid down to cramp the creative animator's flow, except those that define filmmaking in general. As a result, I encourage every young, animated story person to desert the stereotypical (and therefore predictable) cartoon action hero and instead investigate entirely new areas of imagination, creativity, and expression. In truth, there are so many worlds for animation yet to explore, some which have not even been dreamed of so far. Animated storytelling is like the tip of the iceberg; so much has yet to be revealed. I would even venture to suggest that animation's continued existence depends upon it!

Traditionally speaking, when writing for animation, realistic, humanesque characters are best avoided, as they still tend to provide the most difficult challenge to convincingly pull off for both 2D and 3D animators. Even the great golden-era Disney studio failed to solve this problem, causing Walt's writers and animators to ultimately admit defeat in this particular aspect of animated characterization. Animals always proved much richer pickings for them, as we know. Similarly today, robotic and alien fantasy characters seem to provide the most fertile ground for the 3D animator. Although breakthrough virtual reality movies like "Final Fantasy" did achieve a kind of unique and impressive technology-driven photo-realism, the movie still left a lot to be desired as a fulfilling storytelling experience and expression of characterization and personality. No matter how highly rendered and photo-real the 3D characters may be, they still cannot engender the subtlety or minimalist acting capability that real actors can. For example, the greatest actors of stage and screen have a subtlety of look and expression in their eyes, even when they are not actually speaking, that is immediately capable of conveying an emotion, a mood, or a thought. On the other hand, the eyes of even the most exquisitely modeled 3D characters look vacant, glassy, or soulless. I am absolutely convinced that, ultimately, an animator will have biochemically engineered human-like clone characters to animate, which will replace both the human actor and the 3D animated character. However, until that God-like day comes, I think it will remain effectively impossible for an animated character of any kind to pull off the same high level of acting performance that the accomplished human actor can. Scripts and storylines for animated productions should take this into consideration.

Despite all this, I hope there will always be those in the future of mainstream animation who will attempt to seek that inventive and innovative midway point between the cartoon world and that of human realism. The classical art of caricature perfectly bridges that gap often pushing realism to cartoon-like distortion in the process. Chris Wedge's "Ice Age" made a valiant attempt at embracing such Henry Moore-like caricatures when evolving his sculpturally inspired cavemen characters. Sadly, the animated acting performance of these characters left a lot to be desired, unlike the animated animals (especially Scrat, the wonderfully accident-prone, nut hoarder whose Warner Brothers mannerisms stole the show!).

Animated dialogue is also a difficult aspect of character expression for the animator to succeed in. This is due more to the limitations of the medium than a lack of knowledge in the animation community. For example, with a live-action film, if you stop on a single frame during a fast-talking dialogue sequence, you will see that often the lips on the actor's face appear blurred. This is because, at one twenty-fourth of a second,

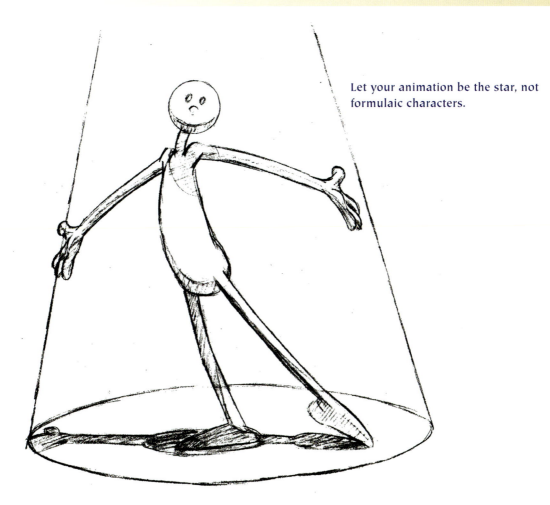

Let your animation be the star, not formulaic characters.

the standard movie camera is incapable of capturing a sharp image of anything that moves fast. Shown at full speed however, the fast-running projected frames do not show the mouth as blurred at all. This is in marked contrast to the far less natural, hard-edged, non-blurred mouth positions the animator has to provide, and probably why animated mouths just don't seem as convincing as live action ones.

Digital technology can offer image blurring on specific parts of the character and that can quite easily include the mouths. However, most independent or student productions have neither the time nor the budget to go over every dialogue frame and individually manipulate the mouths, one by one, as a big Hollywood picture might. The animator has severe limitations on the naturalness of animated lip sync (matching the mouth positions to the words heard), even before they begin! The live action directors, however, do not even have to think about how the mouths will sync up to the sound. With this in mind, it is suggested that the animation writer keep the dialogue sequences in a story to an absolute minimum. The good animation writer will be able to come to terms with this when plotting the length of dialogue sequences, or else find a way to circumnavigate the dialogue problem with other alternatives.

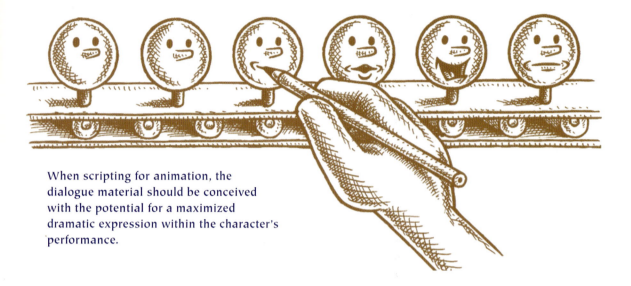

When scripting for animation, the
dialogue material should be conceived
with the potential for a maximized
dramatic expression within the character's
performance.

It goes without saying that the subtlety of delivery and expression that a talented ac-
tor can bring to the screen far outweighs the limited, caricatured performance that a
speaking animated character can deliver, however good the character animator creat-
ing it may be. "Spirited Away" is one of the most subtle, enchanting, and mature films
ever animated, in my opinion. Even so, and even despite the fact that the dialogue is
well-dubbed in English for the easy assimilation of western sensibilities, the actual de-
livery of dialogue is disappointing. This is not to criticize Miyazaki's masterpiece. It is
just to underline that even the most crafted of animation artistry will fall short of the
mark when characters are expected to deliver subtle, realistic dialogue. Some of the
most profound and emotional moments in "Spirited Away" are when the characters
allow the stillness of a moment to communicate their thoughts and feelings to the
audience.

Unless anticipating the most ambitious of budgets, the animation scriptwriter should
attempt to avoid large and extravagant crowd scenes, or multiple character shots with
full and furious action, except at imperative moments. While live-action filmmakers
can herd in hundreds of extras to shoot a crowd scene in a day or so, it should never be
forgotten that the animator has to either draw or model each one of these characters
in an animated film! In multiplying the on-screen requirement by many tens of times
(or hundreds, if the crowd is a huge one) there is a significant effect on the entire pro-
duction, both from a time and budgetary point of view. The same is true of large-scale
action sequences and complicated special F/X shots. Of course, digital technology can
accommodate virtually anything in this day and age, but it is doubtful that the produc-
tion budget will, or the necessary production time to accomplish what is scripted.

Obviously, there will be moments in any significant script when such plot events are
required to occur to achieve climactic moments within the film, but the recommen-
dation is that these are only saved for the few necessary moments and others can be
written in other ways that arrive at the same result in the audience's mind.

These are just a few of the more important danger areas you should consider when scripting your animation. Without a doubt, you will certainly encounter a number more as you progress and become more ambitious. But as with everything in life, the more you attempt, the more you will learn from it. Professor Experience is a great teacher, whether he ultimately teaches you with the carrot or the stick! Animation can be so innovative in its expression that maybe you alone can find new and ingenious ways to circumnavigate all these no-no's. Just remember, the true magic of the animation lies in its innate capability to take us to previously unseen, often unimaginable worlds where we cannot normally go. You should therefore view it as a medium of liberation, not limitation.

NOTE

I always told my advertising clients they could do anything they wanted; it was just a question of enough time and enough money. Invariably, compromises in their lavish ideas modified the approach from that moment on! There is a parallel idiom: "There are three things I can offer you: quality, quantity, and cheapness. Pick any two and let's budget from there!"

Actually, when it comes right down to it, there really is no substitute for a darned good story, whatever medium it is being told in. What is often criticized as cliché is cliché because it works time and time again. That is not to say that I applaud formula pictures, but there are some fine core themes that return in great stories again and again.

I personally believe that the best stories are still those that have a traditional beginning, middle, and an end (set-up, conflict, and resolution), but there will always be exceptions that will astound and inspire. The real challenge to the writer is to express

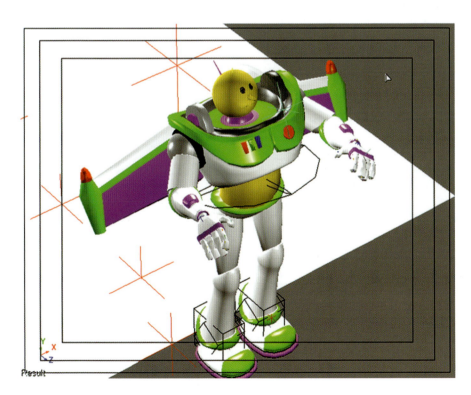

To 3D, and beyond!

these core themes in ways that have not been thought of before. True, there will always be those who transcended the traditional guidelines (and emergent writers and filmmakers should always attempt to cover new ground) but to do so and ignore what scriptwriters have discovered and evolved through decades of triumph (and some disaster) can be a huge mistake.

To break the mold you have to be totally convinced that first there is indeed a genius demon in your pen! Animated classics—the true, great classics that are witnessed in all the very early Disney movies (and more recently through the works of Pixar and a small number of Japanese filmmakers)—are disciplined, well-constructed and creatively inspired pieces of original storytelling. While they do conform to certain traditional strictures, their creative and visual innovation is what sets these classics apart from the also-rans. The secret of all great stories is that they are so inventive that they carry their audience beyond the traditional formulas and clichés that underpin them. Sadly, most contemporary animated movies inherently fail to do this because they mostly see cliché as the end game.

The other secret that the Disney studio, especially, evolved during their golden era was the fact that everyone on staff was encouraged to contribute ideas to the project storyline, in visual terms, not just in writing. Walt was often disinclined to employ scriptwriters. Instead, he encouraged his creative team to sketch their ideas out as story frames of action that could be pinned up onto a board and moved around until a solid storyline developed. Indeed, it was because of this that the notion of a storyboard evolved.

The truth is that even before a single drawing was ever produced, it took many months of dedicated effort by a whole army of wide-ranging Disney talents to create the final movie script. Walt oversaw it all, but, the final storyline was never his sole input. He never wanted it that way for he knew that no one person, scriptwriter or otherwise, would have all the story answers in his or her head. He relied on the visual abilities of his talented staff to evolve ideas into great stories and productions.

Although this initial storyboarded sequence for "Endangered Species" was devised for a different objective, it does also illustrate the process I go through when creating ideas. First I mull them over in my mind for some time, then I let go and switch off for a while, then I get a "Eureka" moment which I turn into tangible reality through my drawing board or computer. Yes, I often sleep on a problem, only to have the solution pop into my mind the following morning!

The greatest enemy that the independent or student filmmaker has when writing a script is isolation. The lack of objective feedback to their ideas often results in a significant lack of basic accessibility in their communication with an audience. I highly recommend that all filmmakers find reliable, objective opinions on their work, especially at the story building stage.

"Endangered Species"

Having conceived of a dual world for the film's storyline (the real world of the animator at his desk and the imaginary world he creates, which is depicted on the movie screen), I attempted to weave in a story idea that not only represented the story of an individual's life evolution, from birth to death, but which also reflected the evolution of the animation industry through the decades of the 20th century.

In reality, the scripting of this film was more a process of pencil sketching and reference film assembly than by actually writing it all out. For copyright reasons, I cannot show my original film edit on the accompanying CD-ROM, but I freely admit that I initially created an animatic of my concept from the onset, using simple drawings to represent the life stages of the animator at his desk and the original film clips I extracted from the sequences I wished to pay tribute to. All this work actually pre-dated everything that was written in the ultimate script! Walt Disney used to create his storylines more from the sketches and storyboards of his in-house creative teams than the scripted text of conventional writers, so I felt confident that this was a good way to go.

The title had been lodged in my mind from day one, when I heard the song of the same name by Waylon Jennings and thought that it applied to the state of my own industry. The next decision was which genre would be suitable for the subject matter. After some significant thought on the matter, I decided that the whole project should have a documentary feel to it, very much after the style of the great wildlife documentaries (such as "The Blue Planet" or "Walking with Dinosaurs"). This gave me the strong concept foundation on which to build everything else.

The secret of all new and innovative animation is to think outside the box and explore new frontiers of idea and expression. This image is the prelude to the sequence in "Endangered Species" that pays tribute to the unique "Yellow Submarine" movie.

I found it incredibly intimidating to relinquish traditional production techniques for the newer digital ones at the outset. But, once I had surmounted the challenging learning curve that this initiation required, I now have to say that I could never go back!

The final serious consideration I needed to attend to was the actual content of visual material and how this needed to be balanced with the extremely limited time and budget resources I had at my disposal. A college teacher's pay is minimal, so I had next to nothing in terms of budget to play with. The Henry Cogswell College in Everett (Washington State), where I was teaching at the time, had specific animation and film-making equipment I could use at will. So I did at least have a studio environment to work in at no cost. This was a huge advantage. The final resource I was in short supply of, however, was time—between classes and during evenings and weekends at home. This meant I could not consider including huge, ambitious scenes in the film, although I did not hold back on attempting to re-create some of the fine animation that graced the industry throughout its existence. I ultimately decided that I would show a solitary animator at his desk in a black limbo world that suggested isolation, which is actually how it feels when you are a zoned-off, long-haul animator working intently on a project. This solution also saved on background artwork too!

The film clips I selected could not be huge crowd scenes or wild and expansive scenes of detailed special effects animation, for they would demand huge amounts of pencil mileage on my part (even though there was some fabulous original material that I would have loved to have tackled). Ultimately, I chose scenes that simply inspired me for their innovative originality, quality of performance, or just their excellence of animated movement. In many cases, I didn't know who had animated each original scene, but they were all significantly inspirational pieces to me and ones I wanted to deconstruct.

I screened an unbelievable amount of animated films, short and long, Hollywood-based and otherwise, and eventually assembled a collection of clips that I believed were on the short list of contenders for inclusion. I then began to sift through these contenders, re-evaluating and eliminating them, sketching scenarios for my animator at his desk, through which he would grow and mature as the historical clips began to grow and mature. Eventually I whittled the whole thing down and that's basically what ended on screen, although at first the film animatic was originally conceived as a four-minute piece, and the final piece stretched out to just over eight minutes.

Once this initial agonizing was complete, I had a structure for my animatic storyline that I could share with others and gather feedback on the basic concept. I demo-recorded the initial voice material myself, to give me an understanding of the timings I needed to work with, knowing I would record the professional actor voices later. A few subsequent modifications ensued after my sharing the whole thing with others. But, by and large, the storyline structure could at last be set in stone, meaning that I was at last able actually sit down and write a script. (This I did mainly for the final voice artists to use during the recording sessions that were to come, for the animatic was all I really needed to work with in terms of story construction and filmic timing.) In all honesty, the script I arrived at was effectively a written transcription of the animatic I had already edited together, clearly not the conventional way of working in this day and age!

Character Design

You can take the character out of Disney but you can't take the Disney out of the character!

Simple is always best!

W ithout question, the script is the most important ingredient of any film, but the character designs play a huge role in the execution of that script when it is animated. The animated characters are the equivalent of a cast of actors in a live-action movie. Your visual casting of the characters is of paramount importance, as is their capability to perform in ways that the storyline dictates. Character designs must work well individually, but they also have to work well together. How many movies have you seen where the principal characters have a particular style of design but the incidental characters look as if they are another species? The design approach should be consistent throughout, from character to character and from characters to backgrounds or environments.

Character designs especially need to caricature the personality and emotional traits of the individuals concerned. It is always easy to create insects, robots, and aliens that will fight out a fantasy adventure script, but it is extremely hard to design humanesque heroes and heroines that have to sensitively deliver dialogue and convey subtle emotions. It is equally important that they don't look insipidly cute, overly saccharine, or wishy-washy. It is extremely easy to create a wicked villain but very, very difficult to create an acceptable hero.

Like live-action casting, it is so easy to fall into visual stereotypes with animated character design. How many TV shows or big screen movies reveal who the bad guy is the minute they walk on the screen? They just look menacing, dangerous, or flat-out bad! Similarly, the male and female leads are always handsome or beautiful, and the fool always looks a fool, so you can identify these characters before they even say a single word! It seems to be the same with animated characters. All too often, we see characters that are just rehashes of previous stereotypical characters. Wouldn't it be exciting if, for once, the animated filmmaker broke the mold and created an evil character that was actually good-looking, or a hero that was actually bad-looking? Shrek is a perfect example of the impact (and popularity!) of the contradiction between appearance and personality. And what if the true personality of a character was only revealed through the plot and acting performance, rather than the give-away, stereotypical design style?

"Ani-mentry, my dear Watson!"

There are signs of hope, of course. Both the male and female leads in Shrek were quite ugly by conventional tastes. This was a major part of the refreshing plot line and yet the princess was also exceptionally beautiful in her glamorous daylight guise too. Better character design demands a greater imagination on the part of the creative team. Characters should not be just a collection of funny cartoons. The director carries a huge responsibility here; if he or she thinks further, then the character designers will travel further.

The Evolution of 2D Character Design

Since anything is possible in animation, there should be little problem coming up with character designs that are both original and exciting for an animator to work with.

However, much of the contemporary animation conforms to the same old stereotypes. In the early 20th century, when 2D animation was still in its infancy, there were few restrictions to the appearance of animated characters. However, as the needs of a professional production operation required (i.e., enabling a whole number of different artists to work in the same style with little trouble), simple, rounded cartoon characters were developed. These characters held little respect for the restrictions of the real world. Their limbs were rubbery, twisty, and able to squash and stretch in length, at the whim of the animator. In fact, these characters soon became known as "rubber hose characters," and the films of the 1920s were dominated by them.

"Rubber hose characters" had simple, rounded shapes and little sense of real human physiology.

Even early Disney used a rubber hose style of movement, until Walt looked for more innovation and reality in character design. The Disney studio, therefore, slowly began to design animated characters with a more human dynamic. They evolved characters that appeared to have a skeletal structure, and that brought in an entirely new challenge for animators. They were no longer able to twist, stretch, and distort their characters' limbs at will. Now these limbs could only bend and move the same ways a human skeleton would.

As animation consciousness evolved further over the years, it became obvious that it was not enough to simply move characters well. Now, if their true personalities were to evolve and be fully convincing for an increasingly discriminating audience, these characters had to emote and feel as well. The personality within the body had to be fully realized, and certain characters even underwent an analyst-style assessment of their psychological attributes. This personality and psychological character development added new realms of animatic expression. In "The Illusion of Life," by Frank Thomas and Ollie Johnston, there is a perfect example of the psychological profile that Art Babbitt developed for Goofy, enabling Art to get into Goofy's head, beyond the surface features.

One of the most timeless characters ever created was Mickey Mouse. Here, tribute is paid to Mickey as the "Sorcerer's Apprentice."

The Evolution of 3D Character Design

3D animation, unlike its 2D predecessor, has by necessity essential limitations to a character's movement and expression. 3D characters require skeletons as their core foundation and can only move in accordance with prerequisites assigned to each joint and spinal movement. There is none of the squash and stretch capabilities of the early cartoons here, although the same effect can be achieved by knowing how to use the joints and limbs accordingly. Aesthetically too, the actual design of the 3D character has already evolved into its own particular type of stereotype. While 2D animation is usually defined as cartoon, 3D is beginning to be defined as sci-fi, humanoid, robotic, alien, and/or superhero. There are, of course, some notable and impressive alternatives to this, such as the Academy Award-winning masterwork "Ryan," by Chris Landreth. But, by and large, 3D defines itself most by the kind of heroes and villains that live and move most effectively in a computer game reality.

3D animation remains unchallenged in the domain of animated special effects (F/X) as well. F/X range from the amazing lifelike artificial creations found in "Final Fantasy" or creature characters that realistically blend into live-action movies, such as "Jurassic Park" and the masterful "Lord of the Rings."

3D animation still has a long way to go before its natural evolution unfolds, so it is too soon to suggest too strongly that it has already developed clichés and formulas. Just as Disney's empire all began with a mouse, so Pixar's emergent empire began with a toy. At the time of "Toy Story," 3D animation and design was just emerging out of the "wow" stage.

As with all new things in their infancy, their novelty alone invokes the wow from all who sees them. It mattered not that this new art form wasn't able to create characters and personalities the way that 2D animation could; the fact that you could see

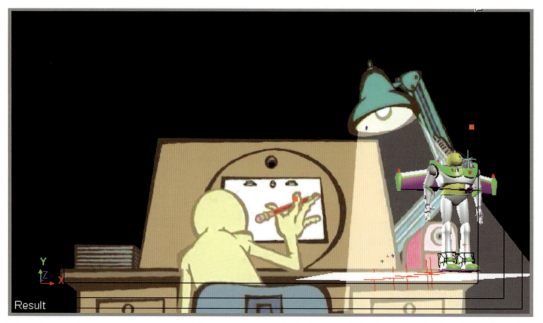

The mixing of the 2D and 3D worlds is now more technically possible than ever before. However, this alliance is often a conceptually difficult one to pull off.

a moving, almost photographically real, three-dimensional object twisting and turning, and morphing and traversing depth, breadth, and scale, was enough. Certainly, amazing as it all was technically, the traditional 2D animators lost no sleep in recognizing that the new medium could not challenge them for character animation, and so they were safe. At least, that's what they thought! Then along came "Luxo Jr.," and the whole industry was blown wide open!

Even with the charm and personality that John Lasseter put into those simple lamps, the 3D world was not quite ready to compete with Disney, not just yet. But recognizing the limitations of 3D character design and animation, Lasseter astutely chose toys as the first challenge to the Disney monopoly. Toys have a limited expectation of movement from the audience's point of view and yet the shapes, surfaces, and textures of toys were within reach of the available knowledge and technology. Lasseter knew that, ultimately, it is the story that makes the film, and if the animated characters moved well, the story lived. The result, "Toy Story," is one of the finest animated films ever made. (Unless you count "Toy Story 2," which was even better!) Suffice it to say, by 1986, 3D animation had arrived.

Even so, 3D was still not ready to challenge the accepted world of blockbuster animated movies quite yet. But it would do so in carefully studied stages. Having conquered toy animation, animators had to seek out a new character realm that would lend itself to the 3D medium. It was found: insects! Insects have the shape, form, and texture that lie perfectly in the domain of computer technology and the limited expectation of their movement was not too major a challenge to the emerging medium of animation. "A Bug's Life" was born. Since then, the Pixar studio has ventured even further into areas of character design that were not thought possible until that moment, such as fantasy monsters, fish, and cartoon superheroes. As with 2D animation before it, 3D has yet to conquer the human form in a way where the characters can act naturally and not look like plastic models or wooden sculptures without the spark of true spirit within them. But, it WILL come!

The mixing of the 2D and 3D worlds is now more technically possible than ever before. However, this alliance is often a conceptually difficult one to pull off.

Animation Style

I suspect that all this goes to suggest that as infinite and as imaginative as animation character design can be—2D or 3D, or even Claymation or cut-out—it still has the inherent limitations, or principles of design, that can drive designers to discover bigger and better things. The worst thing a character designer can do is compromise themselves by doing the "same old, same old" or producing look-alikes (of other characters and productions) that are essentially artistic cop-outs that take the industry nowhere. That acknowledged, let us nevertheless examine the eternal principles of animated character design that need to be taken into account when considering the design of a character for your next animated venture.

The creation of any particular character is perhaps the most subjective thing a director has to contend with. Tastes change from designer to designer, animator to animator, director to director, and, of course, generation to generation. As we have suggested, Hollywood, and specifically Disney, tends to fall into pretty predictable stereotypes, although, admittedly, they have occasionally attempted to breakout from their self-imposed formula straightjacket with varying degrees of success. The TV networks have definitely been far more adventurous in this department and more recently the games industry has begun to develop a design identity entirely of its own.

From the independent filmmaker's point of view, there have been many great and valiant attempts to change the notion that animation is cartoon films. Most notably, in the broad, generic sense, have been many of the Eastern and Western animators, the Japanese and, during the 50s, 60s, and 70s, the National Film Board of Canada. Much investigation of these styles and animation cultures will be very rewarding to the designer in search of inspiration. But in reality, anything can work for animated design. For retro inspiration, it is worth looking at the early designs of pioneer like Winsor McCay and the Fleischer brothers for almost surreal invention. Although a strong admirer of the cartoon tradition of animated design, Richard Williams moved animation design

Richard Williams had no fear of animated complexity or detail. In his Academy Award-winning "A Christmas Carol," interpreted here in the modified Animaticus style, he rendered each character with an infinite number of cross-hatched lines.

forward into more artistic and illustrative realms. His major accomplishment was the Academy Award-winning TV special "A Christmas Carol," which replicated the complex engraving style of John Leech that had been used in the original Dickens book.

Independent animated short filmmakers (in and out of the mainstream cartoon tradition) have always experimented with a myriad of different styles and design approaches, the UPA (United Productions of America) movement in the U.S. being the most successful of the anti-Disney school of design in their day. Despite its detractors, the conventional cartoon approach has always thrived, an influence that is still prevailing in contemporary animation's most recent incarnation, Web animation. We might wonder, therefore, just why it is that the cartoon style is so popular and consistent. Perhaps it essentially lies in the needs of character design when applied to animation. An animated character, by necessity, has to be easy to draw, consistently proportioned from all viewpoints, and should not involve too much pencil mileage.

Apart from the most simplistic of 2D animated styles, characters are going to have to move and be seen from all angles. Whether or not a moving camera is used, the character itself will need to do everything that a live-action actor has to do when performing. Additionally, 2D animation drawings have to be completed in a reasonable time and cost, so a character with infinite detail that requires an hour or more to draw each frame is a definite no-no for a realistic, full-scale production. Even with 3D animation, detail within the character's design adds to animating and rendering time, so detail and complexity needs to be considered on everything but high-budget advertising or more expansive Hollywood productions. Cartoons tend to formulize shape and simplify drawing (rendering), key factors in the production of animation. Cartoon characters are also far easier to copy for a wide-ranging spectrum of animator drawing abilities. Therefore, the cartoon style remains popular, although it is still so refreshing to see a few filmmakers stretch the medium and explore other avenues of caricature and design with their characters.

Early concept frame from "Endangered Species." I paid tribute to "Spirited Away" as it is one of the most original and refreshingly envisioned animated movies ever.

Guidelines for Character Design

The following items are all guidelines that should be taken into consideration when designing an animated cartoon character. Of course, I always believe that rules are made to be broken, as long as you fully understand those rules in the first place and know why you are breaking them. The rules of design and filmmaking are the culmination of decades of discovery and experience, accumulated by untold generations of animators and filmmakers. These rules are therefore established for a reason and should not be ignored outright.

Shape and Proportion

Firstly, the proportions of a character can very much underline a great deal of their personality. A hugely obese character would rarely be expected as the heroic male lead, as usually that role demands good looks, physical strength, courage, and agility. Similarly, a tall, gangly, long-limbed character cannot plausibly move around like a nervy, energetic, bird-like type, as neither can a short, thin, eccentric, and agitated character easily work as profound, mystical wise man. A great deal of fundamental thought has to go into the overall shape and proportions of a character, to ensure that its inherent personality traits be expressed best and, similarly, the relative size of that character to all the other characters it is to be seen with.

In addition to the inherent expectations based on a character's shape and size, note how it also dictates pose and stature.

Some characters are head and shoulders above others!

Head Heights

The standard formula is that the average human being is approximately eight head-heights tall, meaning that the head size is one unit and the rest of the body is measured as seven more heads. Superhero and comic book human types are drawn using these proportions. Most cartoon characters have a drastically different head height ratio. For example, the Power Puff Girls are two head-high characters (meaning the size of the head is the same as the size for the rest of their body). The more you stray from the human norm of eight head heights, the more exaggerated and cartoonish your characters become. Like scriptwriting, the tradition, culture, and genre of the film is often reflected in the design too. For example, the average head height size of a standard character from the Japanese manga school of animation is six head-heights tall.

Model Sheets

The problem with many of the non-cartoon, more illustrative 2D styles of design is that some characters' essential looks only work from a single viewpoint. Therefore, when designing a character for any particular animated medium (2D or 3D), the designer must consider what their design will look like from all angles and from all points of view. Although traditionally drawn animation essentially views everything with a two-dimensional view, one look at the very best of 2D character animation reveals that it is necessary to understand the character from numerous viewpoints, even for something as simple as an animated take or head turn. To ensure that the designer, the director, and the team of animators understand the full structure and nature of a particular character from all possible angles and perspectives, a character model sheet is created.

A model sheet is the blueprint of a character, defining its size, construction, and proportions. The model sheet traditionally must show the character from the three fundamental viewpoints—front, profile, and rear view—with sometimes a front three-quarter and a rear three-quarter view thrown in for good measure. A good model sheet will also define the head-height formula for that character and may even include close-up details of the character's features, such as hands, mouth, and feet. There can often be more than one model sheet per character, depending on the amount of construction detail required by the production team. Additional model sheets might also show specific attitude poses of the character, its relative size to other featured characters, and even mouth positions for vowels and consonants if lip-sync dialogue is anticipated. With Hollywood-level movie productions, if might also be advisable to create 3D clay models (or maquettes) of the main characters, so animators can pick them up and view their shape and form from every conceivable angle. Anything that familiarizes the animator with the character is valuable when designing an animation character.

Although I didn't need a preliminary model sheet before starting "Endangered Species," I did paste together drawings from previously completed scenes to create one.

Color Models

Once model sheets are established, additional color models of the characters need to be created, defining not only the model sheet information but also the colors and possible textures required for the characterization. With 3D character design, this is much more obvious, but in 2D animation, the color models will not only define the actual colors that make up that character but can also define outline techniques, line quality (in terms of the thickness or thinness), any hand-rendered textures that may be laid over the basic flat coloring, or anything else that defines that character from a design and coloring point of view. At the Richard Williams Studio in the 70s. and 80s there was no limit to the styles used for animated character design, whether that be traditional cartoon, "Roger Rabbit" molding, old book engraving styles, pencil-shaded rendering, woodcut hatching, or even old Master oil painting brush strokes. Each of these styles had to be defined in a color model form first, so each animator would know the required animation drawing style.

A color model for one of my "Endangered Species" characters.

Foreground/Background Compatibility

One final point must be made in relation to character design. It is extremely important, especially with the more traditional styles of animation, that the characters in a film are compatible with the background design approach. If two sets of production designers are hired, one for the characters and one for the background (environment) approach, their designs may end up with incompatible looks, especially for the lower budget and faster turnover productions, such as those seen on TV. Nothing is worse than seeing a character that is entirely out of keeping with the styling of the settings, or backgrounds, it is placed within. Of course, if a conscious attempt is made to break the rules (for example, a 2D cartoon character in a live action or realistically 3D-rendered background setting), then a very original, breakthrough look can be achieved. But, mostly, incompatible styles between the character and background approaches are distracting at best, or extremely sloppy and unprofessional at worst. It is essential to test the character design within the background or environmental setting before any commitment is made to the final production design.

"Endangered Species"

The character designs in "Endangered Species" were perhaps the easiest thing in the whole production for me. I recognized from the outset that if this film was to be effective and respectful (letting the inspirational animation be the star, not the characters), then the character designs had to be extremely minimal and simplistic. I also needed, for copyright purposes, if nothing else, to create a parallel universe where the events represented take place in their own, originating world, even though they are based on historical events.

Many years before, when I wrote and illustrated "The Animator's Workbook," I faced a similar challenge. I wanted to visualize the book as simply as possible, so animators of all artistic capabilities could focus more on the challenges of movement than on any complexities of the character design. This led to the simple, yellow man characters that I felt would also work in a film all about an endangered species. I adopted this style as the character design model for the entire film and produced a baby, a child, a young man, and an old man for this family of characters.

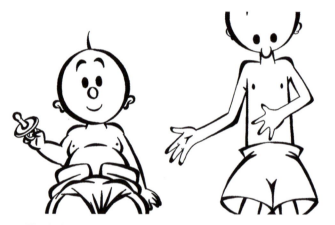

The baby and child character designs for "Endangered Species."

It might be imagined that, in comparison to the splendor and artistic excellence of the originating material, the inflatable stickman approach in "Endangered Species" was far too minimalist, or primitive, to do justice to the material under consideration. I felt the character designs for this film had three important criteria. First, the characters had to be simple enough that everyone can identify and easily comprehend them (even redraw them for analysis purposes, if necessary). Second, I did not want my animated characters to detract from the material they are inspired by and subject to. Third, it was very important to me that the characters were as far away from the original copyrighted characters as possible, to avoid any unnecessary legal conflict or litigation.

Ultimately, character and background design is such a subjective thing that no filmmaker will satisfy the tastes of every member of a movie's audience. In the case of "Endangered Species," the design viewpoint has always been "less is more."

Concept and Environment Design

The concept (or environment) design should not be underestimated in the process of design and development in animated filmmaking. While character design and animation are clearly the most important, it must be remembered that when audiences watch a film, approximately 95 percent of what they see in each scene is the background environment, whether they are conscious of this or not. Consequently, even with mediocre character design and limited animation, a film can be given the illusion of quality or a specific mood or emotional quality, if the background art is inspirational or high quality. The classic Disney movies were famous for their spectacular background art and their great ability to set moods or themes. Even if Disney studio animation and characterization had not been as good as it was, the background art would still have given audiences a superior cinematic experience.

In practical terms, a specialist called a concept artist will evolve an overall visual and color look for the entire project, under the direct supervision of the director. Then, when this look is finally achieved, the same concept artist will develop, in finer detail, a stage-by-stage representation of all the major aspects of the project or storyline. This latter operation may well take place during the pre-production stage. However, quite often, it is undertaken during development, as it is a valuable exercise in envisioning the entire aesthetic overview of the production, prior to scheduling and budgeting taking place.

A basic flat-color concept design from an initial background layout can suggest a great deal about the mood and the ambiance of any scene that is yet to be animated.

If we are considering a standard film production, then the varying moods, emotions ,and actions encountered throughout the storyline will need to be interpreted by way of different visual and color approaches to these moments. Specific colors suggest specific moods and emotions, so the concept artist will attempt to define just what color themes will work best with certain phases of the story. Similar color themes can be selected for the environments of a game project.

The actual artwork treatment is also defined at this stage. For example, will the approach be bright, broad shapes and colors? Will the style be more of a delicate, watercolor look? Are we talking high-tech, computer-generated realism or softly shaded chalk and charcoal textures? Maybe we're going for a brash and anarchic vector effect. All these questions should be asked of the concept artist by the director, and the answers will need to be established at this stage, so that accurate schedules and budgets can be completed as a result of the creative decisions taken.

A digital painting of a non-digital painting being created.

Occasionally, it is necessary to employ more than one concept artist to style a large-scale project. In fact, it might well be that specific background artists and illustrators are employed to fill this role because of particular artistic styles. The whole process can be similar to the careful casting of actors in a stage show or live-action movie, selecting one or more illustrators or artists to fit a particular mood or subject matter within the entire project. This selection can be extremely important when seeking a unique or specific look for the project in question.

As indicated, both the key character models and their appropriate background stylings have to be created and combined at this stage, to reflect each specific theme, element, or story moment, within the project. Once this is achieved, the director, producer, and the rest of the development team will have a far better appreciation of the look and

feel of the project than they did previously. This way, they can better sell the project to others, specifically when introducing it to prospective investors or distributors for their reaction. The quality of the script and the additional attractiveness of the project's look will go a long way to determine whether or not the project will successfully move forward.

"Endangered Species"

With "Endangered Species," I wanted to celebrate both the great traditional stylings of animation's past while also utilizing modern digital technology. However, traditionalists tend to reject the new-fangled gizmo technologies that are accessible to animators today, and the new breed of young guns consider the past as boring, old-fashioned, labor-intensive nonsense, in view of the new digital tools that do practically everything for you today. I feel that both these viewpoints undersell the potentials that either camp can offer. I wanted to bridge the two closer together, under the umbrella of one entirely new entity, to show that the two can not only co-exist but also learn from one another.

As a result, I conceived the film (and this accompanying book) as using two significant technologies that are capable of revealing the two distinctly different worlds—the bitmap environment (which symbolized the world of our traditional past) and the vector environment (which is more reflective of animation's present). Being a film that is wholly based on the technological capabilities of the humble pencil, I did not need to consider 3D concept design, except for the one moment that a Buzz Lightyear lookalike emerges.

I actually found it extremely convenient to assign the more simplistic vector approach to the evolving animator at his desk and the more illustrative, eloquent bitmap approach to the film clip sequences that appear on the screen. Both concepts were simply developments of the originating pencil animation material anyway, yet both toolsets offered a treatment that would take the inherent capabilities of the pencil into quite diverse areas, which seemed to answer the creative questions I had perfectly.

With "Endangered Species" the action takes place around the same animator's desktop environment, although the styling of these settings varied somewhat from scene to scene and era to era.

Project Financing

*The art of financing animation often
requires grace, skill, and finesse.*

From the outset, the cinema was the single most important and glamorous outlet available to animated filmmakers, and it still could be for that matter (although it is now widely accepted that the games industry has a greater amount of production and a higher financial turnover than the movie industry these days!). It all began with the onset of the celluloid film industry, when pioneers like Emil Cohl began to mess around with projected moving images that were created by drawing directly onto the surface of the film itself. Short silent films followed, then short sound films, and then the full-length movie. Eventually, television opened up further opportunities for the aspiring animator. After TV came video. After video came games. After games, the Web blossomed. Next, DVDs. Now, even mobile phones can carry animated product. Who knows what's next? The only certainty here is, there will be something! One look at any contemporary entertainment contract drawn up by a lawyer reveals that the purchased rights to most film products are inclusive of all of the above markets (and in perpetuity), plus all new markets as yet unknown!

It is strange that, with the infinite potential of animation, the only genre of movies considered economically viable for animated filmmakers to pursue is cartoons, family films, and fairy tales. Why can there never be contemporary animated films that speak up to adults and not down to children? Why not consider horror movies, love stories, inspirational adventures, high literary pieces, erotic fantasies, docu-dramas, personal explorations, and so on, the way mainstream filmmaking does? The sub-culture "sex, drugs, and rock 'n' roll" movies of Ralph Bakshi in the 1970s showed some promise in one direction, but their overwhelming lack of technical, filmic, and storytelling competence left a lot to be desired. Nothing significant has evolved in the decades since, except perhaps in the Japanese industry where a whole new animation culture has emerged.

Animation Markets

What follows is brief presentation of the conventional animation marketplaces and how a potential filmmaker might approach them. This list is by no means definitive, as markets and methods of approach are constantly evolving and reshaping themselves.

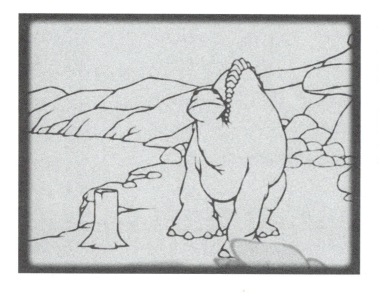

The great Winsor McCay drew his animation and then performed on stage with it to engage his audiences. Techniques are far more sophisticated these days, but it is still all about captivating an audience through storytelling and illusion.

Movies

When we use the term "movie," we generally mean a long film. The Academy of Motion Pictures Arts and Sciences (the Oscar® organization) categorizes a short film as a motion picture that is not more than 40 minutes in running time (including all credits), so anything more than that is a long film. It's a pity there is no marketplace for mid-film categories, as, at the moment, no serious investor/distributor will consider a movie project if it is between 45 to 70 minutes long. I would suggest, therefore, that the ideal length for the animated movie is 80 minutes, give or take a few minutes. This was about the length of the average Disney classic, as the fears of the time were that a drawn film could not hold a modern audience for much longer than that. There have been some exceptions to this, of course; "Fantasia" is 120 minutes and "Spirited Away" is more than 125 minutes.

Television

Television is a very different marketplace than that of the movies. TV offers all kinds of opportunities to the animated filmmaker, including full-length specials, series, program inserts, and commercials. Each has its own requirements and each has its own advantages and disadvantages. With the possible exception of advertising (at least at its higher end), all TV budgets will be minimal, at least compared to Hollywood. Despite the fact that projects conceived for television markets have to be relatively simple, fast, and economical to produce, some of the greatest cartoon classics of all time have been seen on TV. From the earliest days, there were the "The Flintstones," "Tom and Jerry," "Rocky and Bullwinkle," "Yogi Bear" and "Huckleberry Hound," among others. In more recent times there have been "The Simpsons," "Rugrats," "King of the Hill," "DragonBallZ," "SpongeBob SquarePants," and the notorious "South Park."

History shows that breakthrough success on television can come more through originality than quality of production.

Television Series and Specials

The animated series is to television what the comic strip is to newspapers. It is unlikely that TV animation will ever die as an industry, although the time, volume, budgets, and the often uninspired nature of its production make it harder and harder for the creative animator to use anything but the most basic and pedestrian of animation techniques.

I personally have been very lucky in that I worked on the Academy Award-winning TV special "A Christmas Carol" (by Richard Williams) and later directed and produced the animation for two respected PBS specials, "Cathedral" and "Pyramid," the first of which was awarded a prestigious Blue Ribbon award. That said, these productions were made on a shoestring and other than a wonderful opportunity to direct anything of significant length, never reached their full potential because of the limitations of time and money imposed upon them.

The funding of TV projects is different from the funding of movies. Taking a proposal for a television series as the example, a typical investment package (more universally termed the presentation package, development package, or production bible, covered in greater depth in Chapter 3) requires less than that for a movie. At the very least, the package requires a production definition and synopsis document, key designs of main characters and settings, a production budget, finished story scripts and/or detailed outlines of each program's storyline, and the production studio's current showreel (which illustrates the range, capability, and experience for creating this kind of work). The presentation package might also include completed production storyboards of one or more episodes for first-time program makers, or even a fully animated pilot episode which illustrates exactly the kind of program it is being proposed, for larger, well-financed studio entities.

Sales to a television network alone will most likely never cover the production costs of the animated program in question. The main profits from television come from the successful marketing and licensing of the characters. Often, the bigger program production companies essentially donate their programs to the broadcasters for insignificant or minimal costs, solely to guarantee air time and exposure for the characters that all the subsequent toys, games, publishing, and other merchandizing will spring from. It can almost be guaranteed that a filmmaker will barely (if at all) cover their production costs with sales to just one major network. American television is the most lucrative marketplace available to the animated program maker, but it is only with additional sales to television networks around the world, beyond the U.S. market, that the film-maker will ultimately be able to cover their costs and make a profit. The longer a series can run, of course, the more generous the merchandizing rewards will be. This is why the major players in the TV animation production world will invest significant money up front, particularly in the production of mainstream TV series work, to enjoy the greater benefits from merchandizing in the longer term. This puts the small, first-time program filmmakers at a distinct disadvantage, being that their access to real resources, opportunities, and finances are so limited. Nevertheless, the successful exceptions to this rule do make the up-front risks extremely enticing and often well worth the risk.

The more radical approach to mainstream animation by the television industry is still clearly fertile ground for the creative, innovative animated filmmaker. The beast of television needs to be constantly fed, and in huge volume. However, it does get harder and

harder for the innovative and imaginative filmmaker to produce good animated programming. With the worldwide explosion of reality TV and the outsourcing of TV production to the cheaper sources of labor around the world, the combined consequences of this are that broadcasters are spending less and less on original, quality programs and more and more on cheap, fast-turnaround shows that are made with short-term objectives in mind. History shows that everything in life is cyclical, so the days of quality television and quality animation programming will eventually return. In the meantime, filmmakers aspiring to conquer the television markets must remember that their work needs to be done simply, cheaply, and extremely quickly if they are to compete in the current marketplace. It can still be done, but only just.

Television Advertising

Television advertising, on the other hand, offers distinctly different benefits for the aspiring animated filmmaker. Whereas the production studios producing advertising do not actually own their own properties (i.e., characters and ideas) as TV program filmmakers do, they are at least able to attract significant budgets to work with. Animators can express themselves to an almost-Hollywood level (more so in some cases), using state-of-the-art techniques and facilities to keep their production standards extremely high. The eternal frustration of animating TV commercials, however, is that the scripts are often banal and unchangeable; the clients have few imaginative instincts (except with the most adventurous, innovative campaigns); and you can work intensely, day in and day out for months, only to have your work shown for just a few times, in a few regions, in a single part of the world. The lack of creative expression, potential for trying new things, and the limitations to your identity and audience base is quite often extremely frustrating after a while. Nevertheless, advertising is an excellent environment in which to hone your skills as an animator. If you can maintain a steady flow of advertising work, you will have the chance to develop a sharp and experienced production team around you, and you can use this to springboard on to bigger and better things later.

All this said, it must always be recognized that the advertising industry is a pretty fickle beast, where flavors of the month (in style, reputations, and creative talent) can be like a passing wave, raising talented studios up one moment then down the next as the new greatest thing is pursued.

Don't Pigeonhole Yourself

My philosophy was to never have a particular style associated with my work. Instead I developed a strong reputation for producing quality animation in whatever style I was asked to create. That meant I never did the same thing twice if I could possibly avoid it, and I definitely did not rely on doing the same thing all the time. I was protecting myself from being typecast and associated with a style that might lose its popularity. The testimony to the success of this was that I was able to maintain a studio for a period of over 20 years, while other studios that burned brighter in the short term often went out of business within a few years of their greatest successes.

Games

The extensive games industry has been around for some considerable amount of time now and still offers a huge market for the competent animated filmmaker, whether it is just for a job or in the capacity of creator and/or filmmaker. There is a growing preponderance of 3D animation in the games, but the beauty of the games industry for the inspired filmmaker is that, unlike the cinema and television industries, it is still technically and artistically possible for the single animated filmmaker (or group of animated filmmakers) to generate their own product, entirely independent of outside influences. It gets tougher and tougher to do this, of course, as hardware and creative expectations rise, but it is still possible.

Of course, the term "filmmaker" is not a particularly accurate definition when it comes to the creation of a complete game entity. Producing a game is far more complicated than just the production of an animated film. The most recognizable ingredient in a fully packaged game entity is the cinematic, which is the animated, introductory film sequence that most games have to lead us into the game play. (Depending on the nature and ambition of the game, there might also be cinematic sequences that lead from level to level of the game play.) Creating the game itself requires a technical skill and capability of programming that lies beyond the range of most animated filmmakers. It is especially outside my experience! The cinematic aspects of a game package offer much more familiar territory for the animated filmmaker.

The Web

The Web is perhaps the most exciting potential market that beckons the serious animated filmmaker at this time. I say "potential" because, although there is already a significant existence of animation on the Web that has generated a large following of addicted viewers, the true possibilities will not be fully realized until bandwidth is available to support real-time, full-screen playback on the average phone line. At the time of writing, this is nowhere near possible.

When the bandwidth is extended, I believe we will be on the verge of a revolution for all filmmakers, but especially animated filmmakers, the like of which hasn't occurred since the inception of film entertainment itself. At that time, there was a glut of small animation studios across the U.S. (and elsewhere in the world, but most popularly centered in New York and Los Angeles) that were producing a significant amount of short, animated cartoons that supported the main movie feature in the cinema shows of those days. These short cartoons were wild, wacky, surreal, and extremely diverse in quality, subject matter, and content. This mirrors the Internet animation industry today.

The expansion of Internet bandwidth will enable animated filmmakers to realize the same potential that Walt Disney did all those years ago when he incorporated sound, color, and new production approaches to create long-format animated films that could be the feature films themselves. Animated filmmakers will be able to provide full length e-movies live for a worldwide audience. Like musicians, the new animated filmmakers will be able to access their audiences through their personal or studio Web site, potentially reaching just about every computer user around the world. With the excellent digital software that is already available today, filmmakers will be able to create, produce, and exhibit their movies independently. This will provide a greater indepen-

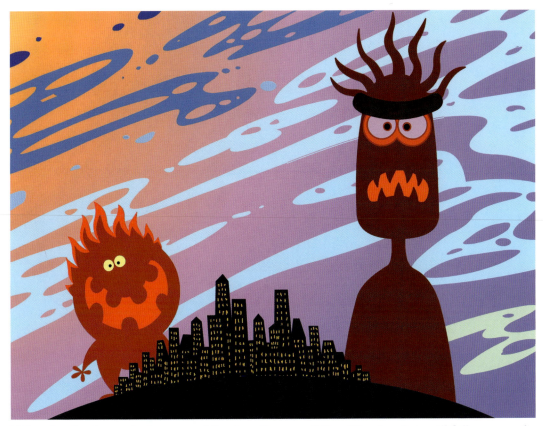

Web animation has evolved exponentially since the turn of the millennium but until full-screen, real-time playback becomes a reality, animated storytelling has to remain limited and dependent entirely on script rather than action content to appease audiences.

dence of expression and a 100 percent increase in the financial returns for their work. Additionally, they will be able to sell advertising time during their online shows and exploit the considerable marketing and merchandizing potential that most animated products provide. This is all considerable additional income to the successful animated filmmaker.

The only weakness with this approach to independent, online distribution is the amount of publicity and word-of-mouth promotion that the cinema and TV is currently so good at generating, prior to a film or show being released. That acknowledged, the same avenues of advertising and promotion would be accessible to Web filmmakers, and the notions of "Internet" and "word of mouth" have always been synonymous. That assured, a successful and resourceful filmmaker should have no problems in getting their product to the world, outside of the current film and television market monopolies. (And they can always sell their project on to all the other exhibition entities as secondary markets if they choose to do so, thereby effectively having their cake and eating it too!)

Digital animation will have to find its own markets, but the technological revolution does give the filmmaker more control over their own creations than their unfortunate predecessors had.

Direct-to-Markets

Currently, the direct-to-video or direct-to-DVD markets are the only other significant markets available to the animated filmmaker, although there will be many smaller and more specialized ones that don't come under the broad umbrella of this book. The mainstream film and television companies monopolize the bulk of the video/DVD distribution routes, although it is becoming more common for a direct-to production to compete impressively in this same arena. Such films tend to speak to a niche audience or have some kind of creative originality that is not seen or that threatens the mainstream producers, or they are simply a great story, well-told in a far-from-Hollywood way. Needless to say, animation can perfectly adapt itself to all these alternatives.

The only drawback of direct-to productions for animation is budget. The returns from direct-to productions are nowhere near as lucrative as the more mainstream market-places and therefore the production costs have to be reduced accordingly. With regular live-action filmmaking, is it perfectly possible for cast, crew, and production people to get together, freely donate a certain amount of their time over a period of days or weeks, and come out with a very respectable, well-made movie that can be readily and cheaply distributed to the regular video or DVD markets. With animation, however, the time commitment by everyone involved is significantly more; months, a year, or more, for a quality independent film of significant length. To pay the production team (even minimally) is daunting, especially in an age of high-expectation audiences. As a result, to make an animated production possible at all, significant economies in time, cost,

and quality have to be made. Discriminating audiences, weaned on the great classics of the past and acquainted with the blockbuster budgets of Hollywood's present, will simply not tolerate sub-standard products for any reason. As a result, cheap productions almost invariably equate with minimal returns, unless they are quirky and off-the-wall enough to capture the public's imagination.

The problem for the direct-to-market filmmaker (indeed, for the independent theatrical filmmaker too) is how to make the film of high quality and integrity, while keeping production costs down to match that market's box-office expectations. Digital technology, to some extent, has liberated the filmmaker from many of the crippling time and production costs involved, but still we rarely see films of quality that emerge from the direct to or independent film marketplaces.

"Endangered Species"

I conceived "Endangered Species" without a specific market in mind. The film was created, first and foremost, to appear in and illustrate this book. Beyond that, the film proved to become more and more an expression of my innermost feelings (and regrets) about the industry I know and love so much. Initially, I inherently felt the need to remind everyone of the tremendous legacy that has been left us by the great master animators of the 2D tradition, and then later, to suggest that with the advent of new digital, technological advances it was not necessary to throw the baby out with the bathwater and consign any notion of 2D animation to the history books. Good animated films are good animated films, whether they are produced by a pencil or a computer. What is important is that a film contains a good storyline and the animated mastery to bring that good storyline to the screen. Pencils and computers are just tools, methods of transferring what is in the mind and the imagination of the filmmaker to the minds of their viewing audience. Neither is better than the other. Both have qualities that the other does not have. "Endangered Species" attempts to transcend attitudes and markets and simply show some of what has been and a hint of what (hopefully) may still yet be. If it proves to be a good film, then it will find its market. If it has a good message, then perhaps it, in addition to the contents of this book which attempts to define the film and its processes, will begin a renaissance that ultimately removes the tag "endangered" from a species that is quite unique.

Scheduling and Budgeting

Although scheduling and budgeting are usually the domain of big studio productions, new students and independent filmmakers should be encouraged to keep these two factors in mind when developing a new project. It is far too easy to embark on a project that turns out to be far too time-consuming or cost-guzzling to complete. Many small, independent productions have fallen at these particular fences in the past, quite apart from disastrous major ones from time to time, simply because not enough forward planning and preparation was undertaken at the onset. Full-fledged, professional productions can never ignore these two aspects of production, simply because both clients and investors demand to know such production implications upfront, before they commit extensive time and money to a project.

The schedule and budget must be attended to as much as the creative work.

Figuring the Cash Flow

Almost invariably the most important aspect to any investment package has to be the budget, but this can't exist without a comprehensive production schedule in place first. With insufficient money to finance an idea, it is impossible for a filmmaker to produce it. Consequently, the financier, investor, or distributor worthy of the name has a significant power over the success or failure of a project development. Such an individual, or organization, will insist on viewing every single production cost right up front and will not even consider the project unless these figures are available, perhaps down to the very last cent.

Investors will additionally require an accurate cash flow of that budget. The cash flow is a week-by-week accounting of what every aspect of the project's production requirement will need (when, by whom, and for how long?) This will need to be calculated from the very first day of production to the very last. Projects are not simply funded by an investor giving the go-ahead and then handing the whole amount of the budget to the filmmaker up front, leaving them to simply get on with the production unchecked. Instead, the money is filtered through in stages, when and as the production requires it. In employing such checks and balances, there is an important peace of mind advantage to both the investor and the filmmaker.

The filmmaker, on the other hand, is protected in another significant way. It should always be remembered that investment in any project is essentially a loan to the filmmaker, so their production can be made over an agreed period of time. The money therefore does ultimately have to be paid back to the investor at some stage, often when distribution is secured and paid for, or else when (hopefully?) the project enters into profit. (Note: A huge percentage of film productions, particularly live-action film productions, often fail to make a profit, although animated film productions have a much higher success rate in giving a return on the investor's profit!) Nevertheless, like

any loan that is undertaken, repayments will also incur added interest costs to the loan, invariably tied in to the amount of time the loan remains unpaid. Therefore, if all the money has been placed in the production account from day one, and is sitting there, unused until some time later in the production schedule, then that money will be incurring huge, yet unnecessary, interest penalties throughout. It is clearly far better for the filmmaker to take only enough of the loan when (and only when) they need it. This clearly underlines an extremely practical reason why the filmmaker needs to have a firm finger on the pulse of both budgeting and scheduling from the moment of development onwards.

To ensure that an accurate cash flow can be put in place, the filmmaker must first precisely work out just when and who and for how long each contributor to the production will be required. In other words, an accurate production schedule needs to be attempted. Certainly a storyboard, if it has been created at this stage, will help with this kind of assessment. Questions that need to be assessed include:

- How many employees are needed?
- How much are they paid?
- How long will they be paid?
- How much equipment will be needed?
- What leased or rented outside contractors or equipment will be required?
- How big does the administrative staff have to be?
- How large a studio space is needed?
- What is the studio rent (weekly or monthly, and in total)?
- What are the studio overheads (heat, electricity, security, insurance, etc.)?

It always pays to prepare for a rainy day before embarking on any major project!

These are all essential factors in this complex scheduling and budgeting equation. For utmost accuracy (and subsequent budget dependability) this is clearly a skill that can take a whole professional lifetime of study and experience to get right. Even the most novice filmmakers will need to make a respectable attempt at it if a particular project is to receive funding. Failing that, they need to hire seasoned professional accountants and/or production consultants to do it for them.

It always pays to refer to someone who can read the fine print better than the filmmaker can!

Contingency Planning

Once the budget is carefully crafted, a contingency cost needs to be added to cover any unknown or unplanned factors that may unexpectedly crop-up during the production. It is almost guaranteed that some unknown or unexpected factor will occur at some stage or other, for life and filmmaking is like that! The loss of a director, or key animator, from illness or accident; the loss of production time through power cuts and bad weather; the sudden increase in production costs through outside inflationary factors are just a few of the eroding factors that can come into play when embarking into the production unknown with a new project. A contingency of 10 to 25 percent of the initial production costs (depending on the degree of risk the productions offers) should be added to the final total to cover for such eventualities. This money does not need to be spent, of course (and hopefully it won't need to be, especially in view of the extra interest repayments), but at least with it there and approved up-front by the investor, you have a safety net. The actual amount of contingency percentage will be subject to negotiation between the filmmaker and the investor, of course, for neither will be keen to make it higher than necessary.

Students and Indies

Students and independent filmmakers do not have the same scheduling and budgetary production pressures placed upon them that a commercial filmmaker does, unless their project requires outside sponsorship or distribution investment for completion. Student projects, for example, are simply subject to the standard term timescales, while an independent filmmaker's project is purely a labor of love that requires no timescale applied to it. Certainly neither situation will have any significant outside commercial pressures bearing down on them, factors that can destroy the simple joys of an animated project.

I still strongly advise that the even most humble of productions should be subject to at least most cursory budgetary and scheduling considerations at their onset, as many a project has suffered from a lack of realism where the confines of time and resources are concerned. From the viewpoint gained from running my own studio for more than 20 years, I would suggest that the graduate who demonstrates the ability to animate simply and well is a far more attractive and an employable proposition than someone who knows the tricks of the technology but cannot bring even the simplest of animated movement alive convincingly!

Investment, Marketing, and Distribution Possibilities

Any animated film that finds existence, regardless of market or style, will have specific production costs attached to it. Even if the filmmaker is making the film entirely on his or her own, there will be certain real costs involved, even if they are as minimal as office supplies or software. The secret is to know those costs up front and to find a way of covering them to ensure that the production can be completed. The preferable way is to do it with other people's money, rather than your own, and that is the challenge that all would-be filmmakers face. However, all too often, filmmakers start out on a wing and a prayer, only to find that later their money runs out. With a short, personal film project, the significance of this is not necessarily damaging, except to the ego. However, if it involves a professional production, with specific contracted commitments to employees, clients, or dis-

Today, animation has to be more than just sitting down and creating moving pictures.

tributors, and with a specific number of difficult, impatient investors pacing the floor of the studio until the project their money has paid for is complete, then the pressures on the filmmaker, and the consequences of that filmmaker failing, are enormous. It is essential that all the costs and consequences of a production be analyzed, anticipated, and appreciated, before a single drawing or a single character model is produced. Once these things are known, the potential filmmaker will be able to approach the various sources of finance or investment available to them with a certain degree of confidence that the production will indeed be completed on time and, more importantly, on budget. This is the kind of assurance that all investors and/or distributors are seeking before any deals can be done and the project goes into production. Much of this assurance can be given through the proposal material offered up when investment is being sought.

Everyone Needs Financing

In writing this chapter, I have the notion of a Hollywood movie production, or perhaps mainstream TV series production, at the back of my mind. At this level of financial investment, it is important to understand how necessary an investment package is to the success and failure of a production, as well as how to actually go about producing one. That said, other forms of animated filmmaking can learn from these higher aspiration models and then scale down their requirements within the needs of their own proposed productions. Each project is unique and films are made for a great number of entirely different reasons and purposes. Ultimately, it is whatever it takes to obtain what is required to get a project proposal financed that is important.

The average film presentation package can take advantage of some of the development measures we have already discussed. Film is just a familiar term of reference, by which I mean it to represent all facets of animated production, not just the celluloid version for the silver screen. To remind ourselves of the development stages (covered in Chapter 1), first comes the idea (the dream), then the blocking out of that idea, then the scripting of that idea, then the designing of the characters for that idea, then the creation of a schedule and budget for eventually producing that idea. The assembly of these well-conceived and attractively presented documents is known collectively as the investment package or project bible. It is with such an investment package in place that the aspiring filmmaker can more confidently present their project to any prospective financier and/or distributor.

Seeking investment for a film project does not only involve the material suggested for the investment package alone. A lot depends on the scale and ambition of the project in question. For example, the proposal for a mainstream movie or TV special might also include a short animated taster of what is being proposed, known often as a pilot film or teaser, and it might even have a sales agent presenting it, especially in the case of a movie. A sales agent is a person whose sole job it is to open doors and secure finance for proposed productions. The best ones are very hard to attach to a project, however, especially an animated project (which isn't nearly as sexy as a live-action production with big Hollywood stars) and they do take a significant percentage out of the produc-

Ultimately, it's all about packaging!

tion costs/profits for their fee, when successful. But a respected sales agent will be able to open a number of significant investment and distribution doors that are usually inaccessible to the average filmmaker.

Even the finance-seeking investment package may first need to be funded, if it is to prove sufficient bait to land the big fish that ultimately will decide the success or failure of a project's production. With the biggest of proposed projects, professional-looking investment packages need to be created by professionals who know how to do such things and these people have to be paid (well) for their services.

In reality, development money (the money required to fund the investment package) is actually the biggest risk for any investor to make in the business of making films. The reality of the movie business, for example, is that each year approximately 50,000 scripts get started. Of these, only perhaps 10,000 ever get finished. Of these, only a very small proportion are taken up by a filmmaking company and developed, and only a tiny percentage of those projects are ultimately financed and made. The annual expectation of even the biggest of Hollywood studios is that if only one of their films hits big, then their costs for everything else are covered. Sometimes, however, even this expectation is never realized. Investment individuals are called "angels" because they put their money into something on trust against all the logical odds.

In view of all the design, scripting, scheduling, budgeting, and legal work involved in putting the package together to give a film proposal an even fair chance of getting somewhere, sufficient funding must somehow be found to pay for all the professional fees involved. The schedules, budgets, and profit projections have to be accurate and professionally tenable if they are to ever stand up to the intense scrutiny of those powerful entities who might consider placing their money on the line. The fact that development investment, quite apart from full production investment, is so hard to come by is probably why so many potentially great animated projects fall at even the first hurdle.

Pre-Sale Distribution Outlets

Taking the Hollywood movie as a model to work with, let us analyze the potential markets that any ambitious animated film can draw profit from. The film's main markets will include cinema distribution (in the U.S. and then regionally, worldwide), TV networks, cable TV networks, DVD and video distribution, toy manufacturing, printing and publishing entities, various merchandizing and marketing interest groups, advertising opportunities, games, spin-off opportunities, and miscellaneous Web promotions and sales. These elements represent the most rewarding slices of a key investor's pie. Investment funding will come from one, or usually all, of these interest groups, in exchange for distribution or exploitation rights of the project in their own particular domain. Occasionally, an independent investor, outside of any of these entities, may step into the fray, attracted to the project through a personal commitment, its special subject matter, or a vision of a particular avenue of financial exploitation. Independent investment is an extremely rare occurrence, so rare in fact, that it's known as "funny money" in the industry.

The average filmmaker usually has to secure film investment from an amalgam of all the regular interest groups mentioned above before going into production. These investments are known as pre-sales. Without a shadow of a doubt, an animated movie-length film will almost certainly not be able to attract completion finance (the whole budget) without a guaranteed distribution deal with a mainstream Hollywood distributor in place first. In reality, the prospective filmmaker usually has to have significant other pre-sale deals in place too; namely, with network TV, video/DVD distributors and even major toy manufacturers, to have any hope of covering the budget. Occasionally, very, very rarely in actual fact, a filmmaker might be able to cover the production budget through pre-sales with the U.S. entities alone, plus a smattering of regional world sales, allowing him or her to exploit other markets throughout the remaining world regions once the film is made.

"Put my animator on the line; I want to cut a new deal!"

More usually, pre-sales with all the possible entities involved will still leave a shortfall on the production budget, whereupon the resourceful filmmaker will have to find ways of reducing the deficit through other means, such as local film grants, lottery donations (depending on the countries involved), angel investors, or, worst of all, rethinking the more ambitious elements of the film's storyline and content to reduce production costs.

The distribution planning of any film has to be meticulous and well thought-through, as the release of a film in the various market places has to be coordinated so as not to damage the markets in each. For example, common sense implies that it will not do well to launch the movie in the cinemas, distribute it through video and DVD, and

have it showing on TV at the same time! The agreements between the three parties are usually spread as far apart as possible, although they will fight with one another for the most favorable arrangement for themselves (with the filmmaker in the middle, of course). Traditionally, the theatrical (cinema) release comes first, followed by TV a few months later, and then it is released on video/DVD a few months after that. This way, all the market interest groups can exploit their particular interests without any competition from each other. Sometimes one of the entities involved will put up almost the majority of the production finance (probably the film distributor) and take on the rights to all the other marketplaces, wheeling and dealing these other rights beyond the active participation of the filmmaker. Established, respected, and good box-office filmmakers can actually have a much greater say in the process of pre-sale deals of course, earning themselves a larger slice of the profit pie. However, first-time filmmakers must expect the probability that the only pie they will ever see will be of the humble variety, of which they must expect to eat a great deal of, if they ever want to see their film made!

NOTE

The essential difference between major and independent distributors is that major studios focus primarily on global markets; if they take on a film for distribution, they will promote and orchestrate its worldwide release. Independent distributors focus mainly on limited, regional distribution. The majors obviously are in many ways far more commercially desirable from the filmmaker's point of view. However, with their power there often comes creative compromise for the filmmaker. Therefore, the independent distributor may be a better (albeit less lucrative) option to go if a creative ethic is more important for the filmmaker.

With movie filmmaking, we are usually talking of budgets of tens of millions of dollars; it is not unexpected that this kind of money is difficult to secure. The pre-sale agreement is usually the best shot filmmakers have of achieving completion financing. Pre-sale agreements do not involve the actual handing over of production cash from the distributors to the filmmaker; it is only an agreement that means that if and when the filmmaker hands over a completed project, then the distribution entity involved will pay to that filmmaker the amount specified in their agreement. For example, with a major distributor, the filmmaker might be offered a distribution pre-sale agreement where the distributor will pay the filmmaker $10 million on the delivery of the completed film negative. This film negative delivery will be subject to all kinds of rules, such as

These days, there's more than one way of viewing animated production.

a specified date of delivery, the quality of the film's content, a strict adherence to the approved script, etc., all rules which, if violated, can mean that the distributor will not pay the filmmaker the money or distribute the film. This can clearly be a huge blow to both the filmmaker and any other film investor that has been attracted to the project.

However, assuming the film has been made in accordance with the contractual prerequisites of the agreement and the film is successfully handed over as required, the filmmaker will then receive the required cash from the distributor and the other pre-sale signatories. What this means, in reality, is that the money to make the film must be raised by the filmmaker and distribution entities are not assuming any financial risk.

The usual source of production funding is the few film-savvy merchant banks that are prepared to lend funds to filmmakers with sufficient pre-sale agreements as collateral. Distribution, marketing, and merchandizing pre-sales are critical to the success of finding production financing and the investment package is critical to finding the pre-sales!

"Endangered Species"

Fortunately with "Endangered Species," I did not have to defer to the judgment of anyone except myself in the production sense. Come hell or high water, I was going to get this film finished, whatever the personal cost was. In terms of finance however, I could not in any way ever expect to cover all the incidental costs with my teacher's salary alone but I somehow believed it would all work out eventually. Despite a fortuitous and illustrious past, my fortuitous and illustrious present does not offer me the necessary resources to fall back on, the way it could when I had my studio in London. It was simply a time, commitment, and endurance thing. Ultimately, it took me two and a half years to produce the drawings that could be turned into digital imagery and then, ultimately, into a film. There were elements beyond my capability that needed to be paid for, of course, and sponsorship was the route I considered at one time. But, eventually, I was extremely moved to discover that the basic good and generous spirit of others enabled me to overcome all the financial challenges that were threatening the film.

In terms of drawing assistance, scanning and coloring, voice recording, post production, and sound and music creation, wonderful people emerged who gave of themselves above and beyond the call of duty, and my gratitude to everyone is recorded sincerely in the acknowledgements. The bottom line was that I discovered that if you passionately and earnestly believe in something that is very important to you, and you are prepared to demonstrate that commitment though your own hard work and sacrifice, others too are infected with that same passion and they will rally to the call.

With commercial productions it is far, far different, and this chapter deals with that aspect of project enabling constructively. However, even with the less-impassioned, commercial productions I have been involved with, I learned that if you put your heart and soul into something, miracles can indeed happen, quite contrary to the production logic that prevails at the time!

The Realities of Securing Production Finance

U.S. distribution profits represent about half of a film's potential market around the world. The U.S. market is the toughest to crack but it is vitally important to any pre-sale success (which, as I've noted, is successful in getting production funding, which is successful in completing the project and realizing any actual sales income).

The Growing Foreign Film Market

Independent foreign animated filmmaking is slowly making its presence felt in the primary marketplaces. Once upon a time, overseas production was perceived as simply a cheap production opportunity, where animators' salaries and studio production costs were far below that of their U.S. counterparts. (And in the television industry especially, it still is!) Now, however, foreign films are beginning to make themselves felt and are consequently taken a little more seriously as a result. This has been actively encouraged by various established events outside of America, where animation has sought to establish its own voice and marketplace. The European animation community, the Japanese anime explosion, and the third world ambitions in countries like China and India (where government and corporate interest has poured huge investments into these industries) are all forces that now have to be given more recognition in the mainstream marketplace. On top of that, the critical acclaim of "Spirited Away" and "The Triplets of Belleville" imply that this resurgence of foreign animated filmmaking is not just a product of economic advantage. Artistic, aesthetic, and cultural values are on the rise as well and Hollywood ignores this at their cost. Nevertheless, ambitious, non-U.S. filmmakers have to achieve box-office recognition and financial reward in the U.S. to claim they have "made it" in the animation sense. Success in the American marketplace is still the yardstick by which all must be judged, however much some would wish it otherwise. But it does seem that the gap IS closing.

The process of acquiring production finance for a project generally not an easy one, and it probably never will be. usually begins with the filmmaker making innumerable phone calls, writing a mountain of letters, and trudging far and wide cold calling, just to achieve one positive response from the usual succession of rejections. Regular live-action filmmakers find it tough. Animated filmmakers find it next to impossible! The ultimate Catch 22 reality is that unless you have a successful filmmaking reputation already, have the incredible luck to be in the right place at the right time, or just have a rich daddy (or angel), you are going to have to make significant mainstream contacts, or at least embrace those who do. The Hollywood/network TV fortress is the most difficult one to break into.

Even with all your ducks in a row you may still need to pray for a little divine intervention!

Occasionally, the high profile film festivals, such as Cannes and Berlin, or those in New York, Los Angeles, Miami, or San Francisco, offer would-be filmmakers with excesses of self-believing courage and initiative the chance to show and sell their wares in a targeted, commercial environment. With a certain degree of effrontery, and armed with a bunch of project-based DVDs and business cards with links to an associated Web site, the resourceful filmmaker has a better chance of an audience with film bigwigs when their guards are down, away from the office.

There is a more accessible, alternative, independent film market out there. Unfortunately though, the reality is that unless your project has an unbelievably low budget (implying that it will therefore not be of good quality, in animation terms) then this market will just not offer the kind of financial returns that will cover the costs of production. Events such as the Sundance Film Festival (www.institute.sundance.org) and the Los Angeles Film Festival (www.lafilmfest.com) offer alternative opportunities for aspiring independent filmmakers outside of the system to rub shoulders with the great and good within it. Other non-Hollywood animation gigs such as Europe's Annecy (www.annecy.org) or the Cartoon festival (www.cartoon-media.be, European Association of Animation Film) are indeed valuable opportunities for independent film and television filmmakers to promote their projects, especially if they have a content that will appeal to a more cultural cross-over audience, reaching out beyond U.S. tastes (but not ignoring them, either). All this said, the stark reality is that for the wannabe animated filmmaker to guarantee that their project is a success, they must first win over the barons of Hollywood, on their home turf in Hollywood. The old adage is true, "If you want to catch a fish, you first have to go where the fish swim!"

Armed with a suitable investment package and impressive pilot film or personal showreel (and somehow managing to make contact with an influential executive who will give him the time of day to consider the project!), the aspiring filmmaker must somehow convince them that he is a solid and responsible professional who can be relied upon to bring a production home on time and on budget and that the project is the best thing since sliced bread and what audiences have waited for, for so long! This is known as the pitch. There is nothing harder than being taken seriously by a top-level Hollywood executive, as any aspiring actor, writer, producer or director, or regular live-action filmmaker will attest. There is, without a doubt, a prevailing prejudice against animation in the mainstream industry that it's just cartoons for kids and can be nothing more.

It is true that anyone can make an animated film, given adequate knowledge, time, and personal commitment. However, the big bucks budgets do enable the filmmaker to make it all that much better, and for larger audiences!

Whether your project is mainstream subject matter or animation avant garde, you will need to invest in the most effective presentation of your material possible. These days it is not impossible, or expensive, to author your own project DVD on your desktop computer. Pitch DVDs would contain everything the prospective investor/distributor would need to know about your project, including all the required paperwork, designs, and sample footage. In addition to that, you might want to print promotional brochures to go with your business cards and project presentation material (especially if you intend to walk that extra mile of the film festival circuit). Of course, a Web site dedicated to your project will mean that visitors from all over the world can access your ideas in seconds, once they know of its existence. Indeed, the modern digital world offers all kinds of unique and innovative ways you can get your material to others if you are having trouble getting started. As with making films, the pitch aspect of marketing ultimately requires imagination, persistence, and commitment to get your ideas across.

It Happens to the Best of Us

I once tried to get a very unique, animated movie epic off the ground. Called "Dreamsinger," it was a wonderfully innovative and serious consideration I had (from a top executive in the animation department of one of the major Hollywood studios) was that it was too political (because it had whales in it), it was too violent (a whale was injured by a whaling gun at one point) and that no American audience would pay to see a film with a young Japanese girl hero! "Dreamsinger" was a darned good project, ahead of its time in many ways, and one that I had spent up to $100,000 dollars of my own and other people's money to develop. Of course, I am not alone in banging my head against a brick wall in this way. This is quite the norm for such a conservative industry when it comes to specific product.

In some ways, animators and animation studios only have themselves to blame. Historically, in terms of mainstream production outside of Disney, most animated movies had sub-standard storylines, were animated badly, and were produced on far too low a budget to have any chance of success. The old assertion that animation is just not a sexy filmmaking medium and that animated movies (outside of Disney) are just not profitable, is therefore hardly a surprising one in the circumstances. Serious directors do have to hold out for the right conditions to make their films well, rather than compromise their art and produce sub-standard products on sub-standard budgets. It is very tempting to start a project with a deficient budget (on the basis of "take this or take nothing"), but ultimately history has shown that low budgets equate with low reviews and low box-office results, which always reflect badly on the filmmaker (and the industry) in the end. It is therefore perhaps better to not make a film at all, if the conditions of making that film are unworkable. Serious animated filmmakers have to demand the same respect and realistic filmmaking opportunities that most Hollywood live-action filmmakers are given.

So much of it is about singing the right toon, in the right place, at the right time! A concept design for "The Hat," a project in development.

Good animation, like all good filmmaking, costs money. Bad animation, the product of cheap production attitudes, means bad box-office. The entire animation industry has to be extremely grateful that films like "Shrek" have done so well. Indeed, "Shrek 2" became the biggest grossing animated film in American history (at the time of writing) before it had even finished its distribution run! The Shrek movies, just like all-conquering Pixar movies, are well-financed, well-produced, and well-animated. Shrek especially speaks to an adult audience and flouts all the conventional opinions of what an animated movie is supposed to be. This is excellent news for an animation industry that so desperately needs good news. (Let those with the ears to hear, hear, and the eyes to see, see!) Now the requirement is for visionary animated filmmakers to continue to push this envelope further, to bravely embrace all the other film genres that conventional live-action films embraces. Then animation, traditional or otherwise, will have truly come of age.

Advice on Sales Agents

One way of avoiding the exhaustive process of pounding the streets, pounding a keyboard, or pounding telephone buttons in search of production finance is hiring a sales agent. The real advantage of an experienced and successful sales agent is that they know the business of film and distribution deal-making inside and out. They will know whether a project is suitable for mainstream (major studio) distribution or independent distribution. A sales agent will know the right numbers to put in place when constructing an effective pitch and how to tailor the filmmaker's proposal to speak to the market it is ideally suited for. He or she knows how to navigate through the often treacherous and complicated distribution contract jungle of negotiation and will know all the tricks and small print traps that the distributors might lay down for the unsuspecting and inexperienced filmmaker to walk into.

Most importantly, sales agents will know just who to make the deals with in the first place and how to reach them. If the filmmaker is a seasoned professional, has made several film deals before, and has an extensive list of contacts within the business, then there will probably be no need for a sales agent. However, for first-timers, or even those who have somehow managed to get a film together before but are daunted by the painful process of going through it all again, then a sales agent is a necessary evil on a project, as is a competent, experienced film lawyer and accountant. Such heavyweight specialists do not come cheap, but, if they are good, they will certainly earn every penny of their fee in the long run.

Even the best animators and filmmakers need a little help and guidance at times.

Little did anyone realize that a small mouse could account for so much!

At their most effective, the sales agent is a valuable bridge between a filmmaker and a distributor. A major film will not find production funding unless it first has a distribution deal in place and the sales agent is the most likely way to get that deal in place. Films are released in territories around the world and the sales agent's job is to make sure that the project in question is sold first to a major Hollywood distributor (ideally) and then as many (if not all) of the individual distribution territories around the world until more that the project's production budget is covered or exceeded.

The most valuable territories that a successful sales agent will seek to sell to are the U.S., Europe, Japan, Australasia, and the various Pacific Rim nations. The distribution revenues received from these markets should (ideally) cover the filmmaker's production requirement costs. However, lower earning markets, such as South America, Russia, and Africa, can make up any shortfall in the budget. That said, if the film's production costs are covered by the main territory distribution deals alone, then these secondary markets will add a little gravy to the plate, creating extra profits for the filmmaker. However, world sales can only come from a project that speaks to a world audience, and therefore localized or single-culture story concepts are often almost impossible to sell outside of the filmmaker's own country.

With animation, uniquely, there are other very valuable and lucrative markets that a good sales agent can exploit. Animation, especially, offers tantalizing commercial spin-offs. Beyond the basic movie release, there are the usual TV, cable, satellite, video, and DVD markets, even the Web (although this will be truer in the future than it is now). Animation also offers additional marketing and merchandizing possibilities in the worlds of toys, books, music, and games. Needless to say, these additional markets can be gold mines in their own rights, apart from the profits made from the mainstream distribution outlets!

To address all these available markets on behalf of the filmmaker, a top sales agent will invariably travel widely, at home and abroad, to meet and schmooze with all the industry bigwigs at the various film events that occur throughout the year, to pull off as many distribution deals as possible in one place. It is an effective process but, unfortunately, one that costs money. In addition to their traveling expenses, the sales agent will often expect the filmmaker to pay (up front) any legal, accounting, and other expenses that may be incurred in putting the right kind of pitch together, in addition to their personal fee of course. On top of everything, the sales agent will also request a significant percentage of the profit from the back end of the film, should it go into profit. (This clearly is the downside for any aspiring filmmaker!) It is very frustrating to have to give away huge chunks of money before any deal is even considered, cover all the expenses along the way, and then hand over significant percentage points from the film's profits. Contrast this with the probability that you will have personally been working on the project for months (maybe even years) then have to work fulltime on the production for another two years, day in, day out, perhaps before it is delivered!

Unfortunately though, this could be the difference of making the film or not ever making the film at all. Distributors are notoriously tough nuts to crack and the process can take years to conclude. A good sales agent, on the other hand, can reach the right people and shortcut the system. You'll have to make a judgment on if you are prepared (or able) to pay for a service that can often realize your dream.

Sales agents are most commonly recognized as a desirable element within the movie-making process but they can be equally effective in the television world, where the same problems of access and experience are imposed on the wannabe program maker. Top TV executives (known as commissioning editors in some territories) are almost as hard to reach as are the movie moguls who green light films in Hollywood. Consequently, a successful and well-positioned TV sales agent will also know how to short circuit the system. (Although many of the better sales agents will be equally effective in all markets, (film, TV, video and DVD distribution, etc.), as their essential talent is selling and deal making of any kind.) The good sales agent will sell to any market that can support profits from the project; since animation is potentially the most marketable and commercial of all the film mediums, it should be possible for them to achieve significant deals for the filmmaker.

With all those positive things said, I must also say that a good sales agent is often as hard to win over to your side as the standard Hollywood or network TV bigwig! They receive mountains of project proposals each year and cannot take on every project. Most of those projects will be unsellable anyway, so a great deal of weeding-out may be done by others in the office before the sales agent ever sees the project. The better agents also limit their time and attentions to a handful of favorite creative talents, so the enthusiastic newbie must make as much effort to pitch their project to a sales agent as the sales agent must make to pitch to a major distributor. They must ensure that their presentation package is of the highest quality possible. A back of an envelope scribble will just not cut it, unless you have a track record and reputation like Steven Spielberg or John Lasseter!

Legal Advice

Specialist lawyers, specifically entertainment lawyers (who deal exclusively with the media industries), are an essential ingredient in any seriously ambitious, commercially-based development. When the stakes are high (and therefore a great deal of finance is required), there arise a number of significant intellectual property traps, as well as other complex contractual issues, that need to be expertly navigated. Most of these legal challenges will lie far outside the skills and the comprehension of the average filmmaker. Herein lies a paradox. Most aspiring first-time filmmakers do not have the resources to pay for the services of such high-powered lawyers until they become fully-fledged professional filmmakers, yet at the same time they will not become fully-fledged filmmakers unless they find the funding to do so! Ultimately it is in the resourcefulness and the deal-making dexterity of the ambitious filmmaker that has to somehow attract the services of a recognized legal advisor to their project, one way or another. This is what often separates the winners from the also-rans in any race for professional industry funding and support.

There is absolutely no point in any commercial project seeking finance unless there is a legally binding contract that provides for the full use of any intellectual property related to that project being in place. Apart from the other skills a skilled and accomplished lawyer can provide the production; this is where they truly have to earn their money. No serious financier will touch a project unless all the paperwork and contractual material is legally secure, whether this relates to intellectual property rights, or else to other contractual issues, production financing arrangements, or simply the hiring of talent for the production. For all these reasons the services of a specialist entertainment lawyer cannot be avoided. The consequences of not having all the legal aspects of the production covered in this way could inevitably result in the production not getting started in the first place, or else if it did somehow go into production, run aground though legal intervention or court injunction as a result of the sufficient paperwork not being completed correctly, or else not being in place at all. With any of these scenarios, the result would inevitably be the financial ruin of both the filmmaker and possibly even the financier.

For this reason, it is clear that the benefits of an experienced (albeit expensive) lawyer to a commercially-based project is indispensable. However, should sufficient upfront funding not be available for the filmmaker to hire a lawyer outright, it might be of interest that some lawyers have been known to take on a potentially successful project on the understanding that they get a small fee initially, then a negotiable percentage of the profits at a later date. (This is not the norm but it does happen.) Needless to say, if this happened, it would be naturally contingent on the lawyer studying the project beforehand and considering it a profitable project in the long term. Although no one can accurately predict what will be profitable or not, to be honest, those lawyers who believe they have an instinct for sniffing out a winner will be more tempted to take this opportunity, which, of course, could be a most attractive solution for the hard-up filmmaker who is unable to pay a lawyer's fee outright.

One final advantage of hiring a recognized, high profile entertainment lawyer for your planned project is that they can often have significant contacts in the entertainment and financing industries. A committed lawyer, especially one who has a back-end interest in the project (payment from profits), might open important doors for you out of self-interest if nothing else!

Always seek the counsel of those who know better than you, even if to do so tests their patience!

An early presentation design I produced when first pitching this film and book idea.

Presentation Packages

The investment package is an invaluable tool for the aspiring filmmaker to seek support and funding for their intended production. Films can be funded by the filmmakers themselves, if they have access to sufficient funds to do so, which is rare. Even then, it is a very brave person who undertakes the risk of a major film with their own money! Some have succeeded, but most have failed. Realistically, the average film will require an outside distributor/financier, or a good sales agent to lead the filmmaker to the distributor/financier. In view of the importance of acquiring support for a film, it might therefore be wise to reiterate what the professional presentation package should actually consist of.

Logline

The two to three sentence logline should be the principal content of the first page of the document package. Executives who are going to be reading any proposal will not want to initially dwell on everything in great detail, being that their time is so precious. The logline overview of the project enables them to quickly decide whether or not the project is for them. If the logline grabs them, they will read everything else with much more interest. If not, then the entire painstakingly constructed package will be

unceremoniously tossed onto the reject pile with all the others! The logline has to be simple, direct, and intriguing. One benefit animation has over other film projects are the striking color images or illustrations that can go along with the logline, to entice a more positive response from the reader.

Storyline Synopsis

Assuming the logline bait is good enough to encourage a nibble of interest from our big fish, the next section in the package has to encourage a full bite by laying before them the entire film's storyline in an easily digestible form. This is most effective as a one-page storyline synopsis. Again, in reducing the entire story to a bite-size document, the proposing filmmaker is ensuring that the entire concept is immediate and accessible to the other person. This one-pager should be succinctly written and express the storyline in its most positive light, leaving nothing to the imagination. Again, as with the logline page, if it fails to be exciting and enthralling in just a few paragraphs, then the entire document will be tossed into the second reject pile, never to see the light of day again.

First-Draft Script

The script is everything! If it doesn't live up to the expectations generated by the first two pages, then the project will almost certainly be turned down. If the script does meet the expectations, then the filmmaker is now getting very close to home base.

However, even if the script doesn't fully live up to expectations, certain allowances may be made for script deficiencies if the distributor still feels that the project is worth pursuing. The distributor may suggest that the project move forward in development further, but with a script re-write. They might allow the same writer to produce that re-write, or they might insist that another writer be brought in. This is a point where the filmmaker will have to make a difficult decision. They must accept the correct judgment of this assessment or else battle hard for the original vision being protected with no changes (but possibly lose the distribution deal in the process!). It is a very thorny moment for the aspiring filmmaker to face and many filmmakers have suffered through this scenario, one way or another. The fact that the script may be the best in the world—innovative, imaginative, and uniquely created for the animation medium—means nothing if the distributor just doesn't get it. Profound corruptions of a great and original idea into formulated predictability could possibly be a risk at this stage. On the other hand, a fresh eye and a fresh writer are just as likely to breathe new life into a script and produce a positive transformation. There is no way of knowing what will occur; it will vary between distributor to distributor, filmmaker to filmmaker, and circumstance to circumstance. Whatever the scenario may be, unless the project's script is approved and accepted by the distributor, the film will not find a deal.

```
                    - T H E    H A T -

                      by Tony White

                 (Pre-title sequence:)

EXT. GNASHVILLE SKYLINE. - NIGHT

GNASHVILLE is the 'toon' equivalent of the real-world
Nashville...Music City, USA.  Above the sleeping toon city,
the departing and almost spent black clouds of a recent
thunderstorm begin to creep away, intermittently revealing
a clear and star-filled night sky above, rim lit by the
bright, white full moon which is concealed behind them.
The camera slowly moves in towards the city streets......

                                       DISSOLVE TO.....

EXT. MONTAGE OF CITY STREET - NIGHT

The Gnashville streets are still wet and deserted from the
recent storm.  To the sound of cool, mellow music, we
slowly explore their emptiness.  Our curiosity satisfied,
we begin to hear the gravelly, worldly voice of our
narrator, HANK WAGGINS.  He has the voice of someone who
has 'been there/drunk it'.  We will soon recognize that
Hank is downtoon Gnashville's 'top dawg', yet someone who
clearly displays a deep affection for the city that gave
him his break when he most needed it....and consequently
someone who keeps a fatherly eye on all and is prepared to
give something back....

                      HANK
                   (v.o.)
          This is my kind of town.  Not pretty,
          but a magical place.  This is the
          heartland of a musician's soul....a
          city where dreams and emotions are
          stripped bare and the whole world looks
          to watch.  This is city of love and
          life, joy and sorrow... and there's a
          tune for every one of them.  This is my
          kind of town.  This is
          'GNASHVILLE'...with a 'G', for 'great'!

With the mention of 'G', we see a street sign pointing to
Downtoon Gnashville....leaving us no doubt that this
Gnashville is spelt with a 'G'.  The camera follows the
sign....
```

The opening page of "The Hat," a movie I once developed.

Key Character Designs and Concept Art

Although part of the development stage, the elements of key character designs and concept art are important ingredients of the presentation package too. Most movies these days have a great dependency on visual action, style, and effects. Animation is all about visual action, style, and effects. Therefore, assuming the script is accepted, a prospective distributor will next need to consider the vision of the project. The presentation of principal character designs is obvious. Having learned all about the main character and their interaction and adventures throughout the script, it is now necessary to add visual definition to everything. Often scripts can be great and the character designs awful, or vice versa! The presentation of the filmmaker's designs for the project may consequently be another deal-breaking moment between what the distributor wants to see and what the filmmaker wants to show them. Although most distributors will not know what they want, they will at least declare what they like. The whole thing is therefore entirely subjective. With this notion in mind, it is the filmmaker's responsibility to ensure that the designs for the project will be attractive enough for any distributor to accept, while also being new and unique enough to demonstrate the strength of the project.

The important thing to remember when preparing to pitch an idea is that it should not be created in isolation. The process best involves the collaboration of colleagues, friends, family and loved ones, soliciting objective responses from them, before the final concept package is shown to the industry people who matter.

Concept art visually defines the settings, the moods, and the environments in which the characters appear. In live-action terms, this will be the locations and the camera style when filming these locations or settings. It is not necessary for the concept art to define every single setting indicated by the script but it is necessary to define the main ones. The animation designs and concept art should inspire a distributor to want to see everything brought to life. Bad design will not necessarily kill the project, unlike a bad script, unless of course the filmmaker stubbornly refuses to re-design part (or all) of the project.

Sample Sequence Storyboard

To further assure a prospective distributor that the filmmaker is actually competent to produce a professional level film from their script and designs, it will very much help for the filmmaker to present a sample storyboard sequence from the film. The storyboard will indicate the filmic, directorial style that the filmmaker intends to use. It is one thing to have a great script and a great design style, but entirely another thing to demonstrate the filmmaker's aptitude for interpreting it all. The sample storyboard se-

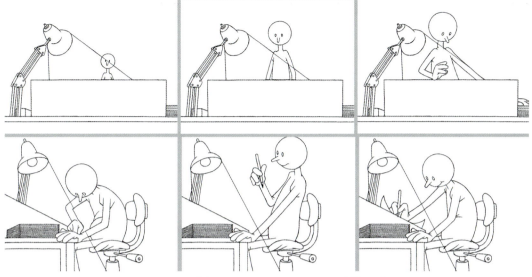

Most people you pitch an idea to will have a very minimum capability of imagining what you are envisioning in your mind's eye. Consequently, without the visual stimulus of designs and storyboarded action, it will be very hard for them to feel confident in moving forward with a first-time filmmaker.

quence is the best way the filmmaker has of illustrating his or her approach to the film without incurring the costs of actually producing a finished animated sequence. Producing a storyboard for at least one sequence in the film will also assist the filmmaker in confronting problems that may well come up in future questioning by an inquisitive distributor, elements that the filmmaker may not have resolved prior to the matter being raised. (See Chapter 6 for more information on storyboarding.)

Animated Taster

A short animated sequence of the film, also called the "taster," could be the final clincher in acquiring a distribution deal. With this, the filmmaker provides the distributor a clear insight into his or her filmic thinking, interpretive qualities, and production skills. Hopefully, a taster will so impress and captivate the distributor that there can be no other conclusion but that this film just has to be made! On the other hand, if the taster is not up to scratch, the potential is that it could well convince the viewer of the opposite, tipping the deal possibility away from them.

To achieve a taster of the necessary quality and polished, professional appearance, the filmmaker may have to beg, borrow, or steal assistance from anyone who can help. For example, a lot of the spoken words, the special effects, the music, and other aspects of the post production that may be required in the taster, will probably lie outside the filmmaker's own capability. In my experience, if the project is innovative and attractive enough, many professionals will want to get involved, without upfront payment, simply for the chance to work on something they would not normally have the chance to work on, should it go into production. With this approach, the filmmaker will attract the finest talent to work on the project while also gaining further experience in working with such talents and the techniques they bring to the table. This is an invaluable experience, to both the project in question and all other projects beyond that.

If a film taster cannot be provided for the presentation package, a showreel—a video or DVD presentation of the filmmaker's best work—must be included. Ideally, the showreel will include short films, excerpts of larger films, and other samples of quality short-form works (such as commercials, etc.). The showreel for a specific project should be tailored to present the past work most comparable in style and technique.

Development Budget

Assuming the distributor is interested in the project, the next (inevitable) questions will be "How much?" and "How long?" It is one thing coming up with a concept that is attractive in both story and content, but another to discover that it is far too costly or time-consuming to have a realistic chance of success in the market it is targeted at. Distributors have categories, or genres, in which they pigeonhole each project proposal they encounter and will have pre-defined box-office targets in mind for each of these markets. If the animated project budget exceeds the potential earnings they anticipate from its box-office returns, then they will not be inclined to green light the project.

If the budget is not in excess of this expectation, then it will definitely prove very attractive to them; the filmmaker should do his homework and come in with a budget price that is beneath the market ideal. At the same time, be aware that there is a strange anomaly within the mainstream Hollywood system—if the budget is too low, it works against the project! A budget that seems extremely low will invoke a belief that this project will not be sufficiently resourced to be of acceptable quality and therefore it will not succeed. It is far better, therefore, to find out what mainstream distributors actually consider to be at the low end of reasonable and tailor the budget upwards from the low figure.

The budget calculation for a film should include the basic production cost figures (of how much, how many, and for how long) as well as the cash flow projection of when each aspect of the budget will be required on a week-by-week basis over the entire production schedule. The budget should also include the planned loan finance repayment scheduling to the merchant bank or private investment angel who actually puts up the production finance using the distribution deal as security.

One final cost in the budget is the completion bond fee. Before a project will be granted a distribution deal and before loan finance can be advanced, a completion bond needs to be in place. The completion bond is essentially an insurance policy provided by an independent outside entity, known generically as a completion bond company. A completion bond is issued after the appropriate company reviews everything contained within the proposed package, especially the budget and the schedule. Drawing from their vast experience in film production and finance, the completion bond company will intensely scrutinize the project on behalf of the distributor and/or the investor to see where the weaknesses and failings are in the overall production plan. Then, for a suitable fee (usually represented as a percent of the production budget) they will guarantee to the distributor/investor that the film will be delivered on time and on budget. If this does not happen, the completion bond company will pay back to the distributor/investor any shortfall that this failure may cause. The completion bond is an invaluable insurance document and no one involved in the production, including the filmmaker, should proceed without one. For this reason, it is perfectly acceptable for the completion bond fee to appear in the production budget, being that it is a major insurance policy against any shortcomings.

Finally, in terms of scheduling, an animated film may not be penalized if it is scheduled to take longer to produce than the average live-action film. By its very nature, animation is a time-consuming process, especially at the high end of production, and this will be understood by the experienced distributor. However, any production schedule longer than 18 to 24 months in total will be scrutinized more seriously.

Evidence of Ownership of Rights and Intellectual Property

As discussed in Chapter 1, the evidence of ownership of rights and intellectual property gives assurance that there will be no future lawsuits or legal claims for damages should anything that appears in the film, or is the inspiration for the film, be subject to outside copyright material. Even copyright material owned by the filmmaker has to be assigned to the production. Signed and written evidence of the ownership of all options, copyrights, literary agreements, and any other intellectual property that is pertinent to the production will have to be fully declared here. This must also include all draft release agreements that future employees of the production will be required to sign, effectively authorizing the production entity free use of anything created on the production.

Mutual Non-Disclosure Agreement

The parties to this Agreement intend to disclose to one another certain technical and non-technical information, as well as business strategies which may be confidential or proprietary to the disclosing party ("Confidential Information"), and recognize the need to protect any Confidential Information that is shared between and from unauthorized use and disclosure.

In consideration of the other party's disclosure of Confidential Information, each party agrees as follows:

1. **Confidential Information.** Confidential Information includes, but not limited to, information concerning inventions, know-how, techniques, patent applications, product drawings, engineering data, processes, equipment, apparatuses, software programs, software source documents, customer lists, financial statements, sales forecasts, and sales and marketing methods and plans.

 Confidential Information disclosed in tangible form shall be clearly marked as "confidential" or "proprietary" by the disclosing party. Confidential Information disclosed orally or visually shall be orally identified as such at the time of disclosure and then be subsequently reduced to written form in a clearly marked document and delivered to the receiving party within thirty (30) days of the initial disclosure.

2. **Information Not Covered.** Confidential Information will not include information which:
 (a) Was already known by the receiving party prior to receipt of same from the disclosing party;
 (b) Is now, or hereafter becomes, through no act or failure to act on the part of the receiving party, generally known or available to the public;
 (c) Is hereafter rightfully furnished to the receiving party by a third party, without restriction as to disclosure or any obligation of confidentiality;
 (d) Is information which the receiving party can document was independently developed by the receiving party.
 (e) Is required to be disclosed in response to a valid order by a court or other governmental body, provided that the Receiving party provides the other party with prior written notice of such disclosure in order to permit the other party to seek confidential treatment of such information.

A confidentiality document is typical of today's legal paperwork. BAUHAUS SOFTWARE

Key Personnel

Part of the project presentation must include resumes (known as C.V.s in the U.K.) of the principal personnel to be involved. Such track records will provide evidence of the quality of talent and experience the production intends on bringing together. Resumes should include (but not be limited to) the career histories of the producer(s), the director, and other key members of the creative team. Even if everything else in the presentation package is exemplary, the distributor will still want to be sure that the people involved are going to prove a good investment. Resumes should therefore not only include a basic history of each individual's employment throughout their career in the industry but they should also include any awards won, critical accolades, and anything else that proves that these individuals are exceptional and capable. It would be entirely wrong to fabricate information within these resumes. But unlike that standard corporate resume which needs to be no more than one page long, it is better to add than take away in this instance.

EDUCATION:
- East Ham Technical College, London, England
- Studied advanced animation techniques extensively with **Ken Harris** (original lead animator of "Bugs Bunny," "Roadrunner," etc.), **Art Babbit** (original lead animator on "Pinocchio," "Fantasia," etc.) and **Richard Williams** (3 times Oscar winner).

EXPERIENCE:
- **Animus Productions/Entertainments:** (20 years - till 2000), Founder/Owner, Director, Head Design/Animation. Awards won for: **"Hokusai"** (**British Academy Award**), PBS Special **"Cathedral"** (Blue Ribbon Award) (also directed/animated companion PBS film; **"Pyramid"**), **"Ink Thief"** Utilizing live action, CGI Graphics, 2D/3D animation, 1994 New York Film and Television Award Honored Finalist, **"A Seafarer's Tale"** 1999 New York Film and Television Award, various other awards including: Clio, Los Angeles Advertising Award, Chicago Animation Festival, etc.

- **Richard Williams Animation Limited:** 7 years, Personal Assistant to Richard Williams on **"A Christmas Carol"** (Academy Award) and Director, Designer, Animator of numerous projects. Awards won for **"Pink Panther Strikes Again"** (Design & Art Directors Award) and a variety of advertising awards.

- **Halas and Batchelor:** 5 years, Head of Design, Commercials, Short Films **"Jackson Five"** TV Series, **"Tomfoolery."** Awards for **"Quartet"** (wrote and directed), **"A Short Tall Story"** (wrote and directed).

AUTHOR: **"The Animator's Workbook,"** Published by Watson-Guptill, almost **80,000** copies sold world wide. The definitive book on animation technique.

LECTURER: To international audiences including the Norwegian Film Institute - Oslo, Swedish Film Institute - Stockholm, Tri-be-ca Grill Guest Director - New York, Israel Animation Guild - Tel Aviv, etc. Featured in multiple television and print

An example from part of my own personal resume. In actual fact I have two types of resume, the one-pager and the extended version (which contains all my essential career documentation on two pages as well as a full list of all the awards I have won).

Project Web site

These days it is very desirable to include a confidential Web site that can be accessed by selected people. This is not a Web site that is public property, for much of the material on it will effectively be confidential to the production team and potential distributor/investor. But it does provide worldwide, 24/7 access to all the material in the project bible (and perhaps more). The filmmaker may make it accessible to more than one distribution entity, who, in turn, may confidentially request that their professional colleagues and/or advisers access the material and then report back to them on it. Even beyond that, a dedicated Web site can be a useful tool. Should the project ultimately be given the green light, the Web site can be modified for public access to updated information on the information proper and, beyond that, offer pre-publicity material and film trailers as the pre-publicity for the film begins to crank up.

Presentation of the Presentation Package

This, therefore, constitutes all of the elements that a professional, comprehensive presentation of a proposed project will require. The material itself will need to be packaged in the form of a bound document, with additional visual material on an accompanying video tape and/or DVD. There are companies, such as Kinko's in the U.S., that enable the filmmaker to produce a very professional-looking document for minimal costs. Ultimately, you might also consider having an integrated design approach for all the presentation elements, such a logo title and design that will appear on the front of the document, on the videotape/DVD label, and even on notepaper or business cards.

I have often used video or DVD interviews to get my message across as part of a new project presentation package. It doesn't guarantee success, but it does allow for my views, commitment, and personality to come across when I am not able to personally pitch the project.

Finally, although all of this material has been targeted at presenting a major film project to mainstream Hollywood-style distributors, the same proposal material will also be required when presenting the project to merchant banks and/or other angel investors when production finance is being sought. It is inevitable that by the time this occurs, the presentation document will be a very finely tuned document indeed, probably the result of several earlier rejections prior to a final distribution deal being finally secured. Suffice it to say, however, that without most (or all) of these significant presentation elements in place, as discussed, none of this will ever happen at all, be it a distribution deal or a finance agreement offer.

Short and Independent Film Developing

Although it is extremely glamorous to consider long-form projects in animation (and I sincerely hope that this book will encourage an increase in movie-making ambition outside of current mainstream predictability), the reality is that most animated filmmakers will make some kind of short-form project first. These proposals require less presentation material, subject to the nature of the short-form project being considered —including half-hour TV specials and other productions, all forms of Web entertainment animation, games production, and commercials. Clearly these will all have different presentation requirements depending on their individual nature. Indeed, some don't even have requirements for funding as they will most likely be commissioned by outside producers.

Even on small, independent or low-budget productions, I attempt to storyboard a color sequence of my ideas to help an investor or a prospective client understand my thinking. Seafarer's Association

Personal films also do not require outside funding as such, so there will be little need to create any form of finance presentation package, unless the filmmaker is seeking active sponsorship from industry manufacturers to help with secondary costs. (A work-in-progress showing of the film during production may secure sponsorship interest, depending on the content and quality of production.) Distribution of personal, short films is not an issue either. Usually it is almost impossible not to secure distribution of some kind with this kind of film, whether it is good or bad, as the Web especially will offer opportunities of exposure to the independent filmmaker, as do the independent short film festivals that occur throughout the world. (Check out www.withoutabox. com for information on these.) Sadly, however, standards of independent personal films seem to be incredibly low so only the really well-conceived and well-made films (such as Victor Navone's classic, "Alien Song") really make an impact and have a lasting value to the filmmaker. (Navone was offered a job at Pixar on the strength of "Alien Song"!)

Such instances aside, there will always be the need to seriously pitch any short-form project that is targeted for any significant commercial outlet via established professional distribution routes. Short-form TV specials, high-end Web series, and all games-targeted productions are the most relevant among these. In these specific areas, it is more usual that the investor will be the first port of call, whether that investor is an individual, a corporation, or even a TV company's commissioning editor. The distribution of commercial short-form filmmaking is not as crucial to the initiation of the project as it is in the movie business, being that the production costs of short-form projects are often far less risky for the investor than in Hollywood. Decisions can often be of the gut feeling kind, or just an instinct that a proposed project is just right for the market at that possible moment. Sometimes TV programs can be commissioned simply because there is a slot to fill and the project is the best of a bad bunch that are available. There are many reasons why short-form projects are commissioned or funded and a major element in all of this for the filmmaker is simply being in the right place at the right time!

There is no way to describe the joy a filmmaker has when hearing that a pitched idea has been accepted by a potential investor or client!

Presentation Packages

The following list of ingredients should provide the filmmaker with a broad outline of the kind of material that a short-form proposal should contain, although it should be emphasized again that every proposal will need to be modified to meet the particular industry requirements. It is always wisest to research the marketplace and its system for commissioning projects, and then adapt your presentation material to conform to this. There is also no harm in actually asking the person you are going to present to just what they require when you do so. The bottom line is that there is nothing worse than securing a very important (and often difficult to obtain and "one chance only") meeting with a high-level investor or commissioning editor, only to find out too late that the material you are showing is inappropriate or unrealistic. It is far better to show less of the required type of material than to show too much of the wrong kind. In reality, a simple idea, scribbled on the back of an envelope, in addition to a hastily produced character sketch and a guesstimated budget may be all that's necessary to find interest with a prospective investor, distributor, or a commissioning editor in a relaxed, informal atmosphere. However, in the more usual formal settings, the better prepared and equipped the filmmaker is, the surer the process will be for the project to ultimately find a green light. In view of this, the following is a sound foundation upon which any formal, short-form proposal might minimally need to be built around.

Story Synopsis

In short-form production, the one- to two-sentence logline is not as important. Although executives in the short-form markets are just as busy, they are far more used to reading a longer outline of the proposed project in question than the Hollywood types. A one-page synopsis is a perfectly acceptable way of soliciting their interest. With animation, it should be possible to find space on the page to include an image or two that dynamically represents the project. As with the initial stages of the long-form pitches, if the one-pager doesn't grab the attention of the person who is reading it, then the whole proposal will be tossed into the reject tray just the same!

Series Bible, First-Draft Script, or "Game Plan"

Having hopefully secured the attention of a potential investor with a synopsis, the filmmaker has to consolidate this by providing a more fleshed-out document which presents the proposal content in a far more specific way. In the instance of a half-hour TV special, for example, a first draft script is best. At about 26 pages long, it will not be too onerous to read, as would an 80- to 90-page movie script at this stage.

If it is a TV series that is being proposed, however (and I include this here as a non-network level of TV series, not its longer form network counterpart), it would be entirely inappropriate to expect all 26 episodes (or more) to be read at this stage. So, it is far better to summarize the entire project with one- to two-paragraph overviews of each individual episode in the series, plus perhaps a sample script at the back of the document. This document is collectively known as a series bible and is the heart of most TV series proposals.

When I have a new idea, I tend to write it out as it comes to me, then edit it down until it fits on one page. This distilling process focuses and strengthens the idea.

The Lonely Little "e".

Once upon a time there was a lonely little 'e'.

He was lonely because he didn't have a word to belong to.

He looked everywhere for a word to join.

First he met the word 'MISERY'. But MISERY was just too sad to even talk to him and sloped off following his own shadow.

Then the lonely little 'e' met the word 'GREED'. But GREED just wanted to gobble him all up, so the little 'e' had to run for his life.

Next the lonely little 'e' met the word 'VIOLENCE'.

But VIOLENCE just wanted to hit him, so the lonely little 'e' had to quickly escape again.

Then the lonely little 'e' met the word 'AROGANCE'.

But ARROGANCE said he was too good for the likes of a pathetic little 'e' and walked away without as much as a goodbye.

So the lonely little 'e' was all alone again.

Finally, the lonely little 'e' met the word 'HATE'.

But HATE simply turned his back o[...] [...] because he didn't want to look at anything that[...]

So now the lonely little 'e' was lo[...] tears.

Then, just as the lonely little 'e' [...] he was joined by a little 'O'.

The lonely little 'e' was delig[...]

```
                HANK  (CONT'D)
        (v.o.)
    It all began the night of the big
storm.  All was still and fresh and
new.  Yet, little did this sleeping
city know at the time that a singular,
lost soul, a one time 'great' in the
eyes of the Music City's country toon
fans, was about to return and shake it
(and myself) to it's knees......!"
A shabby, solitary figure is seen to stumbles
along.....alone and hesitant.  It is Randy Lonesome, a one
time mega star of Country Rock but now a washed-up 'down
and out'.  He holds an old and battered guitar in his
hand.....his only friend in a luckless world.  Suddenly, a
sleek black, smoke-glass limo turns the corner and
approaches Randy, who is preparing to take refuge for the
night in a dark and shadowed doorway.  The limo slides
past, splashing water from a curb side puddle over the
luckless singer.  A vaguely seen passenger through the rear
smoke glass window glances out as the car whooshes by.
```

I find that scripting specific sequences (once the entire idea is structured and blocked in solidly) focuses the idea until it flows more naturally from sequence to sequence.

For a game proposal, a conventional story script is not as important as an overall game plan. The game plan effectively describes how the game is to be played, how it is broadly structured, the nature of the characters involved, and the objectives of the players who are playing the game. The only traditionally scripted part of any game plan might be the cinematics, the short animated story sequences that open the game or link the various levels of the game. The cinematic is therefore very capable of being scripted in a conventional sense.

Key Character Designs and Concept Art

It would be impossible to present any animated project, be it long- or short-form, Web- or games-oriented, without designs that indicate what the principal characters look like or the key settings that they appear in. Character model sheets, colored and line drawing depictions of each major character from an assortment of angles, would well be valuable here. Although a storyline and script are as vitally important to a short-form presentation as they are to the long-form variety, it has been known for short-form projects with poor scripts but great designs to be commissioned. Therefore, the design aspect of a short-form presentation should never be underestimated!

A Sample Sequence Storyboard

It is rare for short-form proposals to include storyboard sequences, but they could be useful in visually complex and/or complicated storyline projects, to give the potential investor a clearer understanding of what the filmmaker has in mind. In other instances, a storyboard element within the presentation document for short-form projects is a luxury, not a necessity.

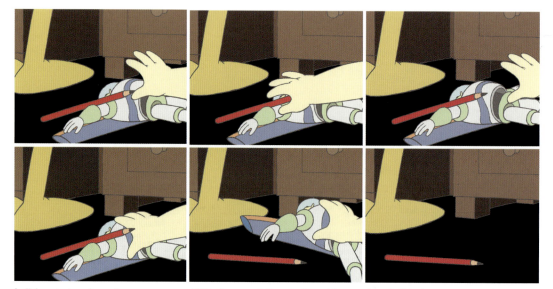

I did not storyboard every aspect of "Endangered Species" in this way, but I did choose to produce a colored version of this particular concluding part, as I wanted to use it for promotional purposes also.

Animated "Taster" or Filmmaker's Showreel

Going to the expense and time to create a film taster to show what a short-form project will actually look like is probably an unnecessary process for the filmmaker to undertake. Maybe in game proposals, a brief working sequence of the game action being proposed would help, but generally, in all other areas of short-form production, it will not be expected that the filmmaker go to this extreme. A showreel, on the other hand, is essential, as this is proof for the investor or commissioning editor that you are experienced and capable enough to pull off the project being proposed. Showreels can run from four or five minutes to an hour, for those with many years of industry experience. It is wise, however, to put all the most valuable and relevant material in the first two to three minutes of screen time, to ensure that the best material is at least seen.

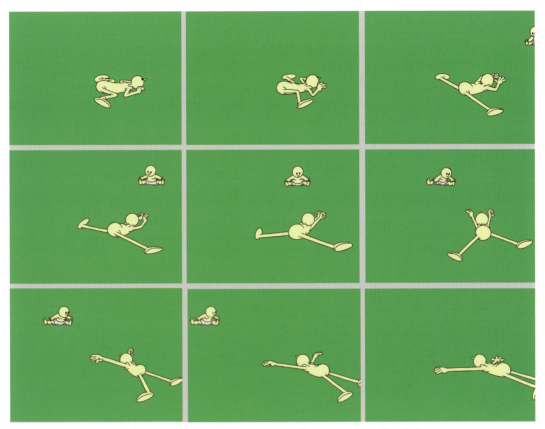

It always pays to invest in producing a short sequence of the project before it is actually commissioned, if you want what you are seeking badly enough.

Project Budget and Schedule

These are two essential ingredients of any short-form proposal which cannot be ignored. No matter who is reviewing the proposal, and no matter which aspect of the industry they represent, they will ultimately want to know "How much?" and "How long?" before proceeding any further. You must be as professional and meticulous in a budgeting and scheduling plan as you would for any other business presentation.

Many investors, and probably many more filmmakers, have gone broke due to an inadequately constructed pre-production budget. It is strongly advised that the proposal budget be produced by a recognized, professional accountant who is experienced in working on film production projects, and who should therefore be able to safeguard the filmmaker and his investor from unexpected and unplanned occurrences.

This should be done with the schedule as well. An experienced producer (of similar material to that being proposed) will be more suited to compile a safe production schedule than the filmmaker, as here too lie many unanticipated unknowns and imponderables that only those who have "been there, done it" will anticipate. The worst thing an inexperienced filmmaker can possibly do is embark on a production that is poorly provided for in these two areas. Should their whole production ultimately go over budget and over schedule, it will either be closed down unceremoniously or completed with another filmmaker at the helm, at the insistence of the investor of the commissioning

editor (both of their heads will be on the block too, one way or another). Whatever the catastrophe, the animation industry is a very small world indeed and word soon gets out that a certain filmmaker is unemployable due to their failures on a particular production. (And there are many highly-talented figures in the animation industry who have been "retired early" or frozen out of the industry because of this!) In short, failed filmmakers become unemployable filmmakers if they don't address the very real needs of the budgeting and scheduling aspects of their production. As a result of this, these sections in the filmmaker's proposal will be scrutinized more than any other.

Chart Of Accounts

STORY FEES & SCRIPT DEVELOPMENT (0100)

Acct#	Description	Acct#	Description	Acct#	Description
0101	Option Fees	0102	Rights Payments	0103	Bonuses
0104	Royalties	0105	Writer(s)-Script Fees	0106	Writer(s)-Bible Fees
0107	Story Editor	0108	Script Coordinator	0109	Secretary
0110	Consultants	0111	Research and Reference Materials	0112	Script Copy Fees
0113	Clearance Fees	0114	Title Registration Fees	0115	Copyright Fees
0116	Writer Travel and Accommodation	0117	Fringe Benefits		

PRODUCER'S UNIT (0200)

Acct#	Description	Acct#	Description	Acct#	Description
0201	Executive Producer	0202	Producer	0203	Co-Producer
0204	Line Producer	0205	Associate Producer	0206	Producer's Assistant
0207	Producer Travel and Accommoda...	0208	Entertainment	0209	Fringe Benefits

DIRECTOR'S UNIT (0300)

Acct#	Description	Acct#	Description	Acct#	Description
0301	Director	0302	Supervising Director	0303	Sequence/Episode Director
0304	Assistant Director	0305	Director's Assistant	0306	Director Travel & Accommodation
0307	Entertainment	0308	Fringe Benefits		

CASTING & RECORDING (0400)

Acct#	Description	Acct#	Description	Acct#	Description
0401	Principal Cast	0402	Supporting Cast	0403	Casting Director
0404	Dialogue Director	0405	Welfare Worker/Teacher	0406	Vocal Coach
0407	Casting Coordinator/Assistant	0408	Studio Costs	0409	Editing
0410	Stock & Transfers	0411	ADR Recording	0412	Loop Group
0413	Working Meals	0414	Mileage/Parking	0415	Travel & Accommodations
0416	Cast Exams	0417	Fringe Benefits		

TOTAL ABOVE THE LINE

PRODUCTION STAFF (0500)

Acct#	Description	Acct#	Description	Acct#	Description
0501	Production Manager	0502	Production Supervisor	0503	Assistant Production Manager
0504	Production Coordinator	0505	Production Assistant	0506	Production Secretary
0507	Production Accountant	0508	Production Consultant	0509	Temporary Help
0510	Materials and Supplies	0511	Rentals	0512	Working Meals
0513	Overtime	0514	Fringe Benefits		

ART DIRECTION & VISUAL DEVELOPMENT (0600)

Acct#	Description	Acct#	Description	Acct#	Description
0601	Production Designer	0602	Art Director	0603	Artistic Coordinator
0604	Character Designer	0605	Location Designer	0606	EFX Designer
0607	Background Painter	0608	Color Stylist	0609	CGI Artist
0610	Sculptures/Maquettes	0611	Research and Reference Materials	0612	Travel and Accommodations
0613	Materials and Supplies	0614	Overtime	0615	Fringe Benefits

MODEL DESIGN (0700)

Acct#	Description	Acct#	Description	Acct#	Description
0701	Character Design	0702	Location Design	0703	EFX Design
0704	Prop Design	0705	Materials and Supplies	0706	Overtime
0707	Fringe Benefits				

STORYBOARD (0800)

Acct#	Description	Acct#	Description	Acct#	Description
0801	Storyboard Supervisor	0802	Storyboard Artist	0803	Storyboard Clean Up Artist
0804	Materials and Supplies	0805	Overtime	0806	Fringe Benefits

SONG PRODUCTION (0900)

Acct#	Description	Acct#	Description	Acct#	Description
0901	Song Composition Fees	0902	Lyricist	0903	Demos
0904	Song Copyrights	0905	Original Song Purchase	0906	Song Producer
0907	Singers/Chorus	0908	Song Coach	0909	Orchestrator/Arrangement Fees
0910	Conductor	0911	Musicians	0912	Instrument Cartage
0913	Instrument Rentals	0914	Music Editor	0915	Copyist/Proofreader
0916	Studio Session Fees	0917	Travel and Accommodation	0918	Overtime
0919	Fringe Benefits				

ANIMATION DIRECTION; PRE-EDITING/FEATURE EDITING (1000)

Acct#	Description	Acct#	Description	Acct#	Description
1001	Editor	1002	Assistant Editor	1003	Apprentice Editor
1004	Dialogue Editor	1005	Animation Timer - Slugging/Sheet...	1006	Track Reader
1007	Editorial Equipment	1008	Materials and Supplies	1009	Overtime
1010	Fringe Benefits				

TRANSPORTATION & SHIPPING (1100)

Acct#	Description	Acct#	Description	Acct#	Description
1101	Messenger & Courier Services	1102	Mileage	1103	Fuel
1104	Taxis & Limousines	1105	Postage	1106	Freight Charges
1107	Custom Brokers & Fees	1108	Materials and Supplies	1109	Fringe Benefits

TOTAL PRE-PRODUCTION

An accurate budget covers every conceivable aspect of a production.

Evidence of Ownership of Rights and Intellectual Property

As with the long-form projects, the use of a recognized, experienced professional in this area is both wise and essential. As with budgeting and scheduling, the legal aspects of a production are too danger-filled to ignore. Investors and/ or commissioning editors will simply not look at any proposal that does not have the appropriate legal paperwork attached to it. You will have to hire a competent entertainment lawyer, prior to the presentation being made, to ensure that the production is legally watertight in terms of copyrights and other intellectual property matters. It also is in your own interest to have an experienced lawyer on board throughout the entire process, so you can be protected from any inadvisable contractual arrangements.

If in doubt, say nothing and let your legal representative say it for you.

Key Personnel

If someone is going to place a lot of money and career trust in the hands of a filmmaker he or she has probably never met before, the filmmaker's track record (and the track record of the key members of the team) will need to be proven as tried and tested. It is important that the investor and/or commissioning editor feel that the people who are working on the production can actually deliver what they say they can deliver, and including resumes in the presentation package is one way of doing this. Investors and commissioning editors will likely scrutinize (and even check up on) what is provided before any go-aheads are given.

"Endangered Species"

In terms of budgeting at least, "Endangered Species" operated on a wing and a prayer, not something I really recommend to others. The committed, personal filmmaker does have to deal with a number of objective realities when it comes to budgeting their production. It is tempting to charge ahead and produce all the drawings and even color them digitally on a desktop computer for no cost except the filmmaker's own time. Yet, even within that self-sacrificing process, there will be considerable higher cost obligations which also have to be recognized and met in one way or another. The following are a few of the realistic costs that even a one-man animated film operation, such as "Endangered Species," can generate:

- tools (paper, pencils, lightbox, electric pencil sharpener, etc.)
- equipment (computer, software, scanner, videotape/CD/DVD disks and burner, etc.)
- overhead (location, electricity, lighting, etc.)
- post production (music/voice talent and recording, sound editing and dubbing, etc.)
- promotion/advertising (Web site, distribution fees, festival applications, etc.)
- any other costs pertinent to survival during the entire production period!

These and other costs will always be present when any filmmaker attempts to make a film. Some will be easily available, others will have to be found through struggle and resourcefulness. Many of the costs can be reduced by sharing facilities with other filmmakers, or else by asking professional studios to loan equipment and services in exchange for film credits of future payments/work offered. Indeed, even the dreaded credit card can be a friend of the needy filmmaker, at least in the short-term, although this is not recommended for anything but a small emergency!

Apart from industry sponsorship, there are local, national, or even international bodies who offer loans under certain circumstances and all should be considered by the independent filmmaker. In fact, it is actually the ingenuity and resourcefulness of the imaginative filmmaker that will triumph over all adversity. Sometimes, the greatest films are not necessarily the ones that critics acknowledge as being so, but they are instead the ones that simply get finished, despite all the setbacks and deficiencies the filmmaker faced in production. Overcoming such adversity is as much a part of being an accomplished animated filmmaker as simply producing stunning, moving animation.

So many failed filmmakers live to rue the day when they were not prepared with adequate pitch material when finding themselves in the "right place at the right time"!

From the very outset I was totally committed to completing this film, in one way or another, come hell or high water. Therefore, budgeting or especially scheduling were never issues I felt the need to confront. It would be clearly pointless to put artificial time strictures on myself, simply to convince me it would be finished by a certain date, especially with the severely limited time and resources I was subject to. I know myself well enough by now to know that, when committed to a specific objective, I am a totally dedicated, hard working (some would say "workaholic") kind of person who would not let things slip. I have never missed a deadline or gone over budget in my life and I had no intention of letting things slip with this heartfelt personal project.

Experience over the years has enabled me to fully appreciate just what is required in most production circumstances and so I entered the production totally open-eyed to what would be needed. I knew I would get it done regardless of budgets or schedules, but that is because I truly know myself and my capabilities (and weaknesses) after all these years of effort. (Although I do admit to the fact that, very late in the production when I was tired and hurting and cursing the fact that I ever started in the first place, I suddenly remembered what I had resolved at the end of my first personal film, "Never again!!!")

Of course, even in that moment of wavering weakness, I did have every intention of seeing it all through, while giving each and every scene the best shot I could. Even the thought of having to re-do the work if it didn't turn out right the first time was not too daunting. For all these reasons the notion of scheduling this production would just be wasted energy and effort.

Budget-wise I had to be really careful. With no money to pay for anything, I naturally had to ensure that everything I did was within my reach and subject to only the equipment I had available at the time. Initially, early on in the production, I did consider the notion of seeking industry sponsorship to help me pay for things that lay outside of my financial capabilities. I enlisted the generous help of a valued friend and filmmaker, Daniel Pezely, in putting a detailed budget and sponsorship proposal together which could be shown to prospective sponsors. However, the reaction to this idea at the early stages proved stupendously underwhelming to say the least, and so I dropped the idea pretty rapidly, preferring to save my energies for the lonely task in hand. I had to face the fact that I was essentially on my own and subject to my own "stone soup" resources.

That said, there is a terrible trait in human nature called procrastination. Being very much aware of this, I set mini-production targets for myself throughout the entire film-making process. With the animatic presenting exactly what needed to be done (and I never changed a single thing, except for adding a few scenes to the very end, late in the production period), it was relatively easy for me to estimate just how long a particular scene should take to animate, scan, color, composite, and so forth. I therefore set myself mental deadlines on each scene. If I thought it would take a week to do and I started it on a Monday, then I would instill in myself that it actually had be finished by the following Monday. I rarely missed one of these internal deadlines, although occasionally life events, teaching commitments, or simply fatigue would play a part in the deadlines being moved slightly on occasions. Fortunately, these proved rare occurrences, rather than the norm.

In essence, when making a film for oneself—with no clients or investors to appease —the responsibility of a successful completion lies squarely on your own shoulders. With clients, investors, and crew to satisfy on most commercial productions, the use of budgets and deadline scheduling is unavoidable; indeed, it is essential! However, with a personal project like "Endangered Species," it is always a matter of getting out of the project exactly what you are prepared to put into it. My wholehearted commitment to this film has always tended to override my instincts for procrastination or to succumb to physical frailties that result in time lost in the studio setting. Animation simply does not do itself; it has to be done by the animator, no excuses.

With any independently motivated film, the filmmaker is embarking on an intense personal commitment. The budget and schedule is invariably limited by whatever source of support you can beg, borrow, or steal at the time—if there are any sources of support for what you want to do in the first place. The secret of success in these circumstances is to simply keep your head down and get through just what needs to be got through, regardless. Keep on keeping on! For me, this is an invaluable motto that should never be forgotten.

4

Rules of Filmmaking

A cliché framing technique maybe, but still one that enables quick visual decisions!

Before venturing further into the mysteries of animated filmmaking, it would be valuable to spend some time to define the basics of all filmmaking. Although the situation is getting better, animation for so long now has suffered from its lack of knowledge (or respect) for traditional film techniques. These are techniques that, over the decades, have made the audience's experience better and more meaningful. These rules are not predictable formulas that limit the scope of the filmmaker, like mainstream animated storytelling. They are principles which in no way inhibit the creativeness, innovativeness, or imagination of the creator. Indeed, once learned, they will actually liberate the filmmaker to express ideas better and with more effectiveness for audiences. It is vitally important to know these principles before the core of the storytelling process, the storyboard, and animation are embarked upon.

It has been long suggested that a process of persistence of vision is what makes film work, although this assertion is being challenged more and more these days. First mentioned in an article by Paul Mark Roget (yes, the man who compiled the famous thesaurus), the theory of persistence of vision states that the brain holds an image a fraction of time longer than the eye actually sees it. Therefore, if an image is projected fleetingly on a screen, the brain will actually hold that image a little longer than it really is visible. Cinematic film projection shows 24 of these fleeting images every second, with tiny moments of blackness between each image. Because the brain is able to retain each image so it overlaps the black moments, it essentially blurs each of the images together so you do not register the black moments at all. Therefore, if each separate image is slightly different from the previous one, the mind will perceive the entire sequence of images as movement (below). It is said that when we sit in the cinema and watch a film, we are in fact seeing equal amounts of black moments and picture moments. Allegedly, it is the persistence of vision that interprets them into a movie.

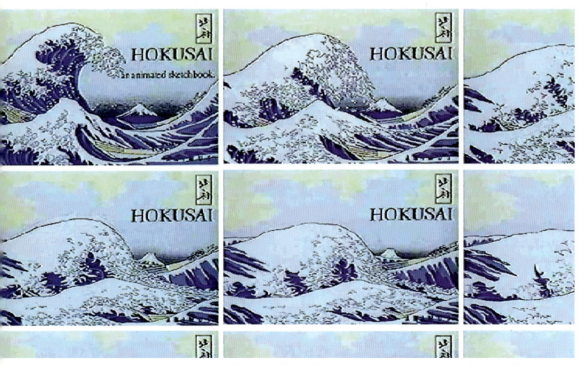

The frame-by-frame movement of this scene from "Hokusai—An Animated Sketchbook" illustrates stylistically the different animated images required to create a breaking wave.

Opposing viewpoints on persistence of vision

The theory of persistence of vision was seriously challenged in the 1980s by researchers Joseph and Barbara Anderson, Bill Nichols, and Susan J. Lederman and, even as far back as 1913, by Kasimir Proszynski (designer of the popular Aeroscope 35mm cine camera), who pioneered flicker-less shutters for film projectors, demonstrating how the notion of the perception of vision was an unsound theory. For more information, visit www.grand-illusions.com/percept.htm.

The effect of flickering objects on the human brain has been long exploited by showmen and tricksters, even way back in the earliest days of the projected image, when all kinds of gadgets and devices that entertained people with their moving novelty were invented. However, it was some time later that the actuality of a regulated, mechanical projection device was evolved, giving rise to the device known as a film projector. Animation, being the art of the moving image, was always right up front of this movement. The earliest animated material that remains are the films of Emile Kohl, who, at the very dawn of the 20th century, drew primitive little stick men directly onto the celluloid itself, as in the figure below. This initiated an enchantment of bringing inanimate objects to life through animation on film.

The process of drawing directly onto 35mm film, using a pen and India ink, shows that even in this high-tech age it is still theoretically possible.

Although the earliest movies offered fascinating insights into popular novelties and people's everyday lives, it took a little while for popular creative drama to evolve. Audiences did stand in line for hours just to get a glimpse of the new magical art form in its early day, but soon more was required to maintain their interest. Serious filmmakers very quickly discovered that just pointing a camera in the direction of a dramatic scene and recording it was boring and predictable, so they began to move the camera to capture differing points of view. This proved to give more variation, impact, and emphasis to what was being filmed.

This variation in camera position, as well as the distance between the camera and the actors, gave the filmmaker an entirely new range of options through which they could paint more expressive and more engaging films. Soon, the development of sound, lighting, lens technology, and other innovations increased the range of these options, and computer-based, digital technology now even allows the filmmaker to transcend reality with special effects. Ultimately there will probably be even cloned, genetically engineered actors, creatures, and performers to absorb and entertain us. But even then, the principles of filmmaking that were evolved in those very earliest days of film history will still have a relevance in inspiring and absorbing stories.

Camera Positions

The first thing a filmmaker should consider when interpreting a script is the placement and framing of the camera. There are three basic camera positions—the wide shot, the mid shot, and the close-up. Secondary to these are the ultra-wide shot and the extreme close-up. With these basic concepts in mind, a filmmaker can transform a sequence into something quite dramatic and powerful.

Ultra-Wide Shot

Sometimes, in the opening of a film or of a new sequence, it is necessary to give an exaggerated sense of scale and proportion in relation to the character. The opening of a western, for example, is more impressive if we see the main character riding through a vast landscape of prairie, forests, and snow-capped mountains as if he or she is barely significant. In an ultra-wide shot, we experience the character being dwarfed, or dominated, by the setting. The ultra-wide shot is best witnessed in some of the great epic movies of the director David Lean, where his figures were so dominated by their wide, ranging environment that they were sometimes like a speck on the lens. The ultra-wide shot is therefore a relating shot of great scale and dimension (see the top photo on the next page).

Wide Shot

The wide shot is, conventionally, the opening shot of any new sequence, often defined as the establishing shot. The purpose of the wide shot is to set the scene, giving the audience an immediate overview of the location, its content, and its relationship with the main character, or characters, within it. This is the reason why most filmmakers will favor the wide shot as their establishing shot for the opening sequence of their film, or for any new setup within a sequence that requires a new location. For most openings, the wide shot should be the preferred shot, but some openings or transitions work better with mystery and intrigue, which the wide shot does not create.

A wide shot can only be a wide shot if there are full-sized characters within the shot, as the wideness of a shot depends entirely on the relationship it makes with the actor(s). Any shot that is larger than the character(s) in view—we can see the whole character from head to foot with much of the location they are in around them—should be deemed a wide shot (see the bottom photo).

The ultra-wide shot includes a lot of background and shows the subject (in this case, the stop sign) as a very small part of the whole.

The wide shot shows the whole character but also the immediate setting for the scene.

Mid Shot

The mid shot requires that the camera be brought in closer so the character is not entirely visible. Usually, the camera frames the character from the waist to the top of their head, although you can have a mid shot of the character from the waist to the bottom of their feet, if it serves a purpose. The mid shot brings the audience in a little closer to the character without the sense of overcrowding him or her.

A mid shot is used if the character is doing something that we need to see more clearly (something that would probably be lost on the audience in a wide shot) or if they are reacting or in some way relating to something around them that we need to see a little more clearly. The character may be noticing something about another character's appearance or they may see something they need close beside them. It is all a question of what the character is doing and what around them is involved in that particular action. In this way, the wide shot and the mid shot are both shots of "relating"—in the wide shot the character is relating to the wider location around them and in the mid shot the character is relating to something that is closer to them. These are therefore more impersonal shots and will communicate that to the audience, even if this is subliminal.

The mid shot brings us closer to the subject.

Close-Up

The close-up is a shot that we use to get right in on the action to communicate something quite specific to the audience, with no other distractions. Quite often, this is a really close shot of character's face as they are speaking or reacting in some way. A close-up shot shows us an area that is approximately from a character's neck to the top of the head. However, a close-up shot can also be one of a hand picking something up, a tossed key landing in an open drawer, a fuse reaching a bomb just before the explosion, or anything else that needs to be witnessed closely (see the top photo, next page).

The close-up especially enables a character to express themselves facially, rather than with his or her body. It enables the audience to get a clear, unequivocal look at something they must not miss if the drama of a situation is to be fully understood. In the genre

of horror, it can also set up a shock for the audience, with the camera locked onto a close-up of a frightened face, then the film cutting to a wide shot of the same scene where a previously unseen monster is now standing behind the unsuspecting victim. The close-up is considered a very personal shot, in the sense that we only need to see the person, or their reaction to something, or something specific that they are doing.

The close-up shot focuses us on the subject and their reaction or action.

Extreme Close-Up

The extreme close-up is exactly what it suggests; the camera moves in so close that the screen is filled with the tiniest detail, as in the figure below. It might be an eye blink or stare. It might be the tip of a match lighting the end of a cigarette. Or it could be a raindrop hitting the ground in extreme slow motion. Whatever the requirement of the shot, the camera takes the audience into its most up-close and intimate detail and makes it impossible for the audience to ignore it. An extreme close-up is the thing that finishes off an action, or series of actions, a shot that records an un-missable moment in a scene or sequence. Being an intensely personal shot, far more so than the close-up, it leaves an audience in absolutely no doubt as to what the filmmaker wants them to see at that moment in time.

The extreme close-up forces the audience in on a particular action, in this case to show the bullet holes!

A quick tip when working out the framing of a scene in animation is to make the shape of the screen with the hands and move them around until the best framing of that artwork is arrived at.

Combining Camera Positions in a Scene

If we view the five camera positions as five colors in a filmmaker's palette, then the filmmaker can paint a more colorful picture by using them all, even if the camera maintains the same viewpoint throughout the sequence. For example, let us consider a scenario where a man is standing alone at the end of dirt track which intersects a deserted country road. The whole action takes place in the daytime, in the middle of a sprawling landscape, with the man clearly waiting for someone, or something, to arrive. The location, being empty and isolated, could well lead us to draw our own conclusions as to whether the scenario is innocent or sinister. Perhaps a well-structured staging of the events that unfold will give us more clues? For example, the opening shot in this sequence might well be an ultra-wide shot of the entire landscape location, with the man miniscule within it. Indeed, the man may well be so far away from us that we don't actually see him at first (top photo on page 99).

The next shot might well be a wide shot, where much of the same isolated landscape is still visible, but this time the man is much nearer, establishing him in a specific location within the whole scheme of things. At this point the audience would recognize that our man is smart and respectable. He is clearly not a tramp or hitchhiker. His smart, but casual, appearance suggests that he is perhaps some kind of professional man, a doctor, a lawyer, or maybe even a successful hit man, waiting to meet up with someone else in a lonely, isolated area.

We might now cut to a close-up of the man's staring face as he looks impassively down the road he is standing next to. This may at least give us more clues as to his personality and intent.

Opening the scene with an ultra-wide shot.

The wide shot gives the audience a better sense of our character.

Moving still closer to the subject.

Now we cut to a mid shot of the man. We definitely begin to sense his impatience (or is it concern?), as he looks down to his wrist watch with a hint of agitation.

Moving out to a mid shot to show the man's action.

We now cut to an extreme close-up of the man's watch face, to see what he sees as well; this also reveals the precise time of day.

An extreme close-up of the watch shows the audience the time of day.

The camera now returns to a close-up of the man's face as he looks down the road with what might be a hint of a scowl or concern. We begin to understand that this man doesn't exactly wear his emotions on his sleeve. At this point a distant car engine can now be heard approaching. The man, perhaps, offers a hint of a smile.

A close-up shot offers more insight into the man's emotions. The next cut might be to the original wide shot of the man in his landscape. However, this time it reveals the car that is approaching. We watch as it slows down and stops a little way ahead of him.

Incorporating more action with a wide shot.

Finally, we cut back to a concluding mid shot of the man. At last he reveals some emotion and smiles as he waves to whoever is driving the car. We still do not know the answer to our little scenario, and perhaps we never will know. However, at least this little staging example has created a desire to know!

The audience sees the character's reaction in a mid shot.

All this is, of course, simply a cliché scenario of how a sequence of camera positions can dramatize and color the events in a sequence to imply a specific storyline to the audience. There are a vast number of other camera options that would have told a different story but the shot selection has explained a specific sequence of events. These may not be the way the story really is at all, of course; the shot selection has merely led us to certain conclusions because of the way it has been built up.

In reality, all that is happening is that a man is standing under a tree, beside a parked car, waiting for someone else to arrive. If the camera were merely positioned in a single, basic wide shot throughout, and the audience basically watched the man standing under a tree look at his watch, then observe the other car coming towards him, then there would be no suspense or storytelling drama implied by it all. In reality, it might be that the man's car has just broken down and his wife was kindly arriving to pick him up! A perfectly innocent event. However, on the other hand, the man might be a drug dealer waiting to make a pick-up in a lonely and deserted landscape. The shot selection can influence the way any film story scenario is interpreted—sinister, humorous, or otherwise—and that is why staging shots offers such significant colors to the filmmaker's palette. Yet camera placements alone are not the only colors on the palette that a filmmaker can paint a picture with.

Camera Lenses

There are four basic lenses: the standard lens, the wide-angle lens, the long lens, and the zoom lens. There is actually a fifth lens called a fisheye, which is worthy of mention too, although this has a more extreme effect on the image than the others and therefore should be used very sparingly, unless the project requires it. Each lens has specific qualities in capturing a scene that the others don't and therefore each offers specific options to the filmmaker when considering the content, impact, and mood of a scene. "Prime lens" is a generic term that describes most of these lenses, which create a fixed relationship between the camera and the object. Zoom lenses, on the other hand, can move the point of view in and out during the filming. All lenses are defined by a measurement known as focal length, which influences both the magnification and the field (area) of view that each offers. Lens selection is more essential to the 3D animator than any other, although 2D animators can achieve the same effect by distorting the perspective and the scale of elements within their artwork.

Standard Lens (50–100mm Focal Length)

The standard (or normal) lens is the one that most still cameras use. It captures the picture pretty faithfully (see below), with little or no distortion at all, and covers a reasonably wide viewing area. Most animated filmmakers instinctively use a standard lens viewpoint in their films for most of the time.

The standard lens does not introduce any special effects to the image.

Wide-Angle Lens (20–35mm)

The wide-angle lens provides more depth to the picture and gives it an exaggerated 3D perspective look. This lens will be required when a strong foreground character, or object, needs to be closely focused upon but with as much of the surrounding background environment being seen in the shot at the same time. The wide-angle lens can focus on the things that are closest and takes a far larger angle of view than the standard lens.

In terms of visual effect, the wider the lens is, the more distorted the central image will be and the more distorted its relationship to the background will be. The basic tendency will be that the things nearer to the camera will appear artificially closer and the things further away will appear pushed even further away. The wide-angle lens is favored by journalists and fashion photographers who have to capture as much of an image as possible but often in a very confined space. Wide shots, as well as mid shots and close-ups, can be seen through a wide angle lens if a particularly exaggerated effect is required between the foreground and background objects (below).

The wide-angle lens offers more of the surrounding background.

Long Lens (85–600mm)

The long lens is used mainly to feature a detailed part of a larger shot when the camera is located far away. The long lens acts like a telescope and brings a far-away object much closer. The angle of view of a long lens is very narrow, so be aware that much of the surrounding background will be lost. This gives a flattening effect to everything behind the object, which essentially lessens any sense of perspective to the relative elements within the shot.

The long lens effect can be seen in most wildlife documentaries, where the animals are filmed from a great distance away. However, the shorter long lenses (85-135mm) are often used for close-up portrait shots as they tend to give a more natural perspective to the features of the face. (The reverse of this, therefore, means that a wide-angle lens used in a close-up portrait shot will enlarge and distort the nose in a way most people will hate seeing!) The flattening of perspective of a long lens will bring a certain surreal, claustrophobic closeness to a crowd shot, such as with a sea of fans chanting at a soccer match, or a character being pursued toward camera through busy rush-hour crowds. The depth of field is most limited on a long lens, which means that the distance of focus around the subject area is not very long; the central object in the scene will be sharp but the immediate and far background imagery will be progressively more blurred.

Zoom Lens (28–80mm; 18–35mm; 70–300mm)

A zoom lens is useful when the camera has to move in and out of a shot while the scene is playing. Unlike the prime lenses, the zoom lens can change between a close-up to a standard lens, or a standard lens to a long lens. A character may be moving forward or backward in a shot and the filmmaker needs to study his facial expression at all times. The zoom lens moves with the action of the scene, so the character's face remains approximately the same size in the shot regardless of their relative position to the camera.

This shot suggests the range of movement that can be embraced in a zoom shot.

Another effect the zoom lens can offer is pulled focus. This is a procedure where the initial part of a scene focuses on something sharply in the foreground while the background is blurred. However, the filmmaker may suddenly wish the audience to see something in the background, so the lens will suddenly re-focus on it as it emerges in the distance, leaving the foreground out of focus (below).

The before and after of a pulled focus shot. It begins with the foreground in sharp focus and the background blurred and ends with the foreground blurred and the background sharp.

While a prime lens can also create a pulled focus shot, the zoom lens offers a forward or backward movement in the lens at the same time, creating a much more contrasting pulled focus shot.

An even stranger shot with the zoom lens is the trombone shot. Essentially, a camera is mounted on a dolly (a special wheeled vehicle that allows a film camera to be pushed around smoothly, changing its position in relation to the object), which is positioned on a track (metal rails that allow the camera to move backwards and forwards in a fixed direction, very much like a railroad track) and then wheeled towards the object. However, as the camera moves closer to the object (enlarging the object in the screen), the zoom lens goes in the opposite direction (zooming out to make the object smaller in the screen).

The resulting effect is that the object of attention stays focused in the center of the screen while everything else in the background of the shot either shrinks or expands dramatically in relation to it, depending on which way the camera is moving (below).

The background perspective distorts as the camera lens zooms in on the subject.

Fisheye Lens (6–16mm)

The fisheye lens gives the effect of an extremely exaggerated wide angle lens, up to 180 degrees of the scene from the camera's point of view (below). The visual effect of the lens is to give a greatly distorted, circular bend to the shot, as if we are seeing the entire reflection of the scene on the surface of a highly reflective silver ball. Fisheye lenses are best used in extremely close, cramped environments, where even a wide angle lens will not encompass the entire scene. Alternatively, the fisheye lens can give an altered consciousness feel to a scene, as if the principal character is drunk, drugged, or dreaming. The fisheye lens can be very disconcerting for an audience and therefore is should be used minimally, unless there is a real purpose in the effect.

The fisheye lens dramatically distorts the scene.

Lighting and Filters

We cannot talk of lenses without also mentioning the use of lighting and filters in the shot. Filters are colored gels that cover the lens and exaggerate the color, tone, or contrast of what is being seen. Modern digital image manipulation techniques enable us to do all kinds of miraculous things with an image these days, long after it has been captured. However, everyone agrees that, in live-action photography at least, the best way of getting the desired effect is to actually capture it through the lens in the first place, whenever possible. Filters give us the option of limiting what the camera sees. They can reduce lighting hot spots (flares and reflected light for the sun or lamps, etc.), they can intensify shadows, and they can even emphasize surface textures that the human eye may not see. The subject of filters and their uses can fill an entire book and there is not enough space to go into such things now but, suffice it to say, for example, a color filter can give a mood or tone to a scene that was not there originally and increases the dramatic effect.

The top-left segment is the original color shot but some of its color is removed, taking it more towards a basic black-and-white shot. The top-right segment has increased contrast and saturation added to it. The lower-left section has been given a cool blue color filter treatment, whereas the bottom-right is much warmer, with red filters added.

Here, the same shot has been treated with a number of Photoshop filters to suggest entirely different visual effects.

Lighting can affect the drama of a shot emphatically. Setting the lights is a major 3D animation challenge and is as critical to the animator as it is to the live-action film-maker or photographer. Exterior lighting obviously defines a time of day and a mood of environment, can emphasize the inhospitable nature of the terrain, or encourage the idyllic nature of a summer's day. The angle of lighting in both exterior and interior shots can dramatically alter the mood. Light shining down from above the character has a distinctly different effect than light which is shining upward upon them. Light behind the character gives a silhouetted, scary quality to the shot that an evenly balanced front light will not give. Rim light (just a hint of light that illuminates the edges of a character or object) allows definition in a darkened environment. A fine spotlight will focus on just a particular part of a scene or character's face. Colored light can create moods too—blue for cold; red, orange, or yellow for hot or vibrant—and these are again created by filters that are placed over the light source. Light, as with lens filters, is a whole subject in itself. You should always be aware of all these often-overlooked options when planning or creating your film.

Here, an original leafy shot (far left) has had two very different filters added to it, creating three very different moods.

Camera Moves

Most shots are static, or close to being static, depending on the nature of the film. However, it is often necessary to move the camera with the action, to follow or illustrate what is going on. For example, a man walking down a street, looking through windows for something may not be an interesting or informative shot if the camera remains in a fixed position and we watch the man move down the street from a distance. It would be much more interesting for the camera to move with the man, to actually see him looking in each window, or even swing the camera around him to look into the window and see what the man sees also. A number of camera moves are available to the filmmaker to accomplish this.

Careful shot selection leads an audience right into a subject.

Fixed (Locked Down) Shot

As the name suggests, the camera here does not move; it remains in a fixed position and the action takes place in front of it. In live-action terms, the camera will most probably be fixed on a tripod to give it stability, or maybe on a dolly with wheels locked. The camera might also be hand-held in a fixed shot (held by the cameraman, without the use of a tripod or dolly), although this will inevitably give a slight movement to the shot, which may be desired. Many TV cop drama shows especially use the hand-held effect, whether the camera is in a fixed or moving position, to provide a more natural, human presence observation on the action.

A locked-down wide shot.

Tracking (Panning) Shot

In live action, a tracking shot is one where the camera follows right alongside the action as it progresses, as with our man when he walks along a street, looking in windows. To achieve this, the camera is actually mounted on a dolly which is fixed on top of a straight railroad-type track that is laid down parallel to the action. As the man moves, the camera moves beside him, along the track, enabling the audience to see everything he does as he does it. In traditional animation, the same effect of moving along with the action, or moving across a wide piece of background artwork that is wider than the screen width, is known as panning. Panning can occur horizontally, or vertically, as when moving up towards the top of a tall building, or else dropping earthwards from a great height, etc.

A full 360-degree tracking/panning shot of a narrow trail through a copse of trees. It begins in the top-right section, pans from right to left along the top layer, and then from right to left along the bottom layer. Ultimately, the action returns back to its original position again at the bottom-left hand section.

Zoom Shot

A zoom shot is one where the camera moves in or out of the action. This may be achieved through the use of a zoom lens (as already discussed) or else by actually dollying the camera on a track that is laid directly towards the action. The camera may start on the part of the track that is furthest away from the scene, and then be wheeled toward it, giving the effect of the action getting closer, and therefore larger, in the screen. A zoom in or out of a shot may not involve the action at all. It may be used to identify a specific prop or object within a larger scene that can either be seen upfront and zoomed out of, or in the distance and zoomed into.

At first glance, there is no sign of our main character, Kermik. However, as the camera zooms in, your attention is focused on his hiding spot. KERMIK PROVIDED BY KIND PERMISSION OF SAILLE SCHUMACHER.

Dolly (Crane) Shot

The dolly (or crane) shot is essentially a combination of the track and zoom shots, although it can be even more than that. Taking the example of our man walking down the street again, the camera might see him as a wide shot from the back (establishing him and the street in one large shot), move into and alongside him as a mid shot, then end up in front of him and observing his face and the inside of the window he is looking into as a close-up. To achieve this, the camera essentially zooms the lens wide for the opening shot as it sits on the end of the track running behind the man (and yet parallel to his action), zooms in as the camera dolly is moved along the track beside him, then zooms in closer as the camera moves to a final position on the track ahead of him and the window. Zoom shots can go further than this of course. They can actually complete a full 360-degree turn around the subject in the shot and can continue rotating around until it is required that they stop.

Kermik is clearly visible in the establishing view here, as is the entire location he is seen in. To draw the audience closer into his features and away from the distracting surrounding environment, the camera dollies around and in on his face.

Well, Hello Dolly!

Professional dollies have wheels that either can be turned in all directions to give a total flexibility of the camera movement, or else on tracks that give the camera a single, linear movement forwards or backwards. They are invaluable in any production!

A 360-degree dolly shot.

There are several ways of doing a dolly shot in live action, but the most practical and straightforward is to mount the camera on a dolly which is itself mounted on a circular track around the subject. The dolly is then pushed around and around the circular track as the cameraman focuses on the action in the middle. The same moving around shot in animation is known as a crane shot. This is easily achieved in 3D animation by simply moving the camera on a pre-defined path, like the circular track used in live-action dolly shots. However, in 2D animation, this shot has to be drawn frame by frame, background and all, if it is to be at all convincing. Today, computers can be used to plot out and establish this action, so all the 2D animator has to do is draw over the computer printouts in the style of the 2D animation and re-film it. In the past, there was not the advantage of computer-aided movement and therefore everything had to be worked out in the head and then on the page, using nothing more than pencil and paper.

Staging

Staging is the positioning of characters within a scene and how they relate to each other, and the camera, as the scene unfolds. The scene may involve one or more characters, and it may even involve one or more cameras. So it is extremely important that the entire scene be staged to make absolute sense when everything is ultimately edited together. The basic staging terminology is not difficult. A one-character scene is known as a one (or single) shot, two characters a two shot, three characters a three shot, and so on. A one-camera shot is usually just referred to as a shot but those with multiple cameras might be described as a two-camera shot, three-camera shot, etc.

This sketch indicated a basic zoom-in, to provide the audience with more information of what is pinned to this local notice board.

Silhouetting the Scene

Whether it is a single shot or a multiple series of shots, in live action or animation, any movement that is filmed needs to be silhouetted if it is to be easily and effectively communicated to an audience. Filmically, silhouetting does not mean that the figure is seen in shadow with a strong light behind it. Instead, it means that the broad dynamics of the character's actions are clearly staged, for example, with arms moving in profile to the camera, rather than directly to and from the camera (where the body mass will partially or totally conceal it).

Staging every shot will lead to interesting and understandable moments in your film.

The fundamental principles of staging a character in a shot are two in number, size, and perspective. Essentially, the nearer the character is to the camera, the bigger they will be. The bigger they are, the more powerful and dominating they can seem. If a character walks towards the camera, or the camera moves towards the character, that character will clearly increase in size and be a bigger aspect of the overall picture (top figure). If the character walks away from the camera, or the camera moves away from the character, the character will get smaller and therefore increasingly less significant from an audience's point of view (bottom figure).

The larger the subject is in the frame, the more power it has.

And the smaller it is, the less important it becomes.

If the character walks away from the camera at an angle to it, rather than simply straight away, there will be a reduction of height across and away from the scene, which is not quite so diminishing as if seen straight on. The same is true of a character walking towards the camera at a 45-degree angle. Plot the points at the top of the head and the bottom of the feet along this angled line of departure and there will be two converging lines that will meet at some point on the horizon.

Here, the power lines at the top of the shot broadly define the angle of its perspective.

The lines define the perspective of a scene (i.e., the further away objects are the smaller they will appear), and the place where these two perspective lines meet on the horizon is known as the vanishing point. This is even more evident with railway lines that head directly away from the point of view towards the horizon.

The vanishing point, where two perspective lines meet in the distance.

The angle of perspective can have a profound influence on the nature of the scene. It is not always recommended that characters walk directly to and directly from the camera. Indeed, it is not even advisable that they look directly at, or directly away from, the camera in general, as this is not as strong a staging as a slight angle is. Aesthetically, if the perspective of the action is slightly on one side of center or the other, that action will be more interesting to observe. This becomes even more important when two or more characters are interacting within a scene.

Keeping characters slightly off-center in a shot provides a more natural and interesting staging.

Elevation also influences the dynamics of perspective within a shot. The camera can either be apparently higher or lower than the horizon. A higher-than-horizon position will literally be looking down on a subject which, if the object in question is actually a character, it puts the camera (and therefore the audience) in a position of dominance over the character (above). This offers a great opportunity in story interpretation terms for the filmmaker. A camera elevation that appears beneath the horizon gives a viewpoint of looking up on the character (or object), which provides a sense of power to the character (below).

High camera position.

Low camera position.

Therefore, in an argument between two characters, a dominant character might always be viewed from a low camera position (looking up at them) while the weaker of the two might be looked down upon using a higher camera elevation. A hero might be viewed from below while the villain is looked down upon. This concept can be equally applied to objects and locations. Looking up at tall buildings in a city suggests the city's dominance of the viewer, or simply that we are seeing everything from a bug's eye viewpoint.

Looking up at a building creates a sense of being tiny or inconsequential.

Looking down on buildings can suggest a more majestic, god-like view of the city, or a giant's view, or maybe just that of a pilot in a helicopter or a plane.

There are innumerable options that intelligent camera positioning and elevation can offer the conscientious filmmaker when they seek to paint a picture with their camera.

The higher and more exaggerated the perspective, the greater the feeling of dominance.

If two people are facing each other and talking, then there are a number of valuable positions that the camera can take: near or far, high or low, left or right.

A few of the camera options for framing a two shot.

The Rule of the Line

However, whatever the camera position, some kind of visual continuity must be considered to avoid disorienting the audience. For example, if figure A (the male) is on the left of the screen talking to figure B (the female) on the right, they must always be staged in every shot so that they are looking at each other from left to right in each shot. Therefore, even with a close-up, one shot on A, he must always be looking from left to right to maintain the continuity of the staging.

Maintain the relative position of the characters, even if they're not always both visible.

Likewise, B needs to be always looking from right to left.

When framing a close-up, it is always better to have a greater space ahead of the subject's gaze than behind it.

Actually, to set the relationship between the two in the audience's mind, an establishing shot of both the characters talking to each other in the same shot, A to the left and B to the right, is necessary. After that, any combination of shots can be used to develop the sense of relationship between the two figures, as long as the basic orientation is that A looks to screen right and B looks to screen left.

Whenever two characters, or even two objects, are in a shot, there is an invisible line that connects them both.

To avoid problems with visual continuity in staging characters or actors, filmmakers have developed "the rule of the line." The line is an imaginary line that joins two people (or two objects) in a shot. If the camera defines an establishing shot where character A is facing character B (see the figure above), then it is easy to imagine an invisible line between them. The simple rule is that the camera must never take up a position in the sequence that moves to the other side of this line. There are a million positions it can take—far to the left, far to the right, high up, low down, close and central, wide and central, etc.—but it should never cross that line between the two characters.

Three similar shots with a high, medium, and low camera angle.

By never crossing the line, you can be sure that the two characters will always be seen looking in the correct direction in relation to each other. However, if the camera crosses the line, then the character, or characters, will suddenly be looking in opposite directions and will disorient the audience.

The orientation of shots A, B, and C are correct. However, when shot D crosses the line, the orientation is wrong and therefore the audience will be momentarily confused.

This is one of the cardinal sins of most inexperienced filmmakers, especially animated filmmakers. NEVER CROSS THE LINE!

Shooting Down the Line

You may want to make a dramatic statement with the staging and although you do not want to offend the audience by disorienting them, you do want a sense of shock or sudden surprise. This is especially true in horror or mystery movies where a victim is suddenly confronted with great danger. To achieve this, a technique known as shooting down the line was developed. Let us take the scenario that a character is creeping along in the dark, scared and uncertain. We might have a shot where the character is coming toward the camera stealthily in the dark.

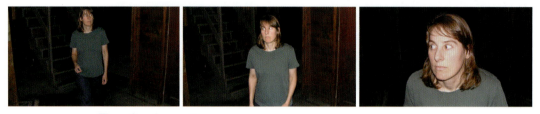

Three framing options.

We can witness the fear and trepidation on her face as she advances towards us. We can stage it in such a way that there is tension in the scene by just having pitch blackness behind and around her, with just a low light illuminating her face, emphasizing her fear. Then, to get a sense of a predator sneaking up on her, we might take up a complete reverse shot of the first, so the camera adopts the viewpoint of an unknown adversary creeping up behind the victim.

The shadow creeping up the back of the subject, as the high-set camera moves closer, is a clear way of communicating to the audience that an unknown person, or thing, is getting closer.

In live action films, this is usually a hand-held shot, meaning that the camera is not moving smoothly as normal but the cameraman is actually holding the camera in his or her hands while walking up behind the victim. This gives a more erratic, real shot of someone closing in, silently and unseen. As the tension builds to a crescendo, we would then cut back to the first shot at the other end of the line, to reveal a wider shot of the victim still walking but now there is a huge terror towering over her from behind, about to grab her.

The shock tactics of this sudden surprise are emphasized by the fact that the 180 degrees of camerawork slightly disoriented the audience. If we return to the notion that there is an imaginary line in this shot, then the line will ultimately be drawn between the victim and the victim's predator. But by positioning the camera actually on that line, and jumping directions along it, we maintain a degree of continuity, while still shaking the audience up.

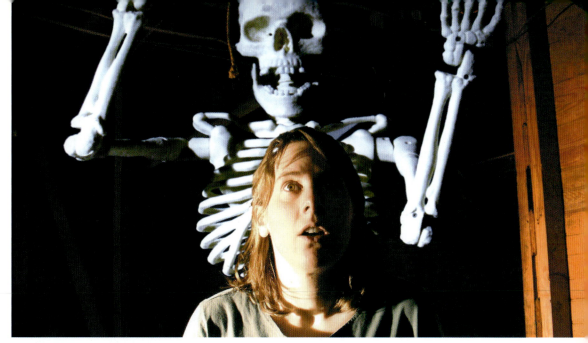

The lower camera angle increases the shock value of the shot.

The camera needs to be set exactly on the line that can be drawn between the two characters.

This technique can be an extremely valuable staging technique at times but, as it is so disorienting for an audience, it should therefore be used sparingly, relying on its occasional shock value to make it especially effective.

Getting Around the Line

Quite often it can be unavoidable that the line has to be crossed in a situation. An unfolding action scene may be taking place in a location that physically prevents the camera from staying on the line for the entire sequence and therefore ways have to be devised to cross the line from time to time. There are three major ways this can happen: the cut-away shot, moving the camera, and moving the actors.

The Cut-Away Shot

Remember, not crossing the line is a requirement that only occurs when a sequence is unbroken from shot to shot in a continued sequence. If the camera interrupts the sequence and sees something elsewhere, then the continuity of the sequence is broken and a new positioning can be established. In our scenario between A and B, perhaps midway through the conversation B suggests it is getting late. They might then both look up to a clock that is outside the window, so the camera can cut to an exterior shot of the clock to emphasize the lateness.

When we return to A and B, we can establish a shot on the other side of the line and continue from there. The shot of the clock face is called a cut-away shot and is always a "get out of jail free" card that the filmmaker can pull if they are stuck on one side of a line and need to move elsewhere. The cut-away can be anything, other than a close-up of the two figures in question, and it should not be beyond the imagination of any filmmaker in creating a suitable cut-away to resolve a particular problem.

By cutting to an exterior shot of the building the characters are talking in (frame 2) we sever the sequence that relates to the line in the preceding shots (frame 1). When we return from the cut-away, we can establish an entirely new sequence where the line is in the opposite direction (frame 3).

Moving the Camera

Another way of crossing the line is to actually move the camera across the line during an actual shot. The disorientation in crossing the line comes from cut to cut, creating a sudden change in direction. However, the astute filmmaker can overcome this by literally navigating the camera across the line during a single shot as the two figures relate to each other in some way. As they are talking, the camera might slowly move around the outside of them, passing behind the back of one while focusing on the face of the other. The line between the characters is clearly marked by the white parking bay divider the characters are standing on in the figure at the top of page 125.

Indeed, the camera could keep on moving around and around the two characters, crossing the line every time it passes behind the back of one of the characters, until it finally stops at a new position. As long as there are no cuts involved, a moving camera will not disorient the audience and will create an interest and intensity in the relationship of the two characters.

Another two shot sequence, showing many of the camera framing options that do not cross the line.

Moving the Actors

If it is not possible to move the camera around the actors, then it is possible to move the actors around in front of the camera. Therefore, as they talk, one of the characters might step away from the imaginary line, cross in front of the other character and end up on the other side of that character from the camera's point of view. In this way, a new line has been established between them without the old one being violated.

A simple filmic sequence—friends meeting and departing.

The line dictates the one-sided camera positioning of the shots, until the cut-away shot to the clock tower allows the camera to be moved to the other side of it.

Creative staging in this way, or indeed using a combination of all these three techniques, to "circumnavigate the line," will produce a more energetic and interesting sequence for the filmmaker (and the audience), if this is required, that is.

Two Shot, Profile

Again, this is the establishing shot. For 99 percent of the time, it is the first shot we will see of two figures talking. I have described it as a profile shot, as often a perfectly symmetrical view of the two figures from the side, equally staged on the left and the right of screen. However, like moves and looks to and from the camera, it is perhaps aesthetically more pleasing to favor one side of center than the other. Fundamentally though, the two shot, profile staging offers a filmmaker an opportunity to portray the two figures at once, establishing their identity, attitude, and relationship in a specific environment, often at the beginning of (and even during) the entire sequence.

It is not always necessary to include the entire head of each subject when framing a two-shot.

Two Shot, Three-Quarter

The two shot, three-quarter staging includes both characters, although with one we see the back of her head and the other we see his face. Again, it is important to maintain continuity of direction if this shot is taken. Remember, A will always need to look to the right and B will always need to look to the left of screen to maintain continuity. Therefore, if we see the back of A's head and the front of B's face, than A must be on the right of the screen and B on the left. If we see the back of B's head, however, and A's face, then B must be on the right and A must be on the left.

The two shot, three-quarter is a great shot to maintain objectivity in the relationship; as with the two shot, profile, the characters are seen equally, although the character with the face visible is favored somewhat because we can actually see what is going on in his or her expression. The filmmaker may choose this shot to emphasize ascendancy on the part of the character whose face we can see, so the audience knows if he or she is angry, intent, patronizing, or laughing. Alternatively, this shot can also be used to communicate a loss of interest, confidence, or patience, or whatever, if they are simply listening to the other character (whose face we cannot see) talking. Whatever the reason for choosing this shot, it must be remembered that it is a shot of intimacy, since two characters can be seen relating to each other in the shot at the same time.

The three-quarter view means that the camera is angled at around 45 degrees to the line implied between the two characters.

One Shot, Three-Quarter Front

This is essentially a close-up of the previous shot. We are looking over the shoulder of the character whose back is to us but the camera is positioned so close that we don't see the back of the character, just the face of the other character. There might be a hint of the other person's shoulder to the bottom corner of the screen, alluding to them, but generally the focus is entirely on the person whose face is visible. Again, in this close-up, the character must be looking in the direction that we have established for the relationship. However, unlike the two-shot, three-quarter shot, this is a shot of isolation or emphasis, not intimacy. Therefore, the character featured in this close-up shot is singled out to make a particular point. She may be arguing and being emphatic or aggressive about something. She may be listening and forming tears in her eyes. She may simply be simmering with rage. Whatever the emotion, the filmmaker can select this shot to make a strong point about the individual in question.

Tighter framing ensures that we focus more on one of the characters in a two-shot than the other.

One Shot, Three-Quarter Front Close-Up

This is a much closer version of the previous shot. It draws us right into the facial expressions of the character we are looking at. The mouth might be saying something vitally important or the eyes may be portraying the emotions the character is feeling when listening to the other (unseen) character talking. It can be a valuable double-emphasis point in a sequence of relationship between the two characters. Again, the direction the character is facing is fundamentally important to maintain the continuity of staging.

Again, the camera is framing a closer view of the subject, so that merely a hint of the other includes them in the action.

Eyeline

When two characters are talking to each other they are invariably looking at each other. That means the eyes will always be in a particular direction. When emphasizing this sense of direction it is always important to maintain a correct eyeline throughout every shot. For example, it is most likely that the two characters in the shot will not be the same height. Therefore, if the shorter woman was A in our example and the taller man were B, then her eyeline would be to the left and up, and his eyeline would be to the right and down.

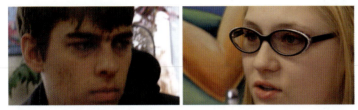

With any shot, it is always important for continuity's sake to make sure the eyeline of the subject is looking in the right direction.

This would have to be consistent in every shot to maintain a continuity of relationship between the two characters, even if they were significantly apart. Sometimes, however, even if the eyeline is logically correct in a single shot, it might be necessary to cheat the angle to emphasize the relationship. On certain occasions when I have been shooting live-action drama and have chosen to focus in on the face of one character that is quite far away from the other, the correct and logical eyeline just does not look right, even though if you step back away from the camera and look at it, it is! As a result, I found that I had to ask the actor to exaggerate their eyeline, either more up or down, or more away from the camera or towards it, just to get a sense of the correct eyeline.

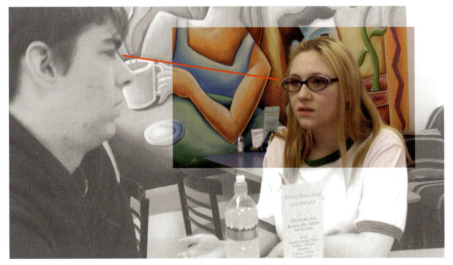

The red line indicates the direction she needs to look to make eye contact with the guy outside of the shot (in the shaded area).

This is a problem that 3D animators especially may encounter, as the same illusion can occur when moving the camera position from a two shot to a close-up one shot on the face of one character. Cheating the eyeline is okay, as long as it basically reinforces the already established continuity of left to right, or up and down.

Three or More Character Shots

Of course, the filmmaker's dilemma is intensified if there are more than two characters in the shot at any particular time. With A, B, and C characters, there are new lines to consider. Character A makes a line with B and a line with C, while C makes a line with B as well as with A.

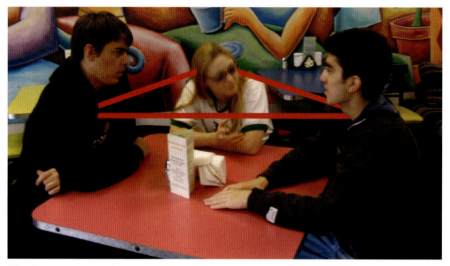

The lines to contend with in a three-shot.

When these three characters are talking with each other and the filmmaker doesn't want to feature the back of the same character all the time, then a great deal of staging ingenuity is required. However, as long at the rules of not crossing the line are upheld and some imagination is used to get around the problems that a three or more shot present, then a careful staging of the action is possible. This is where the value of story-boarding comes into its own, but more of that later.

"Endangered Species"

"Endangered Species," in reality, illustrates very few of these rules of filmmaking! Doc-umentary genre in style, it draws less on the principles that govern drama direction, which is principally where these film rules come into play. "Endangered Species" is more a series of cuts of separate, unconnected images that do not require a significant sense of action continuity from shot to shot. There is continuity, of course, (such as the final Miyazaki sequence, or the very brief leader's ghost sequence that cuts down the line), for all films require some kind of sequential continuity to keep them flowing. But overall, all that was required was the assembly of a series of separate shots that illus-trate the narrative more historically and chronologically than filmically. Actually, I paid more attention to the framing of the shots than the staging or editing techniques con-necting them. As with so many of my explanations of "Endangered Species," do as I say, not as I do! It was just such a unique project that many of the things I would never dream of skipping in a more commercial production weren't necessary here.

Maybe my next film will contain a more drama-based style of filmmaking which will reflect these essential principles of filmmaking. The fact that these principles are not

in evidence in "Endangered Species" should not be taken as an indication by me that they can be ignored or disrespected. It is simply a fact that in certain genres of film-making, specifically the documentary style, they are often not as relevant to the material as the more popular action or drama scenarios.

Scene-to-Scene Transitions

Every shot, in one way or another, leads to another. The usual way is with a cut, but this need not be so. There are other transitions that are available, each of which offers a different interpretation to the scene change. Here are some of the most popular ones and a possible reason for using them.

Here, the light on the animator's lightbox slowly fades on.

The Cut

The cut is so common in filmmaking that it barely merits definition. A cut is simply that, the cutting of one scene to another with nothing in between. The last frame of one scene butts directly up to the first frame of the next. The cut is therefore the simplest and most direct transition of all and probably used more than 90 percent of the time.

A cut transition.

The Dissolve

The dissolve gives a slightly softer transition in the sense that, over a number of frames, the previous scene fades away as the incoming scene fades in. The dissolve can take place over a very few frames (often known as a "soft cut") or it can take seconds to complete, depending on the nature of the transition. A summer country setting, for example, may dissolve into an identical shot (a "match dissolve") which can now be seen in the fall or winter. Where the cut is a punch, the dissolve is more of a caress.

Dissolving from one scene to the next.

The Fade

The fade is a device that concludes one event to begin an entirely new one. Fades tend to be used when a softer, more lyrical transition is required from one scene to another, where a change of mood or pace is required, or else where a movement forward in time in implied. In a fade, the picture gradually dissolves away to black or white before the next scene dissolves up from that same black or white. In that sense, there is definitely a lingering feeling of the exiting scene left with the audience, giving them time to gather thoughts or emotions before the next scene is eased into their consciousness. Of course, this can be done more abruptly with a cut to black (or white) then a cut into the new scene. However, the fade is all about choreographing the transition of one mood or emotion to the others and therefore is a more poetic technique.

The choice between black or white is subtle and can be arbitrary. The most common choice is black. My instincts are that a fade to black has a more lingering, reflective, and subconscious feel to it, while a fade to white is more visible and therefore has a greater conscious, active, and energetic feel to it.

The fade transition.

The Wipe

The wipe is a lesser-used transition these days, though it was very common in the early days of filmmaking. Basically, a wipe occurs when the image of the incoming scene wipes across the screen, eventually eliminating the image of the previous scene. Wipes can occur horizontally, vertically, in circles, in spirals, and in any number of patterns, such as a checkerboard. Most digital editing software, such as Apple Final Cut and Adobe Premiere, have a number of built-in wipes to choose from, but often a wipe is intrusive in the action and can tend to be gimmicky unless used for a specific reason, like a genre movie that attempts to recreate the mood of 1920s movie.

A wipe transition.

The Ripple and Other Special Effects Dissolves

This is another infrequently used transition but it is worthy of mention because it has a cliché value in some circumstances. A ripple dissolve is just like a regular dissolve in effect, except that as the transition takes place it has a rippling water effect. The ripple dissolve is used when the film enters a dream sequence, or a hallucinatory sequence of some kind, or else the action is moving to beneath the water. Like the wipe, the ripple dissolve has become a predictable transition device in many cases, although if used sparingly and wisely it can be effective.

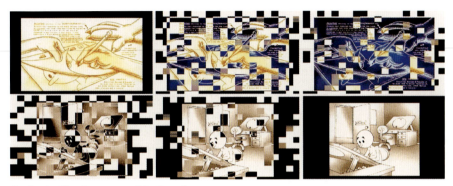

A ripple dissolve, created in Premiere.

"Endangered Species"

Because of its documentary feel, "Endangered Species" relies on cuts to link the various shots, rather than more subtle or extreme transitions. However, I did use an occasional fade to black to emphasize emotionally reflective moments, such as the death of the leader and his spirit's ascent to "the great animation studio in the sky." The documentary style generally uses harsh transition editing techniques, so breaking the precedent here emphasizes more the reflective and mournful moment that I sought to create. I also occasionally used a dissolve transition to soften the change from one mood or moment to the next. However, by and large, the more matter-of-fact cutting techniques I chose to use far better suits the style and genre of the film.

In contrast to all that, however, I deliberately countered the film's inherent cut-based transition style with a softer, more poetic, transformative style for the end credit sequence. This is an attempt to raise the audience's awareness that fine art makes fine films in animation. Of course I am not arrogantly asserting here that my animation drawings are fine art in the fine art, gallery sense. I am instead attempting to underline the fact that when an audience watches an animated film, with action, sound, and color so dominating the senses, it is so easy for them to lose sight of the fact that everything created in that film is based upon carefully crafted pencil drawings, the mastery of which has taken a great deal of time, effort, and artistry to accomplish. This fact struck me firmly between the eyes when I once came across a hard-to-find edition of a book of early Disney animation art. In looking at the magnificence of this art, I was moved to the conclusion that much of it was actually better than the finished work and that many of these drawings respectfully competed with many of the treasured old master drawings that the art world holds so dear! I think that using a more sensitive, dissolve-based transition style for this sequence makes this point much more effectively when contrasted against the film's harsher documentary style.

Screen Aspect Ratios

One last thing that the filmmaker must contend with before finally getting down to the actual creative aspects of filmmaking is the format, or screen ratio. We take screen ratios for granted when we watch a film, be it a cinema film, a TV show, a DVD movie, or a Web-based animation. However, each is rigidly defined in terms of screen measurement ratios and therefore it is important that you know the advantages and disadvantages of each.

Standard Academy (also referred to as the 4:3 or 1.33:1 format) is the format most used in film and television production. The fundamental requirement of the Standard Academy screen shape is that it be 4 units wide by 3 units high, which means for every four units the frame dimension is wide it has to be three units high. Standard Academy is also called TV Academy.

Film Academy is very similar in appearance to the Standard Academy aspect ratio, except that its actual screen ratio is 1.37:1. In reality, this is virtually identical to the Standard Academy format. However, if you are in any doubt, always work to the 1.37:1/Film Academy size, for the worst that can happen is that a fraction of the image in the height measurement will be lost when it is shown on TV.

Widescreen has a 1.85:1 ratio and has a definite advantage over either of the Academy formats for the filmmaker, in that it has a more landscape shape, which lends itself much more aesthetically to filmic landscapes and panoramic views. This means that with widescreen format, more scale and dimension can be integrated into the image, which can only improve the look of things for the animated filmmaker. Widescreen is an enormously popular format, so it can be easily screened anywhere. The disadvantage of widescreen films is that when they are shown on TV, they either have to be letterboxed (have a black bar at the top and the bottom of screen to make it viewable in the Academy format screen) or else have the image cropped (have the film image fit the TV screen vertically but lose some of its image on the left and right side). There's no perfect way of squeezing a widescreen image into an Academy format, but I suggest that the former option is a far more desirable one than the reverse, from a filmmaker's point of view.

Cinemascope (also called "scope") uses an entirely different system from all the other film formats. Scope material is shot and projected through a special lens, known as an anamorphic lens. This lens squeezes the film image inward from side to side, resulting in a horizontally squashed picture when an individual frame is examined with the naked eye. However, after the second pass through an anamorphic lens, the film image is stretched out again when projected onto the screen. The screen ratio for scope animation provides an even wider panoramic view than widescreen. The official format for a scope screen size is 2.35:1, which means that for every unit the artwork is tall, it must be 2.35 units wide.

When projected, scope produces the most spectacular, epic-style picture imaginable. However, it is extremely inappropriate for television use, since it requires even more letterboxing or cropping than the widescreen format.

NOTE

All formats other than Academy are often generically referred to as letterbox style formats, whether they are widescreen, cinemascope, or high definition formats.

High Definition Format. The advent of high definition TV has attempted to bring standardization to all the formats, offering more of the visual advantages of the widescreen format but not requiring the extreme letterboxing or cropping that Academy demands when seen on a TV screen. The ratio for hi-def is 1.78:1 (or 16:9), which means that for every one unit high, the width has to be 1.78 units.

"Endangered Species"

"Endangered Species" uses widescreen format almost exclusively. The exception is the historical footage which is seen as Academy within the widescreen format. I did originally begin to create all the material an 1828 x 1030 pixel resolution widescreen size when starting the project, as it was my intention to finish up on 35mm theatrical film. However, upon the advice of ex-student Gernot Kalcher, of the Victory Studio in Seattle, I eventually switched to the 1920 x 1080 pixel resolution, which is the standard format for hi-def TV, and which is also translatable into cinematic film. The use of hi-def undoubtedly increases the potential for the film's distribution and exhibition, while enabling me to still produce a high quality theatrical film version also.

The widescreen format I adopted for the film enabled me to stage more aesthetically pleasing shots than an Academy format would. The re-created historical material was entirely dictated by the original footage and since these predominately appear as single scenes, you'll be rewarded by returning to the original film material to discover how these chosen shots worked in the context of a greater sequence. (This is especially true of the Disney-inspired material which, almost always, is technically perfect in both a creative and filmic sense.) Being that most of the other, non-historical material was simple and vector-based, it was almost impossible to create depth, softness, and diffused shots as is my usual preference. Nevertheless, the disciplines imposed by vector-based technology do develop other instincts, especially visual instincts, that can often stretch our imaginative processes to circumnavigate these built-in limitations. The framing of some of these shots is a perfect example of this, although I freely admit to the fact that none of this work (in my humble opinion) comes anywhere near to approaching the very best layouts that are to be found in many of the great Japanese animated films, such as Miyazaki's "Princess Mononoke" and "Spirited Away."

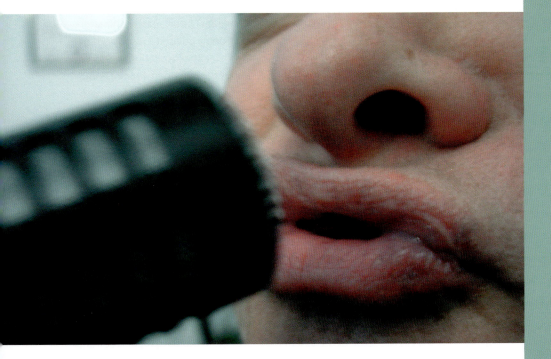

Soundtrack
Recording and Editing

Actions speak louder than words . . .
but first record the words right!

If there is one thing an animated production must have, it's a well recorded and produced soundtrack. Without the soundtrack (and here we are talking about a spoken word soundtrack, recorded by accomplished actors), there can be no expression, performance, or dramatic delivery with any of the characters. Incidental sounds, such as sound effects, secondary atmospherics, and even music, can be added later, but the dialogue material, as well as any sound the animator has to synchronize their action to, has to be recorded first if the character's performance and personality is to be maximized.

The Western system, principally evolved by the Disney animators in the early days, has supported some of the greatest performance animation. Students of the great Disney master animators are strongly advised to study "Frank and Ollie," the inspirational 1995 film about the legendary Frank Thomas and Ollie Johnston, where superb examples of character animation are featured and explained.

> **NOTE**
>
> In the Japanese animation tradition, voices are often recorded after the animation is done. However, it is hard to see how the animators can understand the appropriate timing, delivery, and emphasis a character requires without having first heard the actual recorded words being spoken or knowing the frame-by-frame timing of their delivery. For the purposes of this book (and in pursuit of character animation excellence) I will outline the tried and tested processes involved in traditional Western animated production, as this seems to be the most valuable for generating character performances that sit comfortably with the voiced material.

Talent Selection

The first decision, once the script is written and approved, is the selection of the voices for the main characters. In high profile, Hollywood-mainstream movies, the actors are quite often household names, stars who the distributors feel add insurance to the box-office returns of the movie. However, I have found, over the years, that star actors are not necessarily star animated voice performers. I prefer to use less famous but often more talented and versatile stage and/or radio actors for my soundtracks. There is a whole tradition of voice-over artist in the acting world, performers who are not necessarily famous stars in the sense of the cinema, stage, or radio but have great recording voices and are capable of producing a great range of expression with their voice. The fine traditions of theatrical and radio drama in the U.K. make English actors especially capable in these areas. From a U.S. perspective, the great Mel Blanc was perhaps the most famous cartoon voice artist of all time, lending his masterly voice to many of the original Warner Brothers cartoon characters that are, even now, household names.

Spend a little time watching TV cartoons or commercials with your eyes closed, or listen to a good radio play, and the great depth and range of voice talents available without ever considering a star name will be confirmed. Most animated films will work perfectly well with unheralded voice-over artists, although it is conceded that the film-maker will almost certainly have to resort to star names for a mainstream Hollywood movie. The strongest advice I have for anyone embarking on this process for the first

time is to use a trained voice for the main character acting, unless you have found an untrained person who is an extrovert and is not intimidated by making funny voices and yet who can take performance direction. It is a rare talent to be able to work well in front of a microphone, with no camera or audience to play to, as has been proven to me many times when I have attempted to get a good mic performance out of a star name actor. Actually, stars prove more often than not that they are not capable of performing to a microphone although great actors nearly always can.

A voice that doesn't work for animation is one in which the performance sounds flat, stilted, or wooden, with little expression or timing in the voice, qualities that are the last thing any animator wants when needing to develop a character's performance. Voice agencies in major cities around the world have a large stable of voice-over talent and can provide demo tapes to narrow the search.

It goes without saying that the voice artist selection is a fundamentally important aspect of animated filmmaking. Like radio drama, if the acting is not convincing and the sound of the voice is not invoking the right kind of mood or character, then the whole film can fall flat. The timbre of a character's voice is important too. It would be entirely wrong for a deep, booming voice to be assigned to a small, weak, nervous-looking character, unless a particular and deliberate comedic effect was being sought. Likewise, a thin, light voice would be totally inappropriate for the huge, bullet-headed oaf. Strangely enough, it often works perfectly if the actor recording the voice is similar in stature and appearance to the character that the voice is being created for, although there are exceptions.

Just as regular movie actors need to be aware of the camera or the audience when delivering a performance, so do voice-over artists need to understand the microphone. It is one thing reading the lines from the script with a good voice but quite another to deliver them with tone, shape, timing, and emotional content. The biggest challenge for an animated filmmaker is to coax out of an actor the kind of spoken performance that is required, for it really is not just reading from a script. A less gregarious filmmaker might therefore choose to hire an experienced voice director to supervise the recording session on their behalf, enabling them to simply sit back, listen, and respond to the performance in the background, using the voice director to communicate their wishes to the actor on their behalf.

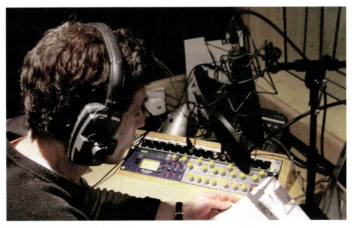

Voice artist Christopher Kent records the narration for "Endangered Species" in his London studio. I was connected by telephone link from the U.S. PETE GOLD

Man on the Street Narrators

With his early film "Creature Comforts," Nick Parks (multiple Academy Award winning creator of "Wallace & Gromit") uniquely recorded real people in real life situations for the voices for his animal characters. As fantastic as the soundtracks were, this was a spontaneous, hit-or-miss recording technique using a concealed mic, documentary style, as it is rare that such untrained voice talent will normally be able to provide the kind of performances required when facing a microphone for the first time.

Voice Recording

Once the voice artist (or most probably artists) has been chosen, it is time to actually record them. The actor is sealed in a soundproof booth ("the box") with little more than the script and a microphone, while the recording engineer sits on the other side of a window, pushing and sliding a whole variety of knobs and buttons to achieve the required recorded sound quality. The filmmaker and/or voice director will usually sit with the sound engineer, supervising the session and directing the actor. But in this modern digital age, the filmmaker doesn't even have to be in the recording studio at the same time anyway! It is not that uncommon for the actor and the engineer to be in the one studio location while the filmmaker is somewhere else in the world, directing the entire session by phone! The delivery of the recorded material can be sped up by technology too. When the session is over, the engineer will either hand over everything or edit the material so that the filmmaker only gets the recorded sections he wants. The material is usually provided on a DAT tape, saved in a .WAV (or sometimes MP3) file or any other industry standard digital format required. One particular advantage of digital technology is that the filmmaker at the end of the phone line somewhere else can immediately retrieve all the required material using the recording studio's FTP site. Such is the wonder of modern technology—material recorded across the world using a telephone can be in the hands of the filmmaker almost instantaneously!

During a recording session, it is fundamentally important that you communicate exactly what is required from the actor during a session. If you don't record it, you'll never have it. It won't magically materialize at some other time or some other place. For some filmmakers, this can be an easy task. Others may prefer to communicate to the actor using the experienced voice director, as suggested. Most voice artists are extremely accommodating and very willing to give their client (the filmmaker) whatever they want. Occasionally, an actor might be temperamental and difficult to deal with. But, on the other hand, the real professional actors will want to give a good performance and make the filmmaker happy. Every one of the professional voice artists I have worked with have never been any trouble to work with and all have worked hard to achieve what was needed. It must be remembered that it is the voice artist's job to keep the client happy as word soon gets around that a particular person is "difficult," and therefore they don't get booked any more.

Many experienced artists, even if the filmmaker is happy with what has been done, might suggest alternative ways of speaking the material if they feel the best has not yet been achieved. Many really care about what they provide and, knowing that they are

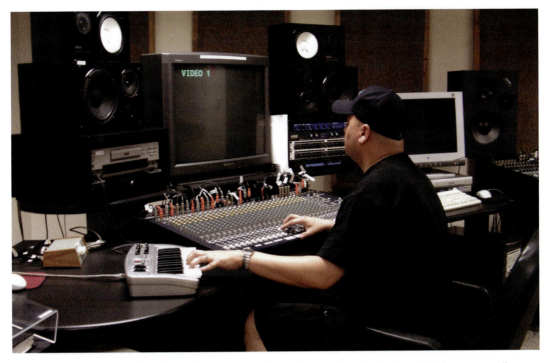

Most professional sound studios will have a soundproof recording booth, in addition to an audio editing console (complete with a scary plethora of indecipherable mixing sliders).

only as good as the last job, they will want to ensure that they leave the session having done their best. It is always wise for you to allow the voice artist a little extra leeway when suggesting ways that a line of script might be interpreted, for no one entirely knows if the experience of the actor could be better than your initial ideas. I invariably let the actor record the lines as they naturally do them, then I ask for modifications if necessary. However, it is almost always true that the actor will deliver a line in a way that you might never have imagined, and this can often be for the better, in my experience.

It's the same with the speed in delivery of a recording. Lines can be read fast or slow, sometimes faster in places and slower in others. Therefore, it is always wise to first get what you want from the actor, at the speed that you believe it should be, then go back and cover yourself with slightly faster and slower versions. This is especially important in short productions like commercials, as so much information is squeezed into 30 seconds. It can be a lifesaver to go back to the recorded material later and select a faster take rather than the time- and cost-guzzling option of a second recording session.

Occasionally, actors will want to not compromise their approach in the way a scripted line is said and therefore may suggest ways in which the line can be re-written so that it can be performed better. Whether or not this is possible (or even desirable?) depends on the nature of the production and the attitude of the filmmaker presiding over that production. In advertising work, for example, it is usually very difficult to change anything, as the script has probably gone though an extensive, time-consuming process of approvals between various levels of advertising agency personnel, as well as their client. The same may be true with a major movie production, where a distributor may

Directors tend to prefer to rehearse one-on-one with the voice artist prior to the actual recording session. SEAN KRAFT

demand contractually that the script be recorded as approved, unless prior approval is granted. (Something that takes far longer than the recording session will allow.) On more personally motivated productions, the filmmaker's discretion may override any adherence to an "if it's been approved, then we can't change it" attitude, as quite often the actor is the best person to understand how words and thoughts might be communicated and therefore can indeed come up with better options than the filmmaker had in mind. It's all really a question of balance, as you should not be steamrollered by a more assertive actor into something you don't want, while at the same time you should keep an open mind to better alternatives should they arise.

In the final analysis, the best soundtracks come through a spirit of cooperation by all concerned. If anyone attempts to dominate or dictate in this situation, whether it be the filmmaker, a distributor, the client, or even the voice artist, there will inevitably be the loss of something that could have arisen if the opportunity for spontaneity was present. I personally prefer to briefly talk with the artist beforehand, to explain what the project is about and the general direction I think the recording should go. Then I allow the actor to go through their own interpretation of the lines first, just in case he or she adds something I haven't even thought of. If they have, then I accept it as improvement; if not, I will suggest to them little changes, such as emphasis points on specific words or timing changes in the speed of delivery.

The universal truth is that the more the lines are read the greater the danger that the performance will become stilted, predictable, and just generally lackluster. Usually it is possible to get an acceptable delivery in four or five takes; with 10 or more takes, there is the real danger of deterioration of performance through repetition or mental familiarity. Sometimes it can be very difficult for the voice-over artist to get exactly what is in the filmmaker's mind for a particular line, no matter how many takes are made to get it right. In these circumstances, it can be useful to take the voice artist to one side, away from the recording booth entirely, and ask them to use their own words to say the same thing as the scripted words. Actors, like everyone else, can have a blind spot for something and just cannot get past what they originally read for the line. But taking them outside of the box, quite literally, and having them talk naturally, frees their minds from the confinement of the actual words and opens them to the sentiment and emotion of what is being said. When the actor can get what the filmmaker is getting at using their own words, they can be immediately placed in front of the microphone again and asked to say the original words with the same feeling that the spontaneous words contained. Nine times out of ten this will give you what you're after, much to the relief of all concerned.

In most animated scripts, there is usually more than one character talking at the same time. It's best to have the actors in the sound booth at the same time, so they can record their lines together. This will bring a natural flow, rhythm, and even an unexpected spontaneity to the lines. Some of the best, unscripted material I have ever recorded came about as a result of actors sparking each other off in such a spontaneous, communal environment. However, if star performers are required, it is quite likely that their intense schedules will not allow them to be available at the same time and in the same place. Therefore, the dialogue sequences have to be produced in stages.

Time, locations, and artist availability will always dictate the way these kinds of situations must be handled. However, in an ideal world, it is best to record the principal character's voice first for a multiple-character scene. You or an assistant should sit beside the actor in the recording booth and read the lines of the other character(s), so he or she has the other lines to work/feed off. The sound engineer will edit out the unwanted material, leaving just enough silence between the chosen principal character's lines for the other actors to come in. Then, the other actors record their particular parts to fill in the gaps, using a combination of the first actor's final lines and a stand-ins prompting to help create a flow and continuity of lines. The preferred takes of each subsequent performance are finally edited together to create the final, integrated dialogue piece.

Finally, a word about ambience. It is my pet peeve that most animated soundtracks, recorded through a mic in a recording studio, sound just like that—recorded through a mic at a sound studio! It doesn't seem to matter that the character is supposed to be speaking in the middle of a rainforest, or on a busy city street, or on a pier beside the crashing sea. In live-action filming, the sound will be recorded live, at the location where the scene takes place, so the sound feels natural to the picture. This is far from true in animated film production, where the voices always sound too perfect and stuck onto the picture, making it an entirely unconvincing experience, even when artificial ambient sound is added in afterwards. Although significant problems can occur with this way of thinking, it would still be infinitely preferable if exterior sound could be recorded exteriorly with portable mics and recording systems and only interior sound be recorded in the recording studio. Technology these days has produced cheap, portable, and efficient recorders that can make this whole process less of a challenge than ever before. Indeed, with such equipment, exterior recording, that is, without the inevitable costs that a recording studio and engineer would bring, might actually bring the cost of the sound production down!

Recording for Animation

Always keep in mind that dialogue recorded too fast will not be convincing, as the inherent limitations of the animation lip syncing lend themselves more convincingly to words that are spoken more slowly. The hardness of a drawn line, or the crudeness of a modeled mouth's shape, or even the real technical limitations of working with only 12 or 24 images per second, means that animated lip movement interpretation cannot possibly be as subtle as regular live-action film. Having the artist speak slightly slower, without it being unnecessarily dragged out or uncomfortably unnatural, will enable you to produce more subtle, slower changes in the lip shape on a frame-by-frame basis, which will make it far easier to produce more natural and convincing dialogue sequences from the audience's point of view. Fast-talking dialogue is a nightmare for any animator, because they don't have enough frames to create the variation in mouth shapes required, thereby producing a flapping mouth that misses the sync more often than hitting it.

One further way of making an animated character's dialogue performance more natural is to encourage the actor to continue with a reading, even if they have stuttered, stumbled, choked, or in some other way interrupted the natural performance of the lines they are reading. In the everyday, professional world of voice-over recording, a stumble or a fluff invariably means that the actor has to go again to get a more perfect one. However, with animation, there can be something quite endearing and

Expressive actors often contort their faces to extreme expressions when attempting the correct voice expression for animated characters. Video taping the recording session can provide an excellent visual reference for animating the final action sequence. SEAN KRAFT

convincing about a line of dialogue if such human qualities are present. In fact, most animators will be delighted to have such hooks of voice idiosyncrasy to work with, as any exaggerated or unexpected voice gesture is a point of emphasis than can underpin a greater expression of personality in the character, thereby making it all that much more convincing on the screen. Likewise, actors should quite often be encouraged to go OTT ("Over the Top") with some lines, as this can also lead to a greater expression of a character's performance. A perfect example of this was with Robin Williams's performance as the genie's voice in Disney's "Aladdin." It was many of the unscripted, impromptu elements that he added that took the character to new, and often hilarious, levels of expression and humor.

Finally, as the interpretation of dialogue is so important in character performance, the animator will benefit considerably from any reference cues to the actor's recording expression and delivery. Therefore, it is always very wise to have a video camera recording the expressions and movement of actors as they are recording. If the delivery is especially dynamic or exaggeratedly active, it would be best to have the actor record standing in front of a floor or boom mic, rather than sitting restrictively at a table (as most voice recording sessions are conducted). With the freedom to move around, actors will most likely express themselves more extremely. If these moves are recorded on tape for the animator to watch later, the more natural the character will appear in animation. Even the most cheaply recorded video footage is better than nothing at all. Most people these days have, or at least have access to, a basic camcorder. This should make possible such a valuable and yet inexpensive investment of time and effort on behalf of the filmmaker.

Recording and Cataloging Dialogue

The process of actually conducting a recording session with an actor, or actors, is quite simple. They will read their lines into the microphone, the sound engineer records everything, and you choose the best takes and supervise the editing into a final master track. Fine-tuning of the master track can be made at the animation studio later, but essentially, once the master track is decided upon, the whole team must work on it as it is. The script can be anything from a single page on a 30-second commercial up to a 90-page screenplay for a movie. Most scripts can be recorded in easy sections, usually scene by scene for films, or even line by line, if special attention needs to be paid to a specific delivery. The best thing is for the filmmaker (or an assistant to the filmmaker) to draw lines across the script to designate the beginnings and the ends of the required sections for the actor. These will then be assigned a letter for identification. Then, as

each of these sections is recorded individually, each take is documented numerically on the script page. The best of these takes is circled and when the session is over, the circled takes are replayed until a final take is selected and cut into the main master edit. In this way, take 4 of section A may be the best ("A/4"), or take 2 of section B ("B/2"), or take 5 or section C ("C/5"), until the master track is completed with all the selected takes.

Each preferred take is identified and circled; it will save a great deal of time, effort, and cost to have these notes if it is necessary to replace the first selection later in production. This process is especially invaluable when it is necessary to record several actors on separate occasions, each recording session being given their own identifiable classification number, as session i, session ii, session iii, etc. This prevents a potentially catastrophic nightmare of session identification if these sessions are undertaken over a considerable time span when memories are likely to have faded.

Today, the miracle of visual technology allows resourceful filmmakers to record their soundtracks almost anywhere. Here, an Apple iPod has been adapted with a lapel mic to record dialogue on location.

During the voice recording, note emotions and delivery that worked well, as well as each of the takes and the best one.

Non-Voice Recording

Material besides voice material may well need to be recorded, such as music that the animation will be choreographed to. Although more ambitious productions will involve the use of a large recording studio with an orchestra or real musicians to provide the musical requirement, the miracle of the digital age means that most music tracks these days can be (and often are) simulated by one musician/composer on a keyboard. Technology can replicate the sounds of anything, from a style of human voice to a fully equipped orchestra and choir, thereby reducing budget costs. The problem with synthesized sound, however, is that it often sounds that way—synthesized! Real music and musicians for films should be used whenever the budget and schedule allow; there really is no substitute for the real thing.

A Foley artist simulates the sounds of footsteps on gravel.

The other essential soundtrack element that has to be created, in addition to voice and music tracks, are the sound effects. Sound effects are often present on a soundtrack but are usually never noticed because they are natural to the action. There are libraries of professional sound effects that filmmakers can buy from Web sites and studios, and there are several free Web sites such as sounddogs.com, but generally the sound effects required for most films have to be recorded live to suit the particular needs of the action.

A particular breed of professional sound recordists—Foley artists—specialize in producing custom sound effects for filmmakers. There are many reasons why a Foley artist could be needed, the main one (on the live action side) being that there may be a problem in recording live sound when an exterior scene is filmed (e.g., different mics are often used in a shot, all off camera, and maybe their sound levels are different, hence a single, consistent level of background track needs to be recorded by a Foley artist). Also, with many films finding international markets these days, separate tracks for dialogue and M&E (music and effects track) need to be supplied, so a different language version of the soundtrack can be dubbed in the language of the country of intended release. This can be the work of a number of different sound people, but in animation especially, it will be mainly the Foley artist who records (almost always in a sound studio setting) the background sound effects. Footsteps on autumn leaves, soft pastry being beaten on a kitchen table, a fisherman casting his nets in a high wind, teeth chattering, anything that is conceived in the filmmaker's imagination and contained in the script will need to have the appropriate sound added to it. (Note: There is a sound specialist, known as the special effects recordist, who will record background sounds that cannot be done in recording studios, such as big scale explosions, multiple car crashes, powerful motorbikes starting up and screeching off, etc.)

Foley artists often have to do the most extraordinary things just to get a sound that is heard naturally and obvious on the screen—in order to get the sound of a bone breaking, a Foley artist snaps a stick of celery next to the microphone! They may hit a pillow to get the sound of someone being punched in the stomach. They may even fry fat in a pan to get the sound of cracking fireworks. Indeed, Foley artists will try anything, however weird, to achieve the sound of the obvious, for quite often the real thing just doesn't sound like the real thing when recorded! In the case of the fisherman casting his nets in a high wind the Foley artist may need to swing lengths of plastic covered washing rope around in the air. The sound of the fisherman's protective clothing squeaking and creaking could be a sheet of moistened plastic sheeting being squeezed and stretched, and the sound of rope being dragged across the wooden bow of the boat might be a bicycle chain being dragged around a table. As can be imagined, this can all easily be recorded in a studio and all will sound as real in the final mix as if it were the real thing being recorded on location, better in fact! In the fisherman example, the high wind and the heavy seas would have to be recorded outside by the sound effects recordist. A perfect example of a sound recordist at work may be seen on the "making of" section of the "Spirited Away" DVD, where all kinds of external

water and other sounds were being recorded on location with a portable tape recorder and microphone. Foley artists really come into their own in the recording studio, where they have to be inventive and incredibly imaginative at times, in keeping with the pure imagination of the animated world!

Once all the elements of a sequence are completed, they have to be mixed onto one master sound take by a sound editor. When the sound of swishing nets, whistling wind, rope dragging on wood, creaking protective clothing, crashing sea and any other sound required (such as grunting in effort and even fish flopping on the deck) are all completed, they need to be equalized in terms of recording levels and electronically woven together so that the overall sound experience works perfectly with the needs of the action. Quite often this entire process is done in "real time," in front of a large screen or monitor that is playing the film action. The sound mixer may do this over and over again, changing the level balance of the individual sounds and their respective speeds of playback, until they finally get the balance and synchronization right. As can be imagined, a huge amount of painstaking work can go into something that appears quite simple on the screen and which may only last for a mere second or two of screen time!

The same playback-to-picture device (recording or dubbing sounds to a moving picture on a screen) will be used for another aspect of the soundtrack, the post syncing of the voice. Post syncing is more a feature of live-action production, where perhaps the words of an actor were not totally audible in a natural setting and has to be re-recorded later. Post syncing is also called ADR (Automated Dialogue Replacement) or looping. Looping is a major aspect of Japanese animated film production, where both the Japanese and foreign language versions can be recorded over the animated action. The original actor in the scene (although sometimes another actor might be used entirely, such as in the case of a commercial, where the original actor's voice is not as warm, comforting, and assuring as the professional voice artist that would replace them) will come into a looping theater and re-record the lines as he or she watches the film clip of the original words up on the screen. Even though it is the same actor doing the post syncing, it can be quite difficult to achieve perfect lip syncing. In terms of animation post syncing, it is often a much more difficult task to make an actor's voice convincingly match a previously animated voice, as anime films will attest!

A Foley artist records rustling leaves to produce the sound effect of burning fire.

Further Foley artist techniques for creating specific audio effects.

A professional Foley artist will most likely not be an affordable item in the budget in a low-budget, student, or personal animated film. Therefore, you will have to record all the sound effects yourself. Nowadays small, pocket-sized, minidisc recorder/players (or even an iPod with a microphone adaptor) can record to a remarkably high level of sound quality, although it must be said that a good microphone makes a huge difference! They are not even particularly expensive and are so accessible that it would be possible to rent one for next to nothing, or even borrow one from a colleague for a few hours. With the correct type of microphone attached (a spot or shotgun mic that records with a minimum of background noise), you can probably pick up all the various sounds on your own. A fisherman casting a net in stormy seas might be a little beyond the capability of this process, but most internal sound effects and many external sounds can be adequately captured and used in this way. Remember too that many of the sounds you hear in movies are not the sounds of the actual things themselves; they are synthesized from anything that offers the illusion of that sound, so ingenuity and imagination are the keywords here. It is quite amazing how we can fool the mind into thinking we are hearing one thing when we're actually hearing something quite different!

We all tend to take so much background sound for granted and effectively eliminate it from our consciousness through such familiarity. However, a sensitive microphone is very unforgiving and will never eliminate what is there. It will capture every single sound—the car driving by, the plane flying over, the person walking into the room and slamming the door in the background, the laughter from outside the window—all of which will be a disaster for you if you have not noticed it when recording what you actually need. Get into the habit, therefore, of being constantly aware, and never, ever walk away from a recording situation without first checking the playback to make sure that you have what you want and it is uncluttered by ambient sounds. You will always regret not doing that as certain sounds available in any moment of time may not ever present themselves to you again.

Most sound effects are not actually added to the soundtrack until the final dub, after everything else in the film is completed. However, occasionally, the production will require the animation to hit specific sound points in the action and synchronize movement to it. In such cases (as with all voiced dialogue material), it is necessary to record up front so the timing and nature of the sound can be worked out before the anima-

tion is attempted. Hearing a sound beforehand can have a profound effect on how the action is choreographed. For example, a character is walking along and steps on a dog's tail. The dog will jump and react in a specific way. The nature of the dog's reaction will dictate just how the character reacts. If it is a pathetic, whimpering yelp, the character will act in an appropriate way. If it is an aggressive, "I'm going to kill you" kind of growl, then the character will clearly react differently. Specific sounds suggest specific movements, so if there is a definite integration between sound and action in a sequence, that particular sound has to be provided and defined beforehand.

Music Track Recording

Music can be a fundamentally important element in a film's soundtrack, for the music can either make or break a film. It is hard to define good and bad music in a film soundtrack. Sometimes a piece of music can be exquisite and yet be so inappropriate or overpowering in a sequence that it might be deemed bad. On the other hand, bad music used in the right context for a movie can be considered good. Perhaps appropriate and inappropriate is a better way to describe music utilized in a film. To avoid any misunderstandings or conflict of creative interest, it is important that you carefully consider the kind of composer used. Some composers are good at one particular thing; others are good at different or many things. Sometimes a completely off-the-wall choice can produce something quite unique. Rock guitarist Mark Knopfler was given his first attempt at writing a film score when he worked on the movie "Local Hero" many years ago. The effect was both entrancing and entirely original. Sometimes speculation and experimentation with the music can completely ruin a film also. Generally, if the audience is aware of the music in a film, then it is inappropriate or overly used, unless the film is something like "Fantasia," where the music was an intrinsic part of the action.

Composer Jamie Hall, working on the music score for "Endangered Species."

Actor Dale Bradrick records in the midst of a simulated rain forest. SEAN KRAFT

When the music score composer is selected, then you and the composer should spend some time together, discussing exactly what will be required for each of the film's sequences; you might even play some existing music you like, as reference for the composer. The majority of composers will welcome this (as long as you give the composer the creative freedom to interpret the samples, rather than simply demand they be replicated). As with professional voice artists, experienced (and even inexperienced) composers can bring something to the party that you might not have thought of, and you would do yourself a disservice to eliminate their suggestions without consideration. Ultimately, the synergy between the filmmaker and the composer will (hopefully) provide a successful, perhaps innovative, use of music in the film. Music can invoke so many moods and emotions and, like animation, it can transcend language. It is important, therefore, that the music used in any film (animated or otherwise) complements, rather than competes with, the visual action. Much of this discussion on soundtrack recording supposes that the filmmaker is working with a relatively reasonable budget. However, in reality, many animated filmmakers reading this book will be in more of a "stone soup" situation than a Hollywood megabuck one. As a result, the issues relating to soundtracks may prove financially taxing ones. Accomplished actors, for example, may be beyond the pockets of most filmmakers. Yet the great filmmakers are the ones who can think outside the box. Instead of employing professional actors for a soundtrack, why not consider amateur ones from a local dramatic society? You may even have friends or colleagues who have amazingly interesting voices and can deliver the lines satisfactorily. Drama schools or operatic societies will also have voices that could fit the bill of many film soundtracks. Many of these people will be delighted to be given the chance of appearing in a film (or at least, having their voice heard in the film), and a fee for doing so may not be an issue. A name in the credits at the end of the film may be all that they will really ask for.

It is the same with composers. Most towns have some kind of orchestra (professional or otherwise), every kind of band, singer, musician, and musically inclined individual, among which might well be the perfect person to produce an adequate music score or soundtrack. A little imagination and a lot of enthusiasm can go a long way. There may even be local tape or radio enthusiasts who have the equipment to record your soundtrack material for free. The reality is that the resourceful filmmaker will never know what they can achieve until they try. Just don't be tempted to use existing, copyrighted material without permission. This may be legally tolerated for a small, student-based production that does not reach out to a paying audience. However, should the project ever get exposure beyond that (or even work seeking interviews), it is likely that you would eventually hear from a less-than-friendly lawyer, protecting their angry client's stolen intellectual property!

Most films will have the music scored and created by the composer after the film is complete or close to completion. With live-action films, the composer begins to block in the sounds and moods the music will take from a rough cut of the film. However, this process, being the last in a long line of production processes, is inevitably against the clock and therefore a source of stress for the composer. With animation, since everything is essentially pre-edited, the music creation schedule can be more relaxed. In fact, a composer can start to block out their musical thoughts as early as the animatic (filmed storyboard), or even perhaps with the final film pencil test (completed, uncolored animation in 2D films) in place. Whatever stage the composer picks up the rough cut from the filmmaker, it will undoubtedly be far sooner than in a live-action production, giving him or her much more time to work on the score.

There are exceptions, of course. In "Fantasia," the music was required up front because without it the filmmakers could hardly have planned and choreographed the action. Therefore, if there is any form of integration, or interpretation, between the music track and the animated action, the music will have to be pre-recorded to accommodate this. Quite often this can prove to be a logistical or budgetary problem. Sometimes, planning and production timings beyond the filmmaker's control impose technical requirements that dictate the music score being produced at the end of the production schedule instead of the beginning, whereas the animators will require it to be produced before. It would double the music budget costs to record the music both at the start of production and at the end, and the post-syncing of recorded sound might be a problem for the musicians also.

I encountered this problem when producing the animated title sequence for "The Pink Panther Strikes Again." Henry Mancini was to record the whole film's final music score at the end of production, but I needed the title music of his theme at the beginning, to choreograph my animation to it. It would have been impossible to have put together an entire orchestra twice or to interrupt the composer's already busy schedule to fly him to London (where I was doing the work and the film was being shot at the time) just to do a few minutes worth of music track at the beginning of the film. A compromise was eventually struck. Once my story ideas for the title sequence were approved by the film's director, Blake Edwards, it was negotiated with Mancini that an experienced composer friend of mine, Howard Blake (who went on to compose the wonderful and haunting music for the animated "Snowman" TV special), would produce an accurately timed adaptation of the familiar Pink Panther theme for me to work with. Howard's (ultimately brilliant) arrangement and score had to be approved by Mancini

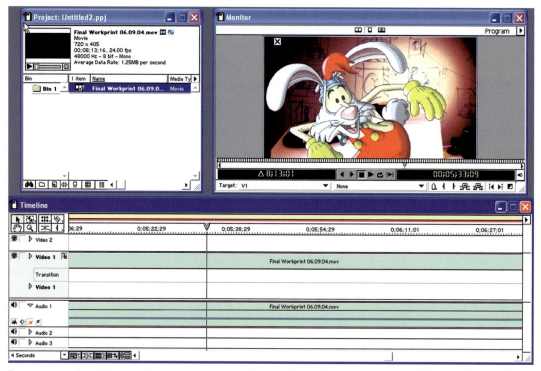

Programs such as Premiere Pro make it extremely easy for animators to work with sound using the wave form audio file layers that can be visually assigned to images via the timeline.

before it could be recorded. But, once it was, Howard hired a small group of musicians (as opposed to a full orchestra) to record the arrangement as it had been planned out by the composer and me. A metronome click beat was dubbed into the final demo recording, so that when the final orchestral arrangement was recorded by Henry Mancini months later it would be identical in both pace and timing. With the approved demo track, I was ultimately able to accurately time and choreograph my animation, producing the award-winning sequence that appeared in the movie.

Since then, contemporary digital technology has brought significant advances to this approach. Now, with sophisticated synthesizing and sampling software, it would be entirely possible to create that Pink Panther demo track without using musicians in a studio and have it approved online within minutes from anywhere in the world! Indeed, in reality, it might even be possible to create the entire final recorded piece with synthesized equipment, although I have to say that the thrill of experiencing live musicians in a large, professional recording studio is irreplaceable. There truly is no substitute for live music, no matter how good modern digital technology is, although modern budgets and schedules often make such things impossible to contemplate. For example, the music for "Endangered Species" was created entirely with synthesized sound. Ultimately though, whatever means of recording is used, be it a simple piano track or large orchestra recording, the essential ingredient of a pre-recorded demo track is the timing. With a mechanical metronome click track in the demo music, it is entirely possible for a perfect synchronizing of the final recorded material and the initial demo track. If the click track timing is constant between the two, they should match perfectly. If not, there could be a disaster when the final track is ultimately recorded to the animation.

Digital editing programs like Sonic Foundry's Sound Forge, enable animation filmmakers to identify and edit sounds phonetically, down to a frame-by-frame basis, using the visually emphasized waveforms that can be clearly recognized in the timelines.

Final Working Track

The pre-recorded elements can now be edited together into a final working soundtrack, the one the animator will ultimately draw to, as it has all the necessary sound elements, positioned and timed, incorporated into it. It will be cut to the entire length of the final movie, silent sections and all, and will have everything an animator needs to plan the movement of the film. The delicate sound balance between the various audio elements will not necessarily be final, and the dubbed elements will not be incorporated, but everything else will be placed as it should be. Once a working track is approved and animation has begun, it will be an extremely costly procedure, in both time and money, to go back and change anything later. This is why it is important that the working track is precisely what the filmmaker wants before the main production swings into action.

The Track Breakdown

With the final master track edited to length, there is one last process that has to occur before an animator can proceed—the track breakdown. In the track breakdown, the soundtrack is analyzed, scene by scene and frame by frame, so that you will know precisely what word, what sound, what syllable, what beat, and what emphasis point hits at any particular frame in the film. For example, if the word "STOP" is being said in a scene, the track breakdown will analyze and record exactly how many frames after the start of the scene the S will begin, then when the T hits, then the O, and finally the P.

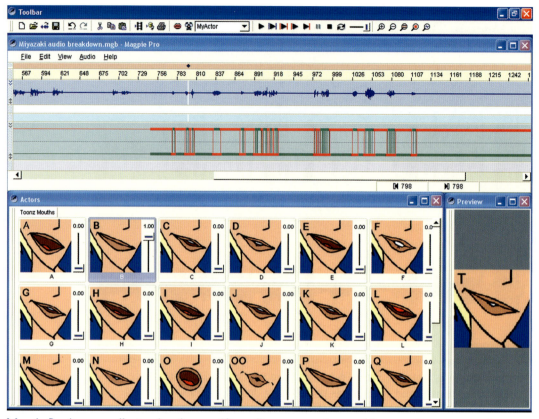

Magpie Pro is an excellent animation-specific audio program that enables an animator to analyze audio tracks and test lip-syncing before any animation is even attempted.

In this way, you are assured that the character's mouth you are animating is in exactly the necessary shape to match each of the sounds, and for the appropriate number of frames, to keep continuity of synchronization. (Each phonetic sound within a word will probably be on the screen for more than one frame of film at a time, especially with slow dialogue.)

The sound breakdown can also break music down into identifiable beats and relevant musical notes or lyrics, so the animation can emphasize and synchronize the action to those particular cues or beats. Similarly, with extended movement that has to coincide with the specific tones, moods, and slides of certain musical notes. The traditional way of creating track breakdowns, using a magnetic film track and editor's sound bench, can be found in my earlier book, "The Animator's Workbook."

Film Speeds and Conversion Ratios

Soundtracks have to run at different playback speeds, depending on the medium and market the film is catering for. For example, a playback speed of 24 frames per second (fps) is the standard rate for a film projected at the cinema. On TV, there is a significant difference in film speeds broadcast in different regions of the world. In the U.K., the PAL broadcast system requires 25 fps. In the U.S., however, the NTSC broadcast system uses a 30 fps system (although it can handle 24 fps as well). Consequently, material created for the U.K.'s PAL 25 fps has to be converted to the NTSC 30 fps system to appear

on U.S. television, and vice versa. For certain technical reasons, conversion ratios are best if devisable by six. Converting from 24 fps to 30 fps is a comfortable ratio but 25 fps to 30 fps is not such a comfortable ratio; frames need to be either dropped or added if the film's length is not to suffer through the conversion. (This is not an easy notion to explain in the confines of this book, so if you are faced with such a conversion situation, seek further advice on the matter or visit the www.animaticus.com forums for specific links to such information, before beginning production.)

Filmmakers should always make their films at the film rate of the market, location, or medium that their film is to be mostly seen in (regardless of their personal local standard rate) to avoid an inferior conversion process. The most satisfactory digital conversions are from a hi-definition original to either PAL or NTSC, then from PAL to NTSC. Films should never be made to NTSC standards if they are to be principally shown on PAL TV. (The PAL format is a superior visual format to NTSC, as it uses 625 scan lines to make up the entire screen image. The NTSC format only uses 525 lines, so its visual definition is not nearly as good. Conversions from NTSC to PAL will only enhance this deterioration in picture quality.)

On the Web, streaming and Flash animation provides for all kinds of playback rates. The optimum will always be at 30 frames per second, and this means more drawings per second for full animation. Flash animation, however, defaults at 12 fps. Conversions made from cinematic film, or any of the other TV broadcast standards, to Web (small screen) resolutions will be fine. Conversions made in the other direction (from Web to TV or film) will look decidedly inferior and should be avoided at all costs.

Most digital programs enable the playback speed of the film or audio track to be changed manually, although most of them tend to default to about 30 frames per second.

"Endangered Species"

The soundtrack for "Endangered Species" was a less than unusual process on this occasion. In part, a certain percentage of the material scripted was based on existing audio material, taken from classic moments in animation's history. Other parts were original narrative, written and delivered in a documentary style. The challenge to me therefore was to obtain voice performances that were compatible with the original voice talent but without having any budget to pay star-name (in some cases) professional talent to do so. Fortunately, "Endangered Species" was never seen as a commercial project; it was always conceived as an inspirational homage to a great (but declining) art form. As a result, the performers I approached, begging bowl in hand, had some sympathy with my motives and objectives, and agreed to record aspects of my soundtrack for either a hugely reduced fee or else for no fee at all. Other voices I used were friends, associates, and students I was fortunate to have access to at the time and who had a special skill at impersonating a particular style of voice. This, I have discovered, is the challenge of independent filmmaking. The impossible IS possible; you just have to be more flexible in the approach and think outside the box of normal production practices.

The most amazing opportunity was obtaining the generous voice contribution of Roy Disney, who provided the voice for the leader's ghost during the "Christmas Carol" tribute sequence. Clearly the leader in the film is inspired by Walt Disney. I had long had the notion of Roy recording the voice for the ghost but I had no way of getting to him to ask if he would. Then, I coincidentally discovered that a good animator friend of mine was in contact with him. I asked her if she would ask him for me and, to cut a long, long story short, he ended up recording the piece for me. (The Lords of animation do indeed move in mysterious ways!) In all honesty, this was not only having a known name recording a character voice for me but it was far more, symbolically important. Being part of the Disney bloodline, and with Roy fighting the Disney studio management at the time for the very same reasons that are raised in "Endangered Species," it was tantamount to having Walt endorsing the project himself. I could not imagine a more ideal person to record that ghost voice, except perhaps Walt himself. I will always be eternally grateful to Roy Disney for his graciousness in contributing to the project and to my animator friend for making it all possible in the first place.

The main narrative in the film is spoken by top British voice artist Christopher Kent. His involvement in the project was perhaps a little less exotic, although it was graced with equal generosity on his part. I felt I needed to find a voice for the narration that had the presence, authority, and warm assurance of the great British wildlife documentary narrator, Sir David Attenborough. Knowing that Sir David was unavailable, I searched the Internet for someone in the U.K. with a similar presence in his voice. My research ultimately led me to Christopher Kent and, although I was 3,000 miles away and I had next to no money to offer, I lay the project before him, together with its importance to me and, of course, my financial shortcomings. It says so much in this very materialistic, celebrity-obsessed day and age, that a top professional such as Chris was so readily eager to contribute to the cause, not only offering to record the narration for me at a significantly reduced fee but also to digitally edit and master the entire track for me at his own London-based studio. As with the Roy Disney recording session, we recorded everything with me directing over the telephone. The actual recording session lasted just over an hour in length. When finished, he immediately edited the selected takes and mastered the final track for me. When he was finished, he provided me an FTP site that

Christopher Kent studying his "Endangered Species" script prior to recording. PETE GOLD

I could access and I actually had the finished soundtrack downloaded onto my computer in little more than a couple of hours after the recording session was over! This proved not only a testimony to the depth of human generosity but also to the wonder of modern technology in our exciting digital age.

The rest of the voice tracks were recorded by my colleagues and students, notable amongst which were Mark Vandiver and Kevin Boze, who gave freely of their time to the project. Other voices were recorded along the way in similar circumstances, such as Aoki Kunitaki, an artist from Nintendo whose voice I used for the young Hayao Miyazaki.

The music was beautifully scored and directed by the young, up and coming composer Jamie Hall. Jamie was another with a generous spirit who donated his services and talents to the project for very little fee compared by Hollywood standards. As the project's musical director, he wrote, scored, and recorded all the film's music, using a finely timed work-in-progress copy of the film, containing a combination of finished animation and work-in-progress pencil tests. I do believe that Jamie's contribution to the film was exceptional.

Finally, I fundamentally believe that this is just one more illustration of the fact that if a project is passionately made, from the heart, for the heart, with good objectives and a professional approach, it will ultimately attract sincere and dedicated professionals who will be happy to help out without thought of immediate gain. Industry logic states that the kind of talent that has been attracted to "Endangered Species" would be out of reach unless fully paid for. But with such qualities as passion, belief, and faith behind it, miracles can happen. Truth attracts truth. Goodness attracts goodness. Generosity attracts generosity. I have always firmly believed this and am proud to say that the proof of the pudding is certainly witnessed with the audio elements of "Endangered Species."

Storyboarding and Animatics

*You can never storyboard a film too much,
although it can feel like it sometimes!*

It cannot be emphasized enough just how important a storyboard is to an animated film production. Unlike live action filmmaking, animation is all about pre-editing and planning the material so that enormous amounts of time and money involved in the production process are not wasted in producing material that ends up on the cutting room floor. This can be totally avoided by drawing up a detailed visual interpretation of the script up front, and creating a fine-tuned filmed animatic from the these visuals, effectively a process of locking-down the timings and actions in the film before a single frame of animation is produced.

Simply stated, a storyboard is a sequence of images (usually drawn) that interpret visually the story content within a script, frame-by-frame and scene-by-scene. The standard storyboard is laid out as a series of sequentially framed and numbered images, somewhat like a comic strip. Each frame depicts a scene (or several frames depict a series of actions within a scene) that represents the visual telling of the story from the camera or viewer's point of view. In the case of film projects, the shape of storyboard image frames will define proposed format, such as Academy, hi-definition, widescreen, or Cinemascope.

Where the storyboard is a means of determining the visual, structural, and staging contents of a film, the animatic (long referred to as a Leica Reel at the Disney studio and other Hollywood entities) is the means of working out the length and timing flow filmically.

Storyboards

A storyboard can be anything from a sketch on the back of an envelope to a highly crafted, fully-colored presentation document that can be used to sell the entire film. (See Chapter 1, "Development," for more information.) A storyboard is not just a work of art; it is a production blueprint that shows everyone on the team what will be required. A completed, well thought-through storyboard is also invaluable for producers, accountants, distributors, financiers, and budget controllers to know just where the money must be spent and why it must be spent in that way.

Storyboards are now the norm in most big film and TV series productions, but it was not always that way. In the early days of the cinema, there was no such thing as a storyboard. Encouraged by Walt Disney, artists pinned sketched story ideas up onto a board so that everyone involved in the film could see and discuss these ideas. These sequential sketches ultimately became known as 'storyboards.' Today, with so many complicated special effects and action-based storylines in films, it would be virtually impossible to budget, let alone produce, a modern film production. Hence, the work of the professional storyboard artist in the mainstream film industry is in demand as never before.

In the case of significantly lower-budget productions such as TV shows, video games, commercials (where it is essential that the client, the creative team, and the production team are working off the sarne page), and personal and student films, the process of storyboarding is invaluable for identifying at the very least, what has to be done and why.

Sheet No. **6**

Sc. ⑯

THE NURSE PACKS UP THE CASE,
MAKES FOR THE DOOR BUT NOTICES
A GLOW IN THE MIRROR. SHE
WALKS TOWARDS IT.

Sc. ⑰

SHE SEES HERSELF AS A SHINING
VISION. THE IMAGE THEN FADES.

Sc. ⑱

SMILING, THE NURSE EXITS THE
ROOM.

The storyboard outlines the actions and effects of
the project.

Storyboard Formats

Storyboards come in all shapes and sizes (below), although pre-printed storyboarding sheets can be bought from most animation supply companies and these are perfectly adequate for what is required.

Storyboards come in all shapes and sizes.

Many professional filmmakers custom-make their storyboard templates. A third option is storyboard software. Storyboard software such as BoardMaster (shown below) and Storyboard Quick make the process of producing and presenting storyboards all the more efficient, although a basic desktop publishing program like Adobe's PageMaker can produce custom-made templates that will suit most filmmaking needs.

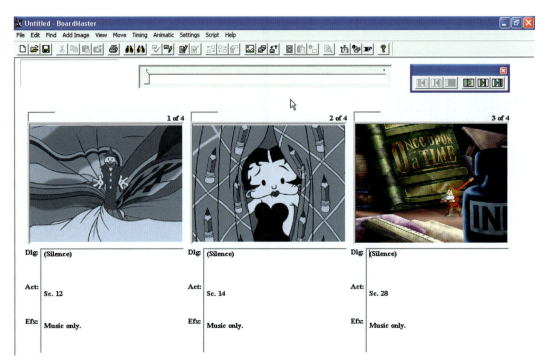

BoardMaster is one software application that makes the creation and presentation of audio/visual storyboards and animatics an extremely simple process for most filmmakers.

I personally tend to use the latter, creating a letter-sized sheet with three picture frames to the left side and enough space on the right to accommodate text and dialogue references. At the top of each of my sheets is space enough for filling in the production name, the sheet number, and any studio/personal logo/contact information that may be necessary.

I often add one more element to my storyboard sheets, especially so if I am boarding out a live-action drama sequence. Next to the main storyboard frames, I will add three or more smaller frames that allow me to add alternative or cut-away shot ideas that may relate to the main frame idea. As discussed Chapter 4, "Rules of Filmmaking," it is useful in to have cut-away shot options. The thumbnail frames enable me to put down any cut-away thoughts I have for the shot, should I need the "get out of jail free" option. It's also sometimes useful to have an alternate shot, just in case the first one doesn't come off or there are alternative shot options in a scene. These smaller frames are therefore invaluable for getting such second thoughts down.

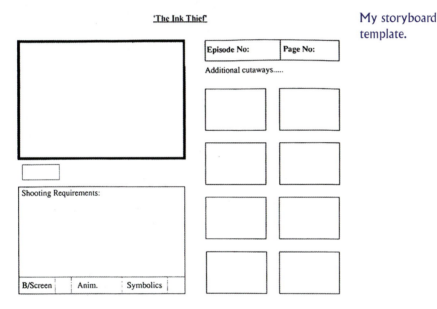

'The Ink Thief'

My storyboard template.

If you prefer pre-printed storyboard sheets, you should have one for each of the three main screen ratios, Academy, widescreen, and hi-def.

It is unlikely that most animators will ever need to use a Cinemascope storyboard sheet, although if they ever do need it, a sheet version of that should be prepared too. With any letterbox format storyboard sheet, I tend to find that the extra width required eats into the text area of the sheet. Therefore, I generally include only two frames per sheet with all letterbox formats, placing areas for the text and dialogue material underneath, rather than to the side, of the frame. With bigger-budget, visually complex productions, it would not be a bad idea to approach Academy style sheets this way too, since you have a larger drawing area to work with.

If the production was an extremely ambitious one (such as a movie or TV special/series involving a large-scale production team), it would ideal if the storyboard sheet master had only one frame, then each shot could be drawn large enough for everyone to read it when pinned up on a board. This also facilitates moving the shots around on the board to reflect developing changes in the story structure.

Creating the Storyboard

In my own storyboarding process, I find it is necessary first to read the script several times, so I understand fully what a writer or filmmaker is really seeking to say with the piece. Often a script contains elements that are not obvious at once, or they build to a conclusion that is not indicated in the initial pages, so quickly skimming the screenplay will not necessarily give a complete picture of what is required. As I am going through the script, I scribble down key words or thumbnail sketches of ideas that pop into my head at the time.

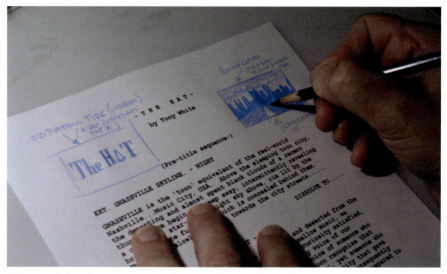

Notes and sketches capture my first reaction to the script.

I also draw lines across the script where I think a particular sequence ends and a new one begins. Eventually, my script will be a mass of scribbles, sketches, lines and off-the-wall thoughts. Then, when I am satisfied I have gotten the most out of my free-association process, I start to sketch out my storyboard, full size, in a much more structured, organized way. As with my pencil animation work, I always lightly sketch out my final storyboards with a blue col-erase pencil. This allows me to draw fast and smoothly and creates a line that can be erased if necessary.

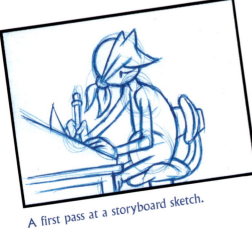

A first pass at a storyboard sketch.

The first thing I will draw in is the establishing shot of any new sequence. In 95 percent of films, it will be necessary to have some kind of establishing shot at the front of every sequence that familiarizes the audience with the setting, the character's situation and the character's relationship to that setting. It also establishes any other props or elements needed in the action that is to follow, either immediately or perhaps later in the sequence. With the remaining five percent of scenes (when an establishing shot is not used up front), I tend to draw out a location sketch on a separate sheet of paper anyway, to orientate myself within the scene without ever actually needing to show it in the final, formal storyboard.

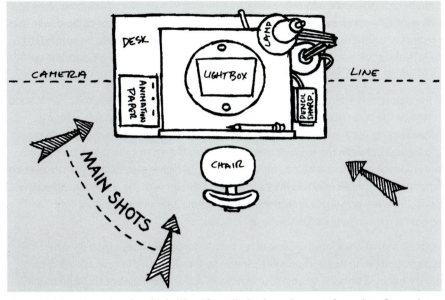

A typical location sketch, which identifies all the key elements I need to factor into that location when drawing my storyboards.

With the establishing shot created, I next block out the rest of my frame-by-frame thoughts in the form of light blue pencil roughs, staging everything in a way that most effectively tells the story. In addition to defining the unfolding story scene by scene, my storyboards will show the relative positions and orientation of each character within each scene, the preferred camera for each scene and perhaps even the intended framing of each camera view, as in the figure above. Chapter 4, "Rules of Filmmaking," covers the various techniques for creating realistic and engaging scenes, including staging, camera positions, and transitions.

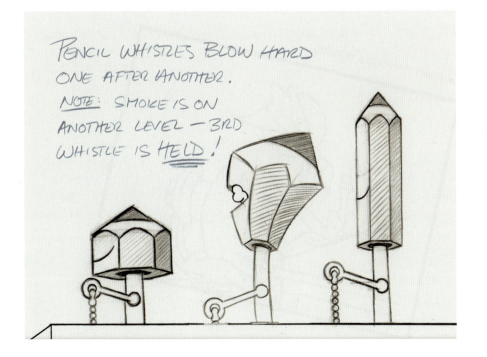

Storyboards define the action in each scene, including character's position relative to one another. It is not easy to offer hard and fast rules for the selection of close-ups, mid shots, etc., except to say that if an action or expression really needs to be appreciated fully by the audience, then you must use the most effective shot to produce the desired effect, such as a close-up shot

If the character is interacting with another character or a prop, then a mid to wide shot might be the best choice. In 3D animation, camera moves are a valuable option in scene staging, especially when there are two characters interacting and ways of crossing the line between them needs modifying. Often, when storyboarding such an action, it becomes necessary to re-think the staging, which is especially true in live-action filming when spontaneity and improvisation on the set with the actors can offer new possibilities not previously considered. The potential of moving cameras, lights, and lenses can be similarly utilized in the 3D process.

With 2D animation, a moving camera is a huge effort to achieve, especially where the background has to be hand-animated frame by frame. So, in this case a moving camera style should be used sparingly, unless there is a large amount of time and money to spend achieving the shot. Panning, tracking, and zooming in and out are preferable options in 2D animation when a sense of movement and dimension are required.

When I have sketched out my entire storyboard, or entire sequence of action, I review the whole thing one more time and make any fixes. It can sometimes take several attempts to get the storyboard flowing just right! The storyboard is a fundamental influence on the personality, the look, and ultimate play out of the film, so it is very important to get this right, prior to production. In big movie length productions, this is something that may actually take a number of months to achieve.

Once I feel the story is correctly laid out, I finish the drawings using either a black fiber tip pen (my preferred choice) or a dark black-lead pencil, depending on what the intention or the purpose of the boards will be.

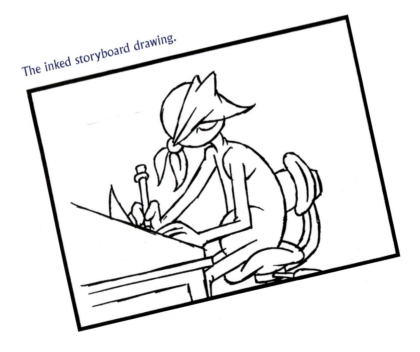

The inked storyboard drawing.

Sometimes boards are created just for internal use, so pencil-sketched boards will suffice. However, on other occasions, boards will be required for presentation or selling purposes, often finished in color or turned into animatics, in which case the artwork will have to be scanned and colored digitally. This will require an inked-in finish, which is an extra level of effort in the storyboarding process.

In terms of coloring, the actual paper boards can be worked over with color markers or else, after scanning, they can be colored digitally with a program like Photoshop. Using color on storyboard drawings often evokes a specific mood or emotion that line drawings alone will never evoke.

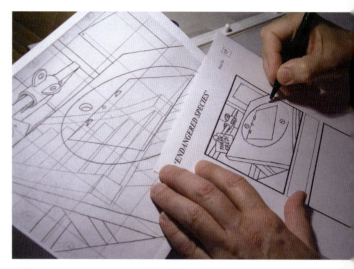

Inking in an important establishing shot that is based on a previously conceived concept drawing.

NOTE

A word of caution for the impatient filmmaker! Although many inexperienced animators and rookie students often insist that storyboards are too time-consuming and superfluous, virtually all professional projects, no matter the length, are meticulously boarded prior to production. Storyboarding is as an INDISPENSIBLE and ESSENTIAL part of the animation and filmmaking process.

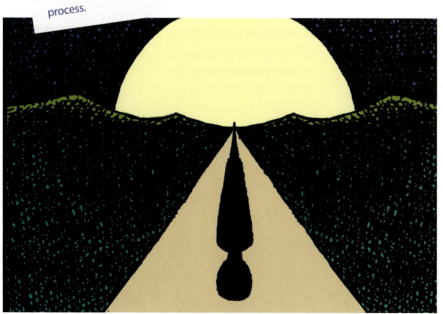

Note the sense of loneliness and isolation the use of simple colors create.

Tips for Storyboarding

Here are some helpful tips and tricks I have learned over the years.

Reusing Drawings

Quite often it is necessary to use the same shot set-up in many different scenes throughout a film. To avoid having to re-draw these scenes each time they need to appear in the storyboard, it is perfectly acceptable to trace previously drawn images (see the figures below) or use a good photocopying machine to copy the original frame then cut and paste versions of it into the appropriate positions in the storyboard.

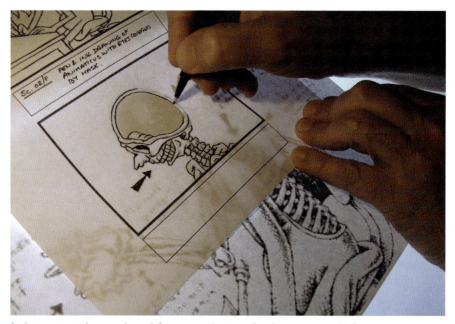

I always re-cycle storyboard frames and artwork wherever possible!

Drawings can be photocopied and then cut and pasted into other positions in the storyboard.

Similarly, everyday technology can come to the rescue if there is a close-up, mid shot, zoom-in, or zoom-out of a particular wide shot that has already been drawn. For example, you could take an initial establishing shot drawing and make an enlarged photocopy to create the same scene zoomed in. (Or use software to do this digitally.) Crop the relevant enlarged areas and paste them into the storyboard sequence frames as needed. It is possible to do zoom-out shots the same way by reducing the image and pasting it into the frame where you need to show the wider shot (although you will, of course, have to draw in the missing surrounding area of the frame when the original artwork is reduced into it).

Here, I used Photoshop to isolate a part of an existing scanned drawing. Then I scaled and printed it out to use as a new storyboard frame.

Another way of indicating a zoom-in is to draw the scene fully then draw a frame around a smaller area within the shot that needs to be featured, connecting this with directional arrows from the corners of the original frame. This can be done likewise for any zooming-out.

Rough sketches show where I plan to zoom in and out of shots.

Panning Sequences

If you need to indicate a long panning sequence (vertically or horizontally), the single storyboard frame is too limiting to draw in all the details that need to be seen. Here's a workaround for vertical pans: Start a new storyboarding sheet and use both of the frames (if there are three frames per sheet on the storyboard sheet, then use all three) to show the entire move. If an upward pan is required, write to the side of the bottom frame "PAN START," drawing an upward arrow along the side of the frames to the top frame, and then terminate it with the words "PAN STOP."

Storyboarding a vertical pan.

Horizontal pans provide a little more complication to the storyboarding process, as there is not usually the surface width on a sheet to draw the full length of the pan required. In these circumstances, I tape an extension sheet of paper to whatever frame is going to require the panning drawing.

Attaching a horizontal storyboard frame.

This paper can be folded in on itself so that it will not stick out from the pile when all the storyboard pages are stacked together, but when opened up it will provide a wider surface for the pan to be drawn upon.

Folding the extended frame will keep it from being damaged when all the sheets are stacked together.

If a really long pan needs to be indicated, then a longer sheet of extra paper, requiring more than one fold to tuck it in, can be used. Horizontal pans do create more problems when storyboarding, especially when the storyboards need to be copied and passed around to others afterwards. However, there will always be ingenious and resourceful ways you can get around these kinds of challenges. The bottom line is that you must achieve clarity of communication, and any means that makes this possible within the storyboarding process is perfectly acceptable.

Numbering Frames

I strongly advise that you studiously number your storyboard frames as you do them. In fact, I often number my planned frames on the script first, so I know how many frames there are to do (and therefore approximately how many sheets of blank storyboard paper I am probably going to need, valuable when trying to estimate a schedule for the storyboarding stage). It is so easy to get wrapped up in the creative process of storyboarding, forgetting to number the drawings as you go. Consequently, when you have a pile of beautifully drawn frames but no numbers to indicate what follows what, or the entire pile gets accidentally knocked on the floor, you will curse the fact that you didn't take time to order and number them in the first place!

If you work through and number an entire storyboard, , then find you need to add a frame or two here and there to make it flow better, you can always give any new drawings an alphabetic identifier that will follow the existing frame drawing they relate to. For example, if the storyboard frame number that you need to add new drawings to is frame 35, then the subsequent new drawings can be numbered 35a, 35b, 35c, etc. before returning to the original following frame, that is 36, in the sequence.

Use letters to indicate insertions between existing storyboard drawings.

Finish the Storyboard

It is very tempting for novice, student, or impatient filmmakers to want to proceed with a project without a storyboard being produced in the first place. This really is unwise. Animation is so time- and cost-demanding that skipping the storyboard will almost certainly be a false economy, both in time and money. No filmmaker, novice or experienced, can ever fully interpret everything without there being some kind of adjustment, re-think, or starting again from scratch involved in places. Even after more than 30 years of personal filmmaking experience, I still find that I have to do this sometimes. Filmmaking is a never-ending process of learning, and therefore I can absolutely guarantee without reservation that the first idea is not always the best idea! It is far better to correct and re-adjust things when the cost of doing so is minimal—when you have just a few storyboard frames to re-draw—rather than when an infinite amount of no-doubt painstakingly produced animated action has to be scrapped and re-done. It can be totally soul-destroying (and budget-busting) to produce what seems like wonderful animation, only to find that it doesn't fit into the overall film structure when edited in with everything else. The storyboard process avoids this situation entirely, which is why it is ignored at the filmmaker's own risk.

"Endangered Species"

Perhaps the most surprising admission (and the most hypocritical, in view of my stance on the necessity of a storyboard) is that I never did storyboard "Endangered Species." Since the film is based on classic moments in animation's history, edited together into an animatic, there really never was the discernible storyline that most films have. Once I had the idea of creating this film, I created digital copies of the classic animation sequences I wanted to play tribute to and assembled these into what was effectively a film animatic. These edited clips, principally selected due to their significance in the history of animation, were then interspersed with my sketches representing what would become the film's vector-based material (the animator at his desk, from baby to old man) linking one historical piece to the next.

I altered my selection of historical film clips several times and, consequently, the drawings representing the vector material that linked them had to be changed too. The narrative material that is illustrated by still pen and ink illustrations throughout the film was actually not added until the film was well into production, when a respected friend of mine, Dan, explained that he loved the animatic material I showed him at that stage but (to a non-animation professional) some of the connecting sequences were obscure. Since the film needed to reach out to audiences that were animation savvy and not, I realized that this was a major flaw and devised a narrative and series of images that filled that vacuum.

Ultimately, I had what might be described as a final animatic of the entire film, pretty much structured as it ended up. For this reason, formal storyboarding was never a serious requirement and therefore this was why this film was a special case for not doing one (though I did storyboard a couple of small sequences to help me get my head around what I was attempting to achieve). I do stress again, however, that storyboards for virtually every kind of production are an absolute requirement.

The Animatic (or Leica Reel)

An animatic is essentially the edited storyboard material, timed to a soundtrack (either the finished track or else an accurately timed demo one) so the entire project can be viewed and reviewed on a screen, or monitor, with a pace and structure that it will ultimately have.

It is one thing to look at a series of immaculately drawn and structured storyboard drawings and have all the time in the world to absorb and appreciate them. However, it is quite another thing to take these same drawings and see them in their ultimate context, i.e. using the filmic time and the pacing they will appear on the screen in the final movie. It will be surprising just how different a sequence of storyboard frames looks when projected onto a screen in real time. Sometimes the drawings may appear too briefly, giving the audience no time to appreciate them or understand the details they contain. Other times they will hang on the screen for an excessive amount of time, making the audience bored and restless. Viewing an animatic will never be like viewing the finished film material, but it is the closest a filmmaker can get to a reasoned understanding of how well the visual material works in situ before the expensive and time-consuming process of the actual animation begins.

Editing software is one of the best tools for creating animatics from storyboard drawings and rough or final audio tracks!

Since the soundtrack and the storyboard drawings have to be complete before production, it actually requires very little extra effort to produce a final animatic to test everything; just scan the drawings and edit them with the soundtrack using a program like Adobe's PremierPro. It would be extremely foolish to ignore this easy opportunity. Even if the storyboard is structurally perfect and you have years of experience at making films under your belt, there is still a lot that can be learned from creating and viewing an animatic. For example, although I have worked on pretty much every film format (in both animation and live action), except a full-length theatrical movie, the majority of my filmmaking experience has been with commercials, over 200 to date. As a result I have an instinctual tendency to plan projects with the same fast-cutting, short-scene techniques that are necessary when making 30-second TV commercials. However, when it comes to long-form projects that involve more subtlety, pace, and drama, I have to consciously resist these instincts and plan my scenes with an entirely different sense of timing and scene construction. Sometimes even stillness within a sequence can work better than continual action, as a prelude for something more dynamic yet to come. The animatic tells me so much about how my ideas are working before I commit to the animation process. Similarly, animators and filmmakers

A simple digital stopwatch is a powerful aid when working out timings for both animatics and animation.

who are experienced at making theatrical movies or long-form projects often struggle to make punchy, snappy animation for shorter formats. The animatic will assist them in discovering just how to work at a sprinter's pace rather than that of the marathon runner. In fact, no one is exempt from the benefits that an animatic can provide, hence its immense importance to the filmmaking process.

Storyboard frames from "Endangered Species" that were eventually used in an animatic sequence.

In all honesty, I have insisted upon including animatic production as part of my established storyboarding classes as, for the reasons given above, I do not believe that creating storyboards in isolation is as complete a learning process as producing storyboards which are then edited into real time animatics. Using such programs as Premiere, Flipbook, or ToonBoom Studio, it is relatively easy for animated filmmakers of all levels and approaches to produce a workable animatic that will tell them more about their filmic decision-making than their pure storyboard alone.

Working with Premiere to establish an important sequence in "Endangered Species."

Creating the Animatic

For general animatic creation, I favor the Premiere route as I find it faster and more accessible to make on-the-fly changes as I work through my animatic. I scan my storyboard drawings (or even the final layout drawings) and save them as individual files using the same numbering system that I have assigned to the frame-by-frame drawings. I scan into Photoshop so I can re-size, intensify, or color the images, depending on the animatic requirements. Then I import these individual files into Premiere, together with my soundtrack master edit, and then broadly assign a specific number of frames in the project timeline that I feel is implied by the script.

I like the way that Premiere displays every scene along the main timeline.

When all this is done, I will play back the entire animatic, taking in the feel of everything the first time; I then review it again to see if my first impressions still hold good, then I finally make specific correction notes (scene by scene) prior to re-working the material.

I also make notes on the timings of each scene, for when I make up production charts and dope sheets.

Notes completed, I will then work my way through the entire animatic and make the necessary corrections, creating, adding, and removing storyboard drawings wherever necessary. Eventually, I will get to the point where I can review the entire animatic once again, as a full-screen movie, to appraise the effect that the new changes have made to the entire piece.

Reviewing the animatic on a regular TV monitor gives further insights into the way the animation is working.

Indeed, it is only in reviewing everything as a whole that the value of the filmmaker's creative decision-making can be safely assessed, as reviewing individual scenes, or sequences (in a longer form piece, at least) can be quite deceptive if taken in isolation. In an ideal world, it is best to even walk away from the finished animatic edit for a day or more, and come back with a fresh eye before signing off on any final decisions. It is amazing just what real perspective can be acquired by just breaking for coffee after the hands-on re-editing process is complete.

I frequently find after the first viewing or two that I need to add new storyboard frames, despite all my years of experience. It is only when you see your initial storyboard thoughts played back in real time that their fundamental deficiencies can be discovered. With general storyboarding, I tend to just draw one or two frames to represent each scene. However, having viewed the animatic, I sometimes find it's necessary to create a beginning, middle, and end storyboard frame for each scene, unless there is absolutely nothing going on in the scene action-wise.

Adding two new drawings to the original one on the left communicated the real mood and action I was after for the scene.

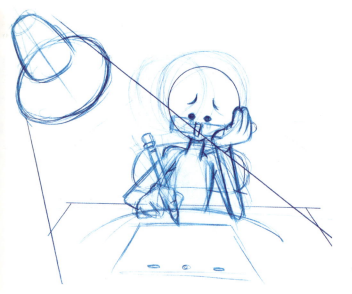

A quick "filler" drawing I created for the original "Endangered Species" animatic.

Even then, additional secondary drawings within the three-frame scene are often required to visually explain less obvious actions within the main action and it is only by watching the animatic for one or two times that this can be revealed. At such times, a very rough sketch, as opposed to a highly finished storyboard drawing, quickly scanned and edited into the rough animatic, can immediately reveal the significant improvements that this important process of re-evaluation can reveal. (Excellent examples of this process are well demonstrated on the bonus features of the "Spirited Away" DVD.)

On occasions, the over-enthusiastic filmmaker includes too many storyboard drawings, resulting in the action speeding by with too many cuts and without anything really being digested and understood by the viewer. If this proves true, the filmmaker will either have to decide on extending the screen length of the film (if at all able to do so) or reduce the number of storyboard frames being used. A third option is to re-think the entire sequence and create entirely new drawings to represent the action better, but this is probably the least desirable option. Again, it is only when the animatic is viewed in real time, on a proper screen or monitor, by a larger audience, that any of these deficiencies will ultimately be revealed. Looking at our own storyboard, in isolation, can never do that.

Screen your animatic for trusted friends and colleagues for their feedback.

Additional advantages that the creation of an animatic can bring to the production process is that the entire production team can view the complete piece prior to starting their work, fully understand, and be prepared for what is to come. It also makes it possible for the producer and/or budgeting personnel (who can assess their original estimates on schedule and costs) to assimilate more fully the earlier scheduling and budgeting decisions and make adjustments, if necessary. The value of the production personnel seeing the animatic prior to production, whether they be creative or administrative, is that it offers everyone a last-minute opportunity to make suggestions that could improve the project or its planned production process. Animation is ultimately team work and the more clued-in the team can be, the better it will be for the film and for all concerned with its production.

Lastly, in a much more practical way, a locked-down, approved animatic will actually provide an editing template that the film's editor (or just the filmmaker in smaller productions) can use for future editing purposes. This will become self-evident if the ideal production process is explained. As the animation for each scene is completed, it will be edited into the animatic (the new animated piece will replace the old drawn animatic material), somewhat like working on a jigsaw puzzle, except that instead of filling in blank space with a piece, each animatic scene is replaced by a more complete one.

For example, if a 2D film production is being made, the editor will perhaps replace a scene's animatic drawings with a pose test from the animator, all the key drawings of a scene, timed out to length but without the inbetweens added. Viewing this in the context of the whole, the scene might then be inbetweened and shot, providing the editor with a pencil test that can replace the pose test material. Then, when the pencil test is approved and colored, the color shoot will replace the pencil test material. Ultimately, this

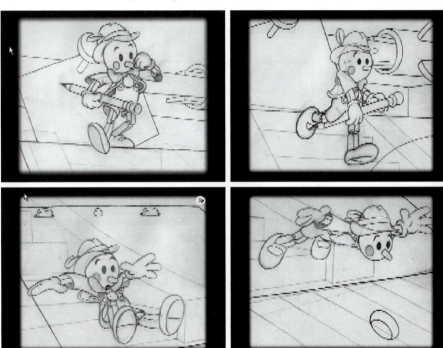

A detailed animatic sequence depicting specific animated action.

too may be replaced by the color scene with special effects added, up to a point where the final footage is edited in. Eventually, all the scenes defined by the original animatic will have the final material edited in and the film will be complete. Throughout, however, it has been the animatic that has been the structure and timing template that the editor has worked to.

One golden rule of animatics, therefore, is that once its final edit has been approved, nothing should ever be changed later, either visually or with the soundtrack, unless it is absolutely necessary! Once the animators start to produce each scene to the lengths designated by the animatic, changes in action or sound will inevitably change the length of the production, which will most likely have a profound effect on the film's length, the production schedule and, more importantly, the overall budget. Changes do cost money and unless a client is prepared to pay for any changes (such as in an advertising production, for example) the filmmaker should always stick with what they have established with the animatic, unless, of course, a huge error in judgment, or a misunderstanding, has occurred at some stage down the line.

If at First You Don't Succeed . . .

Most true experience only comes through trial and error—mainly error—so the novice filmmaker will most likely have to gain their experience the hard way, by making mistakes and learning from them. At the same time, being aware of the dangers, it is possible to avoid the most tragic of these errors by respecting the value of the animatic. The secret of successful filmmaking is always to be aware of or to anticipate possible dangers ahead, and to circumnavigate them before they derail the whole production. Needless to say, the animatic is a valuable tool in this process.

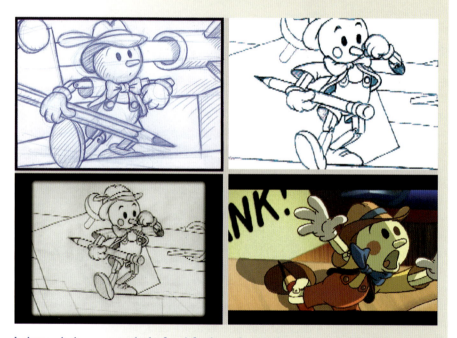

I always derive a great deal of satisfaction when seeing my original animatic evolving through the pencil test and final footage stages.

"Endangered Species"

Although I have admitted that there was never a formal storyboard for "Endangered Species," I can confirm that without the animatic it probably would never have been finished! Since there was so much material to choose from, the animatic for "Endangered Species" was an extended process of trial and error, addition, and elimination. It was only after a significant number of edits and re-edits that I finally arrived at the balance that the final film represents. I suspect that if I had ignored both storyboard and animatic and jumped straight in my original thoughts, I would have had to re-animate the majority of the material that was in my original vision for the project; the animatic process probably prevented that disaster. No matter how professional and experienced you become, there is always something to learn. There was, in fact, a huge difference between the first animatic and the last, and this progression of ideas could never have taken place in any other way.

The other great advantage having an animatic in place before production began was that I could show my creative intentions to others so that they could see where I was going with it. This gave great impetus to the voice talent decisions that were made later and certainly it was a huge asset when the music for the film was first being discussed and initiated. With a precisely pre-timed and pre-edited animatic, the music could be structured and timed-out long before the animation was complete, a rare occurrence in the film business! This has always been the huge advantage that animation has over live-action filmmaking. If approached properly, everything done in animation is based on the notion that all has been pre-tested, pre-edited, and pre-timed during the pre-production period, meaning that all involved can get a clear impression of the project before it actually starts and therefore know immediately just where their contribution can be made to its greatest effect.

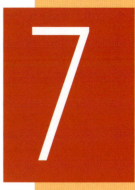

Digital Desktop Production

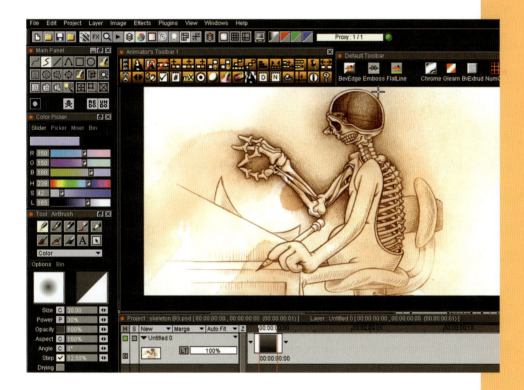

With the all the wondrous digital tools and gizmos available to the animator today, it still ultimately all boils down to three essential ingredients: expertise, hard work, and imagination!

The production of animated films once required large teams of artists, in large buildings which collectively comprised the large animation studio. Nowadays, all that was once done by such a huge team can effectively be produced by a single user on one desktop computer—in theory, at least. We should therefore review just what can and what cannot be done using the magic of modern digital technology. We must also define the production process, mop up a few more production admin issues, discuss the importance of keeping project management, perhaps clarify the roles of the team, and then, finally, talk about the actual animation itself! Armed with all this information, there is no reason why even a novice's introduction to the full process of animated filmmaking should not be an enriching and rewarding experience.

Stages of Animation Production

There are significant differences in the production of the different types of animation but in listing at least the principal two; i.e., 2D and 3D, we will get a much clearer understanding of the general processes that go into all aspects of the medium. These processes pretty much reflect what professional studios have long adopted as the norm, and therefore the functions they represent have been perfected through countless decades of trial and error. We will actually go into further detail on each stage in later chapters, but here is a generalized overview of what it takes to make an animated film through these established production procedures. Student and independent filmmakers will need to adapt these procedures in accordance with their own production capabilities.

Animation (2D and 3D)

Of course, the key production process of an animated film or game is the animation. A single animator, or a team of animators, will be responsible for all that moves in the production and the nature of each animator's involvement will again be dependent on the requirement of the project. For example, it would not be unknown for an animator on a large project to be cast to animate a particular character in the storyline. Animators, like actors, have specific areas or genres of expertise. It benefits the whole production if talents and weaknesses are identified and animators assigned characters, scenes, or features that maximize their strengths. I, for example, have always worked best with physical action animation, such as dancing, running, jumping, and sports-related activities. Other animators have a talent for dialogue, or sensitive relationship interaction with other characters, or environmental movement, etc. So, if there is a choice to be made, it's wiser for me to be cast to a character that was physical, rather than the subtly communicative.

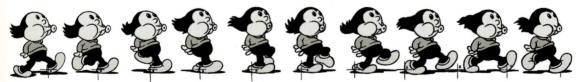

It has long been said that if an animator can create a successful walk, they can create anything, for the underlying principles apply to just about everything else in animation.

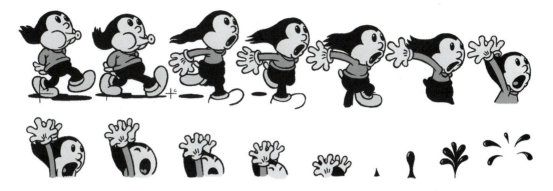

The original Fleischer films were jam-packed with wild and surreal visual gags.
I couldn't resist revisiting one or two of them for "Endangered Species."

Naturally, with 2D animation, an animator needs a significant degree of artistic and drawing ability, which is not quite so true for a 3D animator. I do argue, though, that 3D animators are better at what they do if they pay attention to drawn observation skills; looking at the portfolio Web sites of some of the very best 3D animators confirms my theory.

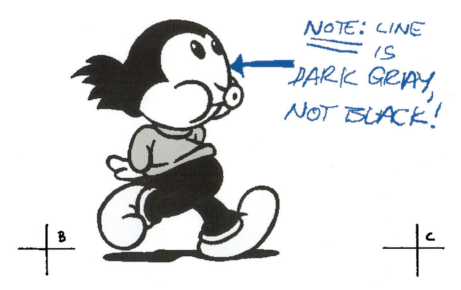

Often an animator's sensibilities will lead to subtle changes from an original concept, such as with this character where the drawn black line is colored a dark gray to give it more subtlety.

Backgrounds (2D)

There can be no animated films without backgrounds. The background (essentially anything that does not move in a shot) sets the location, the mood, and the visual style within which the animated characters will move. Backgrounds can be anything from a basic flat color to a vast and complex watercolor painting. At one time, traditional 2D animation backgrounds were exclusively painted onto watercolor paper, Bristol Board, or similar absorbent water stock, but nowadays most can be created digitally, using technology that offers a unique digital look of its own or replicates the look of the traditional watercolor artwork. Background artists clearly need to have advanced artistic skills and a versatile range of artistic expression as the look of the backgrounds usually changes from film to film, studio to studio.

The original concept art for a black-and-white, Max Fleischer style, silent movie scene in "Endangered Species."

Environments (3D)

Environments are to 3D animation what backgrounds are to 2D. The environmental artist (and sometimes animator) creates the sets and locations that the animated character needs to move and exist in. However, unlike 2D animation (where the background is a basic, two-dimensional piece of artwork), the 3D environment must work in three dimensions and be capable of having the camera view any part of it in detail, from a close-up view to a wide shot, depending on the demands of the production.

Environmental art can be anything from the inside of a box to a vast and lavish landscape. Even within the specialty of environmental work, there are sub-specialists. Some environmental artists are more noted for their interior work, where the quali-

A 3D model of a 3D modeler's environment!

ties of surface texture, detail, lighting, shadowing, and furniture and prop design are important in setting the scene. Other environmental artists achieve wonderful results with more organic, natural exterior shots, such as trees, bushes, grass, rivers, and mountains. Environments often require animated effects, such as running streams, waterfalls, drifting clouds, wind, or rain, all of which might be assigned to the environmental department of a production (as opposed to special effects).

Special Effects (2D and 3D)

If the production is large enough, there will undoubtedly be a special effects department to supplement the animator's work. Special effects can be anything from adding fire or a lightning effect to a shot, to generating a full-blown hurricane or erupting volcano in 3D movies. With 3D animation especially, there are so many overlapping specialties that it is hard to know where the term "animation" ends and "special effects" begins. For example, animating dinosaurs is not just moving a big critter model around on the screen. Nowadays, the audience expects to see the flesh and muscles move under the skin, and even to see the skin deforming over the moving muscles. Different specialists will handle this but are they termed animators or special effects artists?

Animated effects can range from very simple and traditional, like speed lines and dust clouds, to the highly sophisticated ones in modern Hollywood action movies.

Special effects in traditional 2D animation are not so difficult to define. Usually the animator animates the main action and passes the special effects work onto an experienced special effects artist. Special effects animation in 2D terms can be anything from moving water, flames, glowing lights, and even the molded highlights and shadows found on Roger Rabbit styled characters.

This sequence from "Endangered Species" only involved a few levels of shadow and highlight effects, but in the original, many more layers were used.

The special effects animator will either work on an entirely separate sheet of drawing paper, superimposed over the character animator's drawings or on the same level as the key animator's work but in a different color.

Checking (2D)

When all the animation is completed in 2D production, it is necessary to check that everything is correct before the work moves into coloring, scanning, or filming. The cost of redoing work further down the line has to be avoided at all costs. Therefore, checking that all the drawings are there; the instructions by the animator for other departments are accurate and clear; and even that all the artwork is suitable for digital scanning, coloring, or filming is an important stage of all 2D production.

Due to the complexity of most contemporary animation, it is so easy to make a simple mistake that will cost the production dearly. Consequently, it always pays to be eternally vigilant with your work!

Scanning (2D)

When all the drawings are complete, they are individually scanned and numbered. Digital scanning is more and more the preferred choice (over traditional filming using a rostrum camera) these days, as most scanned files are much cleaner and more easily managed throughout the digital production process. (Although expensive, professional digital rostrum cameras can compete with scanned images and are considerably faster to produce.)

It is possible to scan and digitally color original pencil drawings if the line quality is dark enough and there are few breaks or paper grain in the line. However, a black line is best for scanning, which means that pencil drawings, once tested and approved, should be cleaned-up or inked in (as a comic book is inked in once the initial pencil sketched layouts are complete) before the scanning process begins.

With a primary color filter on the scanner, all the blue pencil construction lines can be eliminated from the final scan (see the figure below). This turns basic inked-in drawings into solid-line finished characters, ready for digital coloring.

An inked-in drawing is ready for coloring when scanned with a primary color filter.

Coloring (2D)

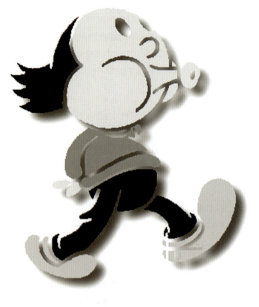

With the holding lines removed, the remaining flat colors on this black-and-white character produce an interesting design in their own right!

With all the artwork now in a digital form, it is relatively easy to add color with a digital paint program. However, there are two basic forms of digital animation these days: vector and raster. Vector animation is more allied to Web and Flash animation, although for 2D desktop animators with pencil drawing abilities, ToonBoom Studio is a much more superior program than Flash, in my opinion.

The interface of ToonBoom is very easy to navigate. Essentially, the main field guide section is the drawing area, the ruled window on the top right is the dope sheet section, and the window at the bottom right is the color palette.

Vector artwork is a mathematically calculated system, which means that once you have a file digitally created you can infinitely zoom in and out without losing sharpness or line quality. Raster is digital animation made up of pixels, the individual points that make up a screen image. If you zoom into or enlarge a raster image, it will pixelate (break up into large ugly, ragged, pixel shapes).

Zooming in on raster (left) and vector (right) artwork shows the difference in quality.

The raster coloring process allows for subtle textures, multi-gradations, soft focus, and blur-like effects that can simulate depth. This, and all other possibilities for coloring treatments and effects, means that raster images can contain a more subtle and illustrative look than vector can. In vector art, the colorist is limited to flat, hard colors with a few basic radial color fills.

Nevertheless, digitally based vector and raster coloring techniques have a significant advantage over the traditional process of hand-painting cels, where the paint is applied section by section to the back of a drawn cel, playing scant attention to the lines being obliterated by the opaque paint (see the figure below). When the cel is turned over, the lines drawn on the front of the cel are still visible, holding the color areas as intended. Hand-painting is messy, time-consuming, infinitely tedious, and is hardly used anymore.

On the left, the back of the painted cel. On the right, the front.

> **NOTE**
>
> It's quite normal to feel that a colored animated sequence seems to run slower than the pencil test. The colored shapes are so much better defined than the jumble of overlapping lines of a pencil test. Consequently, when we see the action of a finished scene in motion, the brain does not struggle so much to understand what the eyes are seeing every 24th of a second, and therefore we perceive the action to be both slower and smoother.

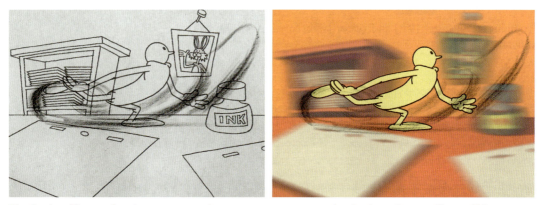

The brain will perceive the more complete scene to run more slowly than the pencil test did.

Compositing (2D and 3D)

Unlike the old traditional approach to 2D animation, modern digital animation techniques in both 2D and 3D animation rely a great deal on the compositing of an image, combining several animation levels, or layers, together to create one picture.

In the old days of cel animation, these layers of animation would be inked and colored onto separate sheets and placed over a piece of water-colored or gauche-painted background. These were then assembled together under a rostrum camera and filmed, frame by frame, until the entire scene was shot. The great disadvantage of this method, apart from the messy and tedious color procedures involved, was the fact that cels attract dust and were a nightmare to keep clean. Also, because of the light-absorbing density of the celluloid, only five cel layers could be used before the background colors became dull and lackluster, or the whites grayed down. This was further complicated by the fact that the lower down the levels a piece of cel artwork was, the more dull its colors became, meaning that painters had to subtly re-mix the colors for each level so that the various level colors matched each other when assembled under the camera. With digital coloring, there are no such problems.

The digital artist can composite an infinite number of layers and never have problems with dust, color deterioration, or inconsistency of coloring between the various layers (which can be infinite in number). In addition, breaking a character down into separate layers enables the animator to economize on the work required. In the figure below, the crow at the drawing board is drawn on three separate layers. The head moves independently of the hand, while the hand moves independently of the body, which doesn't move at all; so the only things that need to be redrawn for each frame are the parts that are moving. When finally composited (as in the inset figure), all three layers will appear as one character. The cat is drawn on its own layer.

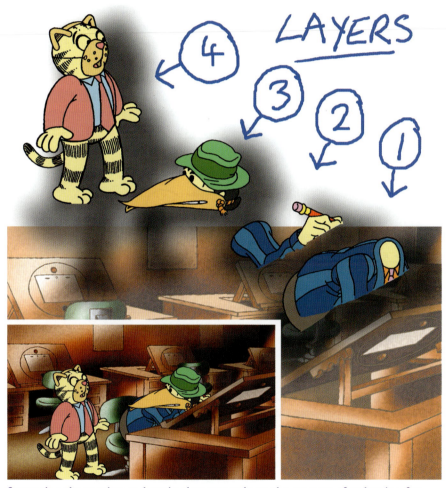

Separating the moving and static elements reduces the amount of redrawing for each frame.

Digital compositing also offers an easy blending of various different mediums, such as 2D animation, 3D animation, live-action film, photographs, illustrations, and graphic artwork, to create a single film image. Hollywood films especially (both live action and animated) thrive on the options provided by digital compositing. Indeed, most Hollywood films these days couldn't even be made without digital compositing techniques!

Editing (2D and 3D)

Since virtually all animation is pre-edited (in the storyboarding and animatic process; see Chapter 6, "Storyboards and Animatics"), the editing of an animated production is little more than assembling the finished individual film clips to create the final film.

Live-action editing is a much more creative process, in the sense that the director and editor take innumerable shot options for each scene in the film and use a process of trial and error and selective elimination of the least desirable options to create a satisfactory edit which interprets the film material best. Animation has made all those decisions before a single scene of the film has been animated and therefore, unless there was a gross miscalculation with the original storyboard or animatic up front, or unless a entire sequence has had to be re-designed, the finished animated scenes will pretty much be dropped into the existing animatic as they become available, until the entire animatic is replaced with the finished, colored, and composited animation footage.

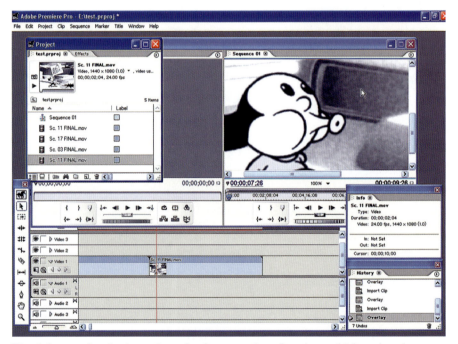

Thank heaven for the invention of software such as Premiere, which makes the editing aspects of animation so much easier for the animator!

Final Dub (2D and 3D)

When the final pencil animation is completed, the sound editor and the film score composer will create the final audio material. (With live-action filming, this often can't occur until the film is edited.) Often, this is simply a process of recording Foley sounds and the composing and recording of musical interludes for the film score composer.

When this is done, a master track has to be completed by mixing and balancing all the sound elements together. With dialogue, sound effects, and music, it is necessary to ensure that audio elements do not overpower each other and that the dialogue is always audible and understandable. The sound editor will go through the entire

film, changing the sound qualities and adjusting the levels of all the individual sound elements until this perfect balance is achieved. Once it is achieved, a final master soundtrack will be struck (recorded), and it becomes the one and only soundtrack used from that moment on. Additionally, for internationally distributed films, this master track will have the dialogue elements removed to form the M & E track (music and effects), to which foreign language versions of the dialogue can be dubbed later.

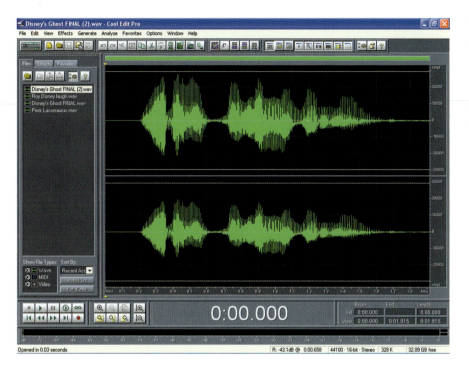

Soundtracks can be easily edited, combined, and timed out with software like Cool Edit Pro.

Digital to Film Transfer (2D and 3D)

Any digitally created film has to be converted to film if it is to been seen theatrically. This has to be done professionally, using specialized film recording equipment that will be outside the reach of most independent filmmakers. A state-of-the-art optical camera system will take each digital image from the completed film and photograph it as a frame of 35mm cinematic film. This is a slow process, but it is still infinitely faster, more controllable, and morecreatively accessible than the old method of attempting to color match and balance each individually filmed scene negative that has been shot on a rostrum camera through trial and error at a film processing lab. New technology allows the filmmaker to sit at an extremely accurate color monitor and tweak the picture and its color, scene by scene, and then reproduce this perfectly with the film in more or less one pass exposure. Although this can still be a tedious process, it is far less so than the old methods which could take days, sometimes weeks, to achieve the required results. Sometimes, even then, the required results were not even obtainable.

The wonderful thing about modern technology is that it enables you to get an infinite amount of visual material into what was once a very limiting film format!

Production Team and Workflow

With so many stages to a production, it's clear that a team of people will be needed to get the job done. While every studio and film may have different requirements or procedures, here are the most likely players in a production. Ultimately, all commercial filmmaking is based on creative problem-solving and each team member is expected to be a skilled problem-solver in their own particular aspect of a production.

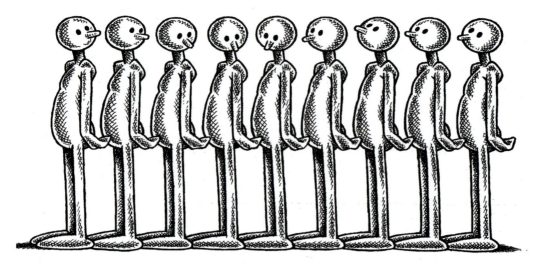

Unfortunately, not every production will have the great nine old men to work on it.

Director (2D and 3D)

The director is the creative top gun, responsible for the creative vision and interpretation of the project. Perhaps, in the amateur world of animated filmmaking, the director may also be the producer, the writer, and one of the animation team too, but in larger, more mainstream productions, the director will stand alone and have the one responsibility with that production. The creative buck will always stop at the director. The director's function at the head of a production may include design approval, storyboard and animatic creation and approval, as well as the creation and distribution of individual scene production material (and instruction) to the animation teams in 2D production. When the animation production is underway, the director will be required to guide, supervise, and approve the work of the animation team, the background artist, and the editing/sound/musical personnel.

All directors will direct in their own individual way and hopefully they will have creative freedom to direct a project with their own creative vision. However, ultimately, they do have to work somewhat in tandem with the project's producer, whose job it is to support the director through the smooth operation of the more administrative aspects of the production.

Producer (2D and 3D)

In animation, the producer is essentially the director's production manager. His or her job is to keep a tight rein on the administrative side of the production, ensuring that the budget and scheduling are being kept under control and that the creative team has everything they need. The producer will also be responsible for identifying and contracting the necessary creative team. Like the director, the producer may have been involved in the legal, financial, and pre-production elements of a project, but not always so. On a large film production, he or she may even be required to raise the production finance in the first place, although this is usually the domain of the executive producer. In some instances, such as advertising and certain film and TV work, the producer's job can also be to attract work for the studio or the director in question, depending on how big the operation is.

But mostly the producer is responsible for running the production and providing the nuts and bolts to keep it going smoothly. Sometimes producers can be involved with the creative aspects of production, hopefully with the blessing of the director; but strictly speaking, the producer's main role is to enable the director and the creative team to most effectively and practically realize their vision (and for the sanity of all concerned it should remain so, in my personal experience!).

Production Manager (2D and 3D)

Although this is more the domain of live-action filmmaking, it can sometimes be necessary to employ a production manager on an animated project. The production manager would effectively be the right hand man (or woman) of the producer, doing the daily chores that relate to animation filmmaking, such as checking the progress of each of the artists on a daily basis, oiling the nuts and bolts of production, and generally supporting the producer in any way needed. Again, this is an administrative role, not a creative one.

Character Modeler (3D)

Although sometimes the character modeler's involvement can be at the pre-production stage, most of the key character models required for a film are created during main production. Usually, there is more than one character modeler assigned to a project, unless the film is a small personal effort with very few characters. The character modeler is responsible for creating, rigging, and weighting all the 3D characters the animators will be working with in the film. The better, or more experienced modelers, will be assigned to the main characters and the less experienced ones will be assigned to the secondary and crowd characters.

Production Designer (2D and 3D)

As with the main character modeler, the production designer's involvement might well be at the pre-production stage, when the characters, backgrounds, and overall concept art is created. It is nevertheless quite feasible that one or more production designers (depending on the project size) remain on staff to handle all the smaller design decisions that inevitably crop up as the production progresses. The designer may not be hired for the entire production period however, although they are certainly a valuable contributor to the team during the early stages of the production proper.

Animator (2D and 3D)

It goes without saying that an animated production needs an animator (or animators) to bring the concept to the screen. Animators fall under many categories (apart from them being either 2D or 3D animators in the first place). There are character animators (who bring performance and personality to the characters in the production), special effects animators (who animate everything that is not character animation, including fire, earth, air, and water effects), graphic animators (who specialize more in the movement of graphics and titles within a production) and model animators (who do all the above things using puppets, models, or clay-based characters to achieve the required effect).

It is the animator's job to appraise themselves fully with the nature, personality and capability of what is to be animated; listen to the director's wishes and timings; then produce the movement and actions accordingly. Although essentially a solo operation, animation is also a team effort and animators must be mindful and respectful of what the other animators are doing with (quite often) the same characters. Consistency and continuity is a very important aspect of many animated productions and therefore the animator needs to attempt to keep this consistency with other animators.

It has been said that animators are shy or frustrated actors. There probably is more than a little truth in this with regards character animators (I, for example, am very good at animating dance action yet I myself have two left feet!), but it is not so true with other types of animators. A large percentage of 3D animators tend to be animation technicians, meaning that they know software inside and out but can only be called character animators when they can bring a character truly alive with presence, performance, and personality through the traditional (2D-inspired) principles of movement. The same is true of 2D animators, although they still do not have to be as technically (software) savvy as their 3D counterparts.

The main difference between the implementation of 2D and 3D animation is that a 3D animator is required to produce all the animation for a scene themselves whereas the 2D animator usually only produces key drawings, and perhaps most of the breakdown drawings, themselves, leaving an assistant animator or an inbetweener to do all the secondary drawings. In larger productions, such as with movies or TV commercials, animators can be cast like actors, selected for their special skills within the broad spectrum of animation capabilities.

Assistant Animator (2D)

In an ideal world, the assistant animator has almost as much capability and responsibility as the main (key) animator. Traditionally, at least at the Disney studio during the golden age, the assistant animator was a major figure in the production scheme of things, not just the guy who did the other drawings.

A top assistant animator would effectively be a lesser producer for the key animator. They would fill in dope sheets and production charts. They would shoot the pencil tests and arrange for them to be edited into the sequence, so the animator could see how the action was working. They would do the other drawings that the key animator left for them but, often, they would also do breakdown drawings and even little bits of secondary animation the key animator either didn't have time to do or wasn't interested in doing. The assistant animator therefore had to be as capable as animators themselves.

If assistant animators had lesser drawings that they too had little time, or inclination, to do themselves, they would supervise the inbetweeners on these drawings. The assistant animator would also be expected to make the tea or coffee, or arrange lunch or dinner, for the animator, if that was required. Surprisingly too, many assistant animators prided themselves on doing all this and no more, many having no aspirations to ever be key animators!

The system did have considerable advantages, however; the principal one being that with all this secondary work done for them, the key animator was free to concentrate on nothing but getting the best possible performance and movement out of the characters they were responsible for. Nowadays, the term "assistant animator" usually means the person who does the inbetween drawings. In some productions, they don't even meet the key animator at all; the production folder is merely given to them by the producer or production manager and they are expected to do the inbetweens and pass the folder back to the production scanner or whoever needs it next, often without it even being checked in some productions. My, how times have changed!

Inbetweener (2D)

The role of inbetweener is a redundant one in most productions today, or else its title is used synonymously with that of assistant animator. In the times when animation operated on an apprenticeship system (where a beginner could start at the bottom and work their way through the various departments until they were eventually assigned to a master animator who would teach them everything about animation), the inbetweener would be a newbie who would work with the assistant animator to get all the lesser inbetween drawings completed for the key animator. The inbetweener would therefore perhaps be asked to do the more mindless, less creative work, the most creative being done by the key animator and the next most creative done by the assistant animator. Inbetweeners did the slog work. However, if they did it well enough, they would eventually make assistant animator and those who wanted to progress further would ultimately make key animator. Today there is no system of learning like that (hence this book!), therefore the inbetweener is just another way of referring to the person who does the inbetween drawings that the animator leaves.

Clean-Up Artist (2D)

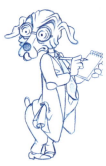

Most animators work rough, i.e., they draw the characters in pencil, to the best of their ability. This is followed through with the inbetweening too. However, from animator to animator, there can be a certain difference in the animated character design, sometimes subtle, sometimes gross. Also, pencil lines do not scan as well as black ink line does. So, with most ambitious productions, a skilled artist will be assigned to review the animated pencil drawings, to give everything a consistency in character design and to ink them in for scanning. This person is known as a clean-up artist.

The clean-up artist clearly has to be skilled in consistent drawing and inking in. Fortunately, the illustrated and comic book industries have provided a ground swell of artists that are capable of doing this, especially in manga-crazed Japan. However, many productions don't consider clean-up to be an essential facet of the production process and therefore the animator is required to produce their own cleaned up drawings that can go straight into scanning. This (sadly) means that consistency of design on a multi-animator project can leave a lot to be desired.

To circumnavigate this somewhat, a few productions will employ a clean-up artist to work over the animator's key drawings but still expect the assistant animator, or the inbetweener, to get the rest of the work cleaned up. Alternatively, a clean-up artist will simply be required to go through all the drawings, prior to scanning, to see (and fix) any lines that have breaks in them, because otherwise the digital color will flood out and fill the screen.

Environmental Modeler (3D)

Like the 3D character modeler, a 3D film cannot exist without backgrounds, whether they are interior settings or exterior locations. The environmental modeling requirement from 3D film to 3D film may be wildly varied. If there are a few simple settings, then it is likely that only one environmental modeler would be required, to both design and model them. However, if the backgrounds are many and complex, there could be a whole team of environmental designers on board, certainly for movie-length productions. Either way, the environmental modeler has to have skills in creating mood and atmosphere with the settings, giving a realistic and natural feel to the environments, whether they are photo-real or abstract. Consequently, it is important that the director of the film casts his environmental modeler well, as good sets can either make or break a movie.

Background Artist (2D)

For me, the background artist, whether they are working in a 2D or 3D environment, is one of the most important members of the animation team. A background fills close to 90 percent of what the audience sees. If the backgrounds appear bad or cheap, the film will appear bad and cheap, regardless of the animation quality. Similarly, if the backgrounds look like a million dollars, then so will the film.

Background artists need a fundamental understanding of the animation process but, essentially, the background artist can come from any artistic discipline: book or magazine illustration, comic book art, or even a fine art. The bottom line is, can the background artist add something to the picture that supports and enhances the animation? If the answer is yes, then that person is a good background artist. Professional background artists can work in many styles and techniques. Traditionally, backgrounds were created with brushes, paints, and paper. Today, digital software can provide artwork that has this look, and much, much more. Consequently, the very best background artists are thoroughly trained in both traditional and digital techniques, the latter being perhaps the most important these days in view of the greater need to produce multiple-layered, 3D real or simulated backgrounds.

Checker (2D)

With the great amount of sophisticated animation, effects, background art, and other production elements required in today's digital environment, it is essential that everything is checked before a final commitment to scanning, coloring, and compositing is made. Checkers go through everything related to each scene's production folder and dope sheet to make sure that it is all there and as it should be. This, of course, was as true in the traditional industry as it is today in the digital one.

The main exception was that the traditional checker was required to check physical, finished cels before they were sent to the rostrum cameraman. In these cases, checks were made that the coloring was consistent, that painting errors and splatters did not show outside the required painting areas, and that the cels were smear-free and spotless before being filmed. The checker has to be a patient and meticulous person, with the eyes of a hawk, if his or her work is to be at all reliable. On small-scale productions, a checker's role is not quite so common, as each department can check their own material for much of the time.

Scanner/Rostrum Cameraman (2D)

Traditionally, animation artwork was always shot by a highly trained cameraman, using a sophisticated rostrum camera mounted vertically over an animation table and raised or lowered on a sturdy metal tower known as a rostrum. As mentioned earlier, all the animation was colored on different cel layers that were laid over a background, under the camera's lens, and shot frame by frame. The highly-skilled, traditional rostrum cameraman is very much an "endangered species" these days, except in the area of digitally recording artwork and text for film graphic and title sequences.

Nowadays, all the layers are invariably scanned on regular desktop scanners, in line form, then colored, composited, and saved into their various appointed layers within the computer. The scanning operator does not need to be well-trained, but he or she has to be meticulous and organized. Most scanning machines used are the regular office variety, with thin aluminum animation peg bars taped to them, to hold the

drawings in the appropriate positions. (See Chapter 10, "2D Animation Overview," for more on the tools of the trade.) However, highly sophisticated, animation-dedicated scanners have been developed for the bigger studio set-ups; they automatically scan the drawings in a stack form (like regular batch-copying office Xerox machines) and then digitally align the scanned files with each other by registering the peg holes automatically. This clearly is a huge time-saver and requires even less hands-on involvement on the part of the scanning operator. (Although, as with all technology, machines still do go awry and it is useful to have someone in charge who is trained to use and fix the machine.)

Inker (2D)

In the past, animation drawings were hand inked (traced) onto cels and painted by the coloring department. The inking was initially done using very steady-handed inkers who used fine brush strokes to copy the drawn lines onto the acetate. Later, pen inking was used and eventually Xerox machines were implemented, essentially photocopying the drawings from paper onto cels, using converted office machines that had the heating elements lowered so the cels didn't melt. Today, scanning has replaced most traditional inking processes, since the cleaned-up and inked drawings, prior to scanning, are essentially their equivalent.

Colorist (2D)

Again, in the past when cels were used for producing animation, the colorist was often known as a painter, as what he or she did was paint the appropriate colors onto the backs of the inked cels. The paint was applied on the back of the cel as it gave a much flatter color when seen from the camera point of view and also meant that is was so much easier to not worry about painting over the lines. The kind of paints used had to be opaque to keep the background colors, or other layers of animation underneath, from showing through the coloring. Paints as simple as standard household emulsion paint were used, all the way up to sophisticated, dedicated paints that were much more bright and colorful but exceedingly more expensive.

Digital coloring has eliminated all of that. Now scanned files are viewed on the screen and colored with the click of a mouse. As long as the inked lines enclose the area to be colored, the process takes a mere second or less per color. It becomes time-consuming if there are gaps in the enclosing lines which allow the color to flood out to other areas of the screen. Some paint software can automatically plug those line gaps but, otherwise, the colorist will have to hand-fill the gaps and then fill the area with color. Filling gaps can be a time-consuming process, hence the need for checkers prior to scanning on larger productions.

Texturer (3D)

The texturer's job is to create final color and surface textures that will be placed on each 3D character model. The textures have to complement and define the nature (and sometimes the personality) of the 3D model. Indeed, with some low-poly productions, such as those for games and the Web, the textures have to actually substitute for the lack of detailed surface modeling capability. Sometimes, the texturer is responsible for making high-poly characters look more natural or realistic, right down to the dirt, scuffs, and damage on the character's clothing. Even though the outcome of their work is invariably seen three-dimensionally, the bulk of the texturer's work is created in a 2D image-editing program such as Photoshop.

Lighting Artist (3D)

As with the texturing artist, the lighting artist is required to give realistic and often subtle effect to the 3D characters and environments. Just like a lighting specialist in live action filming, the lighting specialist in 3D production often has to bring mood, color, and atmosphere to a scene. Consequently, they will need to have an intimate understanding of natural lighting, as well as being technically proficient with most 3D technology.

Compositor (2D and 3D)

With so many possible elements in modern films, it is necessary for one person to be responsible for combining all these elements. The compositor's job is to bring together all the elements, scene by scene. This may be as simple as adding the animation to a background, or as complicated as combining 2D animation, 3D animation, live-action film, model animation film, and an assorted selection of text and graphics. With many animation software packages, specifically 2D animation software as ToonBoom Studio and Digicel's Flipbook, basic compositing can be achieved within the program, rarely needing the help of a specialist compositor. However, with larger, more ambitious and expansive projects, the role of compositor is essential, using desktop technology such as After Effects or even hiring outside post-production houses with expensive state-of-the-art equipment to provide more ambitious compositing work.

Sound Editor (2D/3D)

With all the dialogue recorded, edited, and broken down at the front end of the production, the sound editor's job does not kick in again until after all the animation is complete. At this point, any additional sound elements are created, edited, and merged in with the existing dialogue and new music tracks. The sound editor will supervise all this, through to the final dubbing session, which will result in the production of a finely balanced soundtrack. Final soundtracks are often produced in two separate ways, one with the dialogue track included in it and one that has no dialogue track in it at all (called an M & E track) which is used for foreign language versions of the film. Often, the sound editor and the production editor are one and the same person, requiring that between their duties at the front and back end of the production, the sound editor will also edit the animatic, cut in the pencil test scenes as they are completed, and then replace these with the final color scenes as they too are completed.

Project Management

With any animated production, it is extremely important that everyone is kept in the loop on everything that has been achieved, and is yet to be achieved, at any particular moment in the production period. It cannot be emphasized enough that project management—keeping a finger on the pulse of the project—is a most important aspect of the production process. The larger the production is, the more important it is to know what is going on. The producer or production manager is very much responsible for establishing this, although the animators themselves do have some responsibility in keeping things on track.

Animation is a team game, where clear communication between team members is extremely important.

Progress Charts

A progress chart is a valuable visual barometer to keep tabs on progress from the producer's point of view, but it also provides instant reference for the animator who has one eye on the production schedule. Let us say that an animator has to complete a 30-second commercial within three working weeks. This is 45 feet of moving footage (30 seconds of screen time = 45 feet of 35mm film at a rate of 24 fps) over 15 days. By dividing 45 by 15, the animator knows that his or her goal is three finished feet of animation (or two seconds, if a time scale is required) for each day of the production. Knowing this, it is possible for the animator to draw up a simple progress chart that shows this graphically.

The upper boxes in the chart represent the days of the working week and the smaller boxes beneath represent the footage to be achieved. The simple process of using this chart requires that the animator shades off the days of the week as they go by, while also shading off the actual footage or seconds of animation they have produced each day.

A sample progress chart.

In view of the varying degrees of complexity that animation requires from scene to scene, some days will indicate that more progress than the target rate is made and some days will show less. However, by observing the evolving aggregate of footage versus time, it will be immediately seen that the animator is either ahead of their schedule, or not. For example, let us say that on day one the animator achieves three feet, eight frames of finished footage. The progress chart will look like the figure at right, indicating that the animator's progress is clearly ahead of schedule.

As the production progresses, the animator marks off the day and the amount of footage completed, and an evolving pattern of progress (or lack of progress) will reveal itself, day by day, alerting both the animator and producer to the situation.

The progress chart is clearly a huge benefit to the animator, and to the producer who also needs to know of potential problems and setbacks that are developing. Obviously, if the animator's footage rate is ahead of the scheduled targets, then there is no problem. However, if the progress chart reveals an escalating deficit, for whatever reason, then there is time to make contingency plans to compensate for this before things become too much out of hand.

The progress chart shows the animator whether things are on track or not.

Route Sheets

With the animator taking responsibility for their own progress, the producer has to be responsible for logging the progress of the entire production team, in every department of its operation. To do this, a route sheet should be prepared and updated on a regular basis. A route sheet is a visual chart, or spreadsheet, like the one in the figure below, that logs in the progress of each member of the production team.

Scene	Title	Length (sec/frms)	S/board	Layout	Anim.	Inbet.	Clean-up	Scan	Color	BG	Effects	Compos.	Render	TIFFS
01 (B)	Walt dedication.	07/19												
02 (D)	Introduction (Nar).	27/04												
03 (V)	Baby arrives.	14/21												
04 (V)	Baby behind desk.	06/06												
05 (V)	Baby picks up pencil.	06/01												
06 (D)	First appeared (Nar).(X)	09/23												
07 (V)	Baby draws.	01/07												
08 (B)	Drawing on film.	03/08												
09 (B)	Dinosaur bite.	03/02												
10 (V)	Baby's bitten pencil.	01/09												
11 (D)	Subtle skills (Nar). (X)	08/13												
12 (B)	Ink blot fall.	02/04												
13 (B)	Clown stretch.	05/02												
14 (V)	Baby lifts page.	01/18												
15 (B)	Curtains open.	04/01												
16 (D)	No audio (Nar). (X)	12/20												
17 (B)	Rope pull. (X)	01/01												
18 (B)	Pencils whistle.	01/21												
19 (B)	Oh Boy!	03/05												
20 (V)	Pacifier pull.	01/15												
21 (D)	Mating ritual (Nar). (X)	05/21												
22 (B)	Clown strut. (X)	03/13												
23 (D)	Experience (Nar).	03/20												
24 (V)	Baby grows.	02/03												
25 (D)	Predators (Nar). (X)	02/07												
26 (B)	Corporatus Executus.(X)	06/00												
27 (D)	Solitary (Nar).	08/19												
28 (D)	Exotic display (Nar). (X)	03/07												
29 (B)	Bandleader. (X)	04/20												
30 (D)	Powerful (Nar). (X)	05/12												
31 (V)	Youngster grows. (X)	02/10												
32 (B)	Dwarf arrives.	03/02												
33 (B)	Dwarf on ruler.	03/10												
34 (D)	Not even (Nar).	05/14												
35 (V)	Animator's back.	01/18												
36 (B)	Desk fall.	04/02												
37 (V)	Hand over eyes.	01/22												
38 (D)	Outside herd (Nar).	07/06												
39 (B)	Blurred morphs.	02/03												
40 (D)	Magic (Nar).	12/08												
41 (V)	C/Up smile.	01/07												
42 (B)	Walk down steps.	04/20												

Here is the first route sheet format I used for "Endangered Species." Although I was doing most of the work on the film myself, I still recognized the need to record my progress on every section of the production, for all the 80 scenes, to keep track of everything. This was to prove especially necessary when I enlisted the help of some of my students with the scanning, clean-up, and coloring aspects of some scenes.

Using the data taken from each animator's progress chart, in addition to checking in on every team member in every department (perhaps even on a daily basis for a large production), the producer will use the route sheet to record all progress.

In a set-up where the rows represent every scene in the production and the columns represent every stage of the production, the producer will check off the relevant boxes when the production activity represented by that box is completed.

When designing your own route sheet, it is always wise to include a few extra blank lines and columns for additional categories that may crop up once the production has started. All too often, small things can get overlooked, or unexpected events occur, and the ability to include them in the route sheet at a later date makes it that much easier to ensure that nothing is overlooked in production.

"Endangered Species"

Though I started out with a hard-copy route sheet for the production of "Endangered Species," I eventually moved to an Excel worksheet. Tracking the production progress digitally enabled me to simply fill in each section on my computer as the work was completed, rather than manually fill in the blanks with pen or pencil as was originally intended. It made it easier to transfer the files from computer to computer, when either working from home or in my college studio, which was infinitely more preferable to carrying around a piece of paper for the years it took to complete.

Endangered Species

Just as animation has moved from traditional to digital, so has the administrative process that supports the animation project.

Principles
of Animation

I still remain in awe of the potential that a single sheet of blank animation paper possesses!

Everything moves in some way, from the fast, flitting firefly to the old and eternal mountains that, in the timescale of their own existence, slide and creak and edge their way forward. Movement connects all things and movement defines all things. Humans, especially, are defined by how they express their individual being through movement. From the nervy to the aggressive, from the passive to the arrogant, from the fit to the ailing, all human nature is expressed by the way it presents itself in pose and action. How true is the adage "actions speak louder than words" for the animator!

Though all actions are individualized, the actual process of movement itself is defined by specific laws and principles that are immutable and universal. These principles of movement are the foundation upon which all animation is based, whether that movement is drawn by hand, sculptured in clay, or generated by a computer. Animated action is produced by projecting a series of different positions in a fast, continuous presentation to create the illusion of movement. The real secret of animation is to position each inanimate moment in such a way as to make that illusion real, impactful, and filled with believable character for the viewing audience. It's really that simple, and really that hard!

Early action pose for "Endangered Species" capturing the mood of a moment.

Animation has defined its own principles over the years. Although most of these principles emerged from the traditional 2D world of animation, most definitions, terminologies, and principles of movement can be applied to all of animation's disciplines. Many of these principles will be covered in detail and more specifically in the sections on 2D and 3D animation, but here is an overview of elements and factors of both.

Key Poses, Breakdowns, and Inbetweens

In any sequence of movement there are specific moments, or positions, that are more important than the rest. The most important positions in an action are known as keys. The first and last keys of an action are clearly the most important. However, along the way, there are other keys that define a significant moment within the action. Take the example of a band leader holding a baton. The conductor starts with the baton up high, sweeps it downward, looks to see if the orchestra is following him, and smiles when he finds it is.

NOTE

For an absolute beginner's approach to keys, breakdowns, and inbetweens, my first book, "The Animator's Workbook" (Watson-Guptill/ISBN 0823002292), is a perfect primer. "The Workbook" also explains other fundamental aspects of the animator's art not covered in this more advanced work.

Clearly, the first position and the last position are key positional moments in this scene. However, within the entire action of the scene there are a number of other key positions that strongly define the movement. Every animator may draw this basic action slightly differently, but there are at least two other key positions between the first key and the last key: the baton down position and the look up position.

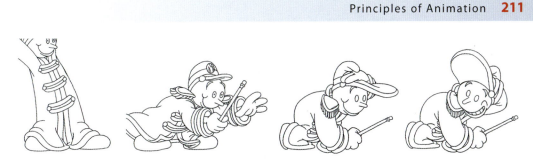

The four key positions in this sequence.

It is now possible to number the key positions. This has a lot to do with timing issues, which we'll do later. But generally, I tend to either time myself with a stopwatch as I actually go through the desired action myself, at the speed that I would like it to go. If I cannot possibly act out the action myself (and animation tends to be full of actions that real people cannot do!), then I imagine it happening in my mind and time that. In actual fact, I tend to time myself several times over a particular action and take an average of all these times as my ultimate timing, as it gives a more reliable interpretation of the speed and timing of everything. That done, it is then a relatively easy task to assess the frame numbers of each key drawing over a specified timing, as long as you bear in mind the project's frame rate (most likely 24 fps, 25 fps or 30 fps.)

The key frame numbers for the bandleader sequence in "Endangered Species."

Using this example, the hat of the conductor falls forward over his eyes and the baton sweeps across his chest (7). Next, the free hand begins to move through after key (25, unseen), start to reach up (37, unseen), and grab the hat (45, unseen).The conductor will then pull the hat back from over his eyes to prepare for the look (57) and then turn his head to actually look (67, unseen) in preparation for the final smile (73). If any of these specific poses are changed or eliminated altogether, then the tone of the entire movement will be different, which is why a good selection of effective keys is so significant. The animator who creates the key animation in a scene is called the key animator.

Beyond the key positions there are other secondary ones, known as breakdowns, that although positioned between the keys have subtle changes that make them not precisely midway between the two keys. For example, between keys 37 and 45 there is a midway position where the hand does not logically take a natural, middle position, but has the hand bending outwards instead.

If a logical inbetween were attempted on the hand, it would pass clean through the brim of the hat.

This deviation from a logical inbetween action creates a more accentuated snap to the hand which gives it a much more convincing action. It is often desirable for this midway position between two key positions to have an extreme or off-center element to obtain a more natural and flowing action. The midway drawing between any two keys is referred to as the breakdown drawing. In this case, the breakdown drawing is numbered 41.

The breakdown drawing is always indicated on the inbetween chart in parentheses. Keys are circled. (For clarity in this book, I've color-coded keys as blue and breakdowns as green. Inbetweens are yellow—see the figures below.) Therefore, the inbetween chart in this case (which is always drawn at the top of the first key drawings) will look something like the art below left.

For greater clarity in this chapter, I color-coded illustrations; key drawings are blue, breakdown drawings are green, and inbetween drawings are yellow.

The inbetween chart for the drum major sequence.

Traditionally, the key animator is responsible for creating the breakdown drawing too, as the defining of its positioning is often similar to establishing a new key positioning (at least in parts of the character drawing). After that, all that remains to be done in the sequence is to create the remaining drawings. Known as inbetweens (or "tweens"), these drawings are usually completed by the assistant animator or inbetweener, in accordance with the chart instructions.

All animation is therefore a mixture of keys, breakdowns, and inbetweens. The skill of a key animator is to position and time the major drawings to make the moving sequence smooth, natural and full of personality. The job of the assistant or inbetweener is to ensure that the drawings are accurate and conform to the positions indicated in the key animator's chart.

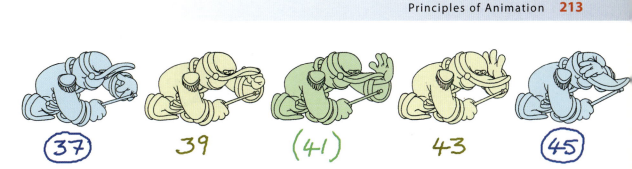

The inbetweens (color-coded yellow) complete the sequence.

Timing

Positioning the location and separation of keys with breakdown drawings and inbetweens is known as timing. Timing is also a word to represent the establishing of the length that each scene and action in a film appears on the screen. Timing in animation can suggest fastness or slowness, subtlety or impact, weight or lightness in an action. Timing can give movement meaning or it can increase tension. An animator can take a number of key drawings and, through the number of timed inbetweens, give a variation of emphasis that will be quite noticeable to the viewer.

The basic truth of animation is that the more drawings or poses there are in an action the slower it will be. Film runs at 24 frames per second, NTSC television at 30 fps, and PAL television at 25 fps. Therefore, if two key drawings have exactly one second of time between them, you will have to assign 24, 30, or 25 frames of drawings to link them, depending on the film speed being used.

Timing has a huge impact on the way things move, so the study of timing is really important. Remember too that it is not enough just to make an object, or a character, to move arbitrarily. Other factors affect movement, such as structure, shape, volume, and flexibility. If a character is heavy-set or obese, it will move significantly slower than a thin, nervy, bird-like character. Therefore, its timing will be different and the obese character will need more drawings. Weight will also affect the way something moves. A feather dropped from a window will take a significant amount of time to fall. A bowling ball, dropped from the same window will hit the ground almost instantly. Their timing will be different and this means the number of drawings needed will be different.

Timing is something that requires a certain long-standing experience of animation to get a feel for entirely. It is often not just a question of throwing in extra inbetween positions to make something move slower. It might work on something like the bowling ball, where there is little structure and flexibility to affect the movement. However, a ballet dancer moving slowly and gradually slowing to a still position will not just require more inbetweens. With so many joints and with a great deal of flexibility, the dancer will be balancing and compensating all the time, requiring not just additional inbetweens to define the action but also more keys and breakdown drawings too.

When animating the tumbling sequence in the figure at the top of the following page for "Endangered Species," I had to key it almost frame by frame, instead of creating

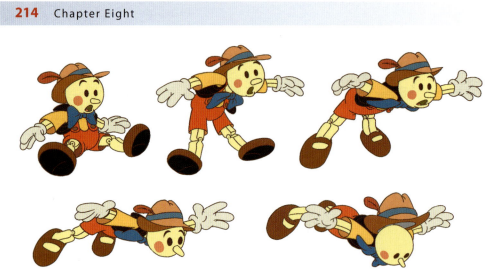

Sophisticated movements may require more keys than inbetweens.

keys and inbetweening the action. This is particularly true of the best 3D animation also. Rather than rely on the computer to put in the majority of the inbetweens for you—inevitably creating a sterile, artificial, soulless sequence—it is preferable to actually tweak each frame individually to make it look convincing.

Even a held, static position may not necessarily be best when entirely still. Human figures, even trained dancers, tend to shake and tremble a little as they seemingly defy gravity or momentum. This subtlety in approaching the timing problem is where an experienced animator comes into his or her own. Remember, the greatest attribute of animation is caricature, and timing is a vastly important element in that process, as all the great Chuck Jones cartoons will attest. The Coyote, of the Warner Brothers "Road Runner" short fame, was essentially a fired-up ball of energy. But this characteristic was heightened even more because his action sequences were often prefixed by much slower sequences that relied on holds and frozen expressions to communicate his thinking moments.

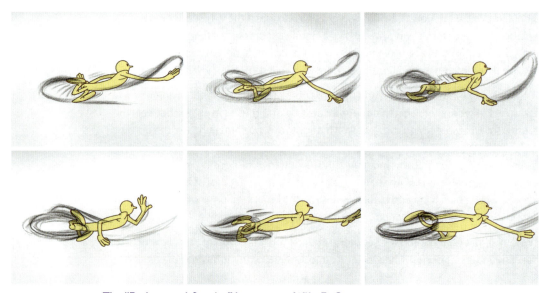

The "Endangered Species" homage to Wile E. Coyote.

Charts

Key animators use a system of charting their timing when indicating the number of in-betweens between two key drawings. Although this 2D-based system does not direct-ly apply for the 3D animator, the Claymation artist, or stop-frame model animator, it can help any animator organize their thinking in a simple, straight-forward way. Using our bandleader action as an example, if there are three evenly spaced inbetweens linking the two keys (37 and 45), the key animator will draw a chart on the first key drawing that looks like the figure at right. The drawings are numbered using only odd numbers, because the animation is planned on twos and each drawing is held for two frames rather than one.

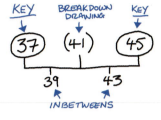

The chart indicating keys, in-betweens and breakdowns for the drum major sequence.

With this chart, the assistant animator will draw the inbetweens evenly between the two keys, as indicated, first creating the breakdown drawing 41 between 37 and 45, then 39 between 37 and 41, and 43 between 41 and 45. If the breakdown drawing is not a precise inbetween and has specific changes in its positioning (such as the angled hand about to reach for the hat), the key animator will most likely do this drawing or at least a significant part of it. The rest of that drawing and the other inbetweens will be left for someone else to draw, noted with "Fin," as in the figure below.

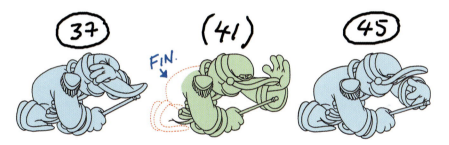

The assistant animator, or an inbetweener, needs to finish 41 before attempting the other inbetweens.

NOTE

You may have noticed that all my initial numbering in this book is usually done with the use of odd numbers. This is because I am assuming that most animation will be shot on twos, meaning that each drawing will be seen for two frames and numbered to match the frame numbers on the film they are to be shot on. If the animation is filmed on ones, however, then the drawing will be numbered with odd and even numbers, also in keeping with the actual frame numbers they are assigned to. Animating on ones makes the action especially smooth on the eye, especially if the movements in the actions are broad and fast. However, if we want to slow this action down by half again, we can simply shoot both the odd and the even numbers on twos, thereby achieving the desired effect.

When inbetweens are charted at equal distances between two keys, it tells the assistant that these drawings need to be evenly spaced from one to the other. Inbetweens like this will give a fast but consistent speed to the movement. If the action needs to be slower or smoother, but still evenly paced, then the chart would indicate that the drawings being shot on twos should be inbetweened and then shot on ones (indicated with even numbers in the figure below. But, if the action needs to be slower as well as smoother, then these drawings on ones can be shot as twos, making the action twice as long.

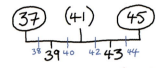

A smoother or slower scene can be created with more inbetweens.

Charts, being a visual representation of timing, are an invaluable aid in helping animators think and helping assistants know what the animator is thinking. However, the nature of the positioning of some (or all) of the breakdown drawings, and even perhaps some of the inbetweens, will also have a profound effect on the way an action acts out. With 3D animation, it is very tempting to leave it to the computer to automatically do all the tweens from key to key. However, it is always best to remember that with more fluid character animation, it is always necessary to manually adjust the breakdown position, and even some of the inbetweens, too. This is why it is also valuable for the 3D animator to use traditional animation charts, even if they are sketched on a scrap of paper or the back of an envelope.

The visual response that a chart provides for action timing from key pose to key pose is a good way of getting a feel for the kind of timing that is being sought. Charting action where the inbetweens are evenly spaced may seem, to non-2D animators, not to merit the use of written charts. However, seeing the number of inbetween drawings between two key poses is a good way of sensing just how long it takes to move one thing to another. Remember too, that no movement really moves evenly, and therefore it is necessary to consider other forms of timing that will definitely benefit from using the charting process.

Slowing-In and Slowing-Out

A great deal of movement requires either acceleration or deceleration in its action as nothing really moves evenly, except maybe machines. You will have to develop the ability to think of this chart-wise and accomplish it animation-wise. Nothing explains this process better than the classic bouncing ball. Almost every animation tutorial in the world starts with the bouncing ball principle. However, like every cliché in life, its greatest value lies in its familiarity and soundness of principle. A bouncing ball encompasses all the elements that the animator needs to know in relation to action that speeds up and speeds down. The rubber ball also embraces the four other factors of timing—structure, shape, volume, and flexibility—together with one other important factor that affects the way all things move, gravity.

The bouncing ball effect, illustrated in the figure below, is simple to describe. A rubber ball is thrown up, then lands and bounces high, then lands, then bounces not quite as high, then lands, then bounces even lower, etc., until it is out of energy and comes to rest. The principles described in this simple action define most of what animation is about.

When thrown, the ball will accelerate into the air then slowly come to almost halt in mid-air as the forces of gravity exert an effect on it (1). Stopping for barely a moment, gravity will drag the ball back down to Earth again, accelerating as it does so. Then, hitting the solid ground (11), the ball will squash then spring upwards again. It will not rise as high as the first time, because the ground hit will have killed some of its velocity and the force of gravity will not allow it to climb or accelerate as much as the first time. It will again slow to a halt (19) and then accelerate downward again, where it will hit (29) and bounce up again (37), actually several times, each bounce successively smaller and smaller, until it finally comes to a halt.

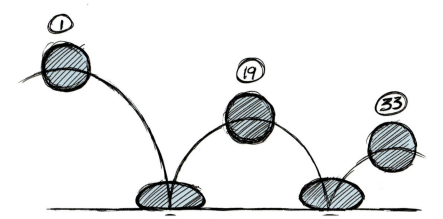

The standard bouncing ball.

Now how can this be defined in a chart? First we have to isolate the key positions, the high points of the bounce and the low hit points. Note that, at its high point, the ball is perfectly round but is distorted at the hit point, as seen below left. When the soft, rubbery matter of the ball hits the hard, unyielding ground, its velocity causes it to squash in one plane and spread out in another. (Remember, the volume of any object remains the same whatever distortion happens to it; volume only lessens if the object splits or parts break off.)

The distortion associated with the rubber ball's hit position is known as squash.

Now, if it was a bowling ball hitting a trampoline or soft grass, the opposite would happen, as shown below, the surface would give and the ball shape would remain intact.

If the bouncing object is harder than the surface it hits, the surface will give way instead of the object.

Now consider the speed of the ball's ascent and descent. As the ball moves from its highest position, it will accelerate from what is essentially a stopped position to a fast-moving one, as gravity drags the ball towards the ground faster and faster.

In the old cartoon tradition, speed was often donated by lines trailing behind an object (called "speed lines") but animators discovered that stretching the object along its path of action (left) gave a better effect of speed, because it simulates the blur you would see in a frozen live-action film frame.

This attempt at blurring by distorting the animation is known as stretch. Many of the old cartoons showed extreme examples of squash and stretch, although today this is reduced somewhat, especially for the more naturalistic approaches of computer-generated 3D action.

Stretching the object conveys speed as it moves in that direction.

If there was no change in velocity, the chart would look like this.

Inbetweening the ball to show squash and stretch will result in a more natural and believable bouncing scene.

If the velocity of the ball is even and not accelerating or decelerating (which is impossible), the charting would look like the chart at top left.. But in reality, the movement is not even when the ball is accelerating downward. The chart at top right shows the more realistic inbetween positions.

The more drawings there are, the slower the action will appear. Therefore, with the bulk of the positions spaced out like this at the top of the move, the effect will be to have the ball start slowly and get faster as the positions spread out.

Once the ball has hit the ground and it bounces up to the next high position, slowing as it does so, the chart would look like the one at right. This time, the inbetween positions are bunched up at the end of the action, ensuring that the velocity of the action slows down as it begins to reach its zenith.

Using fewer inbetweens at the end of the action slows the motion.

From this position, a new chart that requires the ball to speed up towards the next hit position will be created, although as the ball is progressively losing height during the bounces and as each lower bounce will occur in less time, the inbetweens within each chart will tend to become less and less in total.

The action in the figure below, animated on twos, will give a really sharp snap to the bounce, as well as a certain amount of hovering in the air. However, were this to be smoothed out more by animating it on ones, I would be inclined to not inbetween the moves from 11-13 and 27-29, as the resultant snap from the squash position on the ground and the next position up in the air will keep the necessary dynamic required for a strong hit as the ball lands on the ground.

The full bouncing illustration.

The final charts for the bouncing action.

A more complete bouncing ball sequence, based on the full bouncing illustration above and animated on twos, would be charted as seen above.

In animation terms, the charting of a movement that accelerates from one key position to another is called slowing-out and the charting of a movement that has an object slowing down towards the next key is known as slowing-in.

Extreme Positions

Occasionally, it is necessary to take a key position more than a little further than the norm. A great trick of the Warner Brothers animators was to take a key position as far as it could go, then add one drawing beyond that (just for one or two frames of film) which gives the action a fleeting extra emphasis in the pose. Then, once that extended position has been used, the action immediately returned to the original key and then on to the inbetweens that follow. The figure below shows a typical sequence—the laughing clown would work perfectly well with regular inbetweening, but the extreme head movement in the third pose adds just a little kick and makes the laugh more pronounced.

The yellow identifies the extreme position on the laughing clown.

Remember that extreme positions should only be used in fast action sequences that require a sudden, impactful moment. In a slow moving sequence, the position would stand out as an action glitch or inbetweening mistake. Extremes can involve additional inbetweens sometimes (in a slower-moving sequence) but the most powerful application is when they have an almost subliminal impact (one or two frames only).

Arcs and Paths of Action

One important thing for an animator to recognize is the fact that nothing, except the most elementary of machines, moves in an entirely straight line. All action takes place along subtly curved paths of action. We often assume that the arms, legs, head, and torso of a walking human figure, for example, move in straight lines. However, if all the main joint points are tracked in a moving sequence, shown at right, a multitude of arcs (or curves) are revealed during the movement.

Motion almost never occurs along a completely straight line.

Every motion has a path of action, an invisible line along which the action occurs. Most animation paths of action are more effective if they are based on an arc movement (whether it's very subtle or very pronounced). For example, a character flying through the air will be moving along an arc—rising upwards, leveling out at the peak, and descending again until it hits the ground (see the figure below right).

Tracing the character's center of gravity throughout the move reveals the arc.

A pencil scatters papers into the air in an "Endangered Species" sequence.

Follow the tip of the nose throughout the action to see the arc.

Similarly with waving arms (top figure), or a head turning to look in another direction (bottom figure)

Arcs are a fundamental part of all movement and should never be ignored if the action is to appear strong or effective, whether it is movement in 2D or 3D animation.

Holds

Although it's true that most things never cease to move, be it a ballerina in a pose or a hawk hovering for a strike, freezing action for a number of frames (called a "hold") can be very effective. Holds offer anticipatory moments, where the lack of movement is a prelude to a frantic scurry, an unending chase, or an explosion of light and sound. Holds can even offer an economy of effort, where perhaps an entire character will stop moving while just the mouth on another level speaks or smiles. The danger of a hold, however, is that if not approached sensitively, it can be an awkward distraction to the main movement, precisely the opposite of the intended effect; a freezing, or suspension, of life and movement.

With 2D animation there is often an energy (called "boil"), in the hand-drawn lines that suddenly disappears when a position is held. The viewer is used to seeing the accumulation of slightly differing drawn lines move at 12 or 24 drawings per second, only to suddenly see them stop, frozen, for the entire length of the hold. Tracebacks will avoid this sudden freezing. In a traceback, the first held drawing is traced a number of times on separate sheets of animation paper. Logically, the held drawing could be traced for the precise number of frames that the hold is being sustained for. However, if the hold is especially long, you might traceback a fewer number of frames and then shoot these in a random order for the length of the hold. These tracebacks are shot in random order to keep the held line convincingly alive, while avoiding a cyclic action that would show up as repetitive and predictable if shot in their logical order. (Tracebacks are covered in depth in Chapter 12, "Finessing 2D Animation.")

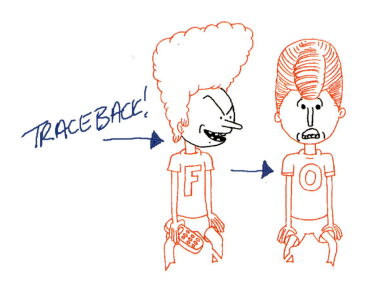

The most obvious use of tracebacks is in this kind of TV style of animation, where there is hardly any movement at all in most scenes, just a shimmering, loosely traced back line.

It might be imagined that a simple hold in 3D animation would be more seamless. However, experience shows that a character suddenly being held for a number of frames in 3D animation actually looks even more lifeless than it does in 2D animation. Therefore, when animating a hold in 3D, there should still be a very, very subtle movement going on in the held position, even if it is almost too subtle to see with the human eye. This very refined inbetweened action provided by the computer will maintain a living quality to the held action. Indeed, this is the nearest thing to a traceback that 3D animation can offer.

Emphasis

The key to all effective animation is, and always will be, in the key poses. If you create weak poses, then you create weak animation. At its very best, animation is a process of caricature. What exists in the real world must be pushed beyond reality when it is animated, if it is to appear real in its own world. Therefore, when creating poses for a specific action, the animator has to exaggerate those poses beyond the real to make the action fully believable. Rotoscoping (tracing from) live action will simply never result in natural or believable 2D animation, even if it is carefully traced and colored to look like animation. The same thing is true of 3D animation that uses untreated mo-cap (motion capture) material. In both instances, the dynamics of the key positions and the timing that links them have to be modified to make them move effectively and convincingly. A realistic image like the one in below left looks like the figure below right when traced and colored like conventional 2D animation—not a very convincing illustration.

The live action image.

The traced and colored version of the live action image is unconvincing.

To create much more powerful images and make the action more impactful and compelling (below), animators must push the dynamics of a pose beyond what was real,

A redrawn, exaggerated pose for a more realistic animation.

Weak poses breed weak animation, so do not be timid with the key pose positions!

The old Warner Brothers animators would advise, "Take a pose as far as you can, then take it some more!" This really is true. Therefore, always study the actual position of a character and extend it into a more caricatured pose. Then, when you have identified all the curves, the stretches, and squashes of that position, extend the dynamics of it even further, to the point where it is almost unrealistic, (below, top). It is actually really useful to have a full length mirror to do this for yourself. But, if this is not possible, perhaps ask a friend to pose for you. Life drawing classes that encourage the capturing of dynamic poses in quick time are an invaluable way of training your eye and drawing hand to achieve this naturally.

Make poses dynamic and powerful and you'll end up with dynamic and powerful animation.

Doing a number of baby sketches before attempting the early scenes of "Endangered Species" helped me understand, and therefore animate convincingly, the baby's walk.

The speed lines technique used for the Coyote-style character in "Endangered Species."

None of this is any less true for the 3D animator than it is for the 2D one. Indeed, it is instructive to review a strong piece of well-animated action footage (say, from a Disney or Pixar movie), frame by frame, to appreciate the real distortions and extensions that are used to create the dynamic key poses that will be there. A frame-by-frame analysis of the action in any old Warner Brothers cartoon will also prove a real education for the aspiring animator!

Anticipation

If an action is to be at all dynamic in its movement and poses, the process of anticipation is important. The law of anticipation says that if an object is going to move forward, it must first move backward a little. Or, before moving to the right, it needs to anticipate this by starting to move to the left a little. Similarly, if a character is to jump upwards, it must first squash down a little.

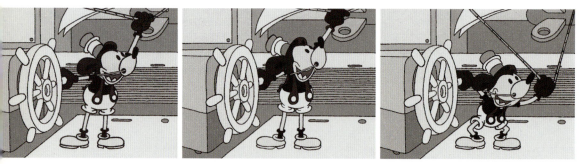

As the character goes to pull down on the rope, he lifts it up a little first to anticipate the major downward action.

Anticipation always gives an important counter point to the main action. It teases the audience into believing that a character or object is moving in one direction when, in fact, it ultimately moves off in the other. This trick, therefore, adds further punch to the ultimate intended direction of the movement.

Timing of anticipation is important too. The best anticipation is sometimes incredibly quick, at other times incredibly slow. How many times have you seen a cartoon character wind up really slowly, almost imperceptibly, then suddenly speed across the screen in the opposite direction? Sometimes we don't even see the run, just the blur or speed lines, or a cloud of dust, that get sucked along behind.

Consider a character pushing himself away from his desk, as shown below. The wind-up to the action would be him slowing-in to the end anticipation moment, where his body moves forward and his leg bends like a tightly wound spring. Then, suddenly, he pushes back and away from the desk, pushing hard on his leg, slowing-out as he does so. The effect is all the more powerful and convincing simply because of his slow-ing squeeze into the anticipation position, then his accelerating faster and faster as he pushes away from the desk. Ultimately, it is the timing and the anticipation that makes this all work so well.

Anticipation dictates that if a character is to move backward, it has to move forward first.

Weight and Weighted Movement

Animation often relies on the natural effects of gravity to make it plausible. For example, a character carrying a heavy object will move far differently from a character carrying an empty box. A character carrying a heavy object but moving as if it were a feather is not convincing. The pose is critical in giving credibility to weight. This is because a character carrying a heavy object will need to stand in an entirely different way to the one carry-ing the feather. For instance, when maneuvering a heavy weight, the character's legs will need to be spaced wider apart to act as a steadying balance. The knees will be bent to absorb the impact of the weight on the spine, and the body (and maybe even the head) will be pulled back to counter-balance the weight, as in the top figure on the next page. The hands and arms will most likely need to be wrapped around and under the weight in order to get a strong grip on it. The steps will be short and shuffling.

Shift the character's weight to counter-balance the carried weight.

Compare this to the pose of the character carrying a light weight, shown at right. Here the legs and body will be held more naturally. With little weight there will be no pull on the spine, no need to spread the feet to compensate for the stress. The body will be fairly vertical, as there is no need to compensate for anything and the stride of the walk will appear quite normal.

Now let us consider a character that is throwing a weight, at the top of the next page. At the far right, our character is holding the heavy sack. To initiate the weight moving in a particular direction, there needs to be an anticipation, or even a series of anticipations through the swinging motion, in the opposite direction. The body must make far more effort in moving the weight, so the posture of the character will alter to accommodate this. The speed of movement will have to be slower, to suggest the weight is difficult to move and the legs will need to bend and then push up to make the throw more effective, as in the drawing at the far left of the figure.

This pencil drawing from "Endangered Species" shows that carrying a very light object does not require any change in the posture or movement of a character.

Throwing a heavy weight first requires anticipation in the opposite direction, then a shift in the character's weight on a downward arc, and finally an extended release posture, with perhaps even a step forward, to convey the effort involved.

This contrasts strongly with the character throwing the lighter weight. Below, the pitcher barely needs to compensate in bodily shift or exaggerate arced paths of action. His action is on arcs of course, but these are more to do with moving his body fluidly through positions that demand speed, rather than for any compensation in having to throw a particularly heavy weight. However, if he were trying to throw a heavy object, like an iron shot putt, his body certainly could not go through this same range of motion.

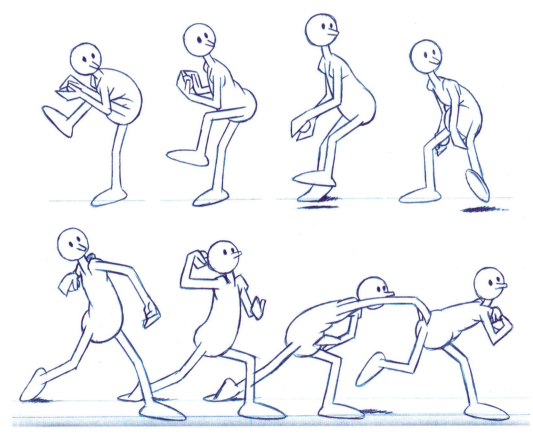

Throwing a light object doesn't require shifting the body weight significantly. Weighted objects react differently too. For example, a ping pong ball and a bowling ball landing on the same surface will react differently. The ping pong ball in the bottom middle of the figure directly below—being extremely taut and springy—will hit the ground and bounce high upwards immediately. It will stay in the air longer, as the force of gravity will have less effect on it, and since the air resistance will be increased because of its lightness in weight, it will tend to float down. In contrast to this, the heavy, unyielding bowling ball will barely bounce at all. It will instead be further rooted to the ground by the force of gravity, which pulls far more heavily on the increased weight than with the lighter ping pong ball. Any wind resistance with such a weight will be minimal. A rubber ball, however, will have more bounce than a bowling ball but not as much float as a ping pong ball, as seen in the upper left of the figure. All these actions will visually define the degree of weight that an object has and therefore the qualities of an object or character being animated have to be a consideration when planning the movement.

The various weights of the rubber bouncing ball (top left), bowling ball (top right) and ping-pong ball (below, middle) create different reactions for each.

Animated characters come in all kinds of weights, shapes, and sizes. The big, ape-like lug character, all brawn with little brain, will move entirely differently from the short, wacky, scientist who nervously jumps around like a bird. Weight also affects the structure and stature of a character. The big lug will need much stronger, heavier legs, probably slightly bent and set slightly apart to compensate for its huge, muscular weight. The mad scientist, on the other hand, might have thin, straight, spindly legs as there is little weight to carry. (Unless he possesses a huge brainiac head, full of knowledge, that presses down heavily upon him!) The figure below shows rough sketches of a variety of body shapes and their centers of gravity. No matter what the action or body shape, the center of gravity should be over the point (or points) of contact with the ground.

Lecture sketches showing the center of gravity in different shaped characters, and where the weight distribution is located above the various points of contact.

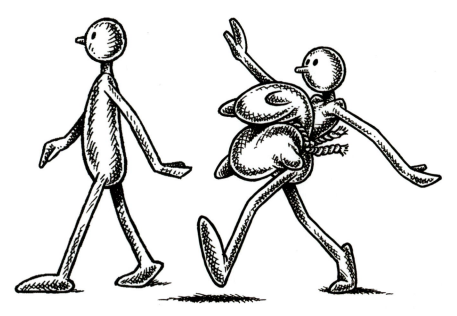

Note the subtle shift of the center gravity in this bottom-heavy ape character as it moves itself from its right foot to both feet.

As a consequence of all these factors, characters all move in their own ways. The lug will almost drag his body around, like the ape above, taking wide, slow, ponderous steps. There will be a great deal of slowing-in and slowing-out at the high position of his stride and he endeavors to first pull his weight up against gravity, then fight to control it as gravity pulls his body down again.

Of course, a regular character will have a more evenly balanced motion as it shifts its body mass from foot to foot, as on the left of the figure below. If the character was heavier or had a big belly or significant weight over the stomach area, the pose would have to be significantly modified, as on the right.

All action is relative to the nature of weight that a character or object has exerting itself upon them. Therefore, no two characters will move alike if their weight, structure, or need to interact with props they are carrying is in any way different.

A regular, evenly balanced character on the left, and one with a big belly on the right.

Flexibility and Fluid Joint Movement

The agile, striding, fluid-jointed character will move far differently to a heavy, limited, tight-jointed one. Consider a cat and a hog. The cat, when at full stretch, is relaxed, flexible and able to squash and stretch its fluid body to achieve considerably extended movements. Its joints will bend and flex, its spine is supple, and its ability to twist and turn suddenly is considerable. The hog, on the other hand, has a locked, tight position. Its legs can move fast but there is limited flexibility as it does, so it tends to move in straight lines. Consequently, the action between a cat-like character and a hog-like character will be far different, simply because of the flexibility and fluidity of their bodies.

Look at the downward motion of the athletic character below. As he lands, his back has a concave shape to it. However, once he hits the ground, the spine shape reverses to a more convex shape, conveying to the audience a significant flexibility (and therefore fitness) to the body.

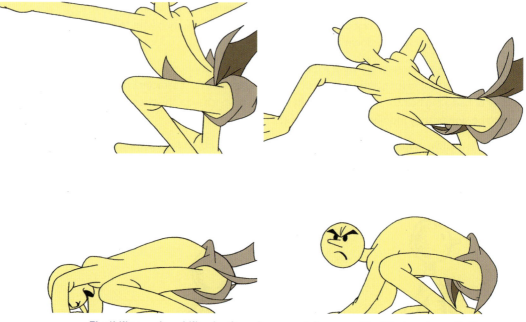

Flexibility and mobility, in the spine especially, are critical factors to realistic animation.

Joint mobility can be factored in significantly with 3D animation at the rigging and weighting stage, although animators and model makers are encouraged to make this plausible within the overall construction of the character. For example, a big lug character will never have the flexibility of a cat. It is possible for the wiry, high-strung mad scientist to have the limitations of a hog but it's more likely that he won't. It is all down to suitability, weight, structure, fluidity; all will affect that way a character looks and moves.

Overlapping Action

Flexibility in movement is not just a matter of character structure and capability. Factors in the movement of secondary objects, such as clothing, hair or props, can give an additional believability to the action. For example, when a character with long hair turns his or her head, there will certainly be some kind of distortion or delay to the motion of the hair. (Except in the case of TV anchors, whose hair is glued down with copious hair spray, of course!) Normally, as the head turns, the hair will delay somewhat. Then, when the head stops its turn, the hair will not only catch up but will most probably continue beyond the head stop position, only to return and settle down eventually where the head is, as in the figure directly below. The longer, more fluid and more flexible the hair is, the more there will be a diminishing back and forth in the hair's action. This is known as overlapping action.

Here, the character's head and body has just stopped moving but the hair continues to swing and settle using a fluid, overlapping movement that will keep the scene alive and believable.

Overlapping action also occurs on clothing. Again, it is entirely unrealistic that a character's clothes will move in exact accord with their body. For an extreme example, consider a running character with a long flowing coat, as shown below. While the character is in motion, the coat will flare out behind him. However, when the character stops, the coat will tend to keep on moving in the direction of the run, wrap itself around the character and swing forward, then will flop back and eventually settle into a static position.

Here, note the stretching of the cloak as the character moves forward and down the steps. Then it bunches up as the character loses his forward momentum and prepares to take the next step.

Overlapping action can occur with props too, such as a character waving a handker-chief at someone on a departing train. As the hand comes down on the wave, the handkerchief will drag behind it. However, when the hand rises again, the handkerchief will tend to drag behind downwards, the effect of gravity and the hand's momentum. Then, when the hand descends again, the handkerchief will pass it and rise upwards again, always a beat behind the hand's action, and so on. The same overlapping effect will occur on a whip being cracked and a horse's tail when at a gallop, etc.

In this more subtle example, note the slight overlapping action on the brim of the drum major's hat.

Overlapping action is a fundamental aspect of animation and bringing authenticity and plausibility to the action.

Generic Walks

So much has been written about walks that it is not necessary to dwell on them too much here. I strongly recommend Richard Williams' superb book, "The Animator's Survival Kit" (Faber & Faber, ISBN 0571202284), to those looking for the ultimate master class in animated walks and many other things. However, to briefly underline what has been said before, walks are broken down into three basic elements: keys, passing positions, and inbetweens (although these are not always pure inbetweens, as we shall see).

Keys

Basically, there are two keys in any walk—the stride positions. One has the right arm forward and the left leg forward. The other is the reverse of this. There are very rare exceptions to this but for 99.9 percent of the time, this is how a general walk works.

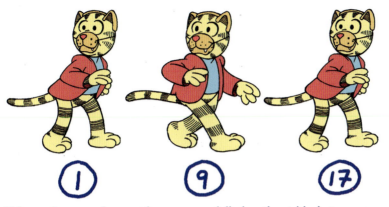

This cat character does not have an especially lengthy stride, but you can see the two stride positions clearly.

Passing Position

The passing position is the midway position between two keys. In all other action, the first inbetween position between two keys would be called a breakdown. With walks, it is known as the passing position. The passing position is where the trailing leg is coming half way through to the front while the body is lifted upwards over the straight contact leg and the arms are pretty much by the sides; see 5 and 13 in the figure below. The body is up on the passing position because the straight leg, directly under the body, pushes it up. Poor walk action has a sliding, floating look that is caused by not having enough up motion on the body during the passing position and down motion on the body in the key positions.

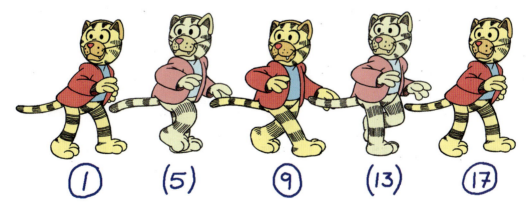

The passing positions, 5 and 13, are the breakdowns of a walk.

Inbetweens

There can be any number of inbetweens on a walk, depending on how fast or how slow the walk will be. An average, fast, cartoon walk will have five frames per stride, meaning that if the animation is on the ones, there will be two inbetweens spaced evenly between the two keys and the one passing position. This walk would be described as a walk on eights, because there are eight frame positions to complete two steps and get back to the first stride position again. A much slower walk might have three inbetweens linking the first key position to the passing position, then three inbetweens linking that passing position to the second key position, nine frames in all for one stride. This would be known as a walking on 16s as there are 16 frame positions to complete two steps and get back to the first stride position.

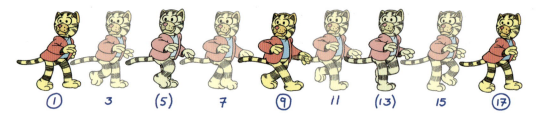

① 3 (5) 7 ⑨ 11 (13) 15 ⑰

These drawings (each held for two frames of film) make for a walk on 18s. Drawings one and seventeen are the same.

The placement of the inbetweens is critical to how a walk will appear. Often the inbetweens are even (three, equally spaced positions between the keys and passing position). However, by slowing-in and slowing-out of a main position, significantly different effects can be achieved in the walk. For example, a walk where the inbetweens slow-in to and slow-out of the passing position, as shown below, emphasizes the height and elevation of the stride, giving a slightly hesitant feel to the stride. On the other hand, a walk that has inbetweens that slow-in to and slow-out of the keys will dwell far more on the down position of the keys, giving a more dragging feel to the action.

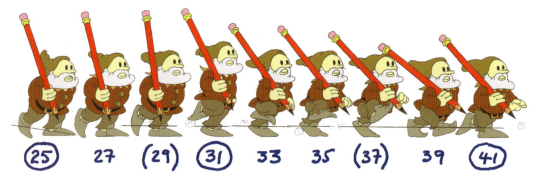

㉕ 27 (29) ㉛ 33 35 (37) 39 ㊶

Slowing-in and slowing-out creates different walks for different characters.

A great deal of the character of a walk will depend on the posture established in the keys, poses that can either underline or contradict the nature of the walks above. The poses of walks have a huge influence over how the character moves through the walks, as does the design, structure and construction. A short, fat, round character will waddle; a tall, thin rangy character will stride more slowly. Does a short, fat character roll like a penguin or shuffle little legs under a flopping body? These are all questions you must ask yourself before initiating a sequence. Note in the figure directly below how a very fat person must not only shift their weight over the contact foot during the action but also bring their free leg out and around when attempting to move it forward. They not only have extreme weight to contend with but also the sheer challenge of getting a very fleshy thigh past another very fleshy thigh.

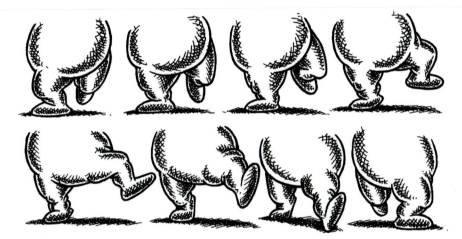

The posture and weight of a character will have significant impact on its walk.

Everything is all in the pose, the timing, and the positioning of the passing positions when it comes to the uniqueness of a good walk. In addition, the feet on the inbetween are never precisely inbetweens. Literally inbetweening the feet would make the action unnatural and wooden. When the back (contact) foot of a single inbetween comes forward, up off from the key stride position towards the passing position, it doesn't actually come forward halfway (see below). Instead., it keeps the toe in contact with the ground to give a maximum push forward.

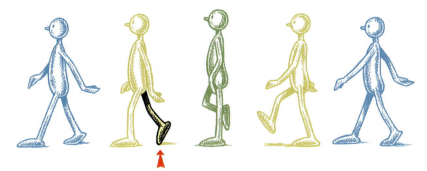

The foot keeps in contact with the ground as long as is reasonably possible.

Then, when that same free foot moves forward from the passing position in one inbetween to the contact point of the next key position, it doesn't just sit halfway between them either. It comes forward instead, beyond the contact position, with the heel a little above and forward of its final contact place, as in this figure.

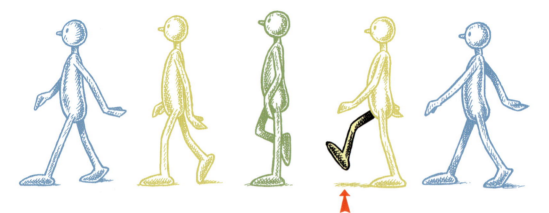

A walk looks more natural if, at the end of a stride, the foot moves just above and ahead of its ultimate contact position.

The complete walk cycle of two strides.

Both these things should occur even if there is more than one inbetween from the respective keys and the passing position, although then, the extreme positioning happens on the first inbetween of the former and the last inbetween of the latter (see the figure at right).

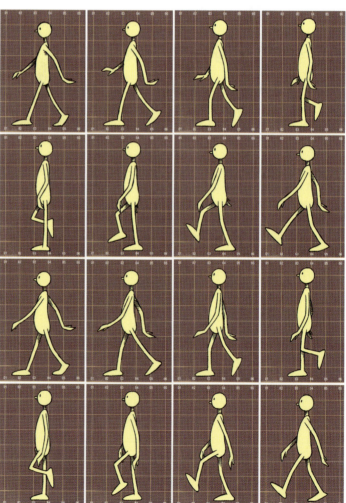

Sometimes, the inbetween after the contact position will have the entire body of the character dip down as the leading leg takes the strain of the body's weight and velocity (seen below), though I personally feel that this would only be pronounced on a character that is heavy or is carrying weight.

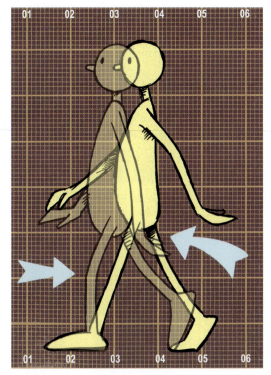

The angle of the body is an important way of defining the nature of a walk. For example, with a regular walk, the body should have just a slight lean forward, to give momentum to the movement. In real life, we lean our bodies forward to give us direction, and our legs move through to keep us upright. If we don't move the legs through fast enough, we will fall forward. Watch babies struggling with their first walks; often they are not coordinated enough to get their free leg through in time and so they fall. Ultimately, they do learn to compensate for the forward, out-of-balance posture we use.

It is often more effective if the body dips and moves forward somewhat on the first inbetween.

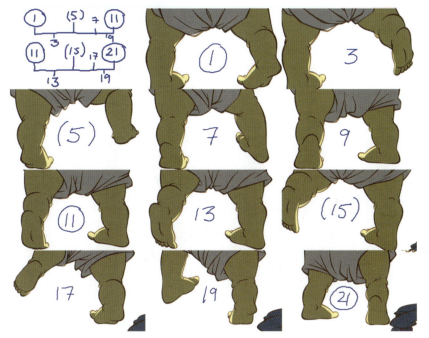

The entire two-stride walk cycle of the baby in "Endangered Species."

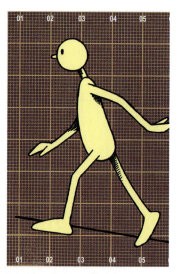

If a character is walking up a hill, or into a strong wind, the forward lean will be much more pronounced, so the out-of-balance position compensates for the resistance, as shown at right.

Walking into resistance requires leaning forward.

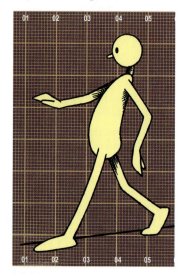

However, if the character is walking downhill, or with a strong following wind (at right), the lean will be backwards to compensate.

To give a natural fluidity to the arms, it will help if the hands and wrists have some overlapping action, as shown below. When the arm is moving backwards on a stride, open the wrist and fingers up slightly to have it drag behind somewhat. Similarly, when the arm is moving forward on a stride, bend the wrist a little more and have the hand drag that way. The resulting feel will be much more fluid and not like completely rigid robot arms.

Walking out of resistance requires leaning backward.

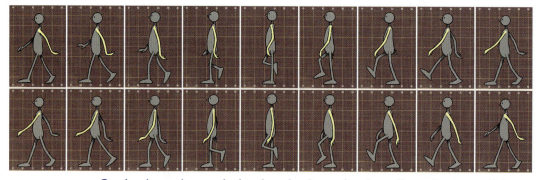

Overlapping action on the hands and wrists makes the walk much more realistic.

An often-neglected fundamental point of a walk is the twist that occurs in the body, illustrated at the right. When the right arm comes forward, the right shoulder does too. However, when the left leg comes forward at the same time, as is normal in any key stride position, then there is a natural twist to the body. This twist reverses with the next stride, where the left shoulder will be forward as well as the right hip. Don't over-exaggerate this twist in your walks, but a subtle use of it will give the walk a more natural fluidity than if it was not there.

Lastly, the head on a walk should be loosened up too. As the body rises to the passing position, the neck can bend forward a little and the nose and head drop down, as on the left, below. When the body sinks down from the passing position to the next key position, the neck could straighten a little, or even bend back slightly, so that the head and face are a little upward, as on the right.

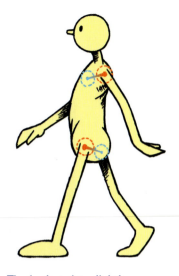

The body twists slightly when walking, as the opposite shoulder and hip move forward.

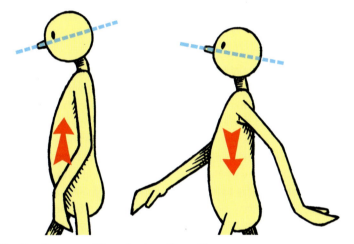

The head moves with each step of a walk.

As with the body twist, do not make this movement too exaggerated, or you will end up with the bobbing head of an imbecile or hillbilly kind of walk, perhaps the opposite impression of what you intended. A finely tuned head movement will give a fluidity to the walk that a more static neck and head will not have.

Walk Cycles

The walks illustrated so far depict a standard walk, moving from one side of the screen to the other. However, there are occasions when a walk cycle is preferred. With a walk cycle, all that is required is for the character to stride repeatedly in the same position while the background pans past. A walk cycle is therefore a repeat action of an entire walk sequence, from key stride one to key stride two and then back to key stride one again.

However, instead of the feet in the action reaching ahead and moving the body forward, as they do on a standard walk cycle, with a walk cycle the feet land forward but then slide back to the last position in the stride (see below), while the character's body moves up and down over the same spot.

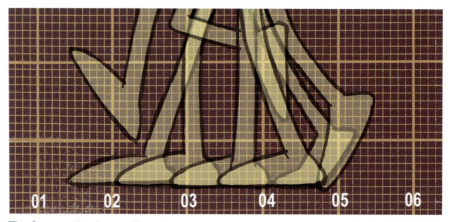

The foot motion in a walk cycle.

Cycle animation can be extremely valuable when a character is doing nothing but walking and has to cover a great deal of distance over a significant amount of time. This is also a useful approach for the animator who is short on time and short on budget. With 3D animation, a basic walk cycle can be created independently, and then applied to the character in all kinds of locations, from all kinds of camera angles. This is in stark contrast to 2D animation which only allows the action to be seen from the point of view it was drawn from. If the scene in which the walk cycle is going to be seen for a long while, then it might be advisable to mix in an occasional alternative walk cycle with a slightly different action, to give a sporadic break in the predictable action that the single cycle movement will eventually reveal. Moving the arms differently, or having the head look up or around, or doing a slight little jump in the step from time to time, serves this purpose adequately. If the walking cycle sequence is especially long, then perhaps more than one alternative cycle action would be advised. The secret of good animation is that if you're using cycles, only you should know!

Personality Walks and Timing

Once you are able to confidently apply the basic actions of a generic walk, it is your duty to go beyond that—all character walks should have personalities that reflect the characters' attitudes or physical attributes, such as the strut in the figure at the top of the next page. For example, the rolling arrogance of a laid-back, punk kid with attitude is far different from the clipped, confined, choppy steps of the precise and anal secretary. This is all achieved in the pose, timing, and placement of key to key positions.

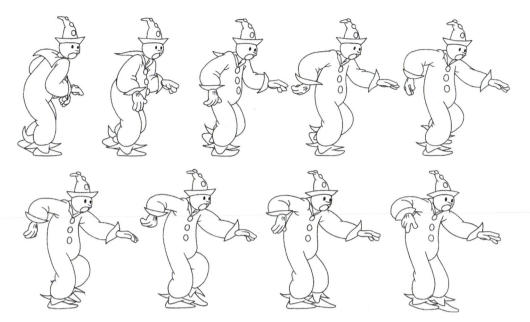

The Cab Calloway strut featured in one of the early Koko cartoon films of Max Fleischer required a very careful application of personality to the action.

Sometimes physical characteristics define character and personality; sometimes disabilities mark the way that a character moves and walks. A character with a leg injury, or where one leg is shorter than the other, will walk with a limp. With a limp, there is a marked difference in timing from one stride to the other. There is also a difference in pose and movement from one stride to the other. A step on the strong leg side will look longer and more natural than the weak leg side. There will be a stronger push, the leg will have much more strength to take the weight of the body, and it will be able to propel the body further forward in its stride than the weaker leg. Consequently, the action will be repeatedly uneven from side to side.

With a Frankenstein-like monster, the coordination of limbs might be different. Perhaps, instead of the right arm and the left leg being forward on one stride, the right arm and the right leg will be forward, with the left arm and the left leg forward on the next stride, as in the figure to the right. This will give an entirely different appearance to the walk, a kind of rolling, circular motion to the body, with perhaps the head fixed always forward, eyes staring vacantly.

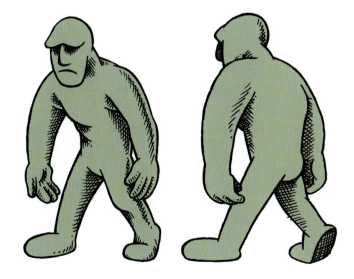

A basic approach to a monster's walk.

When two characters are walking together, one very tall and rangy and the other short and stocky, their stride patterns will be hugely different. The tall, rangy character will probably cover as much ground in one stride as the short, stunted character covers in three to four strides. Their relative speed of walk and their necessary action will be very different. The tall character will be relaxed and low key, but the short character, in an effort to keep up, will have to hustle his way along. All this defines character. All this also defines personality and relationship. Of course there may be other factors that govern their performances too. Is one happy or sad? Is one excited or nervous, etc.? Fundamentally, however, their structure will govern a great deal in the way they walk, although their mood and emotion will also play a role.

Runs and Run Cycles

Runs, since they are much faster than walks, have less opportunity for subtle personality. The fastest run possible can be created using just three positions per stride. Slower runs may get five or six positions, unless a slow-motion effect is required, in which the number of positions will be far greater. A standard run will have around five positions per stride, including both keys.

There are two things to remember about runs that differentiate them from walks. Firstly, the one thing that defines a walk over a run is that at one point a run will have both feet off the ground, whereas a walk will always have one position where the feet are on the ground (see below for a comparison).

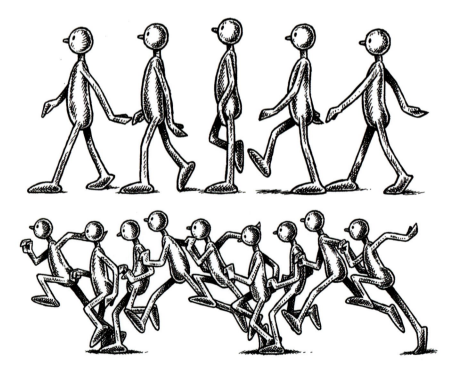

In a walk, one foot always touches the ground, while the character is airborne at some point during a run cycle.

The degree of the body's angle also differs from walking to running. With a run, the body leans much more than in a walk (see the figure directly below). The more the body leans, the faster the run will appear to be. For example, a sprinter will have more of a pronounced body lean than a casual jogger.

Also, to compensate for the pronounced lean, the arms will be bent and pump harder to keep the body balanced. A sprinter has very powerful arms and shoulders that drive hard and fast, causing the legs to move hard and fast as well, keeping the runner from falling forward. However, with the marathon runner, the speed is less, the loss of balance is less, and the conservation of energy over a longer period of time is more important, hence the long, relaxed arms they require.

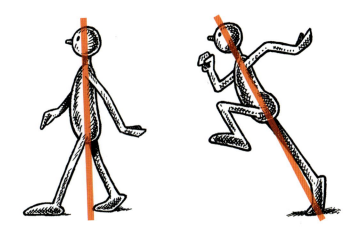

The body angle of a walk is minimal compared to the much more dynamic body lean of the run.

Personality Runs and Timing

As runs are usually so fast to create, there are rarely specific passing positions or identifiable inbetween positions. The slower runs can be analyzed similarly to a walk, where there is a passing position and an inbetween, but only to some degree. However, with the faster runs, most of the action is what is called "straight-ahead animation," meaning that each position is created individually, one after the other, with no inbetweens to be filled in afterwards.

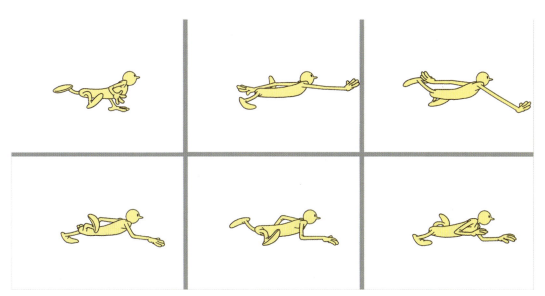

This sequence is based upon a four-drawing run, one of the fastest runs possible.

Consequently, it is far harder to put character and personality into a run. Poses and body structure define a great deal of personality, but as there are so few positions in runs, it is hard to add subtlety to the action. Nevertheless, there are some things that can be done. Firstly, there is the way the arms and legs move. Instead of the arms swinging predictably backwards and forwards, they could loop over and back, as if the character is doing a kind of front crawl swimming action, as seen in below.

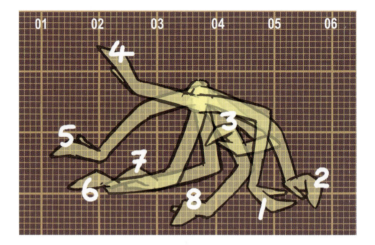

The arms moving through a swimming action, as opposed to a swinging action, on a stylized walk.

The legs could also move eccentrically. For example, imagine that instead of the knee leading the lower foot, the whole leg may look bowed and the ankle actually leads through. Combined with the arm action described above, this would give an entirely different run action, if this were deemed necessary to the character or the scene action. Another characteristic run is the bounding run. With the bounding run, one stride is long and slow and the other stride is short and fast, almost a running limp. The longer stride would have more positions than the short stride, possibly twice as many, with a higher trajectory. The shorter stride would therefore be flatter and require just a couple of positions to get the next stride set up. Repeating this would give the bound, step, bound, step appearance (see below).

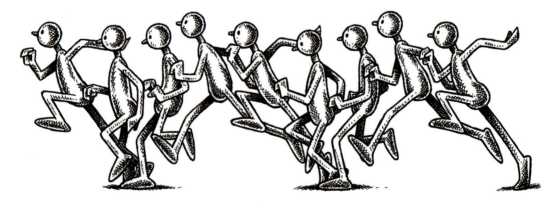

A bounding run has one long stride and one short one.

Finally, although it is required of most runs that the body leans forward, in a very fast scurrying run it can be effective and amusing to have the body leaning backwards with the fast rotating legs dragging it along. In the old days, painted (dry brush) blurs might be added to the legs, to give them a much faster appearance, although today this is not done so often, unless it is possible to add digital motion blurs to the action.

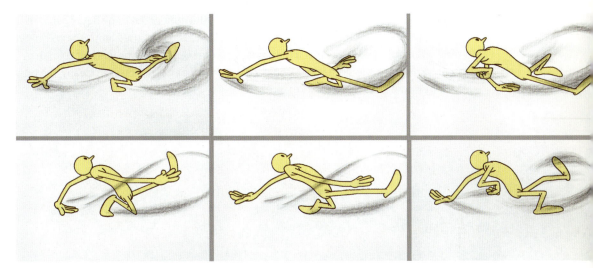

The Coyote's run was led by a fast leg action that pulled the body along behind it.

Whether it is with the animation of runs or anything else, individuality is created by breaking the rules of the generic approach. By making the arms and legs move in un-expected ways, to have the head move counter to expectations also, to have the body countering its natural up and down movement, the character will have an entirely dif-ferent, personal style of motion. Of course, change just for the sake of change will not guarantee the right style for the right character. But observation, experiment, and pushing the norm to new degrees of caricature, will provide the necessary experience and knowledge that creative personality animation requires. It is only through trial and error, and even by making mistakes, that you will learn your craft completely. This is what the great animators of the past did to achieve the levels of excellence that they accomplished, and what the animator of tomorrow needs to do if the art form of char-acter animation is to be further extended.

Silhouetting

When you are seeking a specific look from a specific pose, it's best if that pose is given the greatest chance of recognition possible. If the pose is viewed from an angle where any significant parts of the character are overlapping, confused, or in any other way concealed (as in the character on the left of the figure below), that pose will not register well. Compare that character to the one on the right of the same figure, which is much more effective because the face is not blocked by the raised arms. The technique of silhouetting suggests that if the character were seen as a shape without color or light, the pose should still be recognizable. If the limbs cannot be seen clearly, the pose will be confusing and miss its mark.

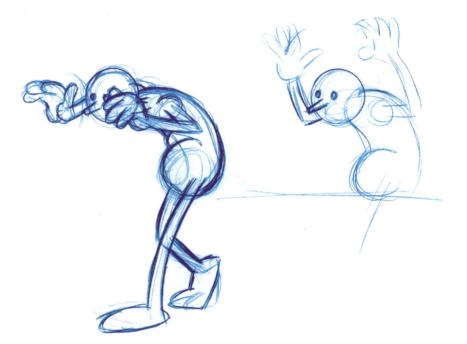

These preliminary poses for a sneak sequence offer a clear example of good (right) and bad (left) silhouetting.

The best animators instinctively silhouette their key poses. However, doing this comes again from experience, by noticing over a period of time what works and what does not. Animators with less experience, therefore, should check their initial key poses before committing them further to breakdowns or inbetweens. 3D animators are especially lucky as, if the pose is a good one but is obscured by the camera angle, the camera angles can easily be adjusted slightly to create the best viewpoint for that pose or sequence of poses. 2D animators, unfortunately, have to completely re-draw each key pose to solve a silhouette problem. Even so, regardless of the form of animation, you should always check your poses for the clearest possible silhouetting before moving on.

Dialogue and Lip Sync

It is always extremely important, with dialogue and lip sync action, to plan everything meticulously and strategically in advance. Aside from the soundtrack breakdown process (see Chapter 5, "Soundtrack Recording and Editing"), it is essential that a total analysis of the dialogue being animated is made and then the key emphasis points marked. These key emphasis points are the foundation upon which all great dialogue action is based.

My experience of lip sync is primarily in 2D animation but this translates fairly well to 3D animation. Essentially, the best lip sync is done by listening. It is impossible to produce good and convincing dialogue without first listening intently to what has been recorded and getting under the skin of its meaning and impetus. On one level, it is just words. On another level, it is a succession of accents and pauses and breaths, and even emotion, that makes up every single line of dialogue. Only by listening intently and frequently will you begin to feel what is really being said in a delivery (not just the sound of the words), and then begin to get a sense of how the character looks, how the character needs to stand, how the character needs to emphasize the words they are saying. Only then, when you are actually under the skin of the dialogue, should you pick up a pencil and draw.

Lip sync is as much about body language as it is about moving the lips in synchronization with the sound. A well-posed physical performance could almost work with no mouth movements at all, as it is the entire body that really speaks in good animation, as any in-depth study of the great Disney animation from the golden age of the 40s, 50s and early 60s will illustrate.

Having totally absorbed the nature of the dialogue by intense and repeated listening, it is now necessary to commit to paper the kind of poses the soundtrack suggests. I often draw a number of performance poses the character might get into when expressing the words, such as in this figure, but without them necessarily being attached to any word or sound in particular.

It is like rough-carving the movement without doing the finishing. When there is a broad sequence of strong poses that express the words that are spoken, I will then assign each drawing to a particular frame in the dialogue sequence. Having established a sound breakdown of the entire scene, logged frame by frame in a program like Magpie, it is so easy to assign a particular key drawing to a particular frame. With the Magpie print out, all the frame

An intense pose sketch for a scene that will ultimately contain lip-synced dialogue.

numbers of the scene are indicated beside the word breakdown and so it is easy to know what frame is associated with what word or sound.

The figure below shows a library of mouth shapes I created for the early edition I had of Magpie Pro. To assign a mouth shape that goes with a sound, I simply listened to the individual frames and double-clicked the mouth position that matched the particular phonetic sound. This selection then shows up as a letter in the digital dope sheet, and as an icon in the lower, right-hand window on the screen. Then, when I played back the entire soundtrack from top to bottom, the mouths show themselves in synchronization with the soundtrack. This neat function shows you if your interpretation and mouth position selections are working with the dialogue before you even begin to draw up the full animation.

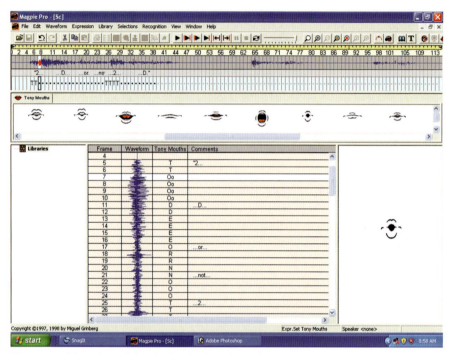

The great thing about Magpie Pro is that the animator can import their own mouth position designs for whatever style of project they are working on.

From this, I simply take my key positional poses and number them in accordance with the frame numbers that go with the sounds or words I want the drawings to hit on.

SEQUENCE	SCENE			5	4	3	2	1	B G	CAMERA INSTRUCTIONS	SHEET
	①		"ACTOR"								①
	/////							1			
	T							3		START	
	OO							5			
								7			
	D							9			
	EE							11			
								13			
	O R							15			
	N							17			
	O							19			
								21			
	T							23			
								25			
	T OO							27			
								29			
	D EE							31			
								33			
								35			
	/////							37			
								39		CUT	

In the left-hand dialogue column of the dope sheet, the dialogue "2-D or not 2-D" is broken down. The animator also lists all the odd frame numbers for the animation to be drawn on twos, so the key positional poses can be circled.

As an extra check, I might shoot a pose test of the assigned drawings. I shoot each drawing for the number of frames necessary to get to the next drawing and then run the sequence in sync with the sound to see if the general performance and planned emphasis points work out. If they don't, I adjust them until they do; the easiest means of doing this is in Premiere. When I have the pose test sequence exactly as I want it, I finally commit to the frame numbers of this correct positioning and number the drawings accordingly.

In this figure, the key positional poses are sketched down the far left column of the dope sheet, after which a carefully timed pose test animatic can be created. The final frame positioning of these key animation drawings in the approved animatic will ultimately enable the animator to accurately number these key poses (the circled numbers) in column 1, using the previously written-in drawing number list.

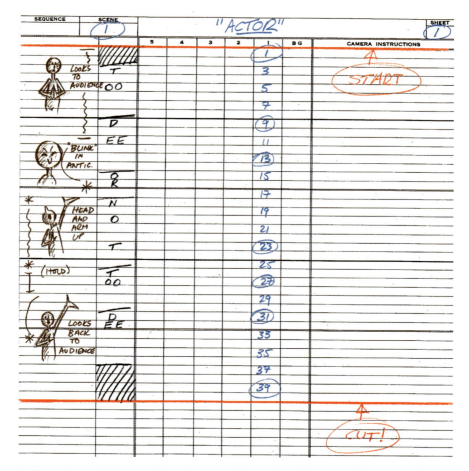

A dope sheet with key positional poses added to the dialogue and frame numbers.

With all the key positional drawings in place and numbered in accordance with the pose test, I create any secondary pose keys required or put in the important breakdown drawings between the key positions. These may literally be inbetweened breakdown drawings, or they may require some extreme positioning with part of the drawing. For example, many speakers use their hands for movement and emphasis.

Therefore, secondary keys or extreme breakdown drawings may have the arms doing a far more independent and differing movement on their own. This is where the secondary keys and breakdown poses really come into their own. This can then all be pose tested again, to check for any other fine tuning that may be required. Once all this is okay, the final inbetweens can be added. However, if the arms (for example) are involved with an independent movement of their own, then even this part of the drawing will not be a literal inbetween; indeed, each frame could be a secondary (or extreme) key of its own. With all the inbetweens added, it is now time to test the entire sequence as a pencil test and then run it with the sound to see if the performance works with the voice.

Although a character's head and body are often shot static, it is invariably better to express the spoken dialogue through whole body movement, rather than with just with the mouth.

Note that even now, there are no mouth drawings involved. When all is well in the physical performance of the animation, the mouth positions are added last. With the sound breakdown and the frame numbers accompanying it, it is so easy to see what sound is going with each frame. However, as all word breakdowns are spelled phonetically on the dope sheet, they can look quite strange at times.

To put the mouths in, simply check to see which sound the mouth is making on any particular frame. Then, knowing the sound being made, speak the sound into a mirror and study your own mouth for shape and emphasis. For this reason, a mirror is perhaps the most valuable piece of low-tech equipment an animator can have—after a pencil, that is.

When the relevant mouth shape is clearly observed, it is simply a matter of reproducing that mouth shape on the appropriate drawing. This is a process that is required for

virtually all the frames of the sequence, especially with fast-talking dialogue, unless, of course a particular sound is held for many frames or the character stops talking and the mouth is closed for a period of time.

It is often undignified pulling faces at yourself in front of a mirror. However, if it gets results indicated, then all your reticence should be cast to the wind!

Clearly, many animated films do not allow for the luxury of such attention to dialogue interpretation. However, it is the conscientious animator's responsibility to push the limits of quality wherever possible. Nevertheless, there are occasions when speed overrules quality and fast solutions have to be found, especially on TV. This is similar with Web animation too, where economy of file size and a limited use of drawings is necessary. In these circumstances, there are a number of shortcut solutions that may prove valuable. The first is that the mouth and the character can be placed on separate layers. That way, the head and body can be held while only the mouths are replaced frame by frame, saving on a great deal of time and effort in the process, as illustrated in the figures to the left and below.

Where the body has to be held and the lip syncing mouth is drawn on a separate level in three-quarter view, it is usually almost impossible to avoid the mouth cutting across the front edge of the held head. Consequently, it is far better to trace the whole head on a separate level and then match this to the rest of the held body.

This would give us a library of interchangeable heads that would provide a big enough mouthset selection to cover most dialogue.

With just these basic mouth shapes, placed on a level separate from the static head and body, a great deal of dialogue can be covered in an extremely short period of time, although for serious animation, this is not the desirable way to go. That said, this kind of lip sync can be quite acceptable (in its own limited way) by adhering to a few basic rules that govern all lip syncing of dialogue. The first is that if there is a vowel sound or any open sound in the track, an open-mouth position must hit it accurately. The consonants are not so important. Indeed, the mouth can be move quite erratically but if the vowel sounds are hit accurately, the lip sync will generally work fine. This is why it is perfectly possible for an animator to lip sync dialogue in a language they don't understand. As long as the vowel sounds are hit accurately, the lip sync will work.

The open and vowel sounds are the most important to a believable dialogue animation.

Secondly, although modern technology allows us to get frame-accurate breakdowns of the soundtrack, and it is very easy to assign a mouth shape drawing precisely to that frame, it is often preferable to anticipate the sound by having the corresponding mouth drawing filmed a frame or two, or more, ahead of the sound sync position. The great Disney animators often anticipated a strong emphasis vowel sound as many as 12 frames early, but I have found that generally, anticipating sound by two to four frames works better than level sync. Some experimentation is required, and with 2D animation on twos, there will inevitably be some jockeying around of sync drawings as the phonetic breakdown will not always put each sound conveniently in two-frame increments. (Far from it, as fast dialogue can have one sound per frame, which creates a problem when the drawings are changing only every two frames.) However, if the animator is skilled enough to average out the mouth positions so they cover most of the important sounds accurately (especially the vowel sounds), the sequence should work fine.

"Cheap" lip sync animation can be achieved by using a minimum number of mouth positions on one layer while the hair and body remains static on another.

Thirdly, with all kinds of dialogue, there is always a point in a sentence or a speech where a particular emphasis is apparent. This emphasis needs to be taken into consideration for even a limited animation approach. Perhaps the arms or the body can hit a particular pose for that one moment, and then return to the original static pose for the rest of the delivery. By breaking up the action in small ways, the audience gets the illusion of performance even if that is not realistically possible. The more that the action convinces the viewers that the character is really speaking the words, the more they will find it plausible and acceptable. To simply have a moving mouth and a static body throughout a sequence will not be at all convincing, like the majority of TV or Web animation; it will look cheap and short-cut. However, introducing the occasional variation to the pose, at a precise emphasis point, will take you a long way in convincing the audience that this is not so.

Lip-syncing is ideally not just a question of adding different mouths to a static head position. Although, sadly, with today's modern production line animation, it is hard to avoid it!

Even a held expression on the face of the listener can communicate a great deal about what the speaking animator is saying.

Finally, always bear in mind that with any dialogue that involves more than one character, the listening character must be part of the action too. A held body and a blinking eye will do that in the most minimal of circumstances. However, observation of some of the world's greatest actors, when they are listening to another, reveals that they are far from doing nothing but blinking their eyes. There will always be some kind of movement, some kind of change of expression, some kind of emotional response going on, even in the most insignificant of scenes. This is the mark of great actors and animators, keeping their characters alive and real even when the focus of attention is not on them. This is equally true for secondary animated characters. In a full and flowing scene of dialogue, the other character(s) will need to be alive in some way to be believable. To achieve this, even in the most limited of circumstances, is the mark of a truly accomplished dialogue animator.

Laughter

Laughter, like all other kinds of takes and reactions, can have individual traits that separate one character from another. There are belly-laughing individuals who guffaw out loud and openly. There are others who laugh internally, where the body shakes but not much sound is released. There are the jerky, agitated laughs, where the head bobs up and down and little else happens. There is no one formula for handling laughs, except to say that the movements have to sync to the sounds. Like dialogue and lip sync, the sounds used are phonetic sounds (it's hard to spell the sound of a laugh anyway!), so

long as the key emphasis positions hit on the most vowel-sounding part of the laugh, just about anything will work. As a rule of thumb, a generic laugh can be more effective if the shoulders move down when the head moves up and when the head comes down, the shoulders rise, as in the figure directly below.

The shoulders go down as the head rises on one key position, then the shoulders rise as the head descends on another.

The biggest thing to avoid with a laugh, unless the project is time-pressed and low-budget, is the repetition of drawings. If you watch people laughing, they rarely keep their head or their shoulders in the same spot. They are either moving side to side, front to back, or up and down. Within these overall body movements, the head and the shoulders are still doing their own actions, countering each other. This begins to give greater opportunity to the animator who is seeking individuality in their laughing action.

As with all animated motion, there are exceptions. For a scene from "Endangered Species," I had to subtly transform a chuckling character's face from a serious expression into a smiling one by simply inbetweening features of the face (see below). This was an unusual approach that I think ultimately worked very well in the final scene.

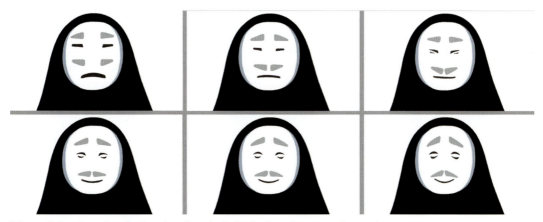

Most of the time, laughs involve the whole body, but there are times when a more subtle transition is needed.

Moving the stomach during the laugh is another way to add a character's personality or style. This is only possible with big-bellied characters. However, instead of having the shoulders move contrary to the direction of the head, it might be possible to have the character's stomach move in opposition to the head and shoulders, or as well as the head and the shoulders. This is obviously subject to the animator's skill in making it all work in unison but a judicious use of timing and overlapping action on the stomach can offer quite amusing effects.

Although this illustration shows a walk sequence and not a laugh one, it does nevertheless demonstrate the overlapping action principle of a belly mass moving in contradiction to the main body mass, a thing that will work just as well in laughter as it does in walking.

Some animators, 2D or 3D, might be keen enough to animate a laugh straight ahead, with no key poses. It takes time and experience to develop a straight-ahead sequence during a laughing sequence, making sure each action peaks at the right sound point, but it can produce a greater and unexpected character performance that the more mechanical process of key positions, breakdowns, and inbetweens does not offer.

Takes

Takes are similar to laughs in that they can be quite unpredictable and quirky at times. A take is a moment when a character sees something unexpected, pauses for a split second to absorb what they've seen and then reacts in a big way to register shock, as seen in the two figures on this page.

Here, a character is lost in thought, then is surprised by something that nudges him from the side.

Here, as an example of a smaller take, we see the same character observing something, reacting away from it, then looking back at it with more intensity.

A single take is broken down into four key moments:

- Observation: Something unexpected happens (or even is said by another character).

- Absorption: The character doesn't move while it tries to register what happens.

- Reaction: The character throws its head in the opposite direction to avoid seeing what has happened, often with the eyes closed.

- Resolution: The character swings its head back to the first position and adopts an expression of open-mouthed and open-eyed wonder.

The take can take little more than a second, or even less in some extreme cases. Sometimes a multiple take can occur for greater emphasis (a double- or triple-take); the bigger the event the character is reacting to, the bigger the take.

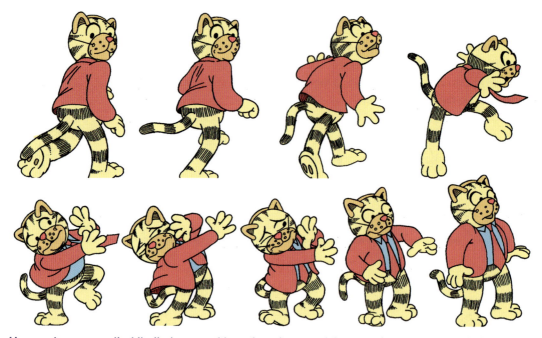

Here, a character walks blindly into an object, then does an elaborate take to come to a halt.

Again, the positioning of a take will vary in accordance with the personality of the character; the big, external, gregarious types will produce bigger takes than the smaller, nervous, shy types will. To push the small and shy characters way out of character, extending the take uncharacteristically enhances the surprise and dramatic nature of the effect. As with laughs, straight-ahead animation can create some of the most hilarious and eccentric takes possible.

Eyes and Expressions

It has long been said that the eyes are the doorway to the soul. In filmmaking, the eyes are the doorway to the personality. When we see a person's eyes, we can tell their mood, happy or sad, angry or friendly. When watching a speaking character's face on the screen, the audience automatically looks at the eyes, never the mouth, to see what the message is. Most animators think that eye movement just needs a black dot inside a white circle. However, to make eye movements especially convincing, the eyeballs must move as well as the pupils. If the eyeballs are treated as if they were slightly malleable (they stretch as the pupil moves), the expression will be much more convincing.

Similarly, when moving the pupils from one side of the eye to the other, it is far more natural to move it on an arc around the eye than in a straight line. Because eyeballs are spherical, not flat, it is far more realistic to give the pupil movement a sense of a curvature as it moves across the eye (see the figure at the top of the next page).

When the pupils are moving from one side of the eyeball to the other, it is best to have a blink midway through the action. In the old Max Fleischer animation style, a partial blink was almost as effective as a full, eyes-closed one. In the middle picture

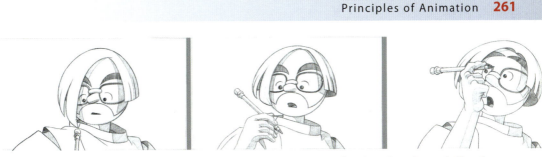

With this young Miyazaki action, there is a slight arc on the path of action that the eyeballs take.

on this page, note too how this character's eyeball immediately turns towards the point where it is going to eventually look, even though the partial blink has not even occurred yet. Most blinks conceal this kind of eyeball shift behind the closed eyelids.

An even better trick to give the move a real kick is to have the pupil favor one side of the eyeball before the blink, then immediately the eyelid begins to open up again and the pupil is already on the other side, approaching its end position. This gives snap and attention to the move which otherwise could just be too soft.

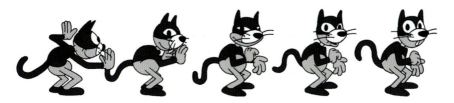

A blink can be partial, more like a squint, and still be effective.

To give a further impact to the change of direction in the look, the head should be involved in the action. For example, if the eyes are looking one way and need to look the other quickly, not only should the pupils arc across the eyeball and the eyelids blink midway, but also the head could turn in the direction of the new look too, moving on an arc to give the final position more attention. Remember, nothing moves in a straight line, unless it is a machine, and therefore a head turn will either arc upwards or downwards from one side to the other. Invariably, a downward arc is best in this kind of scenario, but not always.

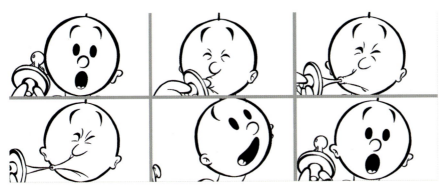

Here, I used a blink, then an extreme eye reaction, to emphasize the struggle the baby had to remove the pacifier. There is also a very slight curved arc to the head's path of action when doing so.

Never neglect the power of expression that eyebrows give to the eyes, even in the simplest of design. You can drastically change the expression of the face just by manipulating the shape of eyebrows. Consider the range of emotions in this figure, generated by just moving the eyebrows in different ways.

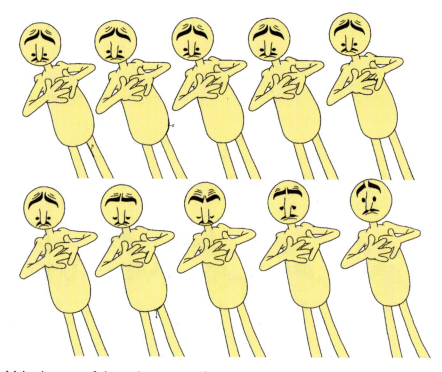

Make the most of the eyebrows, even if there is no dialogue or strong action in the scene.

Just by putting in an upward, central sweep to the shape of the eyebrows, the feeling of despair is greatly enhanced.

By adding some change of expression to the eyes as well as the eyebrows, even greater intensity can be brought to bear in the character, at the left.

Now something about timing. The average eye blink can be done in just a few frames. From a 2D animation point of view (animated on twos), the eyes closing could happen in two inbetweens with the opening requiring one to give an alert snap to the action.

One inbetween on the closing and none on the opening gives a really sharp, alert blink.

Using only one inbetween creates a sharp, alert blink, as shown above.

Adding more inbetweens slows the action and creates a sense of sleepiness or weariness (see the two figures below).

This action has two inbetweens to close and open the eyes to create a slightly sleepy feel to the eyes.

A lot of very slow, subtle inbetweens gives the impression that this character was extremely drowsy. Indeed, he was actually falling asleep!

With characters that don't actually have an eyeball, just dots on a face, it is extremely effective to simply leaves the dots off for two or more frames, then pop the eyes back on again as before. This can be a really effective, stylized blink in minimalist characters.

Popping the eyes off, then on again, is a perfect technique for fast, twitchy, and intense looking characters such as birds, lizards, snakes, etc.

Animating
Step by Step

Prime location available—just add animator!

When all is said and done, there is a point where you are alone with an idea and have to bring it into reality. Every animator works in his or her own way but fundamentally there is a step-by-step process to achieve the best animation possible. This step-by-step process can vary from person to person, from style to style, of course. The following is therefore not a definitive approach to animating but it is essentially the way that I approach a scene of 2D animation, although the process can easily be applied to all animation with modifications of technique and procedure. It starts with a blank sheet of paper and a pencil (or a blank screen and a mouse for some digital animators), although the pencil is always my preferred starting point, whether working in 2D or 3D.

Key Poses

For the purposes of maximizing the process, let's assume that the scene we are about to animate contains dialogue as well as layered action, and the soundtrack has already been phonetically broken down and transferred to a standard dope sheet.

NOTE

Clearly, 3D animators will have to indulge this 2D approach to animation a little. But, in view of the fact that many of the best 3D animators I have met are excellent artists in their own right, and quite often work better when sketching out their ideas in the same way suggested here, I do strongly recommend this process for ALL animation approaches. Clearly, beyond this point however, digital animators will have to adapt this traditionally-evolved process of creation to their own production methods.

After I'm totally acquainted with the soundtrack and its delivery, emphasis points, and general intonation, I draw a series of quick thumbnail sketches that visually express the key moments of the character's performance. Being a traditional animator by habit, I tend to do this down the "thinking" (left hand) side of a 2D dope sheet for ease and convenience. However, other animators can just as easily do this on a separate sheet of paper, or even on the back of an envelope or dinner napkin! It is not important that you draw your thumbnails on the dope sheet or anywhere else, but it is important to think through the action required for a believable scene. However, if you do draw on your dope sheet, at least all the relevant information for that scene is in one central place.

I personally begin with thumbnail drawings, rather than rough or finished layout/key drawings, as thumbnails are a more instant and immediate visual shorthand of what my first thoughts are inspiring me to do (see the figure at left). Quite often, for me, the first thoughts are my best thoughts (although there are exceptions where I work and re-work my thinking several times until I achieve just what I am seeking with a particular sequence). However, this instant scribble process is the one that usually gets me where my mind wants to go, fastest. Remember too, that at this stage of the production, there should already be a confirmed storyboard of the scene, as well as of the scenes around it, therefore the thumbnail process is simply personalizing a visual approach that has already been decided. Nevertheless, by working at the basic approach, through thumb-sized sketches and doodles, I can get a much more refined interpretation, rather than just copying the original storyboard drawing verbatim.

Quick thumbnails capture
inspiration and initial ideas for the action.

A dope sheet filled in with my first thoughts.

Nothing Is Set In Stone

Always keep an open mind that, although you are genuinely putting down your best ideas for a scene, the concept might be changed quite significantly by the director or technical director, or as the scene begins to be animated. This could mean that even you, yourself, change things as you sketch and work from the thumbnail version of the scene or sequence, finding better solutions. The bottom line is that you have to remain flexible and open to new thoughts and ideas about everything as you float in this creative, inspirational moment of production. You may even find that bizarre, off-the-wall thoughts, outside of the original, storyboarded approach, will pop into your mind. Scribble them down! Most times they will be irrelevant, but occasionally the renegade thought is the one that adds that touch of magic to a scene that no one else thought of, directing your sequence of ideas along an entirely new track of thought altogether. This is fundamentally why I find the thumbnail process so valuable. It doesn't commit to the more time-intensive process of finished animation drawings but does give the mind a chance to roam free, creatively.

A very useful additional process to consider here is the preliminary animatic. It is very easy indeed to scan a sequence of developed thumbnail sketches and edit them to the track using a digital editing program such as Premiere (see the figure on page 268) or Digicel's Flipbook. Played back in real time, you will get a real sense of how the final animated sequence works. At the same time, since these are only sketch drawings, it will be very easy to change or add new drawings if the planned sequence is not flowing perfectly and needs some changes here and there. Even these loosely drawn thumbnail drawings will enable you to polish the rough pose sequence at this stage.

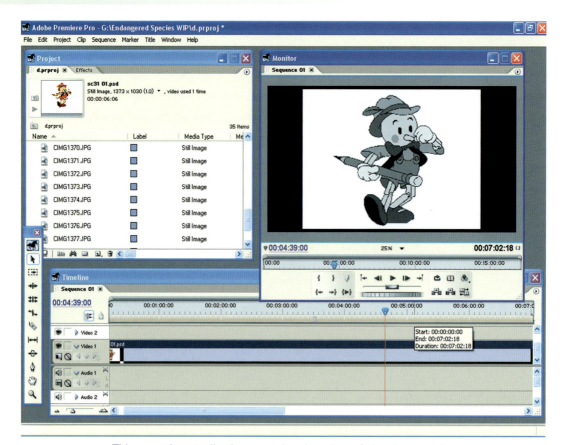

This example actually shows a colored version of the character but very, very rough scribbles will serve the same purpose on an animatic.

With thumbnail poses established and somewhat timed out through the roughly timed animatic process, it is now time to seriously put pencil to paper and work up these ideas into rough but recognizable key poses. Rough poses are better than cleaned-up poses, and they often keep a dynamic quality to the drawing that is lost if you attempt to make every line perfect and accurate. Fluid, worked-at sketches maintain a life to them that cleaned-up drawings never do, and at this stage, the animator is still seeking to keep spontaneity to the drawings to achieve maximum energy to the action. Quite often an acceptable pose will be struck first time but the animator may wish to push it further. Sometimes the best animation keys are pushed twice as far as was first intended, and the rough keys provide more of an opportunity of doing this.

Occasionally, you might get the perfect dynamic and spontaneous feel in a thumbnail drawing and cannot seem to translate that to the enlarged, rough key drawing. When this happens to me, I take the original thumbnail and enlarge it to the key drawing size in a photocopying machine and then draw over it to bring it into line with everything else (see the figure at the top of page 269).

With the rough key drawings completed, it is again wise to create another pose test animatic, matching the timings of the original thumbnail animatic but shooting each rough key drawing for the amount of time it will be on the screen, including the number of (missing) inbetweens that take it to the next key.

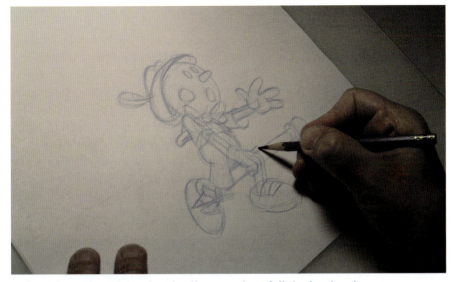

I often like to extend my thumbnail approach to full-sized, animation drawings, no matter how rough they are.

You may have drawn a wonderful drawing, perhaps the best you have ever drawn, only to find it doesn't work as part of a moving sequence. Consequently, it has to be removed to save the scene. Animators always have to remind themselves that, sometimes, they have to reject what they are proud of for the sake of what they are trying to achieve in movement. Fine artists often talk about "learning to kill their babies," that is, rejecting their work if it doesn't achieve what they are struggling to achieve or communicate. This is true of animators too. Don't ever be afraid to work them, re-work them, and re-work them again and again in the pursuit of the perfect action. Then, if they still don't cut it, don't be afraid of trashing them entirely and starting again. This is a more common process than most people would imagine. (The garbage cans of most animators at the end of a busy day will attest to this!)

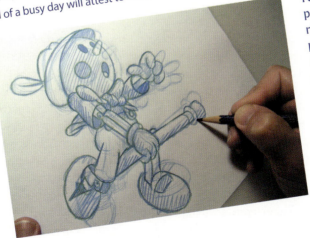

No drawing is precious in its own right; each one is part of a process and must work as part of the whole.

Attitude and Dynamics

Assuming we now have our rough key poses established and their timing seems to work when viewed via the pose test animatic, we should now consider the attitude and dynamics of the poses in question. As hinted above, an animator can create a very attractive key pose drawing but then find that it lacks the attitude or dynamism that this moment in a scene really needs. It is usually just a question that the pose does not push the position far enough. This kind of thing has happened to me over and over again, where I create a key pose that I think is pretty okay, only to find that another, more experienced, animator (or maybe even director) comes along and points out how it can be drawn further than I believed possible. I believe that, in keeping with the wisdom of the past, any key drawing from a dynamic action sequence, however extended it may be drawn, should be pushed as far as it can go, then pushed even further!

No scene pushed my dynamic expression more than this tumbling scene for "Endangered Species."

Those wishing to see the kind of dynamic poses I am suggesting here should try to find "Treasures of Disney Animation Art" (Abbeville Press, ISBN 0896595811), where the great drawings of the old Disney masters from the golden era (Milt Kahl, Frank Thomas, Ollie Johnston, Fred Moore, and their contemporaries) can be seen and marveled at. By studying this book, I observed that dynamic key poses are built around essential lines of force that dictate the shape and even the silhouette of that particular drawing. Invariably too, these lines of force are curved, never straight. The great artists and animators of the past always maintained that nothing that needs to appear strong is ever entirely straight. Even the imposing Doric columns in the Acropolis in Athens were deliberately curved by the ancient architects to give them added structural and visual strength. In animation terms, anything that is perfectly straight in a pose is weak. When key poses need to be especially strong and dynamic, they should always be constructed around arced lines of force (see the figure at the top of the next page).

The arced lines of this key pose create a sense of strength and dynamism.

Fluidity in drawing is fundamentally important if good animation is to be achieved. Remember, wooden key drawings produce wooden animation. Looking again at the drawings of the great master animators of the past, it is clear that they not only utilized strong lines of force within their drawings but applied a fluidity of drawing style too. More often than not, adding fluidity to lines of force will get more out of the pose. The more spontaneous the drawing style is at this stage, the more fluid it will become. It often happens that some drawings flow off the pencil while others are a struggle to get right. I find that the more I concentrate on the details of the drawing, the less fluid and harder to achieve they become.

Invariably, the good drawings are the ones that are drawn roughly and loosely, paying attention to dynamics, shapes and volumes, rather than the details. The bad ones, on the other hand, are the ones that I approach more logically and mechanically, trying to get the detail and the pose right at the same time. Sometimes, due to time and budgetary pressures, it is virtually impossible for me to separate the two. But where the quality of movement is preferred over the quantity of output, you should focus on dynamics and fluidity first and on detail last. "Letting go" when roughing out key poses is the hardest thing to do but, if achieved, the results can be quite startling.

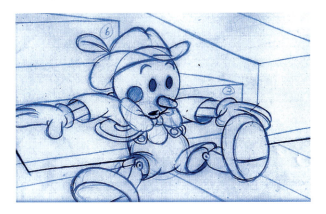

This scene was a particularly tough one to create for "Endangered Species" as not only did I have the dynamics of the animated character to struggle with but I also had to animate the background.

When all my key positions, and perhaps even my breakdown positions, are complete I shoot them as a pose test. The pose test gives a strong indication if the positioning of the keys and the timing from key to key is working well, but before the effort of adding the inbetweens is undertaken. (Far more important in 2D filmmaking than 3D, of course.) If the pose test proves acceptable, then I will send everything to my assistant for inbetweening. If not, I will make changes to the key and breakdown positions and timings and re-test it until it is right.

Inbetweens

With all the dynamic and fluid keys complete, it is time to add in the inbetweens. Fluid keys will create fluid motion, unless, that is, the inbetween drawings are not drawn with the same fluidity as the keys. Poor inbetween drawings can give an inconsistency to the look and movement that will be uncomfortable to the trained eye. Even the untrained eyes of a general audience will notice—they will not quite know what is uncomfortable, but they will feel that something is not quite right. Therefore, assistant animators and inbetweeners have a great responsibility when quality of action is being sought in a scene. The inbetween drawings must have the same fluidity of dynamic that that the key drawings have.

The timing and placement of inbetweens will dictate the general flow and fluidity of the action as well. The fewer inbetweens there are, the faster the action will be, and a faster action does not lend itself to fluidity as there are fewer drawings to influence things. However, alternatively, more inbetweens will slow the action considerably and therefore the fluidity of action will have much more opportunity and screen time to become apparent.

Inbetweening both character and background in this scene proved a very challenging and time-consuming venture.

When the inbetweens are put in, the whole thing will be pencil tested and checked for any flaws or glitches that didn't show up in the pose test. Invariably these will be more timing issues than action issues, as the basic action would have been established with the pose test. Changes may just include adding or removing inbetweens until a new pencil test flows appropriately. As before, the best way of ensuring that the animation is working well is to keep the work rough and simple (below, left) and repeatedly test everything. This doesn't mean ignoring accuracy, but it means not concentrating on inessential drawing or clean-up details that can be added later.

I can achieve a much more fluid and convincing sequence by animating roughly first.

Working with only the essential geometric shapes that make up the character (as with primitives in 3D animation modeling) will achieve enough of the animation to pencil test, without making the work overly complex. Almost all animated characters can be broken down into basic shapes (circles, triangles, squares, oblongs, etc.), making them much easier to move in relative position to one another while working loosely to maintain the fluidity.

Details, like the eyes, the mouth, or even the hair, are not at all important at this stage, just the essential shapes (see the figure at the top of page 274), although minimally indicating them will give more cohesion to the action in some cases. The less there is to draw when establishing the basic poses and movements, the easier it is to make the action smooth and fluid. The details can always come later, at the clean-up stage, and can even be completed by another artist, if time and budget will allow.

Earlier animated characters lent themselves so much more to them being broken down into primitive circular shapes than today's more angular and anatomic characters do.

Again and again I will always preach the eternal truth: SIMPLE is BEST when seeking to capture the essence of a pose or a moving sequence.

When framing dialogue scenes, I prefer not to situate all the speaking characters in a single long (wide) shot. Yes, I do use an establishing wide shot to define the scene at the beginning of a sequence, but I prefer to use mid or close-up shots for the talking sections, so the personality of each character clearly comes across. Of course, if economy of effort is everything, it is possible to have talking characters located in an extreme wide shot, so that the mouths cannot even be seen. However, this does not help the audience understand just who is speaking or their inherent personality, of course.

Adding Mouths

With all the inbetweens in and the correct action confirmed through a pencil test, it is time to add the mouth positions if there is dialogue or sync sound in the scene. I have trained myself not to be afraid of using a complete range of shots when animating dialogue. Quite often, in a long "talking heads" sequence, the dialogue can be very predictable or even boring. Therefore, anything that breaks up this predictability while fitting the nature of what is being said will help the audience through it. This is especially true for TV series work, often defined as "moving wallpaper" by the animation community, due to its emphasis on words and lack of full action animation. Close-ups, extreme close-ups, and even cut-away shots, mixed selectively in this environment, will provide variety and emphasis, if handled well.

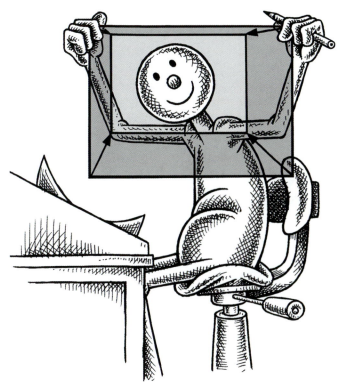

Always consider your framing when preparing to animate a scene. It will influence the way you animate, demanding that it is broad or subtle, full, or limited in movement.

Staging and Camera Angles

When staging a number of shots that are derived from a single, large location, I pre-fer to sketch out a master shot of the full location, including the figures in it, first. This enables me to get familiar with its layout, size and the relationship or various settings and characters involved (see the figure at the top of page 276). I believe that one of the biggest failings in animation is that a great background design is created and then the figures are just dropped in with no thought of style, framing or location. Similarly, with unimaginative camera work when different shots are required. By doing a master sketch of everything first, you will see the various elements that can be played with, as well as the possible camera angles that will be better than just the wide shot, mid shot, and close-up from the same viewpoint. It is much easier to do this with 3D animation, as once the environment and the character models are established, you simply place those characters and move the camera freely until the perfect shots are established for each scene.

Framing is everything in certain scenes that need to communicate (or reveal) a particular person or circumstance.

If animating within a complicated setting for a particularly large number of scenes, I may even build a simple cardboard cut-out version of the set and its characters. This becomes a valuable source of reference that I can study from all angles when seeking interesting ways of staging and framing action scenes. In inventing new and creative shots around a location, especially with two or more interacting characters, you must never forget essential film techniques such as not crossing the line, maintaining action continuity, etc. (Refer to Chapter 4, "Basic Rules of Filmmaking.")

The same action can be framed in many different ways; look for unique and interesting ways to stage your action.

Working with Characters

When working on characters in a scene I always first ask myself certain questions such as, "Do I understand what this character is thinking or feeling?" or "Do I know what is motivating their actions here?" If I am really concentrating on a character, I might even write down a profile of them—their strengths, weaknesses, motivations and essential personality. The more I can familiarize with them, the better I can animate them. This is the essence of good character animation, getting under the skin of that character.

Ed Hooks, in his fascinating book "Acting for Animators" (Heinemann Drama, ISBN 032500580X), cites seven major concepts that an animator should be aware of when starting to animate a character:

- Thinking leads to movement.
- Acting is reacting—Acting is doing.
- Your character needs to have an objective.
- Your character should play an action until something happens to make him play another action.
- All action begins with movement.
- Empathy is the key magic—Audiences empathize with emotion.
- A scene is negotiation.

Essentially Ed Hooks' approach encourages the animator to consider the "inner" process that is going on within the character, as much as a real life actor would the character role they are playing.

Every pose you place a character in has to contribute to the audience's understanding of that character and what makes him or her tick. A character should not just go through the motions of action; there has to be a thinking process behind it all, or motivation, emotion, and need. For example, if a character is picking up something, will the audience know WHY that character is picking it up? Is the motivation explained? Does it need to be explained? Is what he picks up pleasant to him or odious? Is he doing it openly or secretly? It is important to understand motivation and reaction to events and that can be so well communicated in simply a pose or a gesture. The bottom line is, don't just move something—give it a purpose and a motive for the movement and establish this in the posing of the key positions.

Shadows can serve as contact points when characters are not touching the ground.

Extreme Action

Now, in terms of animating characters that need to be extremely active, like one that is dancing, twisting, or tumbling, it is always best if that character can at least have their center of gravity above their contact position with the ground, such as over their foot, even if part of them is actually out of balance. A shadow under the character can be valuable in underpinning this.

On one project, I had to animate a dragon that was dancing around and around while also walking. I struggled so hard to make it work and never could, at least convincingly. Eventually, through a great deal of frustrating trial and error, I discovered that no matter how wild or how out of control the dragon was, if I managed to keep at least one foot on the ground with its center of gravity pretty much located over it, the action worked (below). Even if the character was in the air, turning and twisting, I found that it would still work as long as the center of gravity was logically over where the contact foot (or feet) would be, or even at the midpoint between where the last foot took off and where the next foot was to land. With this notion to guide me, I could add any kind of eccentric, twisting, turning, or arm waving and it worked perfectly. Now, I always concentrate on key positions where the weight of the character is essentially over the point of contact and everything else is secondary to it. As with everything else, if the key positions are right, everything else will work when inbetweened, however many there may need to be.

Animating this dragon was the epiphany that helped me understand the distribution of weight and balance in any action.

Clean-Up

When everything is complete—keys, inbetweens, and dialogue—the animation drawings will be passed on to the clean-up artist who will make them consistent with all the other scenes of the film. In 2D animation terms, the clean-up stage is the defining moment. Often, pencil test animation covers a multitude of sins because it is so loosely drawn. It is only when animation is viewed at the clean-up stage that potential problems arise. Therefore, when animating the rough pencil test, you should look beyond the immediate material and anticipate what the cleaned-up material will look like. For instance, defining lines may appear and disappear within the main action. In this case it will be harder for a clean-up to assess where these missing lines need to be added, so it is the assistant animator's responsibility to make sure they are there, even if the key animator does not include them on some of the drawings.

Most of my clean-up work for "Endangered Species" was done with a basic Paper Mate Pilot felt tip pen. This ensured excellent clarity and recognition of the lines when they were scanned. Many animators still prefer pencil clean-ups, using dark graphite leads or even-drawing mechanical pencils containing anything from an HB to a 2B lead.

Quality and style of animation differs from project to project. However, each clean-up artist, and animator and assistant has a personal responsibility to produce their work to the highest level of their capability, regardless of circumstance. This is what keeps standards high and what endears 2D animation to audiences; its hand-crafted uniqueness makes it entirely different to computer-generated 3D animation. To see the quality and integrity of drawing that can be achieved with a simple pencil, I recommend the work in the "Treasures of Disney Animation" or other historical Disney books of film artwork. Of course, not all animation can be produced to this standard and many styles, thankfully, transcend the traditional Disney style. However, in terms of professional craftsmanship and integrity, these are inspirational pieces that establish a standard that has yet to be bettered, at least from the traditional point of view. The quality of line and construction, the delicacy and control, are quite exquisite in places, the match of any old master drawings displayed in the galleries of fine art around the world.

The first thing a clean-up artist should look for when approaching an animation drawing is to discover where the dynamics of the animator's emphasis is. The strength of the clean-up drawing must lie where there is a strong dynamic quality within the drawing. The use of thick and thin lines in the clean-up emphasizes strength and weakness. Thicker lines make a stronger statement; thinner lines define subtlety or a lesser emphasis. Therefore, with a long arc line that dynamically defines a shape within the pose, the strength of line can be defined by thickening it toward the center of its length. Web animation tends to do this already, whether this a conscious use of the thick and thin concept or just a factor within the software interpretation of a line.

This defining Animaticus Drawersaurus image was a shameful interpretation of Leonardo da Vinci's "Vitruvian Man"!

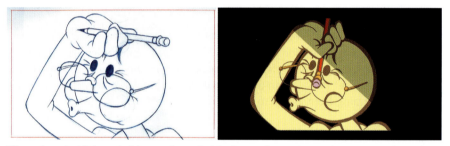

The colored, thick and thin version of this drawn figure is much stronger than the weaker, even-lined original version.

Another example of how thin, even lines do not even closely match the strength and impact of lines that have varying widths.

The worst thing that can happen in animation clean-up is to use an even, unstructured line (unless, of course, it is dictated by the original design of the character). Even lines give a clinical, anemic, or mechanical look to the character, not surprisingly, and many animators and clean-up artists use a mechanical pencil to achieve them.

The use of a structured, thick and thin line for clean-up radically improves the strength and the look of a drawing. However, if a thick and thin line technique is being used, it is extremely important that a consistent approach is maintained throughout all the drawings. If key drawing 1 has thick and thin lines in specific places, then key drawing 2 has to have the same overall feel, as do the inbetween drawings that link between them. This consistency of line has to then follow through on all the keys and inbetweens, of course, otherwise there will be a boil or jiggle within the line that can be quite disturbing. Of course, if the design style of the film is meant to have this effect, then the clean-up artist has to consciously break these rules and ensure that the thickness and thinness of the lines varies from drawing to drawing! However, for most styles, a consistent approach is the correct one. Flipping (or 'rolling') a stack of drawings on the animation pegs will enable the clean-up artist to establish continuity in movement for each line.

I trace all the thick and thin lines as even outlines first (below), then fill them in more solidly using a digital paint program. Filling thick areas manually, at the tracing stage, is an infinitely lengthier process, although I do recommend rounding off all sharp inner corners, prior to digital inking, as these tend to require that the image be enlarged and then manually filled in on a pixel-by-pixel basis.

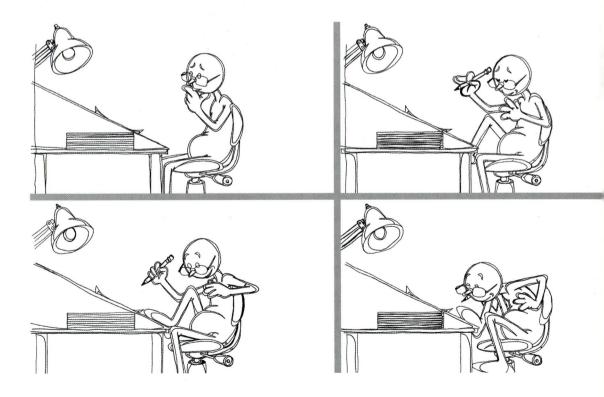

It's faster to draw the thick and thin lines evenly and then fill in the thick lines digitally.

"Endangered Species"

Conventionally, most clean-up drawings are produced on separate sheets of paper from the animation. I did this with "Endangered Species," to preserve the original pencil drawings for this book. However, I sometimes prefer to work so that the clean-up can be drawn directly on top of my original pencil drawing. To enable working directly on top of the pencil drawing, I create my animation drawings in a blue col-erase pencil, although not the non-photographic blue, which I find too light in color to see clearly enough when I'm drawing. (Other animators prefer the red col-erase non-photographic pencil, which can also be fully eliminated at the scanning stage.) I start by drawing lightly and work into it as need be. But, even if I draw heavily with blue col-erase pencils, the clean-up artist can usually erase the intensity from the blue, before it is inked or scanned. This enables them to see a trace of the blue line on the page before they ink.

When scanning in line/text mode, the scanner will easily detect the inked line but rarely will it see the light blue lines underneath. On better scanning systems, the blue can be eliminated using specific filters. The advantage of working in this way is that the clean-up artist can clearly see, on a single layer, what they are drawing and what they are drawing from. The disadvantage is that once the drawing is erased and inked over, the original drawing is irretrievably lost. However, if the clean-up artist is professional and experienced, this risk is minimal.

An example of inking the cleaned-up version directly onto the original pencil drawing.

An aspect of clean-ups that needs particular attention is when a character moves up, to, or away from, the camera; the line thickness should not remain the same. It is usually not so apparent when a particular weight (strength) of line be used in a close-up drawing, but if that same strength of line is used for a long shot (i.e., the drawings are small on the paper), it will appear disproportionate to the close-up. When cleaning up drawings that move to and from the camera, you should vary the strength and width of the clean-up lines accordingly. This will provide a much more natural feel to the action. In vector animation, that line width will thicken accordingly if the drawings are zoomed into or zoomed out of digitally, so there's not much you can do about it.

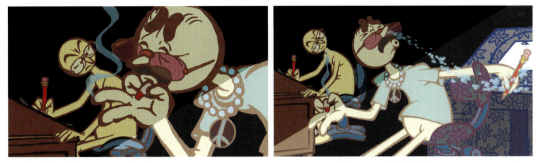

This beginning and end of a vector animation scene illustrates the natural thinning of clean-up lines as the camera zooms back.

Lines are important—vitally important—to 2D animation, even though some will only be seen for one twenty-fourth of a second. It is the clean-up artist's responsibility to be aware of subtle line differences in a character and draw each consistent with the original vision. Lines that do not do their job—that are under-drawn or over-fussy—are called lazy lines. I often see clean-up lines that technically enclose an area for coloring but just look weak and anemic, as shown below. Alternatively, there are lines that are so inadvertently fussy (i.e., over-worked, perhaps using many lines when a single, strong one will do) that they boil like fury when shot. (This is totally acceptable, when planned that way, for example, in a film styled after Bill Plympton. But it is totally unacceptable if a smooth, consistent, traditionally-styled line is needed.)

The lazy lines are too weak when compared to the stronger line technique.

Lazy lines can destroy the dynamism and strength of a key pose or movement by creating inconsistency. Even within a character, there can be a significant difference in line quality. The lines for a character's hair can be considerably different from the lines used for the body, or the facial features, or whatever. To ignore this and treat every line the same is lazy line syndrome. If in doubt, check with the original model sheets for the character. If still in doubt, ask the original designer for a clarification sketch if possible.

The ultimate truth of clean-ups is that good inking can really make a scene, whereas bad clean-ups can certainly diminish it, no matter how good the animated action is. Success with clean-ups is ultimately achieved through sensitivity, drawing technique and consistency. Therefore, it can often help if the clean-up artist is a better draftsman than the animator.

NOTE

It is sometimes possible to create digital clean-up lines directly from finished pencil drawings. If these drawings are drawn strongly enough, they can be scanned in grayscale and then imported into Photoshop where a slight blur can be added. Then, using the brightness and contrast tool, you can convert them to pure black and white lines. It may take one or two attempts, but it will work. This line may ultimately need to be touched up with the pencil tool after this process is complete however, as any gaps that occur in the lines through this process will mean the color fill will flood out at the coloring stage. It may also give an inconsistent thickness to the line beyond a more controlled thick and thin approach. Nevertheless, it is a process that can eliminate the inked clean-up process entirely, if it suits the style of animation being considered.

This baby illustration looks so much more solid and interesting because of the use of a thick and thin line technique.

Drawing for Animators

In this modern digital age, it is a popular myth that computers do everything for you. Yes, computers can assist the modern animator so much that it might almost be said that it is easy to animate today. Yet ask any professional, however much they rely on modern technology, and they will tell you that nothing is easy! Indeed, the better animators are extremely well-versed in traditional skills and if these are not necessarily in traditional 2D animation skills, they are certainly in the skills of traditional drawing. Take one look at the Web sites of some of the most notable and accomplished digital animators around and you will find a huge interest in and ability for traditional drawing.

The function of any animator is to observe life, then reproduce it in its animated form, hopefully plausibly, and hopefully with caricature and personality. Drawing is also about observing, then reproducing what is observed. Drawing is a process of under-standing and a process of hand/eye/brain coordination and can be of huge benefit to digital animators. I know this is not entirely a popular view across the industry, espe-cially, the 3D industry, but I do firmly believe it is something that separates good ani-mators from the bad, the artists from technicians. It is not even to say that an animator has to be a great artist, or even a skilled drawer. It is just that, in the process of look-ing and observing what is being seen, there is a quality of understanding that tran-scends the imagining of what is real. The drawing animator understands dimension, depth, volume, and form. This doesn't just mean abstract orthographic elements, as seen through a 3D software interface, but a solid, observable reality that can be seen, sketched, and understood intuitively. The human figure, or at least creations built upon the qualities of the human figure, is the challenge where many animators are found wanting in the creation process (an example is shown below) and therefore attempting a significant amount of figure drawing, ideally from life, teaches the animator so much about this process before they begin.

In real life, even the most well-balanced of human faces has certain differences from one side to the other, so when drawing a character it can actually be wise to build in deliberate differences from one side to the other on occasions.

It is probably true that there are great animators (specifically 3D animators) who do not draw, nor do they intend to draw, and yet they are accomplished at what they do. Yes, there will always be exceptions to the rule, for those who are born with an inher-ent natural talent can transcend normal barriers. However, a study of the industry across the board indicates that the great number of accomplished animators who have worked hard to achieve what they can do have done so with either an inherent draw-ing ability or they have worked at it to hone and polish their drawing skills. There is also a growing trend by studios to employ 3D animators who have both a drawing ability and a capability in 2D animation, as experience has shown them that these artists tend to make the best, the most adaptable, and the most adept animators. This is especially true of character animators, where understanding the human form, together with its infinite subtlety of movement and structure, can only be accomplished through obser-vation and a drawn recreation of what is being observed.

Modern technology does make it possible to be an animator without any need to draw. This cannot be denied. Even modern 2D technology enables animation of sorts, where you can draw images straight into the program without ever touching pencils or paper. In some ways, this is very desirable. However, the question has to be asked of the most simplistic amongst these programs: has this made animation better? Or is it just cheaper and faster to do it that way, regardless of the end quality? These are challenging questions that every serious student of animation needs to address. Can a person be an animation artist without ever being able to draw? Technically, the answer is yes. Creatively, however, I think not. History shows us that to be a great and accomplished character animator, you must have a desire to know and express life through drawing, if not classically well, then at least insightfully well, as in the figure below.

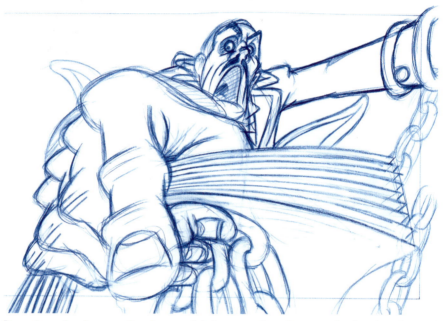

By seeing what is normal and natural, it is so much easier to make drawings beyond the norm or into the supernatural, as this animation rough key suggests from "Endangered Species."

It is my absolute conviction (and the published conviction of many animation greats that have inspired our industry, in both 2D and 3D animation) that to reach an ultimate pinnacle in character animation, you have to study and understand the human figure in all its complexity. Drawing is the foundation that supports this kind of understanding. If you cannot understand a body in structure and movement, then how can you translate its movement in dramatic and meaningful ways? Consequently, an understanding of anatomy, as well as an ability for drawing that anatomy, is important. Drawing from life is the preparation and the warm-up for accomplished character animation. A concert pianist must go through extensive fingering exercises before a big concert. A ballet dancer or athlete has to go through stretches and warm-up exercises to prepare. In the same way, the animator needs to draw, their form of stretching and preparation for the main event, whether that event is using 3D software or the increasing imperative, the paperless 2D animation studio.

Once all the software, the plug-ins, the technical jargon, and the special effects mystique are stripped away, what remains is a fundamental need to understand the mechanics of the human body and how to represent these in form and movement. Ultimately, a true animation master will know how a body works and how it needs to move, based upon years of study, analysis, and practice (below left). So, where does this confidence and mastery come from? It comes from observation and application. In other words, drawing!

The old convention of three-fingered cartoon hands came from a need to economize from overly fussy drawing in animation, as well as a realization that four-fingered characters actually looked clumsy, like a bunch of bananas, when animated. Such defining conclusions came from trial and error when drawing such things over a long period of time.

Drawing Terminology

Having discussed how important it is to your experience to draw, it might be helpful to explain a few of the major drawing terminologies.

Point of View (POV)

The point of view (POV) is the view that the observer takes in when looking at a scene, from the side extremes to the extremes of top and bottom, as in this figure.

A low, behind-the-character point of view, adding a more original sense of drama and impact to the overall shot.

Horizon

The horizon is the meeting point between the ground and the sky from the observer's point of view (see below). If the horizon line is seen low in the shot, then the POV is high. Conversely, if the horizon line is high in the shot, then we are using a low POV.

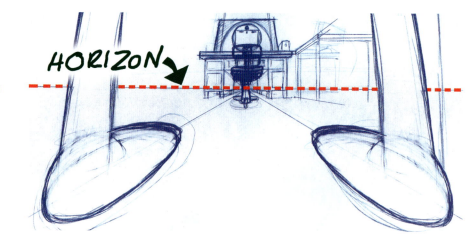

The horizon line.

Perspective

Perspective is the concept that all objects reduce in size the farther they are from the observer. For example, railroad tracks, observed traveling to the horizon, will give the illusion of joining together in the distance.

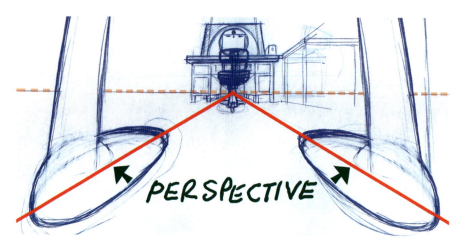

Perspective lines.

Vanishing Point

The vanishing point is the point on the horizon where parallel lines, such as those of a railroad track, wall, or building, seem to converge on the horizon line.

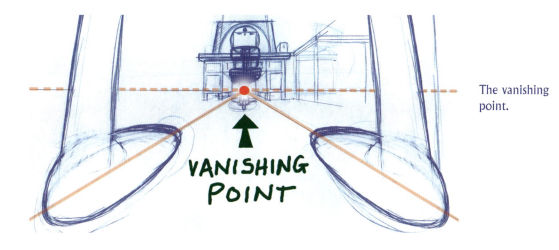

The vanishing point.

Foreshortening

Foreshortening is the illusion where the more an object is turned away from the observer, the more the parts of the object furthest from the point of view seem to recede, as if seen through a wide-angled lens.

By drawing the tip of the finger so much larger and the head and the shoulders of the figure so much smaller, the foreshortening effect gives the illusion of a greater depth from the front to the back.

Plane

A plane is a surface area that is limited by specific edges (usually vertical and horizontal, but not always so). Most objects are made up of surfaces which are themselves composed of planes, such as a box with its sides or a house with its sides and roof.

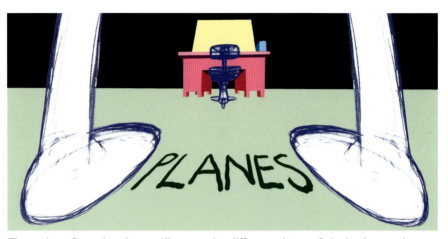

The various flat-colored areas illustrate the different planes of the background.

Drawing upon Life

As suggested earlier, if you are attempting to animate a complex sequence of body movements, I strongly recommend you act it out yourself, as slowly as possible, watching yourself in a large mirror. This is an approach that can be extremely instructive both visually and internally (in other words, you get to actually feel what the action is like). However, the most convenient technique of all is simply drawing as someone else slowly acts out the action, key position by key position. These sketches, however simply or crudely drawn, will be your most valuable research notes on the sequence you are attempting. If another person is not available for modeling, then try to find a movie or video footage that is close to the action being created. (Indeed, a valuable exercise for student animators to attempt is to take a favorite moment from a movie, then working with the soundtrack for timing and dialogue, try to recreate it in animation with different characters and different settings.) Using the freeze button on a VCR or DVD player will provide the same kind of key position studies that a live model would supply.

Any self-respecting animator should constantly refer to movement in life. Be amazed and intrigued by the sheer beauty and complexity that human movement possesses, especially when it is rehearsed movement and honed to perfection, like the movements of a ballet dancer, mime artist, or athlete. Such actions define, in a supremely pure and lyrical way, the kinds of movement all animators need to have stored in their memory banks for future use. Keep a sketchbook of observations of the key positions of these movements and you will have an invaluable database to draw upon, literally, at any time. My British Academy Award-winning film "Hokusai—An Animated Sketchbook" was entirely inspired by the artist's sketchbooks, an experience that opened my eyes to the value of observed and drawn movements from life.

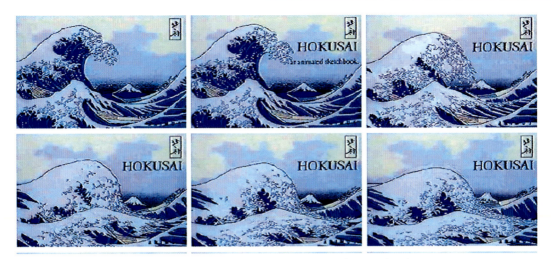

The impressive thing about all of Hokusai's work was the masterly way that he was able to define so much visual information using a minimal amount of subtle, well-crafted lines. Here, I took his famous "The Great Wave off Kanagawa" print and extended its dimension through time and space. Hopefully, I captured the spirit of his line technique also.

I have mentioned this elsewhere but I will mention it again as it is an important point to know. Tracing from live action (rotoscoping) is a process that can be valuable but it will never achieve the same quality and artistic spontaneity that sketched key frame action can provide. Using traced frame-by-frame drawings, as in 2D animation, will produce totally disappointing results as the movement will appear wooden, unreal, and soulless. It is quite surprising that this happens but time and experience have shown that unmodified tracings from live-action film material is never convincing from an animation point of view. The same applies to unedited mo-cap (motion capture) action for 3D animation. Both require key position editing by an experienced animator to make the movement look real, even though the original material has been faithfully taken from real life! To bring more reality to traced live action material, key poses often need to extend more dynamically, and the position and timing of the inbetweens need to change accordingly, to render the final action more real in animation terms than does the real thing simply used as it is.

This simply underlines that the additional something that the human element brings to life and technology makes the difference in animated filmmaking. It is in the caricatured expression of what is real, such as is achieved in observing and drawing, which translates the mundane into something much more real and convincing when it is animated. This can only really be achieved by drawing studies, by seeing what is there before your eyes, and then taking it beyond that reality to something that has a life and personality of its own.

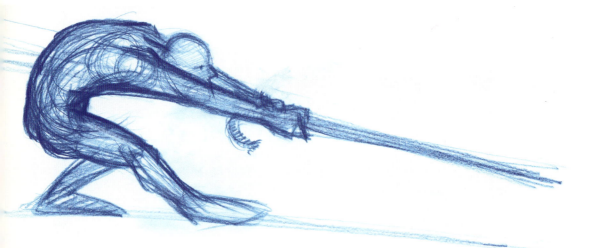

This was a simple 3-minute sketch preparing me for a scene that would require a character pulling on a rope. This was an exercise in understanding the dynamics involved. Maybe this is akin to a pianist doing their 10-finger exercises just before a major performance.

Through this process of looking, understanding and then drawing, the animator is able to take movement to another level, as did the great Disney animators of the distant past. With the masterpiece "Bambi," for instance, the animators spent a great deal of time drawing nature and animals (specifically deer) first. They brought animals into the studio to study and draw before they committed this movement to the drawn animated magic that ultimately emerged. Through drawing from life, they inherently understood the structure, movement, and personality of the creatures they would be animating.

Much of conventional 3D character movement still lacks that special ingredient that the best of 2D animation offers, that one organic step beyond reality that separates the artist from the technician. This is missing because the tendency of 3D animation is to ignore the observing and drawing process. Things are changing, however, principally motivated by the work of the great Pixar studio, which values drawing and the traditional principles of animation when developing personality and movement through the computer-generated medium. Of course, none of this means that to become a good animator you have to draw like Rembrandt or Leonardo da Vinci. However, it IS through the conscious practice of visually observing, interpreting, and then accurately portraying what is seen through drawing or sketching, that a real instinct and understanding of pose and figure dynamic will evolve.

Although not as powerful and elegant as the final pen and ink drawing I ended up producing, this early pencil sketch defines the basic pose and arced lines of force.

I initially wondered about the value of life drawing, especially when I was at art school. It seemed not to be such fun at the time, and for what? I was going to be a typographer and graphic designer after all! Life drawing, for me, was like algebra—remote and unnecessary for what life was about to require

of me. I have still never found any practical use for algebra in my life (not surprisingly though, as I'm not a scientist or a mathematician) but I am so relieved that I was made to appreciate the value and the necessity of life drawing when I ultimately took on animation as a career.

My teacher, the famous illustrator and cartoonist Ralph Steadman, taught me the value of observing and expressing what was seen through form, line, and shade. He was never one for the photographic representation of a model; he wanted it "down and dirty," accurate to the lines, volume and planes that made up the human figure. To our intense irritation at the time, he would sit down and carve into our neat and pretty first drawings, burying them in his broad-line, aggressive style of what we could only term "barbed wire." We so resented it when he started the process, burying our soft, tentative lines with strong black pencil strokes that we grudgingly began to appreciate when we understood what he wanted us to see. Taking us beyond the surface, we really learned how to see what was there, the underlying structures, the tensions in the skin and muscles and the effect that light has on form, enabling us to define it better. All this was tremendously valuable for my future, although the full value would not really emerge until the emergence of 3D animation demanded that I knew my subject in all dimensions, not just from the viewpoint of one, as in 2D.

Later in my career, while working for triple Academy Award-winning animation director Richard Williams, I attended life drawing classes specifically designed for animators. The purpose of these classes was not just to interpret the static form but to capture moments of movements in short-timed, more imaginative and relevant drawing exercises, such as asking the model to rise from a lying position, walk to a coat hook, lift a coat from it, put the coat on, and then walk towards an imaginary door. The model was asked to hold each successive key position in this movement for just a few minutes (sometimes for even just one minute!) and we were required to draw the essential proportions and dynamics of each pose. Each drawing (essentially a key pose sketch) was filmed separately for about 12 frames each, then played back to show the effects of pose and timing on drawn-from-life action.

Screen timing was never an important element in these exercises. What really mattered was that we observed and rapidly captured the essence and line dynamic of the pose the body was describing in each position. This is the essence of animation key framing and by attempting this through drawing exercises, we were much better able to appreciate just how much further the drawing could take the pose than the actual position we were looking at. This is no less true today for the computer-based character animator than it once was for the traditional pencil-based animators.

As a result of my learning to observe life and movement through this kind of drawing study, I have long been able to instinctively push key positions a lot further, and far more dynamically, than I would ever have dreamed of doing. The ability to caricature action can only be learned when combining the need to observe and analyze with the necessity to push and extend the nature of what is there. There can be no distinction in the benefits of these kinds of exercises for either 2D, 3D, or even Claymation animators; all are about observing the key elements of a movement, then expressing their essence and dynamic in a way that enhances the animation process. Learning to identify and then express this through the process of drawing is the fundamental requirement that underpins any understanding of life and movement.

Even as mature artists, we still require a childlike wonder when it comes to observing and understanding the world through our pencil-driven explorations.

Animation students should remember that the ability to draw is very much recognized in the major studios within the industry, and often even 3D animation companies will require an applicant to display a tightly edited portfolio of accomplished drawings. This can be a difference between getting a job or not. As far as I am concerned, if someone can demonstrate innate artistic skills that show an aptitude for understanding pose and movement, then they can easily be trained to push buttons on a computer. The reverse can never be true. I have even come across students who bring in films that have won international awards and yet they cannot draw a single strong pose or are unemployable because of their attitude or indifference to the work required of them. A developed drawing ability gives the animator, and student animator, a greater flexibility and versatility in moving any style of form of action in an accomplished way, whether the subject is Mickey Mouse, Buzz Lightyear, or the Mona Lisa.

10

2D Animation Overview

*Some of us have been 2D animators
for longer than we care to remember!*

The process of traditional 2D animation has been revolutionized with the advent of new computer technology over the past two decades or so. Today, with literally just a drawing board, a scanner, and the relevant software, anyone with knowledge of the animation process can make (and even distribute via the Web) a film. That said, 2D animation is still, at its very best, a painstaking, hand-made process that requires knowledge, drawing ability, and a significant amount of time and money. It must always be born in mind that it is not just tools and technology that makes good animated film. It all begins with a pencil and the ability to use that pencil. What ends up on the screen; that is, living, breathing characters that are alive with personality, is the one defining element that separates a great film from a mediocre one. Anything that falls short of this mark is just moving pictures.

Animators should always strive to push the expression of their characters to the limit. Here are two thumbnail pose sketches for a game concept; one is barely adequate, while the other takes the dynamics of the pose to a more acceptable level.

It's All About Pencils and Paper

It is surprising to me just how many individuals still prefer well-made 2D animated films to most 3D animated ones. Even among students and independent filmmakers, there is a resurgence of the tradition. The only danger in losing the big studio industry is the fact that the tradition of knowledge is at risk of passing away, with the loss of the long-cherished apprenticeship system, as well as the loss in continuity of knowledge and experience that this can bring. This is a fundamental reason I wrote this book.

The process of 2D animation is still slower than any other, is still more work-intensive, and is in many ways less flexible and adaptable than its 3D counterpart. But its inherent hand-finished nature offers a more organic, aesthetically unique, artistically excellent quality, like what the great Renaissance artist and painters gave their work. Traditional animation could easily become a much-prized art form that stands up beside Leonardo, Michelangelo, and Rembrandt.

Despite the technological revolution, 2D animation is still all about pencils and paper. There is no escaping this fact. The best drawn 2D animation can only be achieved by drawing, which means working on paper and then importing the image into the digital medium. Technically, it is possible to draw directly into the computer, but if full performance, crafted animation and subtlety is to be achieved, then the control of drawing directly into the computer has to be significantly improved. As it stands now, existent digital drawing tools may work for Web-quality animation but are still far too crude and uncontrolled to meet the standards of top quality movie productions. (See Chapter 14, "The Paperless Animation Studio," for more information.)

The earlier 2D filmmakers evolved a system of production that was honed to perfection through tried and tested methods over a period of many decades. Indeed, that system of production has barely changed in the new digital age and is still pretty much as valid today as it was in the old days of cel and film camerawork. (Refer to Chapter 7, "Digital Desktop Production," for an overview of the process.)

Script

As indicated in Chapter 1, "Development," the script is probably the most important stage of any film production. A 2D animated film script differs significantly from most others in that with traditional animation there is no flexibility of camera, shot, and lighting (as there is with 3D animation) or with the performers (as there is with live-action filmmaking). Everything has to be drawn, and once drawn it is very difficult (and expensive) to change things later. Also, being so time-intensive, 2D animation cannot easily handle subjects that involve hundreds and thousands of characters. "The Lord of the Rings" trilogy would be impossible to do in 2D animation! Extended dialogue also offers a challenge to the 2D animator that often leaves the material unconvincing or wanting.

Honor must be given to the contemporary heroes of the Japanese tradition for ensuring that the great art of pencil animation has explored finer and more imaginative worlds of expression than the West has ever dared consider.

Sometimes it's a challenge to pick the mouth position for fast-talking dialogue!

Storyboard

The storyboard is an indispensable element in the production of a 2D film. The storyboard will reveal significant plot and filmic deficiencies in the script before the extensive production effort is initiated. With larger productions, the storyboard may be created by a team of artists under the guidance of the director. With short films and commercials, however, it is quite often the director who will create the storyboard. (See Chapter 6 for more on storyboarding.)

An early "Endangered Species" storyboard concept I later rejected.

Soundtrack

After the script is finalized and while the storyboard is being created, the soundtrack can be produced. Since animation relies on an accurate synchronization of the action to the sounds, especially in terms of dialogue and lip sync, all the voice tracks have to be recorded and edited together before the animation stage proceeds. In fact, without a track edited to the final length of the intended film, the director cannot accurately plan and time out the required action.

The music "score," the background music that accompanies the action and dialogue, is usually recorded after the animation is complete. (See Chapter 5 for more on the process of creating a soundtrack.)

A good audio track is always important to a well produced animated film.

Track Breakdown

Once the soundtrack is recorded and assembled to length, the sound editor analyzes the track phonetically and records this breakdown to frame-by-frame accuracy on a master set of bar sheets. Traditionally, bar sheets were the essential timing foundation upon which traditional 2D films were constructed, although with new digital production software, sound breakdown information can now be saved in a computer database and printed out on a scene-by-scene basis when and as required.

Frame	Waveform	Phonetic	Word
70			
71		O	...over...
72		O	
73		O	
74		V	
75		V	
76		V	
77		R	
78		R	
79		R	
80			
81		F	...forty...
82		F	
83		F	
84		F	
85		F	
86		O	
87		O	
88		O	
89		R	
90		R	
91		T	
92		T	
93		E	
94		E	
95		E	
96		E	
97		E	
98		E	

Third Wish Software's Magpie Pro offers both a visual and a phonetic frame-by-frame reference for animators wishing to attempt tight lip sync.

Designs

While the soundtrack is being recorded, and perhaps before the storyboard is even started, the overall designs of the film are produced. The production designs on major films will include all the characters, meticulously drawn and defined in character model sheets, in addition to key concept art that will establish the mood and background stylings for each major sequence within the film. With shorter films (especially commercials), the single character designs will be created, in addition to perhaps just one piece of final background art that will establish the look of the backgrounds for the rest of the production. See Chapter 2 for more information on character and environment design.

Sometimes even thumbnail designs can go a long way to establishing the mood and pose that the final scene artwork requires.

Animatic (Leica Reel)

Combining the final track with the storyboard drawings, the director will create an animatic or leica reel. As explained in Chapter 6, the animatic is a filmed version of the storyboard, timed and edited to the established soundtrack. The animatic is an invaluable final check that the storyline, the soundtrack, the scene/shot selection, and the proposed timing and action continuity all work as anticipated, prior to the expensive animation production taking place. The animatic is also the director's final creative indulgence, where new thoughts, changes, and experiments can be made with no real cost to the production proper.

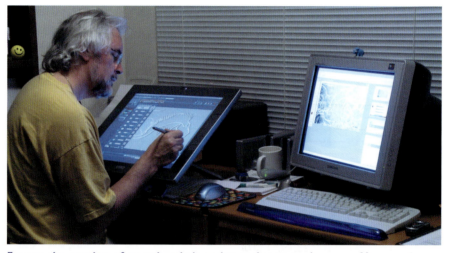

For me, the creation of an animatic is an intensely personal process. However, in big studio productions it can involve whole teams of creative people, all working together for a final result.

Layouts

Layouts are required to show the precise size, position, design, and location of everything in each scene. There are two types of layouts—character layouts and background layouts. The background layout defines the setting and design of just the background (everything that doesn't move), while the character layouts (one or more, per scene) show all the key action positions of the character on that background.

Each of the character layouts will also need to communicate the essential emotion, storyline, and major action poses in the scene, in addition to size and location. Ideally, with the layouts completed, the director/animator can shoot or scan them and have them edited into the existing animatic to create a more complete look at the film concept. At this stage, subtle fine tunings can be made to the timing and staging of the shots, prior to the irrevocable stage of establishing the dope sheets for each scene. For this, it pays to devote a great deal of thinking time to the project before animating.

The thinking you put into a project at the very beginning is always greatly rewarded by greater results you get out at the end!

Dope Sheets and Production Folders

With the final (layout) animatic in place, the film should now be fully constructed in terms of individual scene staging, timing, and action continuity. Consequently, the director can now establish the final dope sheet and production folder for every scene. The dope sheet is a detailed list of the action required, the precise length of the scene, the specific action timing within it, the layers of animated action required to create it, and the sound breakdown on a frame-by-frame basis. The director and/or editor will time out the length of each scene in the final animatic and mark up an accurately timed dope sheet for each. The dope sheet will indicate the start and end of the scene, the frame-by-frame phonetic analysis of the soundtrack (if this is necessary), and specific action notes defining what is required from the character's performance within that scene.

Without the dope sheet, the animator simply will not know how long the scene will last, at what places within the scene the action will happen, where the lip sync will occur (if necessary), or what the director is looking for in terms of character timing and performance.

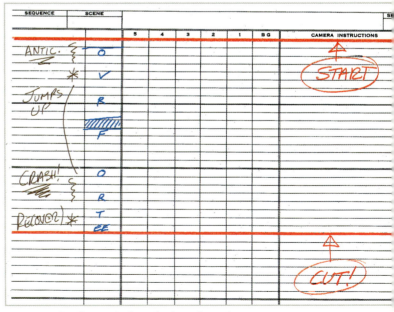

An example of a typical marked-up dope sheet.

With the scene dope sheet completed, the director will staple the necessary pages that relate to that particular scene together within an outer production folder cover so that pages cannot be separated or lost. The outside of the production folder contains space for the production name, the scene name and number, and any other relevant information that is required. Each completed production folder will be handed over to an animator when they are required to start on that particular scene. Occasionally, animators are required to animate through a whole sequence of scenes, in which case they will be given all the scene folders/dope sheets that relate to that particular sequence. (For more on production folders and dope sheets for 2D animation, see Chapter 11, "2D Animation Basics.")

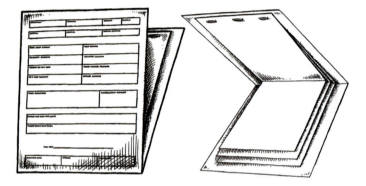

Dope sheets are usually stapled to the inside of the scene's production folder.

Pencil Tests

With the animatic approved and the production folders completed, the animator will be handed the scene production folder/dope sheets to animate it. The scene production folder will also contain the necessary layouts that will relate to that particular scene. With these, you will have all the information necessary to create the animation in that scene that will bring it to life. It is likely that you will also have a copy of the animatic of the film, to assess where the particular scene fits, where its action is coming from, and where it is going next. With all this information, you will be able to create all the key pose frames that will dictate the action.

An assistant animator will then take these key frames and provide all the inbetween drawings that link them together, based on your instructions. Then the entire finished scene is filmed to create a pencil test (also known as a line test in the U.K.). Pencil tests are quite simply the moving line drawings of the action, filmed and timed as requested by the director. When available, the pencil test is edited into the animatic and assessed to see if it needs any modification. If it does, then the scene will be passed back to the animator for corrections or necessary changes. If the pencil test is approved, then the scene artwork will be passed on to the clean-up or ink and paint departments for further work. By editing the pencil tests into the original animatic, the action continuity of the entire film begins to develop, giving the director a better idea of how everything is working in the entire entity.

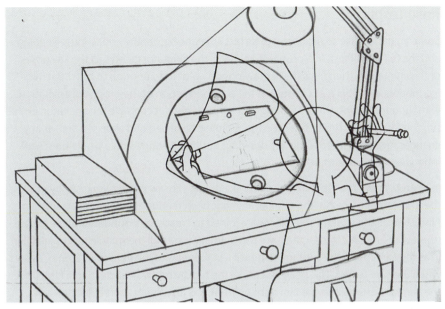

With a pencil test, the background shows through the character, so animators have to learn to read the action, even though the character is just an outline.

It's still better than in the "old" days, when the action was tested in negative form, as white lines on a black background.

Pose Tests

Some animators like to produce a pose test animatic before they go to inbetweening and the full pencil test. In a pose test animatic, the animator creates all the key poses of the animation, then films these drawings on holds long enough to cover the missing inbetweens. This gives a sense of the pace and action of the proposed animation without undertaking the actual slog of the inbetweens. It can save the animator, or the production, a lot of time if the pose test animatic is viewed and assessed first, as any changes involve just replacing key drawings and not having to do a whole bunch of inbetween drawings too.

In a sense, animated filmmaking can be like doing a jigsaw puzzle; you start by placing the four corner pieces in (the original animatic and creating the dope sheets for each film), then all the straight side pieces are joined to create the boundaries of the puzzle (the layout animatic and/or the pose test animatic), then all the middle pieces are filled in as they are found (by adding the pencil test scenes and the final color scenes, as and when they are ready). This really does take the headache away of creating a film. Once the animatic establishes the film right up front, it is just a matter of replacing each scene, at each stage, as it is completed, gradually building the entire project up from non-moving held images, to pencil tests cut to the timing of the audio track, to the final animated and colored action that completes the film.

Even the most basic of poses, created for the storyboarding / animatic stages of production, can avoid a lot of the headaches—and heartaches—of the animation process!

Clean-Up

On larger productions, it is often necessary to have a team of clean-up artists who take all the approved pencil animation drawings and clean them up, so the rough animation is tidier and more in keeping with the original character design style. The clean-up artist modifies any drawing flaws in the character drawings of each scene and applies a consistent line look to everything before it is scanned and colored. In smaller or lower budget productions, it is usually the animator (or even a capable assistant animator) who will ensure that the character is compatible with the approved character design, whether this is in shape, form, or line technique. (For a more detailed review of the clean-up process, please see Chapter 9, "Animating Step by Step.")

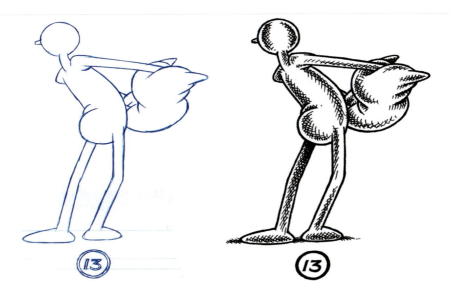

For most digital animation, I animate in reasonable detail using a blue Col-erase pencil, then clean-up on a separate sheet of paper using a black, fiber-tip pen.

Having a clean-up artist on the team takes a lot of pressure off the animator, because then you can focus solely on the fundamental action and performance and not worry about the finished drawing style. Released in this way, you can rough out the character in fast, basic shapes, rather than be bogged down by the minutiae of design detail.

I draw reasonably accurately when I animate my characters, thereby reducing the clean-up stage to more or less a tracing procedure. However, other animators can work very rough with their drawings, requiring a greater contribution from the clean-up department.

Ink and Paint

Once upon a time, the cleaned-up animation drawings would be individually traced onto separate, thin sheets of acetate, known as cels, then hand-painted in accordance with the original design. Now, the majority of productions are produced in a digital environment, so the drawings are first scanned, then colored electronically, using either bitmap or vector technology. This clearly is a faster and more economical way of working than the old time-consuming, space-consuming, and messy process of hand painted artwork.

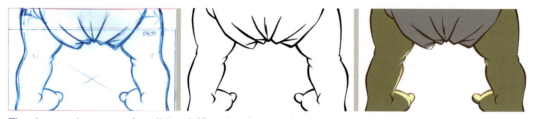

The three main stages of traditional 2D animation production: pencil drawing, clean-up, and coloring.

Backgrounds

While the animation is being inked and colored, the backgrounds are being created separately. Using the background layout drawings, the background artist creates one single, painted piece of artwork that goes behind all the animated action. The exception is if there are foreground elements that go in front of the animated action also, using the same painting technique as the background. In this case the background is created in separate layers, and the animation layers are composited between them.

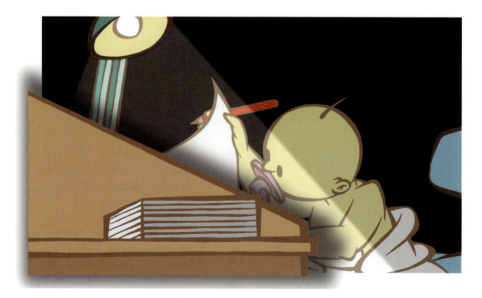

Here, I have separated the background elements (the light and chair) and the foreground element (the desk) to show how the animation level(s) (the baby) can be placed in the middle. The light beam is a special effect on a level behind the desk.

Backgrounds generally have to be colored consistently, in the style of the original color concept designs created for the project. Sometimes backgrounds are stand-alone pieces of art work and sometimes there are several matching backgrounds required for a number of successive scenes that make up an entire sequence of action in the film. Overall however, all the backgrounds in a film have to have a consistent color technique that is compatible with the line and color stylings of

My monochrome background art for a Max Fleischer-styled Ink Blot sequence in "Endangered Species," created entirely in Photoshop.

the animation as a whole. They can either be created using traditional techniques (i.e., paints, inks, brushes on watercolor paper, or boards) or else produced in a purely digital environment, using such programs as Mirage, Photoshop, or Painter. Backgrounds can be anything from simple colored approaches to intricate and masterly paintings that would impress even the most discerning art critic.

Checking

When all the animation artwork is colored and the background artwork in place, it is wise (on large-scale productions, at least) to employ a checker who can go through everything, scene by scene, to ensure that there are no mistakes and that nothing has been left out. The checker needs to be a meticulous, detail-minded person who is capable of going through everything in a painstaking search for any errors or omissions. Incomplete or incorrect material that has slipped through the cracks can be quickly or efficiently fixed before the scene is finalized. That way, a great deal of lost time and cost can be avoided if something goes wrong later. On smaller productions, each member of the production team will have to check that there are no mistakes in his or her own work, before the material moves on to the next stage.

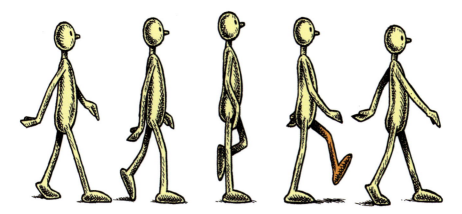

It is not uncommon for coloring errors to slip through the net on a pressurized production line. The checker has to be extremely vigilant so errors do not end up in the final production.

Final Shoot/Composite

Once all the artwork is completed and checked, it can finally be composited together. Traditionally, painted animation cels and background artwork were filmed, frame by frame, onto 16mm or 35mm film using a specialized rostrum camera. Today, the bulk of compositing is done in the digital environment, where the various elements can be combined and processed filmically within a single desktop computer. Using the animator's dope sheets, the compositor (or cameraman, if a traditional cel film is being made) will assemble everything contained within the scene —animation, backgrounds, and special effects, etc.—into one complete entity. Output is either to a digital medium (hi-definition, or QuickTime, Windows, or Flash) or else is rendered further onto cinematic film for public exhibition. This is done on a scene-by-scene basis until the entire film is complete.

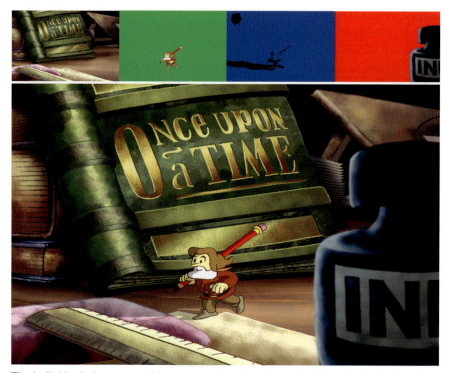

The individual elements within a scene: the character animation, the background art, the shadow effects, and the final composited image.

Final Edit and Dub

With everything composited, it finally falls on the production editor to bring all the separate scenes of animation, as well as all the audio elements (dialogue, music, narration, sound effects, etc.), together to complete the final film. With the final edit, scenes are cut together in sequence, in accordance with the original timings of the animatic. Dialogue and sound is synced up to the final picture and any additional sound effects required (known as Foley sound) are recorded individually and then synced in with the final picture too. Lastly, the music (if required) is brought in and all the audio elements are combined, mixed, and balanced into a final master track at the dub stage.

The Tools of the Trade

2D animation has its own unique technical practices and procedures that you need to know before work can begin. Although many aspects of animated filmmaking overlap with other forms of animation—some even overlap with live-action production—certain tools, technologies, terminologies, and techniques specifically apply to 2D animation only.

Lightbox

The lightbox is such a traditionally important asset in the animator's toolkit and, unless working in an entirely paperless environment, it is almost impossible to work without one. However, as an animator (or their assistant) becomes more and more confident, the use of the lightbox should not become a dependency. Most (aside from the very finest-moving and detailed) inbetweens can pretty much be done by eye, without the use of backlighting, once the artist's visual judgment is finely honed enough. The use of flipping (covered in Chapter 11, "2D Animation Basics") and just by getting a feel of the character and its movement should enable an animator (or assistant animator) to create more accurate and confident inbetween drawings.

The use of a lightbox is absolutely essential in a tight inbetween situation or when tracing back an existing drawing. When you can avoid the use of a lightbox for everything without error, however, you are probably ready to make the next step towards graduating to an animator in your own right. That said, it will still take a fair amount of time for you to reach the stage where both accurate and good quality inbetweens can be produced.

Lightboxes come in all shapes and sizes; the standard lightbox is basically a large, wedge-shaped box with a cold light bulb lamp inside and a white, translucent, Plexiglass® (Perspex®) top surface that can handle sheets of paper up to 16 inches wide. Professional lightboxes either have the large, drawing area of Plexiglass cut into a circular shape so it can rotate for animation viewing from all angles, or else the circular section is removed entirely and a precision-made, fully rotating animation disk is inserted into the hole, providing an even better drawing and animating opportunity. But even a sheet of Plexiglas sheet, propped up against some books, with a cold light beneath it and a peg bar taped to it, will do. However, conventionally useable lightboxes (below) range from the inexpensive LightTracer II, to the state-of-the-art Wacom Cintiq which enables the animator to draw directly into the computer, eliminating the need for paper entirely. (More on this in Chapter 13, "The Paperless Animation Studio.")

A traditional LightTracer II (left) and a Cintiq digital tablet (right).

Peg Holes and Peg Bars

2D animation requires that each drawing be registered with the others to prevent any slipping or sliding while drawings are being created or scanned. The industry has created a peg bar registration system—each sheet of animation paper has consistently punched peg holes that fit snugly over a peg bar fitted to the lightbox. The same process will then be used when the drawings are scanned. In this case, the peg bar is taped to the side of the scanning area so that every time a drawing is scanned, it is positioned consistently with every other animation drawing in the sequence.

Taping the peg bar to the side of the scanner ensures that drawings remain in registration.

The most popular peg bar system is the Acme peg system, which consists of a round peg in the center with horizontally elongated pegs on either side of it. For really low budget, home-based productions, it is perfectly acceptable to use a standard three-hole (U.S.) or two-hole (U.K.) office punch for registering drawings. The two-hole approach does mean that a custom-made peg bar will have to be created for the animation desk/scanner, probably using the correct sized wooden dowels as the registration pegs, as outlined in "The Animator's Workbook." (However, I have heard that similar peg bars are available from one or two online suppliers.) Of course, Acme peg bars and hole punches can be obtained from just about all animation supply stores or Web sites, as can pre-punched animation paper of all sizes. Unpunched animation paper is also available for those animators who have specific hole punching needs, or who have already purchased an Acme hole-punch.

A standard Acme animation punch.

Peg-Bar Registration

The animator's peg bar needs to be permanently taped to the side of the glass viewing area to maximize the drawing area (field size) to be seen by the scanner. Invest in a good, thin, aluminum peg bar. Other peg bars, such as the cheapest plastic ones, are usable, but the thickness of their base means that the paper is slightly elevated when positioned on them. This can lead to a slight inaccuracy when scanning.

Tape your peg bar in a position to maximize and keep consistent the scanning area.

Field Sizes

The size that a 2D animator ultimately has to draw to is known as the field size. Field sizes vary according the nature, genre, and budget of the production. For example, in the interests of economy and affordability, animation students will usually work on standard letter paper, which will give them something like a 10 field to work on, which means that the drawing area they will be working to is 10 inches wide and whatever that makes as a height dimension (depending on what screen ratio they are working to, such as Academy, widescreen, hi-def, etc.). The paper they will use will therefore be either 11″ x 8.5″ in the U.S. or A4 in Europe, because this is the cheapest available. In the professional world of animated filmmaking, however, there are two essential sizes: 12 field or 16 field (15 field in the U.K.), meaning that the width of the drawing area for each is 12 inches across or 16 inches (15 inches in the U.K.) across by whatever the screen ratio height is. The 12 field size is the one most used for the majority of animation projects that are seen on a TV screen or computer monitor.

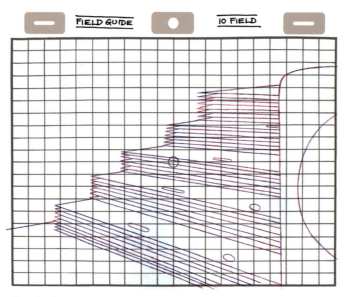

This background layout for "Endangered Species" has a 10-inch field guide superimposed over it, to indicate the area of the artwork that will appear on the screen.

The three most frequently used sizes of animation paper: 10 field (mainly student and independent productions), 12 field (non-movie productions), and 16 field (movie productions).

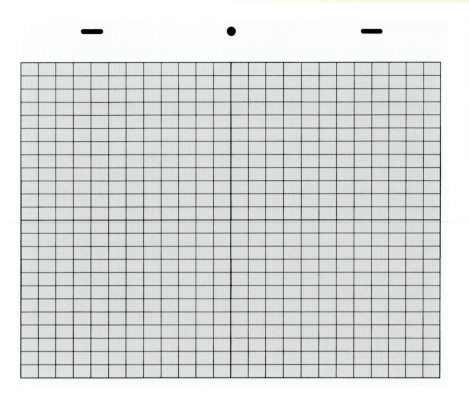

This is a standard, 12 field guide (graticule) which has the visible screen area shaded for clearer recognition.

The 16 field (15 field in the U.K.) is used for most movie work, because the greater drawing detail afforded by the larger area creates a better finished film for projection on a large cinema screen. Animation paper suitable for all field sizes can be obtained from most regular animation art stores.

A 16 field graticule, similarly shaded.

Field Guides

One important aspect of 2D animation layout work is the framing required within the field area. Most scene staging will require that the whole field area is all the camera will ever be required to see. Therefore, the framing of the shot will either be a standard 10, 12, or 16 (15) field. However, on occasions, it may well be that alternative framing of the artwork is required, for example, when the camera is moving from one part of the shot to another. The filmmaker might want a close-up of just one part of the shot to begin the scene with, then have the camera zoom back to reveal the entire field by the end. To illustrate this to the animator, it is first necessary to accompany all the layouts for any particular scene with a chart of specific framing references, known as a field guide, that define the precise areas to be zoomed into or zoomed out to.

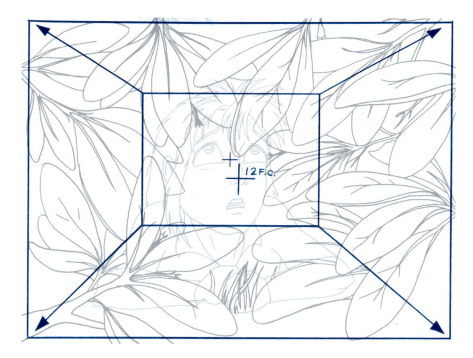

A typical scene field guide, indicating the appropriate zoom-in required for that particular scene. FROM "THE CHANGELING" BY SAILLE SCHUMACHER.

To create a field guide, the layout artist uses the appropriate size graticule that is necessary to the scene or production. Graticules come in several sizes (the most typical being 10, 12, or 16 field) and are divided up into specific field grids which contain numerous cross points to assist the animator in locating specific points within the overall field.

Graticules are naturally shaped in accordance with the proportions of the screen ratio format being used, i.e. Academy, widescreen, hi-def, etc. The various cross points of the grid offer location points within the graticule that the layout artist can refer to when identifying the center of any framing and the different field sizes (framing) chosen will represent the area of the shot that the camera sees when positioned on that center point. The center point is the central location where the horizontal center line and the vertical center line intersect. A properly drawn field guide will therefore show the parameter of the screen's view, plus the center of that area (the field), the field centers, and the

direction of moves from one framing to another, as dictated by the needs of the shot. Needless to say, it is important that everyone on the production uses the same reference indicators, so that no misunderstandings take place.

The center of a full 12 field grid is always defined as a 12 F.C. and the center for a 16 (15) field is defined as 16 (15) F.C. These centers will define the key central measurements of all the other location centers identified in the field guide.

The entire grid of the 12 field graticule is divided into 24 sections: 12 units on either side of the horizontal center line and 12 units on either side of the vertical one.

Directions around the grid are defined from the key center position, indicated as west, (left of the field center), east (right), north (up), and south (down).

The compass directions indicate placement of elements relative to F.C.

The size of the smaller frame required within the full frame area (such as when indicating a zoom-in or a zoom-out) is known as its field and can be anything from a 2 field up to the full field.

The location points for smaller fields (frames) within the main field are always determined by their center position, measured out from the full field's center position.

The center of the 8 field is located three fields south and three fields east of the 12 F.C.

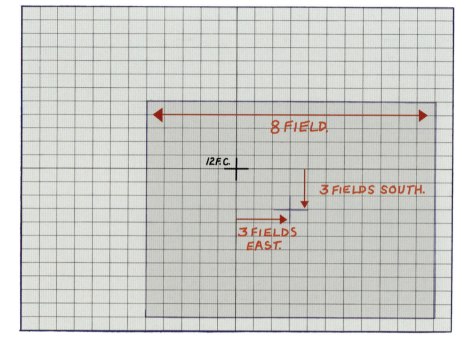

With all this in mind, a standard 12 field guide should always look like the one below.

The actual 12 field area is shaded in for clearer recognition in this illustration; normally it will be left white.

This field guide establishes that you have to draw within the 12 field area; anything drawn outside of that area will not be seen. Sometimes, due to production error, the cameraman and/or scanner operator may not precisely line up with the full 12 field guide and so the drawing may not reach fully to the edge of the screen on one or two sides. Therefore, to avoid lines that end abruptly like this, you should actually draw a little outside the field guide area. This extra drawing outside of the full frame is known as the bleed area, which only needs to be about a quarter of an inch or so all round.

Images should bleed a little outside the field guide, to protect against accidental trim in scanning or filming.

When the camera is required to create a close-up framing within the full field area, then a field guide showing both the start and end positions of that move, and the direction of the move, will need to define everything visually. For example, a scene that starts with an 8 field that is centered in the middle of a 12 field, then moves back to reveal the full 12 field will look like the figure below. (The shading is for illustrative purposes only and is not included in production work.)

The framing and arrows indicate the start and end for special framing and camera motion.

Alternatively, if the 8 field framing needs to be off center and maybe start at the top-right of a 12 field set-up, then the field guide for this will appear as in Figure 10.37. Note that now the center of the 8 field is not the same center as the 12 field; its center is indicated with a grid reference that is now north and east of the 12 F.C.

This field guide indicates an off-center opening that zooms out to show the full field.

Similarly, if the animator wants the scene to end up on a 16 field but starts out (a "track-out" in 2D animation terms) on a 6 field, centered at four fields north and six fields west of the 16 F.C., the field guide will look like the figure below.

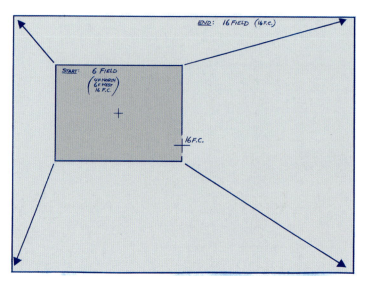

Another tracking-out field guide. If the scene were a track-in (if the camera started out on a 16 field and ended up on the 6 field), the arrows and the start and end indications would be reversed.

Of course, field guides depicting camera movement within a scene were far more relevant in the pre-digital days, when the rostrum cameraman literally shot the artwork frame by frame over the areas indicated. Nowadays, in the digital era, the full screen artwork is scanned, colored, and composited and the camera moves are often added afterwards. This means it is not necessary to limit drawings to cover the visible areas indicated by the field guide. Indeed, in certain aspects of 2D digital animation, it is quicker and more efficient to actually draw the full field artwork and program the camera moves afterwards. Nevertheless, if you know from reviewing the field guide, the approximate areas that will be seen eventually, you can place special emphasis on the action within the visible areas.

Field Size Limitations

Although traditional 2D animation has always defined the 12 and 16 field sizes as being the norm, the reality of much desktop digital animation hardware is that these sizes may not be possible for many filmmakers. 2D animation also used to be shot on rostrum cameras that could easily cope with these field sizes but, today, most animation is scanned in on regular scanners, hence the problem of this field sizing. Most scanners only accommodate a letter sized scanning area, which, at maximum, will only provide for approximately a 10.5 field in the Academy format.

In most cases, the reasonable expectation of a 10 field Academy field size is the most likely. Of course, some independent animators (and most studios) will be fortunate enough to have larger scanners, which should comfortably provide for a 12 field and possibly even allow up to a 16 (15) field size.

A large-sized scanner with a 16 field drawing ready to be scanned.

Clearly, hardware capabilities will profoundly affect the kind of field sizes an animator will have available to them when working, meaning that most individuals outside of the professional studio set-ups will most likely be working in the 10 field area. In such cases, it is important that a 10 field graticule be created by the animator before they begin their work. In fact, the animator is advised to always line up the scanner (or video camera, if the animation is being filmed digitally) with the appropriate field guide or graticule before the scene is recorded, as the equipment positioning could have been changed by others. Not doing so runs the risk of the animation not being positioned correctly.

The original layout for this scene in "Endangered Species" was created based on a 30-inch field size.

Overlarge Field Sizes

Occasionally you may need to work larger than even the maximum 16 field standard field size. This may occur when an extreme wide shot of a scene is required, or else with a long panning sequence that reaches out beyond the maximum standard field size. If the 2D animation is a vector-produced project, then this is not such a problem, as the great advantage of vector animation is that it can be zoomed in or zoomed out without any screen pixelation or detectable loss of line and edge quality. (See Chapter 13, "2D Vector Animation," for more information.) The figure below shows an example of a vector-based zoom-in (top), and a zoom-out move (bottom).

Zoom-in on a vector-based animation.

Zoom-out on a vector-based animation.

However, for 2D bitmap work it will be necessary to draw larger and scan larger. To be able to draw larger than the maximum standard 16 field, the animator must first find the largest scanner available. In the U.S., photocopy chain stores such as Kinko's often have larger sized scanners available to customers. Professional scanning agencies will most definitely offer even greater scanning area opportunities, but these facilities may not be in the geographical (or financial) reach of most independent or student film-makers. It is possible to scan sections of the artwork and then tile them together in a program like Photoshop later.

Large images can be broken into pieces for scanning and then reassembled digitally.

If larger-size scanning is absolutely not possible, it is far more sensible for the filmmaker to quite go back to the drawing board (literally and figuratively) to re-storyboard the entire sequence to avoid the larger scene. If facilities for larger sized scanning are available, however, you will need to establish the maximum field size you can scan and then plan the layout artwork to accommodate that. The layout artist (and animator/background artist) will need to draw everything on paper that is larger than the normal 16 field available to them. Large-sized paper can, of course, be bought from paper suppliers or non-animation paper can be punched to accommodate registration.

Pre-punched animation panning paper.

The only real registration problems that might arise with larger-sized animation work is that it is extremely easy to accidentally jog large sheets of paper from side to side as the drawing hand moves across it. Slippage distortions from drawing to drawing will produce pronounced jiggle on the screen when the animation is shot, almost certainly meaning that the whole scene will have to re-animated and re-shot. The most guaranteed way to avoid this problem is to tape down the sides of the paper before you start drawing.

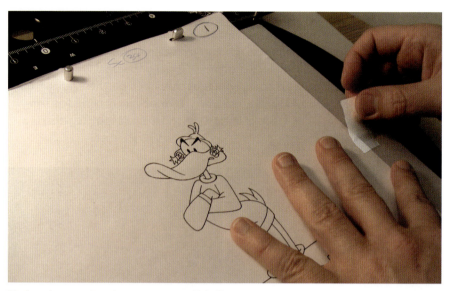

Taping down animation paper to avoid slippage.

Large-scale animation drawing is clearly not an ideal way to work, but with a careful approach to this kind of work it need not be catastrophic.

TV Cut-Off and Safe Titling

It used to be that when film was shown on TV, there was a huge cropping of the outer image at the edges, sometimes losing one or two fields! Nowadays, with improved technology, this is not quite so true. However, cropping still does occur in certain areas where TV technology or reception is bad. As a result, a safety net system has been adopted to help ensure important imagery is not lost. TV cut-off or safe titling should be built into every layout (except Web animation, which has no screen cropping complications).

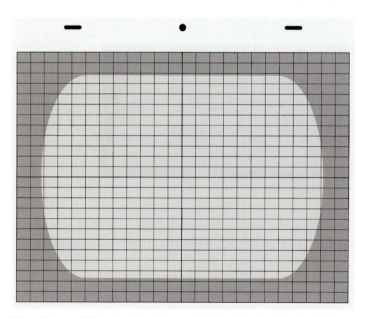

The older, traditional animation graticules often had a shaded area around the edges to indicate the TV cut-off or safe titling area.

TV Cut-Off

Essentially, TV cut-off assumes the most extreme loss due to cropping, one to two fields around the outside of a 12 field, or two to three fields around outside of a 16 (15) field. As a result, everything of importance that needs to be included in a layout should be drawn within the safety area of the TV cut-off.

This precaution is especially relevant in advertising, where the product shot may be placed too far to the edge of the field, only to have it cropped in the TV cut-off area during transmission. An advertiser who has spent tens of thousands of dollars (or more) on a commercial will not want to have the very product being advertising cut off, or partially cut off, on the screen! On all large productions where the layout artist is not the animator, the layout artist should always clearly indicate the TV cut-off area on every field guide (maybe even in a different color) so that both the animator and background artist are aware of the danger areas.

Safe Titling

Around the edges of the average TV screen, there is a slight fall-off in shape and definition, dependent on the nature of screen used. This fall-off may not be noticeable on moving and still photos, but with text and graphics it can be very obvious. An additional safety area, called the safe titling area (one to two fields, depending on the size of the field), has to be established for all text, graphics, and credits. Safe titling is especially important in advertising and TV titles work where any form of distortion and fall-off can be critical. Graticules that show TV cut-off and safe titling have been devised which look like this figure.

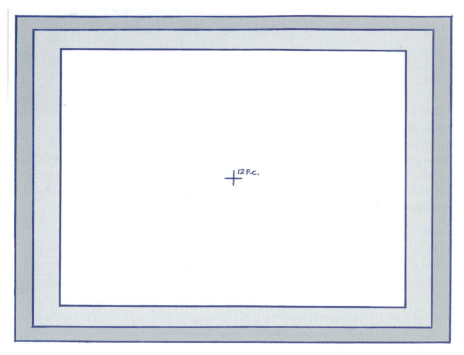

Although perhaps an extreme example, filmmakers are nevertheless recommended to work within this kind of safe titling area when integrating text into their animation.

"Endangered Species"

The layout stage was one discipline of the pre-production stage that I did most studiously adhere to. Once the animatic content and timings were finally established, I was free to focus on the precise layout designs that would ultimately dictate the nature of the animation.

The layouts for the historic sequences in the film were fairly well-defined before I had even started. It had always been my intention to work out how the original masterly animation of these sequences was done, re-produce them in the film and then communicate the knowledge of how it was done to the readers of this book. It was a relatively easy task to study the layout design of the original scenes and then re-design them to suit my own design requirements. The layouts could not be an exact reproduction of the originals, of course, as this would not suit the particular scenario of the sequence in my film, plus it might infringe on the existing copyright. But it was the spirit of the scenes I was attempting to capture, both in the animation and the background design, not their visual exactness.

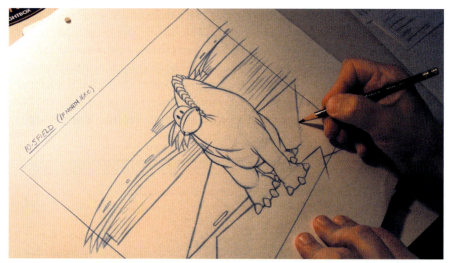

In the dinosaur sequence of "Endangered Species," I was keen to maintain the essential spirit of the original Gertie film, without compromising the original's copyright. Clearly, the background is fundamentally different to the Winsor McCay version but the dinosaur was harder to modify. I settled for having my Animaticus character spherical-head style but with a snout mask to give a basic dinosaur head appearance.

The vector animation sequences were more liberating in some ways; since they weren't inspired by original footage, I had more creative freedom. Nevertheless, I did have more than one attempt at some of the scenes, as more interesting ideas emerged when I saw what I had initially done edited into the completed animatic. Realizing that some could be improved, I either repositioned much of the imagery or started from scratch and created an entirely new layout design for the scene. At no point, however, did I dare animate anything prior to being totally satisfied with the layout, as I was not prepared to re-animate scenes that did not work in the final analysis. (I don't mind spending hours and hours to create original animation, but I totally hate having to change things after they are finished, even though this can be necessary from time to time!)

For the most part, I produced layouts in either a 12 or a 16 field size. I actually preferred working in 16 field. I have always tended to work on a 12 field with most of my work, especially TV commercials, so the move up to 16 field gives me the sense of greater movie-scale expression that a lot of the original inspirational material was based on. At the same time, working larger means that the footage is more costly to produce and more time-consuming, due to the additional pencil mileage that larger drawings require. I tried to find a middle ground, restricting my larger field work to the scenes that would benefit from this extra size dimension.

An example of three different animation layout sizes: a double 12, a single 12, and a single 16 field.

The layouts were drawn using nothing more than a standard blue col-erase pencil, which is my favorite for animating. I began by creating a field guide for whatever scene I was about to work on, which I finally outlined in a thick black ink line. This provided a good framing template within which I could draw my finished layout. (Also, when setting up the framing for the scanning of the animation drawing later, it offered a clear and precise framing guideline that is easily detected by the scanner.) Then, with a new sheet of paper over the field guide template (on the animation pegs), I roughly and lightly sketched out the layout design I had visualized in my mind or liked in the existing animatic sketch.

Accurately drawing out the framing edges.

Working extremely roughly and lightly, I was able to immediately get my initial ideas down in a way that I believed would work best but, at the same time, I could easily erase and work over them again till I achieved what I wanted.

Roughing out a drawing, then cleaning it up using the same blue Col-erase pencil.

Once I finally had the layout sketched out the way I wanted it, I rubbed down the lines until they were just light enough to see (using a kneadable eraser, which works best for this purpose, as shown below), then I drew over them with the heavier clean-up line, so that the layout drawing was good enough for final scanning and editing into the revised animatic. Alternatively, if my rough sketch was too heavy to easily erase, then I would place a fresh sheet of paper over it and draw a cleaned-up version on this new sheet until I had created what I needed for scanning (the figure at the top of page 327).

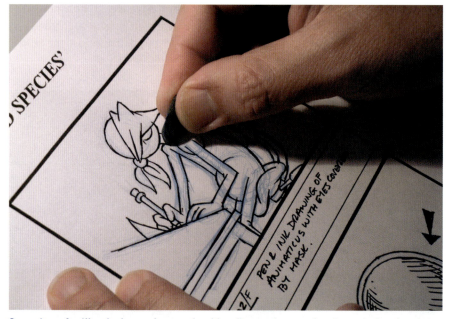

Sometimes I will rub down the surplus blue lines prior to cleaning up the drawing in pencil or pen, or else I will clean the blue off after the drawing has been cleaned-up (as indicated here).

Inking in on a separate sheet of paper.

This was all well and good when the layout I was drawing was the static pose of a character plus a background; it could all go on one sheet of paper. However, if that character in the scene was required to indicate several actions within the scene, I would separate those character poses from the background design and create a different layout drawing for each one. This completed, I would subsequently number the background layout as BG 01 and the animation level drawings as 01A, 01B, 01C, etc, of course adding the number of the scene to each layout sheet too. For example, the figure below shows a two-layer composition, one for the animation of the pencil character and the other for the background. When the pencil throws the papers into the air, I placed the animation of the paper on a separate layer. This enabled me to hold the pencil in the throwing pose while the papers continue to fly about.

An initial layout for a two-layer composition.

Once I created my layout drawings, I scanned them and edited them into the final animatic, to get a better representation of how the animation would ultimately look. To combine the animation layouts with the background layout for each edited frame, I would first import the scanned files into Photoshop, assemble them as appropriate layers, and then merge these so they became a single file that could be imported into Premiere for the animatic editing.

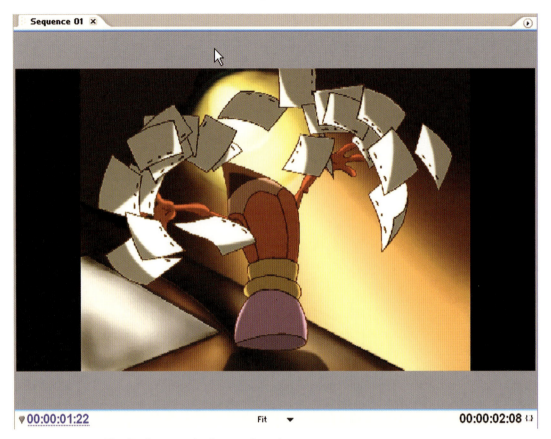

The final, composited paper-throwing scene.

I also used Photoshop to intensify the drawings (or increase their contrast) at the same time, if the original pencil images were too light to read clearly when viewed in their animatic form.

When producing layouts for "Endangered Species," I avoided scenes that required camera moves because I didn't have any standard panning mechanisms available. The pen and ink illustrations that were used for most of the narration scenes were the exceptions. The minimal movement within these was created in the computer so that there was some kind of life and movement in them. Otherwise, they would be just long, static shots with nothing at all going on.

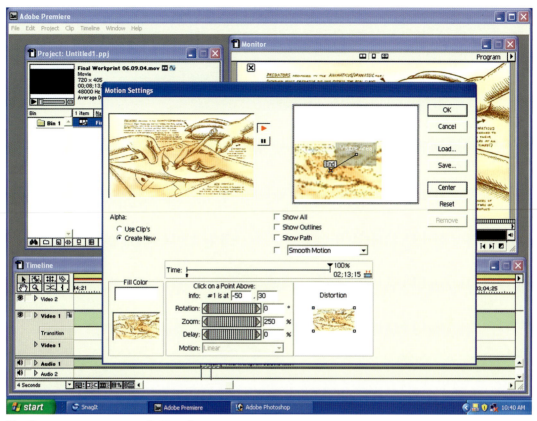

Plotting out camera moves in Premiere.

I achieved the in-shot movement with either the motion function in Premiere or dedicated hi-definition software. In general, I find that digitally constructed moves (other than the basic creeping in and creeping out of the camera) are never as good, or are never as visually satisfying, as the old, traditional rostrum camera-based ones that were hand-crafted by the cameraman or the animator. I am sure that an experienced user of dedicated programs like After Effects can achieve quite sophisticated camera movements. However, I still most definitely prefer the old technique of actually hand plotting onto the layout the frame-by-frame moves that the camera needed to make for all panning and zooming shots, which the rostrum cameraman was able to manually plot to the side of his camera as he shot the scene. This is not to say that I was never happy with the moves that were created for "Endangered Species"; I most definitely was. It's just that in a day and age where digital technology answers the prayers for most filmmaker problems, it's sad to know that the more organic, hand-crafted skills of traditional camerawork can no longer find a place in the contemporary digital production line.

2D Animation Basics

The best animation is all about pose and timing.

2D animation is not just a matter of sitting down at a desk and producing an endless sequence of drawings without any planning or forethought. The very best of animation utilizes a large array of processes and techniques that ensure that it is achieved competently and moved in accordance with the animator's (and the director's) wishes. The following is an explanation of the most important processes and techniques that go into successful 2D animation. It is theoretically possible to animate on "a wing and a prayer," but the techniques explained here will provide a surer way of achieving what is required.

Keys, Inbetweens, and Timing

The one thing that differentiates 2D from other forms of animation is that it is based on a fundamental two-fold approach toward movement: keys and inbetweens. Keys are called that because they represent the key positions in any movement. For example, if an arm is pulled down, a drawing of the arm's up position will be created, then a drawing of its down position (below).

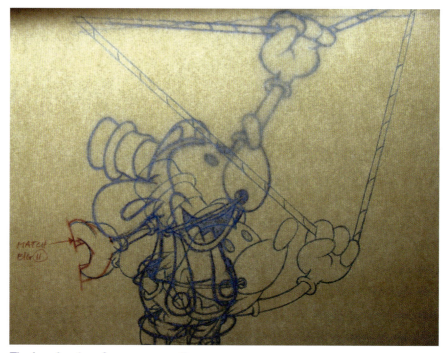

The key drawings for an arm motion.

All the drawings between the two key positions are known as inbetweens (next page, top). The skill of the animator is to identify and create all the essential key positions within a movement, then know how many inbetween drawings are required to make the movement between them work.

Note that with this action there are four inbetweens placed between the two key drawings.

The latter skill is known as timing, which is something that takes a great deal of experience to appreciate fully. In other words, the more animation you do, the more you learn what works and what doesn't. This is the way of becoming a master. Nevertheless, even a rudimentary application of these basic principles will bring good results if understood fully.

By way of illustration, a character is lifting a sheet of paper on a desk. The down and up keys would be 1 and 9 respectively, seen below. The first inbetween, positioned exactly midway, would be 5 (top of page 334).

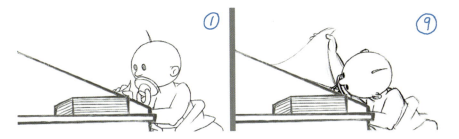

The simple process of lifting a sheet of paper is numbered as key drawings 1 and 9.

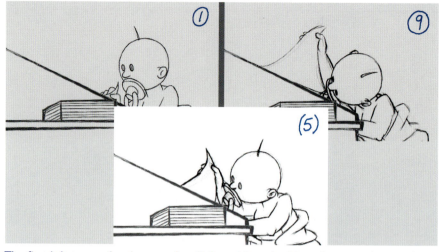

The first inbetween drawing, number 5, is positioned midway between the two key drawings.

If these three drawings alone are filmed at 24 fps, the action will barely take the blink of an eye—a quarter of a second if the drawings are shot on twos! To slow the action down, more inbetween drawings have to be added. Adding just two more inbetweens, 3 and 7 (below), will make the action now last not quite half a second.

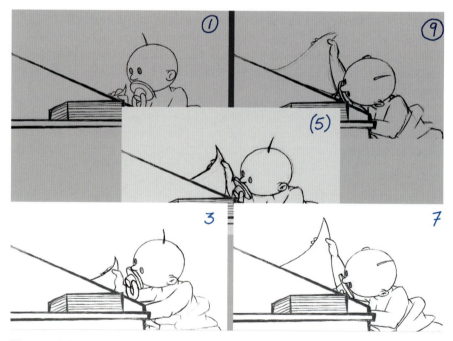

The next inbetweens, 3 and 7, are positioned in the middle of drawings 1 and 5 and 5 and 9 respectively.

More inbetweens will make the lift even slower, depending on how many inbetweens are actually added. This illustration shows inbetweens for each existing drawing pair (2 between 1 and 3, 4 between 3 and 5, etc.), making it almost twice as slow again.

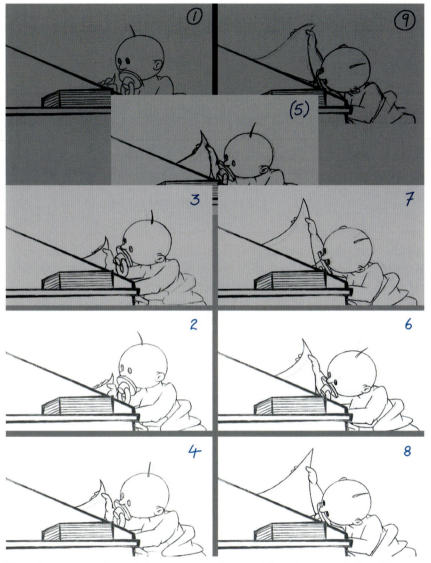

Now the even-numbered inbetweens are drawn midway between their odd-numbered counterparts.

Charts and Inbetween Counting

To communicate the spacing and numbering of inbetweens from one numbered key drawing to another, you need to draw a simple chart on the first key drawing to indicate how many inbetweens you want and how they are to be arranged. A typical animator's chart for this particular sequence on twos is shown below.

This chart shows three inbetweens linking the two keys. Again, these are indicated using odd numbers, suggesting the animation will be shot on twos.

If you wanted to inbetween the action further, the chart would look like this.

Now the inbetweens include even numbers also, giving the option of shooting the action more smoothly on ones, or doubling its screen time by shooting the drawings on twos.

The middle inbetween, 5, is indicated in parentheses on the chart. This is because it is the central inbetween and needs to be created first. This first inbetween drawing is always known as the breakdown drawing. For added clarity, the breakdown drawing is always indicated above the chart line, and the key drawings are always circled. The secondary inbetweens are numbered normally, without circles or parentheses. This establishes a visual hierarchy to help the assistant understand the animator's intentions for the inbetweens.

When a large number of drawings are being inbetweened in a chart, numbers written above the chart line indicate frames that should be drawn first, and frames last in hierarchy of completion will appear beneath the line. Consequently, an assistant animator confronting the chart in Figure 11.8 will first inbetween the breakdown drawing (5), then the odd inbetweens (3 and 7), then the even inbetweens (2, 4, 6, and 8).

Ones Versus Twos

Animation on ones is used when the action is very broad-moving or fast acting, or if there are sections of that object that overlap the same object in the preceding and subsequent frames. It is far easier for the eye to follow the action of a quickly moving object if there is a different drawing for every frame. This gives a much more fluid, smoother look. Where the same fast action is animated on twos, the movement could be as fast but it would appear choppy, or staccato, with much less of a natural smoothness to it.

For example, in the following figure, the body of the skidding character is central in the frame and the background pans past behind it; the character's body will always need to overlap the body on the drawings before and after to achieve a sense of smoothness. As a result, I could animate this scene on twos, even though the background panning behind it is moving on ones. However, if there was no overlap with twos and the character was traveling quickly across a static background, the animation would have to be inbetweened on ones; otherwise it will appear jittery or jerky.

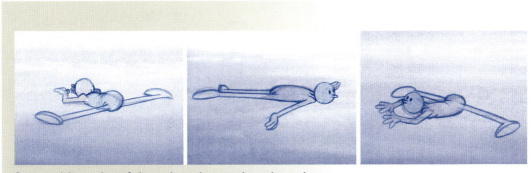

Scenes with overlap of the main action can be animated on twos.

It is important that you clearly communicate your intentions for the numbering and positioning of inbetweens to the assistant animator, which is why understanding the key charting system is so important. The chart is usually placed on the first of the two keys, between the center peg hole and one of the outer ones. Also written beside the peg holes is the drawing number, the scene number, and maybe even the sequence number (on larger scale productions).

Looking at the chart below, in the distant days of Disney animation, drawing 5 would have been termed the major breakdown and drawings 3 and 7 the minor breakdowns, with the rest called inbetweens. Most studios today would just use the terms keys (1 and 9), breakdown (5) and inbetweens (2, 3, 4, 6, 7, and 8). The key animator is generally responsible for the keys, the breakdown, and maybe parts of the more important inbetweens (the minor breakdowns), although though this will vary from key to key. In the case of basic animation, the key animator will just draw the keys and expect the assistant animator or the inbetweener to draw the rest.

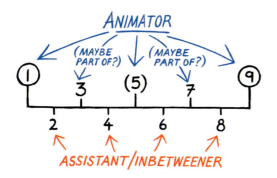

A typical chart for a standard animation move, two keys, a breakdown, and six inbetweens shot on ones.

For example, if a head is turning from one direction to the next, the breakdown drawing may not be a natural inbetween position, perfectly between the first key and the last. Here, the animator would most likely do the breakdown position, so the assistant animator who does all the inbetweens knows what is going on. In this action, as the head turns on an arc, I would also add a sketched in path of action (see the figure on the following page), or else lightly sketch in the other key positions, so that the assistant knows my thinking. I might also make notes on the chart itself, to emphasize what I am wanting.

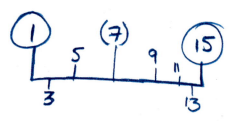

An arc chart illustrates movements on a specific arc.

A great deal of discussion has gone on about how many inbetweens an animator should leave an assistant to do. I personally would never leave more than two or three to a trusted assistant, and perhaps only one, or maybe two easy ones, for an inexperienced person. (I almost, without exception, will do the breakdown drawing myself.) But other animators are different. When I was assistant to the late, great ex-Warner Brothers animator, Ken Harris, he once left me 17 inbetweens to do! It is true that this was a slow-motion sequence between two similar keys, but it does give an idea of what can be expected of a trusted assistant from time to time!

Straight-Ahead Animation

There is an alternative to 2D animation with keys and inbetweens: straight-ahead animation. Straight-ahead animation is an approach where there are no keys at all but the animator simply draws the first position, then draws the second position, then the third, and so on and so on till the entire sequence is completed. It is much more of a "hit or miss" system, as things like size, volume, and proportion of the character can alter exponentially as the sequence of drawings builds up. But there are advantages when animating something that doesn't easily break down into keys and inbetweens, such as a character flying through the air.

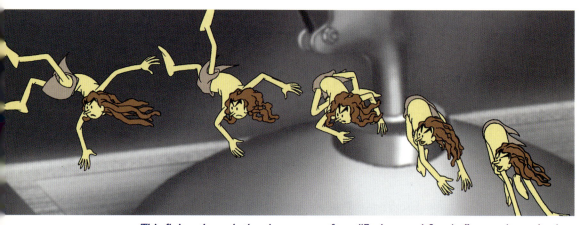

This flying through the air sequence from "Endangered Species" was animated using straight-ahead animation.

Slowing-In and Slowing-Out

Charts usually indicate inbetweens that are spaced evenly throughout an action. But real movement is not like that. Unless we are talking about the predictable action of a machine, everything that moves is in a process of speeding up or slowing down during its movement. For example, in the close-up action from "Endangered Species" shown below, the character's mouth slows into its end position as he puffs.

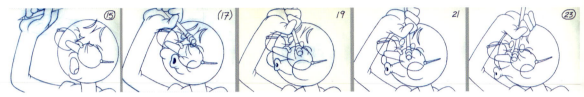

Action never occurs at a steady, constant rate.

Notice that there are more drawings around the end part of the movement with fewer in the middle. The more drawings there are, the slower the action will appear. Here, I wanted the action to slow down at the end of the move. In animation terms, the process of accelerating out of a key position is known as slowing-out and the process of decelerating at the end of an action is known as slowing-in. Slowing-out and slowing-in are two of the most important motion tools in an animator's armory. If you charted the slowing-in action of the mouth movement in the figure shown above for the assistant animator, it would look like this:

The chart for the slowing-in action of the figure shown above.

To create the effect of slowing-in, place more drawings at the end of the sequence. To create a slowing-out action, (i.e., the puffing mouth would start slower, then accelerate) the extra drawings would be included at the front, as shown below.

Putting more drawings at the beginning slows-out the action.

For clarity's sake, I tend to write most of the slow-in/slow-out inbetweens above the line until the very last one, which is below the line. If there are significantly more inbetweens in a chart, especially where the animation is on ones, I put all the odd numbers above the line and all the even numbers beneath it.

I divide the information this way because then there is less chance of the assistant misreading my intentions. This is just my personal preference, and every animator has his or her own approach.

As implied, slowing-out and slowing-in is used when a change of velocity is required. The sleeping, snoring animator shown below is a perfect example of this.

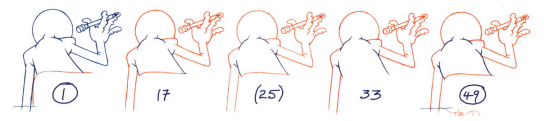

The keys starting with drawing 1 and ending with drawing 49 create a very slow action. But since it was so slow, the action was completed on only the odd numbers and was shot on twos.

The chart for the snoring sequence.

Refer to the chart above. When the inhale action reaches its mid-point (drawing 25), it needs to slow down significantly before stopping at the second key, the height of the snore (drawing 49). Then, returning towards the midpoint of the exhale (again, drawing 25), it accelerates, then slows down again past it, as it returns to the original exhale position (drawing 1). To create a little more tension with the breathing, the inhale needs to be slightly slower than the exhale motion. From its return to the first position, however, the entire action repeats again in a cyclic motion (always returning to and starting with drawing 1).

In actual fact, since sufficient drawings were created on the inhale (shown in the figure on the right), the action for the exhale can be repeated in reverse, but using fewer inbetween drawings than with the inhale action (see figure on following page).

Acceleration and deceleration occur in most aspects of nature. Things rarely are constant in motion, so you should consider this when charting your inbetweens.

Each drawing is held for two frames on the inhale.

A number of drawings have been strategically removed to increase the speed of the exhale.

Working in Thirds

Occasionally, there are circumstances where you actually need even movement between two key drawings but only have two inbetweens to do it in. If you chart this action normally, so there was a logical breakdown drawing and then one more inbetween, it would create either a fast slow-in or slow-out, depending on which side of the breakdown drawing the inbetween is on. However, this would hardly give an even movement between the two keys. To avoid this, the use of thirds has to be applied. To best inbetween on thirds, first assess an inbetween that is one-third the distance from one key to the other, then inbetween that drawing with the more distant key. For example, for the chart below, the first inbetween to be created would be 3, positioned one third of the distance between 1 and 7. Then 5 would be created as an inbetween of 3 and 7. Obviously, good and accurate judgment has to be exercised when creating the first one-third drawing, but once this is established, the rest is relatively easy.

With thirds, the distance between all of the drawings involved has to be equal.

Thirds are not encouraged, to be honest, as they are often extremely difficult to do, especially for inexperienced animators or assistants, since creating the first one requires a great deal of initiative. Perhaps adding an extra inbetween (for a total of three) to the chart will provide less of a challenge or, if thirds are totally unavoidable, the key animator should do the first third (breakdown) inbetween for the assistant. Or, if a perfectly even movement is not necessary, a two frame slow-in or slow-out might work just fine.

How to Inbetween

It might just help to point out how a 2D inbetween is produced in the first place. To begin with, place two key drawings on the registration pegs.

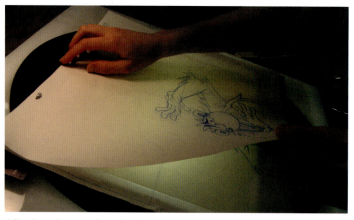

Aligning the two key drawings.

Place a clean sheet of paper on the pegs and turn on the backlight.

Adding a page for the inbetween.

Now draw lines inbetween the main key drawing lines, intersecting them as precisely as possible.

Drawing the inbetween.

> **NOTE**
>
> Sometimes, with tight inbetweens like this one, your hand might nudge the top sheet of paper out of alignment. Therefore, in this kind of situation, it is advisable to tape the top sheet down on either side, before you begin the drawing.

Inbetweening is, of course, very much easier to do when the lines of the keys are close together. However, when there is a large distance between them and they are in broadly different positions, certain key points between them should be established so one drawing can be superimposed over another and the resultant inbetween be made simpler. For example, let us consider a floating, rising ghost character shown below.

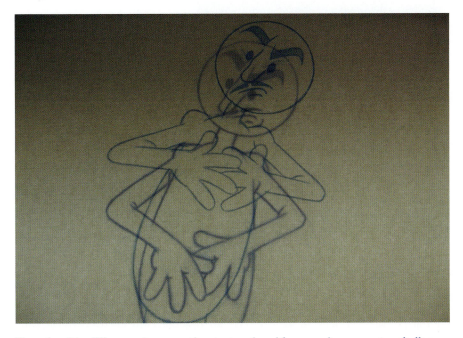

There is a big difference between the start and end keys, posing a greater challenge for inbetweening.

In this case, with two keys in position and a new sheet of paper over the top, either roughly sketch in the estimated position of the inbetween using nothing more than eye judgment, as shown below, or locate the midway positions using between the two keys as guides to work from.

The key points can be sketched in lightly but they do need to be as accurate as possible, and over as wide an area of the key drawings being used as possible, to ensure greater accuracy.

You can create a more accurate inbetween by locating essential points along specific paths of action that link wrists, elbows, knees, ankles, etc.

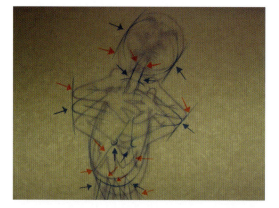

Each arced path of action has to be calculated for each individual part of the entire character action.

Key points are used when it is not entirely obvious where an inbetween's mid-line will go between two diverse keys. Usually, as indicated above, to find the essential key points of a new inbetween, you should lightly sketch out paths of action that link matching aspects of the two keys and then locate the middle of this path of action by marking the precise key point. Using the previous example, the elbow key point position is shown below.

Drawing a path of action to find the midpoint for the elbow position.

With all the key points located along all the paths of action between the two keys, you now have the information to create the new inbetween by means of superimposition. However, before that is explained, a few pointers on paths of action.

Paths of Action

As we know, only engines and rigid mechanical devices move in straight lines. So, when there is a broad movement between two keys, you have to assess the direction, or the path of action, within the movement, not only from one key to the other but to subsequent keys beyond them. It would not do to choose an arc (curved path of action) between one set of keys, only to find that it moves in a different direction in the next one of several keys. So, when assessing a suitable path of action in a sequence, you must first establish the overall pattern of moment, then specify it in the context of that overview when working from key to key. For example, if a ball is flying from left to right across the screen, it is very easy to identify its path of action. Here, you should not only estimate the center of gravity in the ball, but also its outside edges for consistency.

The initial drawings for a ball's motion through the air.

The sketched-in paths of action for the ball would look like the figure below.

The path of action drawn in.

Clearly, the ball is not traveling in a straight line, but on a significant arc. So this will profoundly influence the positioning of the inbetweens that are required in this action.

The inbetweens for the motion.

A selected path of action has to be logical, of course. It must conform to the basic laws of physics (unless it is a cartoon sequence that is defying gravity!) and it must relate to the continuity of previous and subsequent keys or else it will be visually erratic and unconvincing.

These straight inbetweened paths of action do not conform to a natural flow of movement.

Superimpositions

Assigning inbetweens to a character or complex shape is much harder than inbetweening a passing ball. This is where superimposition comes in. By finding the correct paths of action, then assigning the correct key points of the inbetween, all the relevant reference points on the three sheets of paper can be superimposed over one another as closely as possible.

To superimpose animation drawings over each other, take the top two sheets off the pegs and line them up, over the backlit lightbox, one on top of one another, so that the key of one sits as tightly and as accurately over the top of the other. The key points of the third sheet are then positioned as closely as possible midway between the relevant linking parts of the keys lying beneath it. Now tape the whole thing down to ensure that nothing moves as the inbetween is drawn.

In this example, it is very easy to superimpose the head and shoulders over each other. However, the hands are moving, so it is impossible to accurately line them up at the same time.

This way you can much more confidently draw the basic inbetween from one key to the other, knowing that the overall position of the inbetween will be accurately defined by the key points.

Inbetween what is easy (such as the arms) and then put in new key points for the parts that are not so easy (such as the fingers).

Multiple Superimpositions

Often, two key drawings can be so different that you cannot possibly create the inbetween from one single superimposition alone. In the earlier example, first position the bulk of the points that can be inbetweened with the initial superimposition, such as the head, torso, etc. Then, if an inbetween was still too difficult to assess (such as an arm in this example), take the top two sheets off the pegs and line them up again, but this time paying attention to only the positions and key points of the arm. This way the arm can be inbetweened separately from all the rest.

By positioning one arm and hand key drawing over the other, it is easier for the assistant to create a more accurate inbetween. When this is complete, the other arm would be similarly superimposed and inbetweened.

By individually superimposing sections within a drawing, you can complete the entire figure much more easily and accurately than if just "eyeballing" it (i.e., just using visual judgment). The face is a particularly important subject for individual superimposition, as it is very important that a character's features stay accurate and well proportioned throughout.

Faces are especially important to superimpose individually.

Invest in Tape!

I can't possibly stress enough the importance of taping down your drawings. Quite often, hand pressure alone can cause drawings to slip and twist out of place. Any form of tape can be used, as long as it is not so sticky that it tears up the animation paper when you remove it (below). The best tape is the standard yellow-colored camera or masking tape, closely followed by Scotch tape or Cellotape. Taping down the superimposed drawings also frees-up the assistant's other hand, enabling him or her to more easily flip the sheets while working.

The tape indicated here is parcel tape, which works fine but can tear the paper if not removed carefully.

Dope (Exposure) Sheets and Production Folders

Although the digital age of animation has well and truly arrived and the traditional processes are pretty much long gone now, except, of course, the importance of pencils and paper, I still find two elements of the past worth clinging to—dope sheets (known as exposure sheets or x-sheets in some quarters) and production folders. It is a popular belief that animators just sit and draw funny cartoons all day long. Well, of course, animation is a lot of that, but it is so much more about time and project management too. A good animator needs a good organized mind as well as an ability to draw. Now that animation scenes can run at a variety of different film speeds, through a variety of different screen formats and using an infinite number of action and special effects layers in the digital environment, it is so necessary to have your thinking processes working well and consistently. Contemporary animation is now, at its core, an art, a science, and a business management operation all rolled into one!

There are other practical information elements that have to be implemented too. For example, every drawing, every layout, and every background has to have specific information added so they are not lost or misplaced, creating potential chaos to the production. The necessary information required in these cases would be the sequence, scene, and drawing number if it is a series of animation drawings or a layout (with each key also containing the required inbetween chart); the sequence, scene, and background number, if it is a background; then all this, plus much more, if it is a production folder! Animation paperwork can be scary or tedious when you first see it but, once explained, dope sheets and production folders can actually become your best friends!

The Dope Sheet

The dope sheet contains all the necessary information about the scene. It might serve as a "note to self" for the animator, but it also is a crucial communications tool for the assistant animator, the scene compositor, and anyone else in the project's production line. The dope sheet (often, more than one page per scene) includes the sequence, scene, and page number information; phonetic soundtrack breakdown; the scene start and end (cut) points; the animator's action notes; animation layers; drawing order; inbetween timings; detailed shooting/scanning instructions, etc. The dope sheet is the one place where you can clearly organize your thoughts and then share them with others in the team. A section of a typical dope sheet is shown below.

SEQUENCE	SCENE									SHEET
			5	4	3	2	1	B G	CAMERA INSTRUCTIONS	

Although dope sheets can differ from country to country, or even studio to studio, the essential information presented on them is pretty standard. The first thing to realize is that the dope sheet is comprised of many scary vertical columns and even more horizontal lines. However, once these columns and lines are understood, the dope sheet becomes a friend, rather than an enemy.

The top section has space for the sequence, scene, and page number information, together with additional space to write in the scene title, where relevant.

Each of these sections needs be filled in every time a new dope sheet is used. That way, if the dope sheets ever get scattered or mixed up, this basic information makes it easy to identify and re-assemble them without much fuss. That said, it is the remaining information on the dope sheet that is most necessary in the animation process.

Broadly speaking, the narrow, horizontal lines beneath the top information represent every frame of film in the scene. The vertical columns, on the other hand, represent the layers of animation, including the background. Specifically, from left to right in the figure below, these columns indicate your personal notes column, the dialogue breakdown column, six columns for the initial animation layers (with digital animation there could be an infinite number of columns but the six represent the maximum levels possible for the old cel animation approach, including background artwork) and then the camera instructions column.

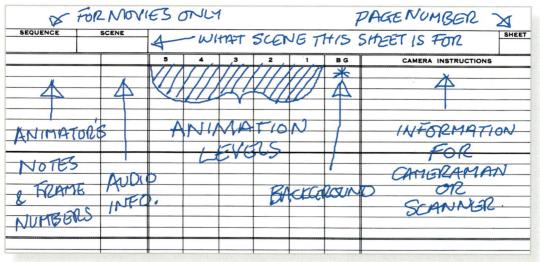

The various areas of a dope sheet.

Frame Lines

The number of frame lines representing the scene to be animated will depend on the speed and the kind of film being used. (If film is even the medium to be used!) Filmically, there are 16 frames in every foot of 35mm projected film and 24 projected frames for every second of film time. Therefore, if the animator is working in 35mm film, every 16th horizontal line on the dope sheet is printed heavier, to identify each foot of film. Additionally, as 24 frames make up a second of film time, each second of film is often represented by a double line. When marking up a dope sheet on any scene I am about to animate, I always indicate each second in a circle on the left-hand column.

ACTION	DIAL	EXTI

01
02
03
04
05
06
07
I FOOT — 08
09
10
11
12
I SEC. 13
14
15
16
17
18
19
20
21
22
23
24
25
26
27
THE 'I SEC.' 28
POINT 29
INDICATED ON 30
DOPESHEET 31
BY ANIMATOR 32

How I mark each second of film on a dope sheet.

NOTE

Of course, you'll need to modify this if you are working in any other film format or a digital environment. Most digital software defaults to 29.97 fps but should be taken as 30 fps (30 frames per second) for convenience sake.

Remember too that whereas U.S. (NTSC format) TV can broadcast films that are produced on both 30 fps and 24 fps, the U.K. (PAL format) TV broadcasts at 25 fps, which means these traditional 35mm dope sheet markings cannot be applied so easily. Flash animation for the Web can be set to playback at any fps rate required but the standard is 12 fps. So, as long as you remember the differences in all these formats and tailor the dopes sheets to fit the requirements of your particular production, it is perfectly OK to use the standard dope sheet format and adjust it accordingly.

Examples of one second of animation on dope sheets for 24, 25, and 30 frames per second.

Animator's Notes

Looking at the following figure, the far left column is described as the animator's personal note column because it is essentially the place where you can make action notes, sketch ideas, outline frame timings, etc., without infringing on the main information sections of the dope sheet. This column is basically an ideas, time, and motion scribble pad, where you can think out loud before beginning the animation process.

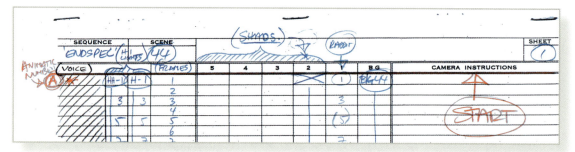

A sample of the top of a completed dope sheet for "Endangered Species," which was animated at 24 fps throughout.

I also find that writing in the actual frame numbers throughout the scene, as shown below, helps with the drawing numbering/layering compositing process later. I have the sheets pre-printed with the repeating numbers 0 thru 9 on them; for greater convenience and speed, I only have to add the front number(s) ahead of them each time.

I number my frames throughout the scene for easier compositing later.

Audio Breakdown

The next column is the audio breakdown column. This column contains informa-
tion that the sound editor has supplied—a frame-by-frame phonetic analysis of the
soundtrack, showing exactly on which frame(s) each sound, or word, or music beat
falls. With phonetic breakdowns, the words are not necessarily spelled as they are writ-
ten. For example, if the word being analyzed is "caravan," then it could well be phoneti-
cally noted as k, aa, rrr, e, v, aa, n. Similarly, "plume" might be broken down as p, l, oo, m
and "carbonate" would be k, ah, b, o, n, ay, t. A sample audio breakdown from "Endan-
gered Species" is shown below left.

If the soundtrack is musical and not dialogue based, then the breakdown column will
display both the music beat (marked as a colored star on the precise frame they fall
upon, as shown below right) as well as the lyrics broken down phonetically.

When broken-down phonetically, the phrase "Oh, look!" will appear like this on the audio column of a dope sheet.

Colored stars mark the musical beat.

If the soundtrack is music-based only and has no lyrics, such as with the original mas-
terpiece "Fantasia," you would need to write down the sound the music makes in terms
that you can recognize and understand. For example, a drum beat could be marked as
D–R–U–M if it took up 11 frames, or a trumpet note could be recorded as T–R–U–M–P–
E–T over 17 frames.

Using different color pencils for different musical instruments, even as single continu-
ous lines drawn down the audio column, with no written, phonetic interpretation at
all, is another approach. Obviously, a full-length composition for an entire orchestra
cannot be recorded in detail on the narrow, limited column of the dope sheet. But, if at
least the main beats and sounds are recorded, you will have enough timing informa-
tion to choreograph the animation in sync with the music.

Animation Layers

The next six columns are reserved for five layers of animation and the background. As indicated earlier, traditional 2D animators discovered that a finite number of cel layers were possible, as each layer of cel absorbs a significant amount of light and each subsequent layer reduces the illumination of the image below. Of course, digital animators requiring more that five layers of animation will have to create their own custom-made dope sheets or else cut and tape two sheets together.

The figure below shows a partially completed layers section. Defining these layers from right to left, we can see that the first, the lowest, is the background. Each scene will more than likely need a new background, although quite often a background can be re-used in certain other scenes in the film. Simply write in the BG (background) number here when this decision has been made.

Then, depending on how many layers the animation needs to be produced on, you will dope (write in) the animation numbers from column 1 moving to the left. Most simple action animation requires only one or two layers. A great deal of animation layer management can be defined through clear thinking at this stage. Each layer of animation defines what needs to move and when and what can remain held without movement. Parts of a character, or even different characters, within a scene can be moved to different layers on specific frames of film when they need to be animated or kept still. However, the best animation keeps held positions and layer juggling to a minimum.

The animation layers for a sample scene.

This figure illustrates three layers of animation, plus the background. The numbers without any prefix on them represent the main animated action. The other two layers, prefixed by the letter S or the letter M are additional layers that relate to the main layer. Instead of needlessly writing the letter at the beginning of each one of the numbered drawings in the secondary layers, just write it on the first frame and draw a line down the column in front of all the subsequent numbers in that column, to show that it prefixes all of them.

Every level of animation should be given a different identifying letter. It might even be convenient to make the preceding letter correspond to what the level represents, such as B for the body level, H for the head level, A for the arm level. However, although desirable for clear identification purposes, this is not always practically possible. If in doubt, use the ascending letters of the alphabet to represent the ascending numbers of the levels, i.e., A for column 1, B for column two, C for column 3, etc. It really doesn't matter what letters are used, as long as none are duplicated. It's also helpful to indicate clearly what each column represents in the scene. This can be very useful when several members of the team are required to access the same scene during its progress through the production. I choose not to put any identifying letter in front of the drawings in the main animation column, as to do so would add extra numbering work and the more economies that can be made, the better. However, I do meticulously ensure that all the other layers have a logical preceding letter in front of the drawing number.

Shooting or Camera Instructions

In the days when animation was filmed on rostrum cameras, the right-most column was extremely important, as this was where the shooting instructions were always written. Instructions such as field size, track-in (zoom in) and track-out (zoom out), start and end points, special effects, etc., were written here.

Digitally, a great many of these camera instructions are redundant these days, as much of the camera action is either controlled by the digital software at the time or in post production. However, it doesn't hurt to write here what you have in mind. The beauty of digital technology is that the best track-in and track-out timing can be better achieved by experimenting at the pencil test or even film editing stage, but, even so, marking up the first intentions on the dope sheet at least provides a starting point. Special effects can be indicated on the dope sheet too, but these also are more often computer-generated after the animation stage these days. Even so, this column still is reserved for you to indicate the start and end (cut) frame of the scene, which does apply to all animation whether it is traditionally or digitally created. The camera instruction column may also indicate the frames required for fade-ins or fade-outs at the beginning or end of the scene, or layer elements within the scene.

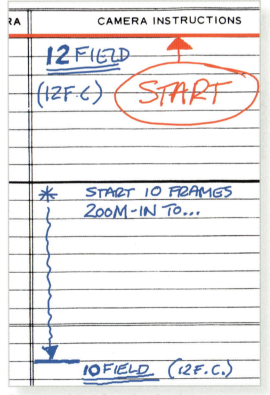

Just some of the information that the cameraman, or the person scanning the artwork, might need.

Rules for Dope Sheets

Regardless of design or production format, it is extremely important that the information indicated by the dope sheet is both clearly thought-out and neatly written. The dope sheet is the most important paperwork the professional animator has to work with, as fundamental to animation as a music score is to music. As a result, the dope sheet is an absolute record of your thinking, timing, structure, dialogue, and camera planning. To make it more effective, however, it is absolutely essential that the material written on it is clear, concise, and easily understood by anyone who reads it. Here are some additional notes and guidelines for dope sheets.

- Always write clearly and legibly, preferably in block capitals. Write in pencil so notes can be easily erased and changed when necessary.

- Make sure that every page contains the sequence, scene, and page number at the top. It is so easy for artwork and dope sheets to get lost or misplaced in the flurry of production.

- Name every level of animation, other than the main level, with a unique prefix letter, whether it's just A, B, C, D or initials that indicate the content of the layer.

- Remember also that the numbers of each drawing, if animated on twos, should only be odd numbers; animation on ones should include even numbers too.

- Keep the doping of a scene consistent. If you number your drawings by matching frame numbers, then everything should be done that way (see figure below). Changing your numbering suddenly will create confusion. Sometimes, in re-using particular drawings throughout the scene you cannot avoid changes in numbering. But, if you are aware of the potential confusion, then there is little chance of the confusion arising. (I have seen animators write in arrows in the camera instruction column to indicate that particular numbers are being re-used. Similarly, re-used numbers can be written in to indicate that they have been used before.)

Number drawings as consistently as possible and indicate clearly when drawings are re-used.

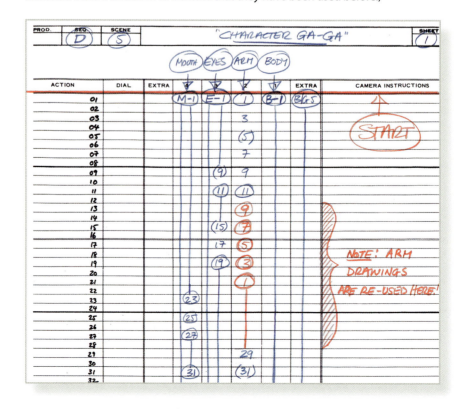

- Clearly mark the beginning of the scene with a START arrow and end the scene with a similar CUT arrow.

- Write down the appropriate field size at the start of the scene, as well as any camera instructions that are required, even if it seems obvious (see figure below).

- Make sure that every scene dope sheet is accompanied by a field guide (see below), so the cameraman or scanner knows precisely the area required to be seen.

- For greater clarity, consider using different colored pencils to write different instructions on the dope sheet. For example, I use a black pencil for the animation numbering; a blue pencil for the START and CUT points; red for field size, scanning, or camera instructions; and brown for the audio breakdown notes.

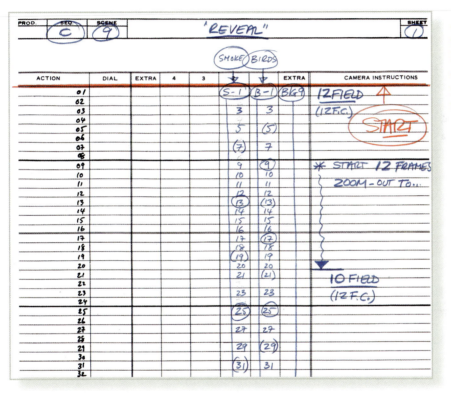

Always specify the field and field center on your dope sheets.

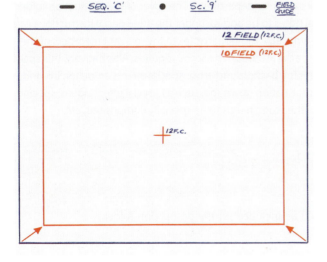

This field guide clearly indicates that the scene starts as a 12 field (12 F.C.) and then tracks-in to a 10 field on the same centerline.

The Production Folder

Each scene of animation artwork requires a means of keeping everything together and showing all the detailed requirements of that scene. In 2D animation, that is the production folder, a wrap-around scene file that contains the dope sheets, the animation layouts and/or field guide, the animation drawings, and the background art. The outer cover also needs to communicate specific information about the scene which is both accessible and readable .

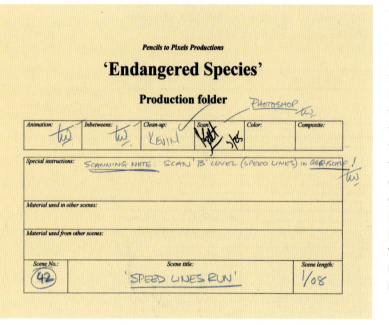

The cover of a typical production folder from "Endangered Species."

A standard production folder needs space to include the production name, the sequence number, the scene number, the footage length (that is, how long in feet and frames the scene is), the director's name, the animator's name, the assistant animator's name, in addition to signature space for the people who created the animation, backgrounds, inking, coloring, checking, scanning/camera and compositing, which they will fill in as they complete the work in their respective departments. One-man or small-scale operations might not need such an elaborate design, but it can't hurt to have a checklist of activities to complete.

Special Instructions

Each scene has special requirements that lie outside of the usual production process, not necessarily major variations, but some that need to be communicated to the production team beyond any particular department. The cover of the production folder leaves space for additional notes to be added, under the title Special Instructions (see below). This is where you write any additional notes to the relevant members of the production team for any special attention the scene requires. Alternatively, this space could be useful for the director, background artist, special effects animator, ink and color personnel to write information down too, such as special effects ideas, specific coloring instructions, how the scene needs to be specially composited, etc.

Special instructions should be included on the production folder.

Material Used From Other Scenes

In larger productions especially, it is common to share artwork from one scene to an-other. Animation drawings, background artwork and other elements can be saved as li-brary material for other parts in the story. With low-budget productions, this is actively encouraged, to cut down on time and budget costs. Therefore, it is important to know what material needs to be used from other scenes when a new scene is being created or completed. This section in the production folder facilitates this, with the relevant re-cycled artwork and scene number it is taken from included here.

> *Material used from other scenes:* (i) DRAWINGS ① — ㉟ ARE FROM SCENE ⑲ !!!
> (ii) USE B/G FROM SCENE ⑮ !!!
> *Scene No.:* *Scene title:* *Scene length:*

Indicate material from other scenes that can be used in this one.

Material Used in Other Scenes

For the same reasons, it is possible to say what material from the current scene can be used in other scenes. With such information on the production folder, team members further down the line know that this artwork needs to be saved and moved into the appropriate scene(s) when the time comes.

> *Material used in other scenes:* USE THIS BACKGROUND IN SCENE ㉗ !!!

Indicate any material from this scene that will be used in others.

Attached Dope Sheet

The scene dope sheet should be included with the scene produc-tion folder. The safest and most certain way of doing this (so that the dope sheet and the folder do not ever get separated) is to staple the dope sheet to the in-side of the production folder. If this is done in the correct orien-tation, it will be possible to read the cover of the folder, open it, and see the information on the dope sheet from the same point of view.

The production folders and dope sheets for "Endangered Species" were all printed on standard 11" x 17" paper, stapled together at the top and then folded over lengthwise. The production folder was copied on ivory-colored paper, to differentiate it from the white dope sheet pages.

Flipping and Peg Bars

Those who remember the animated magic of playing with flipbooks when they were a kid will understand the value of flipping. Flipping is one of the most valuable skills you can acquire. Flipping is a method of testing the animation before actually committing it to film. The process is achieved by flipping a number of animation drawings rapidly in sequence, in precisely the same way as the old flipbooks worked. Flipping can be done with drawings on or off the animation peg bar. A peg bar can hold about five drawings for flipping, while flipping off the peg bar can be done with as many drawings as can be comfortably held in a hand at once. These different techniques are known as bottom pegs flipping, top pegs flipping, and whole scene flipping. However, before describing these three techniques in detail, let us take a step sideward and discuss using peg bars in general.

There is a distinct air of elegance to the art of flipping.

Using Peg Bars

As explained in Chapter 10, the animation drawings have to be punched and placed on animation pegs to establish and maintain accurate registration from drawing to drawing. There are two systems of registration pegs that can be used, Acme and Academy. Three, if you consider the regular office punch and home-made dowel peg bar (see "The Animator's Workbook") as a system in itself. (Four, if you count the new plastic peg bars cheaply available to match the standard, three-hole, office punch used in the U.S.!) In all honesty, it doesn't matter which of these systems are used, as long as the animation paper, peg bar, and camera or scanning equipment used to capture the artwork all use the same system of registration. The most popular peg bar in the industry, by and large, is the Acme peg system, seen below.

The Acme peg bar system.

Top Pegs vs. Bottom Pegs

There has always a debate in the 2D animation world as to what approach is best—top pegs or bottom pegs. The majority of the industry favors bottom pegs. However, a strong-minded minority of animators prefer top pegs. I, for the record, subscribe to the second approach.

Bottom pegs have traditionally been adopted by the animation industry because, originally, it was proven by accountants or time and motion experts that it was quicker and more economic for a cameraman to put animation drawings (or cels) on the bottom pegs of their camera tables when shooting. The decision was therefore an economic thing, with no artistic or aesthetic consideration whatsoever. Consequently, entirely in the interests of budgetary cost cutting, studio animators were required to fall into line with this system and it has subsequently never changed. Surprisingly, the decision has never been questioned, and is still not, even though rostrum camerawork is rarely a part of the 2D animation industry anymore!

More enlightened studios, however, put the animator's interests first, rather than the cameraman's. My experience at the Richard Williams studio showed me that with pegs at the top of the drawing area, my hands were significantly freer for drawing, because the pegs were not in the way. I have always found this to be a superior way to work, but I do respect the fact that many other animators think differently. After all is said and done, it is ultimately the work that appears on the screen which is important, not the system used to achieve that work!

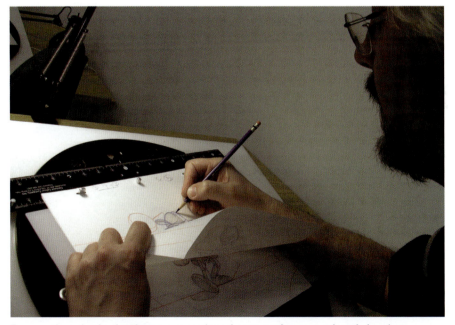

For me there is absolutely no comparison between the easy, relaxed drawing freedom that the top pegs positioning offers over the far less comfortable, pegs-in-the-way-of-the-drawing-hand irritation of bottom pegs.

Today, there is no reason why animators cannot make their own minds up with regards to top or bottom pegs, since rostrum camerawork is hardly a factor. Pegs on the scanner can be at the top or the bottom of the artwork, with digital software easily (and automatically) making 90, 180, or 270 degree image rotations whenever necessary. The fact that so many animators hang onto the bottom peg system, despite the irrelevance of economic motivation, surprises me. To my mind, anything that assists you in doing good animation should take precedence over the cameraman's needs, since even in the old days he or she would not exist without the animator's work. In a live-action film, you would not have the cameraman or sound man dictate how the actors deliver their lines. Why need it be so with animation? Life is all about challenging existing precepts to find better and more fulfilling options from the infinite amount of possibilities both within and without ourselves.

Of course, the one eternal argument in favor of the bottom pegs approach is the matter of flipping. Devotees of the bottom peg system maintain that it is impossible to flip five drawings on top pegs, as you can with five drawings on the bottom peg system. This is actually not true, although very few people know the difference between the two flipping systems and have therefore not tried them.

Bottom Pegs Flipping

Bottom pegs flipping (sometimes known as rolling) is undeniably the easiest of the two peg systems to do. Simply put five consecutive drawings on the bottom pegs, starting with the lowest number at the top then down to the highest number drawing at the bottom, then interleave your fingers with the top four sheets. Then by coordinating the finger movements, you can quickly flip the drawings up (and down) in sequence, to see the movement they make when viewed from the top. Your free hand will probably have to hold the drawings secure on the pegs while they are being flipped.

Whereas it is very easy to flip (roll) drawings on bottom pegs, if is often difficult or uncomfortable to look over the top of the drawings as they move, especially if the animation is at the bottom of the sheets, near the pegs.

Top Pegs Flipping

Top pegs flipping, and the technique required to achieve it, does require more coordination and practice to accomplish it satisfactorily. However, it is well worth pursuing as, if achieved, it puts the unquestionably superior possibility of top pegs animation within your reach. With the drawings located on the top pegs it is clearly impossible for one hand to interleave with them and flip the drawings. Therefore, top pegs flipping is a two-hand operation. Use the index finger and thumb of one hand to hold the second from top animation drawing, and use the next two fingers of the same hand to hold the top sheet.

The one-hand finger position for top pegs flipping.

With your other hand, hold the fourth and third drawings in the same way.

The two-hand finger position for top pegs flipping.

The difficult part comes now. In order to achieve a flipping sequence, the fingers of one hand have to coordinate with the other, using the fingers to lift each animation drawing in sequence, one after the other. This can be hard for some people and will take a certain amount of trial and error to get it right. However, as with learning to ride a bike, drive a car, or play a musical instrument, once you learn the technique, it'll never be forgotten.

Top pegs flipping is, in my mind, far superior because you can easily see the moving drawings, even if they are at the top of the sheets.

The one obvious thing about top pegs flipping is that as the two hands are required to lift the drawings, it is impossible to hold the sheets down on the pegs at the same time. To get around this, stretch a large rubber band over the registration pegs to prevent the drawings from flying off.

Stretch a rubber band across the top pegs to hold the drawings on the peg bar.

Whole Scene Flipping

The last flipping technique to consider is whole scene flipping. Whole scene flipping is essentially the equivalent of making a flip book from part or all of the finished drawings in a scene of animation. Place the drawings together in reverse numerical order, with the lowest number on the bottom to the highest at the top. Hold the bundle and flip each of the drawings, one by one, from bottom to top, with the thumb and forefinger of your free hand. This will provide a flipping effect that enables the whole scene to be viewed as a moving sequence, even though it may take a little grip adjustment and repeated practice to get it right and see the images flowing fluidly.

If the drawings stick together when leaving your thumb, try fanning out the pile of drawings first, to give the thumb more flipping area on each drawing.

I firmly believe that animators cannot call themselves true animators until they have learned each of these three flipping techniques. To make a moving sequence work well, it is necessary to constantly check the drawings, to see if the movement created is working. Flipping is an essential skill for quick interim checks of the drawings, regardless of peg system adopted. But remember that no matter how good you are at flipping, you won't be able to achieve the consistency of speed that film will give the drawings. Flipping is only a rudimentary test for the action.

Whole scene flipping offers a very accurate insight into how an action is moving.

Fanning the stack of drawings helps keep them from sticking together as you flip.

Finessing 2D Animation

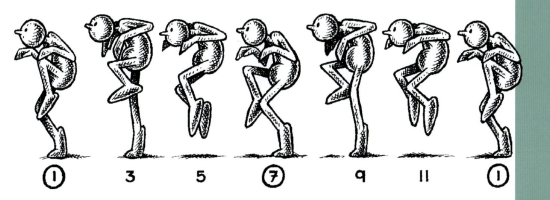

A fast sneak action is significantly different from a slow sneak.

There are still some subtle little finessing techniques that will make the whole process much easier for you as the animator and much more believable for the audience. This chapter covers a few finessing techniques that I have always found most valuable.

Tracebacks

A traceback is where an animator or assistant animator traces several identical versions of a same static drawing, to give the illusion of life to that drawing even though it actu-

ally doesn't move. Tracebacks are also employed when part of a key drawing is moving relative to a previous drawing but the rest of it needs to remain static. For example, where the head of a lamp is moving but the rest of it remains static from key to key, the static part of the second key would be traced back from the first. In this case, the animator indicates the parts of the second drawing that need to be traced back from the first at the inking stage in red pencil (below).

The static part of the hand is traced back in a different color for easier identification.

Tracebacks make it faster to reuse parts that remain static from drawing to drawing.

In another example (next page, top), if areas of a new key drawing need to be traced back from drawing 33, the animator would clearly write this beside the part of the drawing that is new. The directive "FIN" tells the assistant animator that it is his or her job to finish the drawing.

Animators can leave traceback directions for their assistants.

Take the unfinished new drawing and place it on the pegs over drawing 33, securing it by lightly taping both sides. Then make an accurate tracing of drawing 33 onto the new key drawing, in red, to differentiate to the inker what was the original drawing and what was the traceback (below).

It is very important that the traceback part of a drawing be extremely accurate if that part of the image is to appear static.

When the inbetweens for traceback sections are added, it is important that you do not inbetween the traceback portions. Instead, each one should be accurately traced back from the original drawing (in this case, number 33) so that there is no shift, distortion, or jiggle in the traceback lines when the animation is tested.

The golden rule of tracebacks

Always create tracebacks from the original key drawing, never from another traceback. That way the tracing will always be consistent, solid, and stable.

Today, with digital technology, it is simple to cut and paste the part of the drawing that needs to be traced back and produce a perfectly stable held position. However, in quality traditional animation, it is much more desirable to have a certain organic feel to the line; that is, although the character's lines do not move, they do have an energy about them through these repeated tracings. But they must be done carefully, as sloppy traceback areas create lines that jiggle and boil wildly throughout the scene, potentially distracting the audience from the action that is needed to be seen.

Eccentric Movement and Staggers

A great deal of animation using the key system can be too mechanical, even, and predictable. To give more effect to this possibly predictable action, it is necessary to consider more eccentric action approaches. Techniques such as takes, squashes, stretches, and staggers come into this category.

Takes

Takes are the reaction a character expresses when showing surprise or when not believing what they are seeing. A single take is broken down into four key moments:

- Observation: Something unexpected happens (or even is said by another character).

- Absorption: The character doesn't move while it tries to register what happens.

- Reaction: The character throws its head in the opposite direction to avoid seeing what has happened, often with the eyes closed.

- Resolution: The character swings its head back to the first position and adopts an expression of open-mouthed and open-eyed wonder.

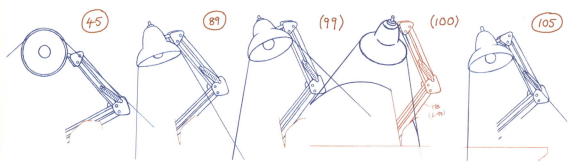

The four stages of this lamp take: observation (45), absorption (89), reaction (99 and 100 for a stagger), and resolution (105).

The staging of this particular take is interesting, in that as the lamp reacts to what it sees it and shakes its head in disbelief between the reaction stage and the resolution stage. To do this, I created two reaction drawings, one with the head of the lamp to the left and one to the right, and inbetweened these both back to the final resolution position.

The timing of a take is important. The establishing pose is mostly held static. Then, the look is achieved, after which there should be a pause in the action as the character absorbs what it is seeing. Then, after the suitable hold period for this mental absorption, the reaction is reached directly, away from what is being looked at and fast. Lastly, the movement towards the final resolution pose might be slowed-in to, to bring the entire take to a close. Note: The final resolution pose can either be a re-use of the establishing pose, or else a newly-drawn key position that reflects change in the character as a result of it witnessing what it has witnessed.

SEQUENCE	SCENE (70)								
FR.No.		5	4	3	2		BG	CAM	
81		81		9	B-15	L-45	BG-70		
82	STEP	82							
83		83		11	(83)		(83)		
84		84							
85		85		13	85		85		
86		86							
87		87		15	87		87		
88		88							
89		89		17	(89)		(89)		
90		90							
91	STEP	91		19					
92		92							
93		93		21					
94		94							
95		95		23					
96		96							
(4) 97		97		(25)	97		97		
98		98			98		98		
99		99		27	(99)		(99)		
100		100			(100)		(100)		
101		101		29	101		101		
102		102			102		102		
103		103		31	103		103		
104		104			104		104		
105	STOP!!!	105		33	(105)		(105)		
106		106							

Note how the alternative actions, the left and right drawings, interleaved as odd and even numbers, effectively give the "head" its shaking action.

Squash

Traditionally, squash and stretch were overly exaggerated poses in animation, where characters were rubbery and pliable to the extreme. These were in the days of rubber hose and Max Fleischer animation.

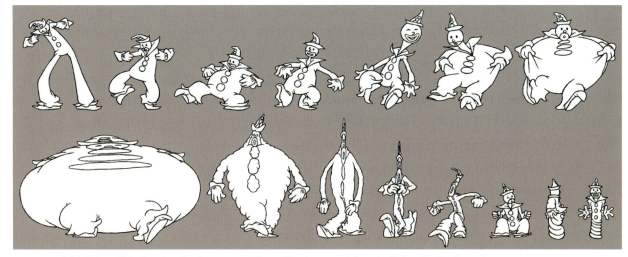

This Max Fleischer-inspired sequence from "Endangered Species" clearly displays the extreme amount of both squash and stretch in old-school characters.

Today, where most animated characters possess a solid anatomy and the notion of a structured, skeletal foundation beneath their skin, the old idea of rubbery extremes are obsolete. Nevertheless, the principles of squash and stretch remain valid, although today they are implemented within the limits of the anatomy, without the distorted, rubbery feel. Instead, squash is achieved by simply extending the natural capability of the pose, to points further and more exaggerated than the regular key drawing would be. For example, if a character is about to move upwards, he would first squash down as an anticipation of that upward movement. However, instead of the body making an impossible, fluid, rubbery squash as in the old days, the animator will create the impactful equivalent by pushing all the natural structural and joint led capabilities of the body to an absolute plausible position of squash.

A squash contracts a character's body within the limits of its anatomy.

Of course, if the character is both rubbery and flexible by nature, then the more fluid squash position will be perfectly valid.

Stretch

A stretch is the opposite of squash. In a stretch, the body extends itself beyond the norm to create an illusion of reaching or striving for something, as in the figure below. Using the same example, once the character has squashed down, it will now move upward and push its extension as high as possible from its original positioning. Again, in the old days, this would have meant an unnatural, rubber-like stretching of the body beyond normal proportions but with more realistic characters, the stretch is created by simply pushing all the body characteristics to the maximum with no unrealistic distortion or extension of the limbs or torso whatsoever.

A stretch extends the character to the full length of its limbs.

However, as indicated, by the time the character reaches the top of the move, the stretch will return to a more natural extended position for the body, prior to gravity drawing the character down again.

After a squash or stretch, the character should return to its normal posture.

Staggers

Staggers are not so much a process of creating distorted or extended drawings but more a process of using the doping on an exposure sheet creatively. A perfect example of a stagger is when a character bounces off a diving board. Once the character is in the air, the board will bounce up and down quickly until it comes to rest. That is a stagger. Staggers can also be applied to an arrow hitting a target or characters reacting to a situation.

To achieve the slight stagger at the end of the character falling down the desk and getting his head stuck in "Endangered Species," I actually animated the action using five key drawings, and this dope sheet.

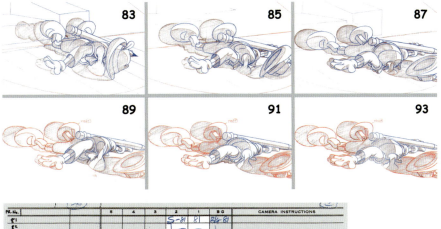

The five key drawings, plus one inbetween, for this scene.

The dope sheet for this scene.

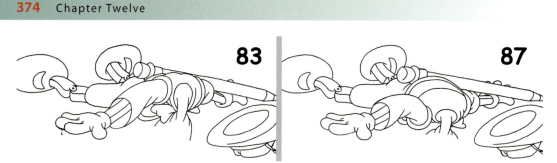

The key positions of the head movement.

With any kind of stagger animation, small or large moves can be equally effective. In the preceding scene from "Endangered Species," I used five keys (83, 87, 89, 91, and 93) and a little creative doping to achieve the desired movement which presented a brief, fading stagger on the head and neck. Drawing 83 showed the head trying to pull out of the hole, whereas 87 had the head firmly planted deeply into it. I inbetweened these with just one drawing, 85. However, key drawing 89 was an immediate "head pulling out of the hole" position again (actually stretching further out than on key 83) with two inbetweens slowing back into key 87. The inbetweens for this had key drawing 91 as effectively a passing position, with key drawing 93 as more of an inbetween.

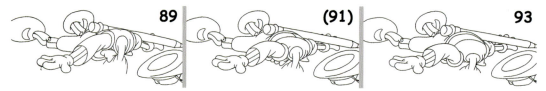

The main position between the two head movements.

I doped the action with consecutive numbering up to drawing 89. I staggered the doping so the head staggered wildly at first, then settled down to the end position (87). The drawings looked like this:

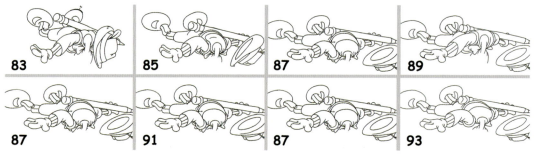

The entire sequence of drawings.

Take care not to overuse staggers, but when they are used correctly, and when they are suitable, they can create a lot of impact with not much more extra work.

Panning and Camera Moves

Most animated scenes do not require any camera movements. However, occasionally the camera is required to move, and therefore animators need to know the do's and don'ts that are involved.

Panning and Tracking

There have always been moving shots in animation. Moving shots provide scale, breadth, and depth to the action, where the camera either follows a moving character along an extended background or moves alone to establish a wider dimension to the scene or setting. Alternatively, the camera may either need to move upwards, away from the action, or else downwards to find the action. All these types of moves are known as panning or tracking shots.

We tend to take pans and tracks for granted in live-action films, as the camera is moving more often than not. However, any moving shot with animation often has to be worked out very carefully, as extra artwork and a modified approach to the process is required. In the old days of cel animation, when a long pan across a scene was required, everything had to be produced on special long acetate sheets (called two, three, or four field panning cels, depending on how long they were.) These panning cels were to hide the cel edges that would show up on regular fields when the camera moved past them, or they moved past the camera. Nowadays, in the digital environment, background artwork still has to cover the length of the pan. The difference is that the animation can at least be drawn on standard field size formats, and then electronically combined with the background layer, using alpha channels, with no cel or frame edges showing.

Panning animation paper (and cel) can still be obtained from most animation art stores and Web sites. Standard sizes include 3 x 12 field size (three 12 fields joined together) and 3 x 16 field size. It is even possible to get a 4 x 12 field or 4 x 16 field paper/cel. Animation paper or cel can be purchased in long rolls and cut to custom sheets if required. Digital productions are not dependent on cel and paper edges showing when panning, so you can tape together as many standard field sheets as necessary if longer artwork is required.

It is also possible to use panning techniques on a static shot too. Occasionally, a character is required to walk (or run) into the scene, cross it, then exit on the far side. The hard way of doing this is to actually animate, frame by frame, the character into, across, and out of the frame. However, to do it more economically, it is possible to have the character walk on the spot, using a walk cycle, then (starting with the character out of the shot entirely) pan it into, across, and out of the frame in one continuous movement created in the computer program. The only thing to be remembered with this technique is that the background should pan each frame the same distance that the contact foot on the walk cycle slides, so there is a sense of contact and no slipping or sliding between the foot and the ground. This is so much easier to do in a digital environment where pretty much everything is at the control of a button. In the old cel animation days, the walk cycle had to be inked and painted in the center of long cels that had the equivalent of a full, clear field on each side of the character. Then, no cel edges would ever show when the character was positioned out of the shot at the beginning and out of the shot at the end.

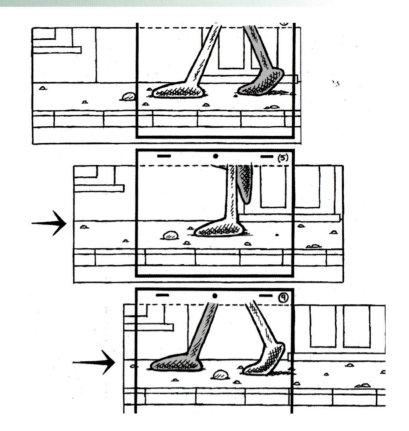

A walk cycle on a panning background. The far leg is shaded here for easier identification.

Pans can be horizontal, vertical, or diagonal. They can be shot on ones or twos, although ones are recommended, as the twos give the movement a much jerkier look. In truth, the best results come where the pan and all the animation are on ones. This applies even to track/pan movements, where an initial wide framing of the entire shot moves-in to a closer shot within the overall scene (or vice versa). You indicate where and how fast the pan moves by marking the field center points, frame by frame, on the scene's extended layout drawing.

Here, the key-frame-by-key-frame, red markings on the layout of an evenly-spaced 16 field pan are highlighted. Note that the moves indicated are established as field center points.

Tracking shots can be defined as shots where the camera moves and pans at the same time; with panning shots the camera just moves along with no in or out movement. In a tracking shot where the scene starts with a 12 field and moves in over 16 frames to an 8 field which is 4 fields north and 4 fields east of the 12 F.C., the dope sheet instructions would look like this:

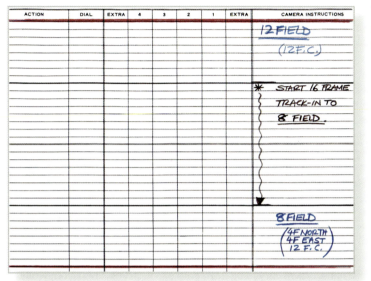

The dope sheet for a tracking shot.

Remember, camera moves are only considered tracking shots when the field changes sizes and their respective center positions are different. Any movement, in or out, that is on the same center position is simply known as a zoom-in or zoom-out and would be represented on the dope sheet as shown below.

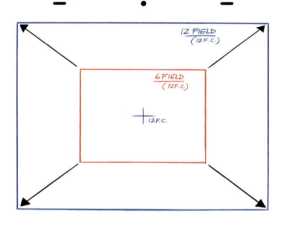

A field guide that describes a basic zoom-out over 16 frames from a 6 field to a 12 field.

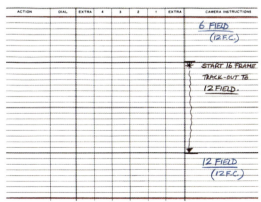

The dope sheet for a basic zoom-out.

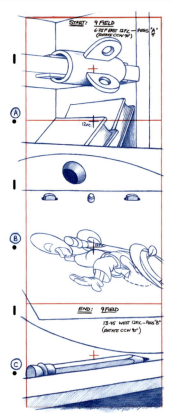

The background layout and field guide of a typical side-pegged vertical pan.

Side Peg Pans

Some pans are vertical, moving up and down, such as pans up buildings that simulate elevators rising or pans down to represent something falling to the ground. The technique of creating vertical pans is different from the horizontal pan—the extended artwork has to be turned at right angles with the pegs ranging up and down along the sides, not at the top or bottom. The artwork also has to be created at right angles to the pegs. In the old rostrum camera days, the camera table would have been rotated 90 degrees and the artwork panned up and down.

Today, vertical pan artwork can be scanned horizontally in sections, then tiled together (digitally joined) and rotated 90 degrees in the computer and subsequently panned as required.

Curved or Arced Pans

Not all pans move in straight lines. Rostrum cameramen (and/or animators) would create a panning chart (or layout) that would show the start and end positions of a pan. Then they would plot the center point of the movement using carefully calculated increments along a hand-drawn curved or arced path of action line. This layout would be attached to the side of the rostrum camera and, using a metal pointer that indicated the center of the camera placements, the artwork would be moved slowly along the incremented path of action and shot frame by frame.

A curved-pan background layout / field guide for "Endangered Species."

Nowadays, with many digital software programs, it is perfectly possible to create any form of camera movement. Applications such as After Effects, Flash, and ToonBoom Studio offer incredible camera movement flexibility to the imaginative animator, in

both the raster and vector arenas. Anything is pretty much possible. However, the only thing to bear in mind with any curved or arced pans is that the path of action, together with any tracking movements that may be added, is that the frame by frame movement should not be too sudden, sharp, or convoluted; otherwise the audience will end up seasick. (Unless that is the objective, of course!) Curved camera movements on arcs should be smooth and easy to follow, with no sudden turns or corners to negotiate.

The beauty of digital software over traditional methods, however, is that computers make it so easy to preview any number of varied pan options within the program, and in an extremely short amount of time. The old rostrum shoots, on the other hand, would actually take a day or two to complete just one option!

Repeat Pans

Sometimes it is necessary to have a long, extended panning action in a scene and yet there is neither the time nor the money to actually draw a long and detailed background to accomplish this. For example, perhaps a character is running on a cycle and the action needs to cover a great deal of ground. A repeat pan technique, three fields or longer, is probably the solution. It actually doesn't matter how long the background art is on a repeat pan, as long as the first field and the last field are identical in shape, content, and color.

Here, I have color-coded a background layout for a repeat pan which shows how the first field position and the last field position are identical.

Note that for the repeat action to work, everything in the front and end fields must be 100 percent identical to each other, in design, coloring, texture, etc. If this doesn't happen, there will be a noticeable jump in the action. With digital technology, it is so easy to guarantee identical artwork at front and end because you can copy and paste.

With a repeat pan, the camera pans from the first field in even increments, until it covers the entire length of the background and reaches the end field. However, when it does reach the final end center position of the last field, it does not use that frame but jumps back to the very first field again and continues to pan from there as before, and so on and so on. If the scene is particularly long, this procedure might be done several times, giving the illusion that the action (and the artwork) is continuous. The technical secret is to make the panning increments even and seamless throughout, especially with the linkup from the last and the first move positions, so that when it makes the changeover, the movement is identical and there is no kick (sudden change of speed) in the pan.

The dope sheet of a repeat-pan scene shows how the movements on the background level cycle back to the beginning once the penultimate end position is reached.

To create a repeat pan, I always start with the animation cycle. Then, when I know the size of my character and the distance that the feet slide on the walk, I do the layout, both in terms of its relationship to the character's position and the length of pan it has to be to coincide with the foot slide. With the distance between the front and end center positions of the pan established, I can now draw in my background details. I actually do this on a separate single field sheet of layout paper, the initial parameters of which I take from the first field of the repeat pan layout.

The first stage of drawing a repeat-pan background layout is to mark the centers of the first and last frames.

The first frame design is drawn onto the background layout. Then, this is traced onto a separate sheet of paper, making sure that the center of first frame is also traced off too.

I then identically trace the end frame from the traced design, so it matches the first. Now it is a simple process to complete the layout by drawing-in the design details that link the two.

Place the traced design sheet under the end frame of the repeat-pan layout and again accurately trace it, making sure the center positions line up perfectly.

The completed layout, including identical first and last frames.

NOTE

To get a perfectly accurate center matching position, I give the pasted version some transparency, which enables me to line up both centers, before returning it to its original opaque mode and then merging it with the underlying background.

With the entire layout completed, I scan and color it as I would any other background art. However, instead of coloring the end background, I just color the first field area. Then, in an image editing program such as Photoshop, I copy and paste this into the last frame position (see below), making sure that the centers match up precisely before finally saving it.

A color copy of the first frame is pasted and merged into the last frame position.

This digital process wonderfully ensures a perfect match from the first frame of the panning artwork to the last. With these in place, it is again simply a matter of finalizing the linking artwork to match the two and the entire repeat pan background is complete.

The only real disadvantage of a repeat pan is that if it goes on too long, the audience will notice that the objects in the background are repeating, killing the illusion that it is all happening along one extended landscape. However, this can be avoided to some extent if the pan is created longer than three fields from beginning to end and that the scene doesn't last too long. Clearly, the more fields created between the front and end repeat fields of the pan, the less chance there is of seeing the repetition. At the same time, using too many fields defeats the object of saving time and effort in the first place.

Panning Charts

Panning charts can be extremely valuable in visualizing the overall action and timing of a pan, whether these are for curved or straight pans. The beauty of such charts is that they show you exactly what will be on any particular frame of film within the scene. As seen in the curved pan on page 378, the panning chart indicates the start and end positions, as well as all the required panning field centers along the pan's path of action line which links them. An additional advantage of drawing out a traditional panning chart is that the animator can actually plot their own movement manually if necessary, allowing for special movement timings, such as slow-outs and slow-ins, etc.

A vari-speed panning chart is demonstrated below. With a traditional repeat pan action, the panning distance from frame to frame would be equal, so there is no change in pace as the background pan cycles. The panning chart here calls for the camera to accelerate away from the first position (slowing-out) and decelerates into the end held position (slowing-in). This is more common for a non-repeating pan.

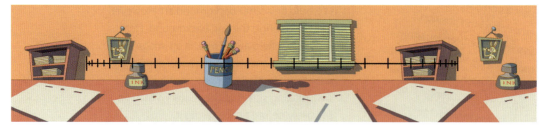

This panning chart calls for a slow-out at the start and a slow-in at the end.

The best panning shots in classic Disney movies were not shot at an even speed. The Disney animators crafted the pan in accordance with the needs of each particular scene and used panning charts to arrive at their final movement. That said, for most basic panning shots, a movement that is even all the way through will probably be okay. However, if a panning action starts or ends with a hold, then a more graduated pan movement (slowing-out or slowing-in) is required to avoid uncomfortable sudden stops and starts. The slower-in the pan; that is, the smaller the increments are on the panning chart path of action, the slower and smoother everything will be, and the less chance there will be for any strobing (covered later in this chapter) to occur.

Zip Pans

Occasionally, extremely fast pans are necessary, movements that move from one part of a scene to another in just a few frames. These are known as zip pans and provide a sudden, dynamic impact point, where an unrevealed part of a scene can be introduced in a matter of a few frames. A zip pan can move almost faster than the eye can perceive on occasions. In the rostrum camera days, it was said that anything that panned 0.25 inches per frame or more was a zip pan. The digital technology of today, however, provides that motion blur can be added to the pan as well, giving an even more natural feel to the speed of the action. In such cases, the direction blur should be the greatest in the middle phases of the pan and then lessen as the front and end slowing-out and slowing-in link the action to a static view.

The art below shows three examples of motion blur in a fast panning sequence. The frame on the left has no motion blur. The middle frame has slight motion blur added to it and the final frame has extreme motion blur added. Motion blur can be added digitally in all directions, not just horizontally.

Increasing the motion blur increases the sense of speed.

A clever scene-to-scene distance cheat can be achieved by using two connected zip pans. This is achieved by zip panning the camera away at the very end of the first scene. Using extreme motion blurs, a fast cut (or even dissolve) links the middle of the first pan to the middle of a second zip pan that is on its way to arriving at the opening shot of the next scene. The illusion achieved is that the camera is zipping away from one location and arriving at one some considerable distance away, without actually creating the artwork to do that.

Two zip pans dissolved together to provide a smooth transition from one fast-moving scene to another.

To give additional impact to a really fast and erratic zip pan, you can overshoot the end of a zip pan a little. Indeed, it could even overshoot and then zigzag back to the final position, to suggest that the camera is searching for where it needs to be. This kind of overlapping action on the background can be very effective if timed just right, giving an even more frenzied feel to both the speed of the pan and the arrival of what it is being revealed.

Camera Shake

A valuable panning technique to be aware of is camera shake, when an impact is emphasized by the whole scene shuddering. Camera shakes are most effective if their action matches the animation being followed. For example, if a character is running from left to right and hits a brick wall, the action can be better emphasized by having everything shake from side to side. Similarly, if a character or object falls from a great height and hits the ground, the scene has more impact if it shakes up and down.

Camera shakes are achieved when a panning action overshoots the final position, returns back and passes the final position, moves forward again past the final position (but not quite as far as the first time), returns back and passes the final position another time (but not as far again) and so on and so on, until the camera at last comes to rest in the final position. Each move needs only a few frames to achieve, shot on ones, until they inevitably lessen and come to a final hold. Diagrammatically, the move effect would look like the art at left (although in reality, the zigzagging back and forth would occur over the same path of action, of course).

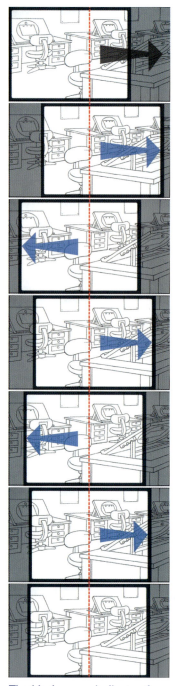

The black arrow indicates the direction of the original pan, while the blue arrows indicate the direction of the overshoot over the ultimate central (red line) position each time.

Pan Speed and Strobing Problems

Strobing occurs when a background with many vertical lines pans horizontally at an incompatible speed, creating a strange, jerky shuddering. It can also occur with vertical pans where there are many horizontal lines, or even in the spoke of a cart, if the turning action is not timed correctly, giving an illusion that the spokes are going backwards rather than forwards or are jittery in appearance. The effect can be very disconcerting for the audience and often kills the intention of the scene by distracting the audience. Strobing is especially likely if the panning action is produced on twos or higher.

To avoid strobing, a horizontal pan has to be first executed on ones (with any companion animation also created on ones) and as few evenly spaced, vertical lines created within the background artwork as possible. The same ones rule has to be applied to vertical pans also, although there needs to be an avoidance of evenly spaced horizontal lines in the background in this case. If an animated character walks on twos and yet the background is panned on ones (a common feature with low-budget animation), the foot contact with the ground will slide on every other frame. If the animation is on twos and the background is panned on twos, there will almost certainly be a sense of jerkiness to the scene anyway.

If it is impossible to eliminate a significant number of vertical/horizontal lines from the scene, then a panning movement of a tenth of an inch per frame or less is recommended. The slower the pan, the lower the chance of strobing, unless it is a zip pan, in which case there will be no problem since everything is moving so fast.

Shadows and Effects

Animation can really come alive with a clever use of shadows. A striking example of shadow art at its best was in "Who Framed Roger Rabbit," where multiple layers of shadows and highlights captured a new, stylized three-dimensional look in 2D animation. That breakthrough brought a fashion for this kind of molded shadowing that has been seen in advertising commercials ever since.

This example only uses a few layers of shadowing and highlighting effects. But, even so, it illustrates the principles that the Roger Rabbit approach discovered.

Shadows of all kinds can give a greater sense of form and dimension. They can also root the character to the floor. When colored darkly, animated shadows can give a distinctive, dramatic, theatrical effect.

This scene from "Endangered Species" makes full use of a single shadow to create a distinctly dramatic effect in the scene.

To create shadows, you must first establish the location and direction of the light source that is creating them. Once this is established, the shape, size, and length of shadow can be established.

For this scene I simulated a strong, close, low-down light source to inspire the shadows.

Transparent shadows need to be created on a layer separate from the main animation. If the shadows are merely a darker shade of the character's main color design, they can conceivably be traced and colored on the same animation layer. But I recommend putting them on a separate layer, where characteristics like intensity and opacity are so much more controllable.

In the Roger Rabbit approach, the shadows are actually added transparency layers with varying degrees of width and intensity, with a similarly highlighting effect created on the opposite surfaces.

Shadows define the side of the character that is furthermost from the light. Shadows also define the character's point of contact with the ground, as well as the direction from which the light is coming. This can be very useful if the time of day or the season needs to be emphasized.

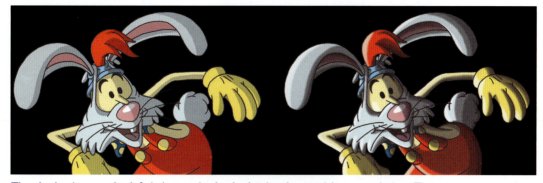

The shadowing on the left is just a single shadowing layer, with no gradation. The shadowing on the right however shows that, through layering and a balancing of these layers, a great deal of molding and expression in light and shade can be achieved if required.

Practically speaking, the process of creating animated shadows is to take a key drawing, place a new sheet of paper over the top of it, and draw any body or ground shadows that need to be defined. It is not necessary to shade in the shadows, just the unbroken outlines (for subsequent digital coloring), and accurately match the lines of the animation that have the shadows.

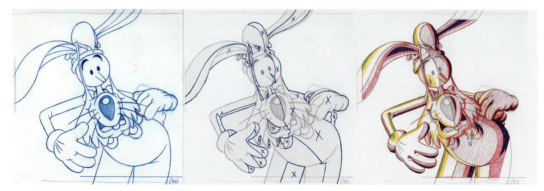

With this scene from "Endangered Species," I first produced an acceptable pencil test of the main action (left). I next penciled-in the main shadow areas, frame by frame (center). Finally, I color-shaded the various levels of shadow that I needed, each ultimately being traced separately onto different SF/X levels before scanning and compositing.

In terms of consistent shadow animation, once the first key is completed with a shadow layer, the next key needs to be placed on top and a new shadow created for that. For increased consistency, I repeated from one to the other, to more clearly visualize the movement of the shadow as it coincided with the movement of the animation.

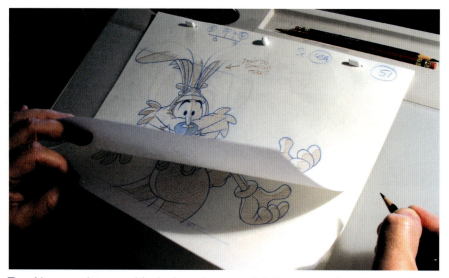

To achieve consistency with shadow placement, it is important that the preceding drawing be placed beneath the new one for the correct positioning. Sometimes, a number of drawings will be flipped to ensure a smooth transition from one to the other.

When all the keys in the scene have had shadows added, the drawings are handed over to the assistant animator for inbetweening. Remember, all shadow drawings are placed on an additional sheet of paper, so they are separate from the key drawing, unless, of course, they are opaque shadows, in which case they can be drawn on the same layer as the animation drawing.

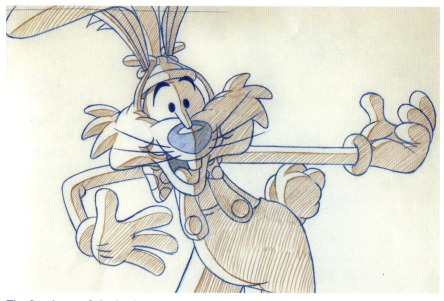

The first layer of shadowing.

If placed on a separate sheet of paper, they should have the same numbering as the principal animation drawings they work with but with an S prefix.

A section of dope sheet, indicating its four layers of shadowing ("S" to "SSSS"), in addition to the main animation level.

Sometimes, shadow work can be extremely complicated and the traditional key/in-between approach will just not work. In these circumstances it might be advisable to use a straight-ahead technique for the shadows. To do this, the first key drawing is positioned and shadowed, as discussed above. However, instead of shadowing the next key and creating the inbetweens separately, the second drawing is placed on the pegs and shadowed accordingly, using repeated flipping techniques to establish just where the shadow positions will be. Then, when this shadow is complete, the third animation drawing is placed on the pegs and shadowed accordingly, now using a three drawing technique. The entire scene is completed in this way, moving on from one drawing to the next to create the required shadows.

Once the shadows are completed and approved in pencil test form, they will be scanned and colored with the rest of the animation drawings in the scene. Then, when composited together with the rest of the scene artwork, they will be given a degree of transparency, depending on how strong or dramatic they need to be. This is best achieved by trial and error first, although whatever decision is reached on one scene will have to be carried through on all related scenes, of course.

Shadows can add warmth or coldness to a scene, simply by the kinds of colors the shadows are painted in. The image on the left has a transparent black shadow. The image in the middle has a transparent red shadow. The image on the right has a transparent blue shadow. Each gives a decidedly different sense of mood and emotion.

Shadows in different colors create different moods.

Rotoscoping

Rotoscoping is the process of filming in live action, tracing it frame by frame, and us-ing the tracings as the basis for an animation sequence. Rotoscoping can be extremely valuable in the context of movement research. However, all too many times, animators will color and composite these traced drawings with a background, passing them off as real animation. Although a relatively cheap and fast process, this does not lead to good animation because rotoscoped animation is not as fluid, flexible, and convincing as regular animation. Rotoscoped drawings often have a wooden feeling, even though they may be slavishly and accurately traced from good live action. It is only when these tracings are caricatured and re-timed by an experienced animator that the sequence will come to life as convincing animation. I strongly discourage the practice of using rotoscoping as animation. At the same time, I do emphasize that rotoscoped drawings can be invaluable as action reference material that can be observed, flipped, and recre-ated into good, original animated movement.

This figure shows a live-action bowling sequence that has been traced for animation reference. If inked, painted, and shot as they are rotoscoped, the animation will look extremely dull and wooden. However, beneath the initial tracings, I have added key drawing suggestions (in red) that will give the real poses a much more dramatic and even natural feel to them when they are shot as animation. I have also added suggest-ed timing charts that will indicate that real time framing needs to be worked with to make the original movement much more impactful and believable.

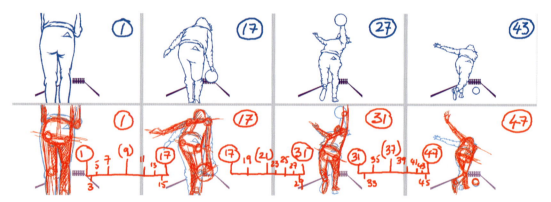

A rotoscoped sequence and my suggestions for the animated version.

Actually, rotoscoping animation by the great animators of the past can be an invalu-able tool for the student animator to understand just how these great master anima-tors achieved what they did. I define students of animation as anyone, at any age, who wants to refine and improve their movement skills, and therefore I include myself in this category. I have never been more thrilled than when, years ago, I first flipped ro-toscoped drawings of some of the greatest scenes of Disney's Frank Thomas and Milt Kahl, work that underlined the difference as to where I was and where they were. This both humbled me and inspired me to become better and better at what I did with my own work.

2D Vector Animation

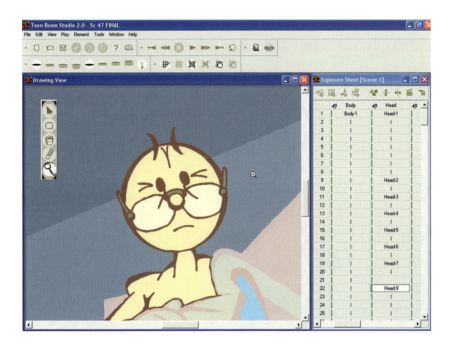

The ToonBoom Studio interface suggests how familiar this vector program is for the traditional animator.

The invention of vector graphics is one of the biggest advances in modern digital arts technology in recent times. Vector animation differs from conventional animation in several ways and therefore demands a separate, albeit brief, look at its techniques and procedures.

Vector-based graphics were developed when it was realized that Internet bandwidth (and even the regular computer technology of the time) was not powerful enough to deal with the graphics and animated imagery that users and creators for the Internet were increasingly beginning to demand. Before vector technology appeared, the best capability for animation on the Web was GIF animation, where a number of successive, highly compressed files were shown sequentially, albeit relatively rather crudely, when compared with other movie media. The limitations of GIF animation initially restricted their use to simple moving graphics and animated logos. In more recent years, GIF animation developed a certain capability that is still valuable today, and more software is available to increase the quality of GIF animation.

Programs like Ulead's GIF Animator can make the creation of Web-based animation fun and very professional looking.

Then a single vector-based product, Macromedia Flash, was introduced and completely transformed the animation capabilities of the Web. Flash not only brought a far greater capability of movement but it also added sound to Web-based animated filmmaking too.

Vector technology translates text and images into mathematical formulas that are represented by points in space (next page, top). Consequently, these smaller data components can be quickly and economically distributed across the Internet, as opposed to raster (pixel-based) approach that requires far larger sized files. Even so, the Web still has a reasonably limited bandwidth capacity, and even the smallest vector movies have severe limitations over animation for TV and the cinema. This is best illustrated by the fact that although theatrical films run at 24 fps and worldwide TV runs between 24 to 30 fps, animation on the Web is limited to only 12 fps!

On the left, a pencil drawing and inked-in line and on the right, the vector version in ToonBoom Studio.

It will take about two minutes for 250K of material to load on a 56K modem, which is why animation for the Web has to be created with the smallest file sizes possible. Traditional animation on the Web would require characters changing anywhere from 12 to 24 times per second, which would produce an overload on everyone's computer, making the whole exercise impossible. Consequently, the greatest Web-based Flash animation is a blend of illusion and technical slight of hand. Undoubtedly, Flash animation is as much a creative process of file management as it is the art of masterly movement. Like the clever stage magician, the Flash animator has to perfect the art of showing the audience just enough to convince them they are watching full animation, without it actually being so.

Animation, especially vector-based animation, has flourished under this Web revolution and Flash has dominated the marketplace for Web applications since its introduction. Surprisingly though, it wasn't ever really designed for traditional animation purposes in the first place; it was a Web site creation tool that just happened to have an economic animation capacity also. That said, the resourcefulness of traditional animators adapting the program for their own use has made Flash animation an industry standard all of its own. Even 3D animation programs are starting to render movies into the Flash movie format these days, meaning that no aspect of animation is any longer restricted from exposure on the Web (the limitations of the lower frame rate aside). That said, from the traditional 2D animator's point of view, Flash techniques still have significant limitations.

Computer technology and capability have developed significantly since its earliest incarnation, with more traditional-style, vector-based 2D programs, such as ToonBoom Technology's ToonBoom Studio, offering some spirited opposition to Flash's domination. ToonBoom, for example, has enabled traditional animators to take full advantage of the low file sizes of vector animation, and provides tools and techniques that are far more familiar to the traditional way of working. This is why I turned to ToonBoom Studio when creating the vector scenes for "Endangered Species," although I fully recognize that the economic approach to Web animation that Flash offers has many huge advantages.

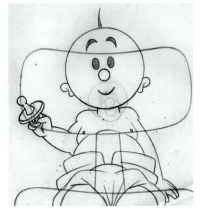

A pencil and companion vector image from "Endangered Species."

The Value of Limited Animation

When TV became a major marketplace for traditional animators and filmmakers, the need for economy of movement and speed of display became paramount. This developed into a system of economic animation production that was championed by studios like Hanna Barbera, years before the even more limited approach to animation demanded by the Web. Yet these severe limitations are not exactly the choice of Web animators. They are much more tied in to the severe restrictions that Internet bandwidth imposes on design and movement. Until bandwidth technology improves significantly, Web-based animation still has visibly reduced quality, although animators are beginning to push the boundaries of Flash to come up with things that make up for limited animation technique. Vector animation outside of a Web application has no such limitations, of course.

By comparison, many of the cheap and limited animation techniques characterized by the earlier Hanna Barbera TV shows are now considered quality animation the light of some of the extremely limited Web animation that is around today. Limited animation should not necessarily be considered bad animation, as quite often a limitation in one direction can produce innovation in another. What constitutes good vector animation on the Web is the skillful creation of maximum results from the minimum resources. As with all other filmic disciplines, the storyline of a Web movie is by and large still the most important ingredient, particularly as Web-based animation is clearly incapable of providing the level of character animation that other areas of the animation industry can offer. (Invariably, with Flash animation there is a minimum of movement and a strong emphasis on holds and cycles.) The animation is often produced on threes or fours, or even more. Consequently, this is why the storyline needs to be of the highest order if a production is really going to work.

The Basic Approach

It has to be accepted from the outset that Web-based Flash animation simply will not have the same fluid performance and execution as the more tradition forms of full animation. The medium is audio-, design- and layout-focused, meaning that the animation usually has to be minimized in order for it to effectively play across the basic telephone-line bandwidth capability that the Web has to offer throughout the world. Flash characters are generally created on layers, so arms, heads, or even mouths and eyes are animated separately. Sometimes they are created from predetermined cut-out shapes, like "South Park" or "Monty Python." ("Cut-out" style animation of this kind is much better handled with a vector program like Lost Marble's Moho, which uses a more 3D-like system of "bones" to move and manipulate image elements.) Both approaches mean that a library of animation assets and actions can be created, used, and re-used throughout a project.

A vector drawing created in the ToomBoom Studio.

It is, of course, theoretically feasible that vector animation can somewhat success-
fully emulate the old Warner Brothers Road Runner timing technique—short bursts
of fluid animation punctuated by static poses that dramatize the action. But this has
to be planned and worked for, sometimes pushing the limits of the medium to its ex-
tremes. That said, all vector production has to follow the traditional production line
procedures: ideas, script, storyboard, design, animation, backgrounds, and soundtrack,
etc. It is just in the actual execution of the animation that things have to be severely
restricted.

Writing for the Web

A good story is a good story is a good story, and this is no less true for Web vector
animation than any other form. However, the content and intended performance
level for the characters of a Web film need to be carefully adjusted to suit the medi-
um. Most entertainment films in animation rely significantly more on dramatic action
and visual movement than their Web cousins can. Here, a greater emphasis on the
narrative or the frozen, posed gesture is much more important. Until bandwidths are
powerful enough to carry data that will enable full-screen, real-time playback, there
is absolutely no opportunity whatsoever for animators to provide fluid, full anima-
tion (i.e., on ones, or even twos) for the average Internet viewer. As a result, scripts
for Web animation have to be more focused on the narrative and visual design rather
than on action and dramatic subtlety. This is no less true for game scenarios than it is
for movie storylines.

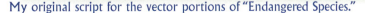

Sc.01: 'Endangered Species' is written on screen... pull back to reveal desk.
Sc.02: Baby appears, walks up to desk.
Sc.03: Reverse shot of baby at desk.
Sc.04: Profile shot of baby as he picks up pencil and (freeze frame)...

Narrator:
The **Animaticus** first appeared just after the turn of the 20th century, an era that was to
be known as the '**Draw-assic Age'**.

Sc.04 (cont.): begins to draw on the desktop.
Sc.05: Emil Cohl-style drawing on film.
Sc.06: Winsor McCay-style 'Gertie the Dinosaur'... who bites his pencil.
Sc.07: Baby does 'take' to bitten pencil (freeze frame).
Sc.08: Max Fleischer-style inkblot gag.
Sc.09: Koko the Clown-style background twist.
Sc.10: Baby looks under paper.
Sc.11: Betty Boop-style character opens curtains.

Narration:
It was initially believed that Animaticus had no audio capability whatsoever. But later
evidence revealed that sound was essential element in his development.

My original script for the vector portions of "Endangered Species."

Storyboarding for the Web

The significant limitations on writing for the Web have to be reflected in storyboarding too. It is absolutely no use whatsoever if the script is narrative- or dialogue-driven and yet the storyboard indicates the characters acting wildly or performing wildly during the lines. Emphasis has to be based more on the dramatic set-up, rather than the dramatic moving gesture. In this respect, drawing a storyboard for the Web is like illustrating a comic book for the print industry (except, of course, the kind of wild action poses on the printed page cannot possibly be brought to life in animated Web adventures). It is more in the dramatic framing of carefully crafted design and layout, rather than the potential for movement, that storyboards for Web projects can resemble the visual creativity of the comic book genre. Talking heads, rather than moving bodies, is very much the order of the day for most Web films and hopefully a carefully constructed script will enable the storyboard artist to achieve this. The skill is to create as much visual action in a single pose in motion, or a carefully structured sequence of poses in motion, as possible to get the story across. The skillful use of library assets (pre-conceived and executed characters and environments) and cycle animation (using the same few drawings to create a repeated action, such as a continual walking action), reused throughout the storyline, are excellent scripted economies that will suit a vector-based approach.

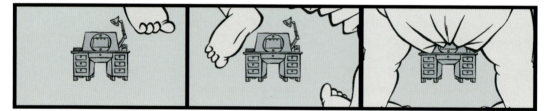

Early storyboard frames that visually describe the opening vector sequence in "Endangered Species."

Web Characters

Vector characters can be created in drawing programs like Adobe Illustrator. A pencil drawing from "Endangered Species" has been imported into the program and is being traced in a vector style line.

Web-based character designs need to be considered carefully. For a start, the character coloring needs to be flat and basic. It is really not possible to employ an illustrative or rendered approach to the coloring, unless using a library of cut-out objects that can be moved and manipulated economically. Radial fills can give a hint of tonal change but is really limiting in some cases. Traditionally styled soft shadows and blurred image effects are not easily possible, in view of the mathematical basis upon which vector imagery is based, although it is now possible to simulate these things with Flash to some degree. However, using these simulation techniques is much more "expensive" in terms of data files sizes, something that needs to be avoided with Web applications of the technology. Artists familiar with such vector drawing programs such as Adobe Illustrator will understand this and will be at home with Flash

design techniques. Alpha channels (invisible masks) and gradients (digital colors that blend from one color to another) are possible with Flash. But such techniques do significantly add to the overall data size of the project if used incautiously.

Soundtracks

Quite often, because of the limited nature of the technology, the soundtrack for a Web project has to carry more weight than is perhaps usually necessary. Many Web soundtracks move the storyline along, and therefore it is important that this part of the production be clear, concise, and well-constructed. The best approach to take is that the soundtrack for a Web project is like a good quality radio show, with some visual elements added later. Treating it as if it is to be listened to and not seen in conjunction with an animated image will ensure that it is effective and does the job it is intended to do. Consequently, it is important that the filmmaker puts as much production value into their audio elements as possible. The soundtrack will ultimately be created in the MP3 file format. But, during its the editing process, it can be created on anything from a professional DAT format to a standard, home-based WAV format, although the higher quality of equipment and format the original can be created on, the better the end result MP3 will be.

The ToonBoom Studio dope sheet with the audio track column highlighted.

Always make sure that your audio track is easy to hear!

NOTE

Flash actually has two different sound settings, event and stream. Event sounds keep the soundtrack and the visuals separate, though they play together. If the final output requires perfect synchronization between the two, then stream should be selected. Stream also allows for scrubbing; running the audio backward and forward to analyze its phonetic voice breakdown or its musical beat points. However, stream does tend to make larger file sizes than event.

The Animatic

It is not as easy to produce an animatic for Web vector animation as it is with regular filmmaking. That is not to say that it's impossible, just that it's a little more convoluted. In order to view Flash artwork, the visuals need to be made up of many individual parts of a character that have to be created beforehand. Consequently, to create an animatic requires that all these parts are designed first, pretty much completing almost all the production elements that the final production will require before the animatic can be assembled. On the other hand, it is far easier to produce a quickly drawn, scanned-in storyboard animatic of the proposed idea in Premiere (for example), before going to the complex and time-consuming process of creating finished Flash characters and environments. Of course, with a rough pencil animatic in place, it is then comparatively easy to block out a more polished animatic in Flash when the character building work is created for the final production work. Consequently, I would prefer to block out my ideas with an initial, drawn storyboard animatic in a digital editing program first, then work in Flash after the basic structure of the project is blocked in.

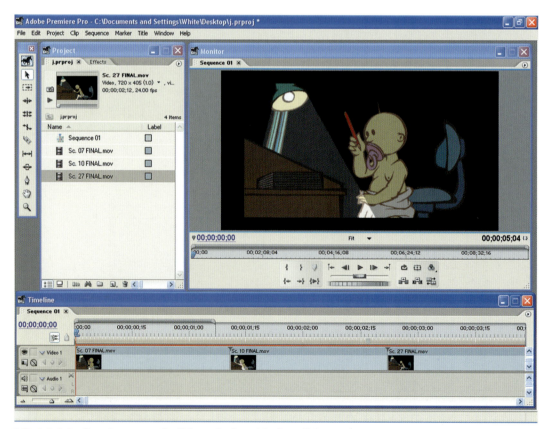

I find Adobe Premiere more flexible and adaptable for editing my animatic.

Vector Film Production

Vector animation is usually divided into two separate expressions, games-based or entertainment-based. Other uses of the art form defy expression, such as the wonderful and imaginative creativity of www.vectorpark.com but, by and large, these two approaches cover most of the uses for vector animation. Flash is also used to create exciting and innovative interactive Web sites, but we'll focus on vector-based animation production here.

The disciplines of games and entertainment each require individual production processes to create an end result. The entertainment process uses the conventional stages of production: concept, script, storyboard, animatic, rough animation (mainly key frames and some inbetweens), pre-final (inbetweened animation), and then final (completed animation with lip sync). Games production, on the other hand, requires a slightly different approach: concept, creative overview (a process which defines all the screens of action with text, as well as sketches of screens and game-flow charts), design (finished color renderings of each element within the game, yet without any interactivity built in), game beta (showing animation and game play), game alpha (a final testing process prior to completion), and final (the finished product).

Either way, there is a great variance of these stages from studio to studio, of course, but generically the production overviews suggested here are a safe, reliable model of how things should be approached. For the vector sections in "Endangered Species," I used the conventional process of filmmaking indicated above, except I created my original animation drawings outside of the program, then I vectorized them when importing them into my software of choice, ToonBoom Studio.

ToonBoom Studio is a vector-based answer to a traditional animator's prayer!

Animation

The difference between games animation and entertainment animation is significant. While the latter can be much the same as regular animation production covered in other chapters, animation needs for the Web and games industry needs to be approached with an eye to production economy. Because the processes and file-size limitations require simplified animation, the work can be done quicker. For example, with Web animation, it is not unusual to expect that up to five minutes of animation be produced in a three-week period and with a very limited library of animated actions. Conventional animation, whether it is 2D or 3D, could not possibly compete with this, except with the most primitive and expressionless animatic style possible. In order to make the greater footage rates that Web and games animation require, the vector animator needs to make an art form of economy, utilizing a less is more philosophy. This means that, with Flash animation especially, a disciplined and structured approach to design and color concepts alone is fundamentally important.

Even vector animation requires a stage-by-stage mastery of the animated action if personality and emotion are important to the storytelling.

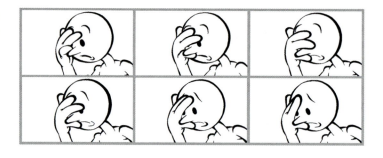

Design

As indicated above, designing characters for a more traditionally styled vector animation production requires a conventional approach using drawing, scanning, and digital coloring techniques. However, if the project is Flash-based, certain principles apply. The first rule is that, since all animation has to be of minimal file sizes, the characters have to be constructed in the most economical ways possible. Therefore, characters are rarely full figure designs. Instead, they are often made up of a number of separate bodily elements (head, eyes, mouth, torso, upper and lower arms, upper and lower legs, etc.) that are combined to create an entire figure. If the scene permits, the same arm and the same leg may even be used for both sides of the body.

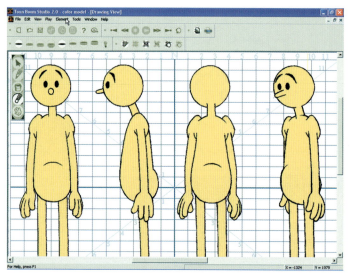

An early, vector-based design page for my Everyman character in "Endangered Species."

Characters rendered in Flash are commonly broken into several elements that can each be manipulated on separate layers. MONTE MICHAELIS

Indeed, if a close-up of the hands is required, the fingers might even be created using separate elements by breaking each finger into three separate units, with two of the same units modified for the thumbs. Having all the character elements as individual pieces means that only the parts that have to move are moved, and the rest of the body remains static. The real economy with this approach is in the fact that each separate body part can be created and stored in an overall production library and then used, re-used and re-used yet again in as many instances throughout the production as is necessary. Using the same body parts over and over again adds no significant burden to the existing volume of data that has to be uploaded into a computer's temporary memory when a film or a Web site is initially accessed; the upload time will be entirely dependent on how small or large the library of elements is. The accomplished Flash designers are masters at minimizing the size of their animation library resources before even starting the animation. For instance, if a character is seen walking in profile, the near leg can be animated as a complete cycle and then reused behind the body level, with a slight adjustment of its timing, as the far leg. This way, you get two legs moving for the price of one!

The real skill in designing all this comes when the join points of various body parts have to be attached to a layer with no appreciable sign of the join actually showing. If a character is all the same color, there is no problem with this, as digital colors are the same no matter which layer they are on (unlike traditional cel-based animation). However, if a number of colors are used and the character is wearing significant clothing, then the skill is to find matchline opportunities to join elements together, such as the jaw line of a head over the neck, a necklace around the neck, or the cuff of a sleeve, etc. This is all part of the challenge that the Flash designer needs to face, and great ingenuity is often required.

Remember, no two characters can ever look the same, so it will require even greater ingenuity to discover ways of achieving this from design to design and scene to scene and yet keep the library elements as small as possible. Color-wise, vector-based design places a great deal of emphasis on brightness and impact.

Since Web animation, for the most part, has no controls or censorship issues attached to it, Web productions are often more political, racy, edgy, or off-the-wall than other forms of animated production. Consequently, characters can range anywhere from the sexy to the anarchic, from the cute to the alien/monster/fantasy/vampire/martial art/high tech killer creations that are perhaps becoming a little too familiar these days. Sadly, subtlety does not seem to be part of the standard Web design's palette, so far.

Once assembled, all the visual elements of a Flash animation character should mesh seamlessly. MONTE MICHAELIS

The Web, by its very nature, is an international stage which has to often transcend culture, taste, language, and geographical boundaries if it is to be truly successful. Nothing can be too complicated or intertwined. These limitations make it very easy to see why the more commercial, intellectually accessible sites can become predictable and formularized and therefore, like the cinema and TV industries before it, it is sadly becoming increasingly hard for the professional designer of popular Flash content to find originality and innovation when catering to such broad-based audiences.

Backgrounds

With Web animation, the backgrounds form an important part of the overall effect of the scene. With the limitations imposed on the animation technique, it helps if increased attention is paid to the background styling, by way of compensation, although such backgrounds are usually created using raster technologies, which make larger file sizes. Flash-created backgrounds, of course, will be far more economical. With the right design, color, stylization, perspective foreshortening, and other aesthetic tricks, the background work will certainly enrich the overall piece. A character featured in a well-crafted and aesthetically stylized background will provide a far greater dramatic impact than in a plain and underachieving background. With the camera functions of most vector programs, an even more dramatic effect can be generated with a multiplane/parallax approach. Ultimately, the more thought and effort put into the backgrounds, the more the filmmaker will evoke a greater sense of mood or emotion in the sensibilities of their audience.

Two backgrounds for Flash animated films. MONTE MICHAELIS AND SAILLE SCHUMACHER

Hanna Barbera: A Worthy Role-Model for Web Animation

First time Flash animators for the Web would do well to study the best of the Hanna Barbera school of limited animation techniques. Hanna Barbera perfected the art of economy of animation in storytelling. They were able to move just enough on the screen to keep the illusion of animation going while still telling good stories. They were able to animate tremendous amounts of lip-syncing dialogue with the smallest library of mouth positions imaginable, another valuable economy for Flash animation.

Remember that Flash allows for every piece of a character's body to be manipulated individually as if they were free-floating, cut-out pieces of paper.
MONTE MICHAELIS

Inbetweening

With digital technology, it is very tempting to use the mechanical inbetweening function that some vector programs have, rather than creating regular hand-drawn inbetweens. Automatic inbetweening is a huge saving in terms of time (and undoubtedly cost, in the way of professional productions) and Flash is capable of any number of wonderful techniques because of this.

But inbetweening is an inherently educational experience for the young trainee animator; by letting the software to do that aspect of animation, they miss out on a real learning experience to get a feel of just how drawings, spaced differently in varying circumstances, produce different kinds of fluid movement. Animators should never entirely depend on technological tweening alone. Also, computer-aided inbetweening rarely gives the opportunity for eccentric breakdown positions or slowing-in and slowing-out, which is another aspect of the learning process that young animators need to understand. There really is no greater learning experience than that of trial and error, trying and testing, although the advantages of Flash tweening are just too seductive to ignore if used discriminately as well as creatively.

Flash includes a tweening functionality, which smoothly morphs one shape into another while changing position on screen. MONTE MICHAELIS

Lip Sync

With conventional animation, it is extremely important that lip syncing to dialogue is not limited to the mouth. Body posture, dramatic movement, and face and eye expression all contribute to the lip sync action to create the entirely convincing delivery. With Web animation, however, it is rare to have the luxury of getting anything but the mouth level moving, with perhaps a little eye action and occasional head movement thrown in to offer more expression. With really important emphasis points, there should be at least some movement of the body, up and down or forward and back, so the Flash lip sync animation is a little more than just straight lip movement. It may not always be possible, but the more that can be done, the more convincing and emotive the delivery will be.

It is more likely in Flash-based animation that there is no movement at all during lip sync action, except on the mouth layer. However, as most audiences look at the eyes when a character is speaking, the Flash animator should remember that some expression in the face is only going to help the audience be convinced that the character is truly speaking. The Flash animator could develop a set of eye assets that can be integrated into the action in the same way that the mouth is being used (see the top of the next page).

Lip sync deserves more attention than it is usually gets, especially in Flash animation. Profile-oriented lip sync, especially, where the mouth cannot be just positioned over the forward-looking face as a simple overlay, is a bigger challenge to the animator/designer. Since profile animation has no static match lines to work with (other than if the character has facial hair or a five o'clock shadow), the whole face has to be part of the mouth level. The foundation of all Flash-based lip syncing is that the animator creates a separate set of interchangeable mouth shapes that can be placed over the face to match the audio track, frame by frame. Whether this be a simple mouth overlay, a whole head drawing or the mouth matched to a convenient beard and moustache, the challenge for the accomplished Flash animator is that the audience has to believe that the character is talking and there is some degree of emotion and personality in that character's delivery. The Hanna Barbera system upheld the proposition that most

Lip-sync in Flash is as easy as dragging and dropping a pre-rendered mouth position into place. MONTE MICHAELIS

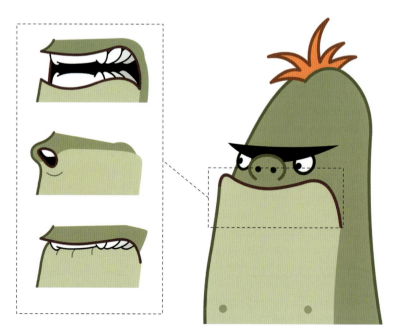

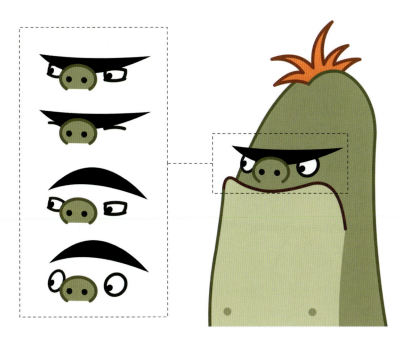

Flash does enable the animator to render eye movement in advance and then drag and drop the appropriate expression into place as needed.
MONTE MICHAELIS

economical lip sync can be achieved with five mouth positions. Obviously, if more than five positions can be created for the lip sync, then the delivery will be smoother and more convincing.

Fine Tuning

Even though vector animation needs to be created in a very limited way for the Web, the technology still provides the means to add subtle touches to the action when fine tuning it. Indeed, some Flash animators excel in utilizing such techniques to take their work just a little further than the expected. For example, from a movement point of view, if an arm is required to move up to a pointing position, the successive breaking of joints approach can be utilized. To do this, instead of just moving the arm up evenly to its final pointing position, the arm should be broken down into various individual parts, such as the upper arm, the forearm, the hand and the individual fingers, which can be moved independently and sequentially to provide a more natural and dramatic action to the point. Similarly, all the principles of weight, anticipation, and overlapping action can be applied to the various objects if they are designed and broken down appropriately. These are all the sleight-of-hand tricks that the Web animator needs to add to their work if the viewing experience of their audience is to be enhanced.

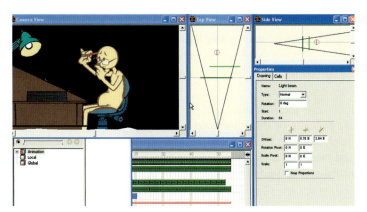

ToonBoom Studio, like Flash, has the exciting capability of moving the camera view through the scene, providing visual effects somewhat akin to the early Disney multi-plane approach.

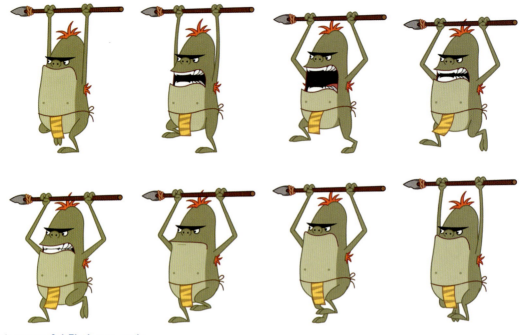

A successful Flash run cycle. MONTE MICHAELIS

Being Resourceful

If the key principles of movement are aesthetically and artistically utilized within the animation process, the limitations of the economies required in Web-based productions can be overcome. By creating enough recyclable object elements within a character's design, it is possible to achieve fluid and sophisticated movement. In a human hand, for example, there can be many object elements that make up the fingers; with more elements comes the potential for more subtlety of movement. Flash offers an inherently extremely economical way of exploiting this potential. For example, instead of having separate elements to represent each section of each finger, it is entirely feasible to use just three elements from one finger and re-size, re-shape, and re-assign them to create all the segments of the others (see below). Indeed, with real ingenuity and patient application, it would technically be possible to design just one finger element and modify it sufficiently to produce the three joints for every finger, as well as the two moveable elements for the thumb, all with no increase in file size.

Individual pieces of art, called symbols, can be duplicated and manipulated in Flash for easier and more economical file management. MONTE MICHAELIS

In many ways, Flash animation is very similar to the kind of cut-out animation made popular by Terry Gilliam's famous animated sequences in "Monty Python's Flying Circus." However, unlike traditional cut-out animation, where every element needs to be individually created, cut-out, and hand-moved under the camera, Flash provides a unique capability for the re-modeling and re-use of objects within the production. Less will always be more with Flash and other forms of vector animation, and so the resourceful animator, fully knowledgeable of the established principles of movement, can always find new ways of achieving great animation on the Web, despite its significant handicaps.

Non-Web Vector Animation

Not all vector animation has the limitations that Web-based material does. Software such as ToonBoom Studio offers all the capability of the traditional animation studio and does enable movie footage to be exported into other formats, including movies that can be streamed on the Web using Flash, AVI, or QuickTime formats. Applications like ToonBoom do allow animators a great deal more creative freedom when it comes to producing animation for the Web. But, the greater file size required for such movies results in longer download times, or the chance of the film "sticking" when being played via smaller broadband widths.

Framers (animators creating vector key frames) and tweeners (assistants who produce the inbetweens) who use Flash for non-Web applications, such as TV, DVD, or cinema productions, have much more creative freedom than their Internet-based colleagues. Consequently, non-Web vector animation opens itself up to a more fully animated style of animation. ToonBoom Studio and similar programs can still take advantage of library-based, recyclable body elements, but they are also able to practically create full animation on ones. Cycle animation (such as for walk and runs) can be cre-

A frame from a Web-based short film. MONTE MICHAELIS

atively and selectively applied, and the advanced camera techniques that programs like ToonBoom Studio can provide add an extra dimension to the appearance and energy of a scene. I expect that full animation will be possible on the Web some day. But until that day comes (when bandwidths improve to support full-screen and real-time playback), the creative use of cycles and layered objects will still be an essential element in the vector animator's arsenal.

Flash is perfectly capable of reproducing certain quite recognizable design styles!
Here is a frame from a short film produced for TV broadcast. MONTE MICHAELIS

The capabilities of Flash and ToonBoom Studio, in addition to all the other vector-based software applications, are being exploited more and more for broadcast and other traditional film opportunities. Flash was never meant to make movies, but a number of studios are using it as a means of maintaining tight schedules and keeping costs down. ToonBoom Studio also offers significant savings opportunities in both time and cost, yet this program is specifically designed for a more traditional-style 2D production. Both are significantly inexpensive, compared to the higher-end professional studio level applications out there. I used ToonBoom for the vector sequences in "Endangered Species" as it very much suited the traditional animation approach the film demanded. The thing that most attracted me to ToonBoom was the fact that it accommodated the integration of pencil-drawn original animation, as well as offered the opportunity to move the camera through an infinite number of animation and background levels in a quasi-3D and multi-plane camera way. I'm sure, however, in a different production and with different creative demands, Flash would be a better choice for vector output.

Games Production

Most of today's interactive game animation is 3D, though there are signs that 2D animators are not giving up the fight just yet. As 2D digital technology gets better and more versatile, the ability of the games animation extends into more and more acceptable areas. Games animation does give a little more freedom of expression to the animator than Web animation does, although it is marginal. Both, however, are subject to the same specific technical limitations as productions for other genres.

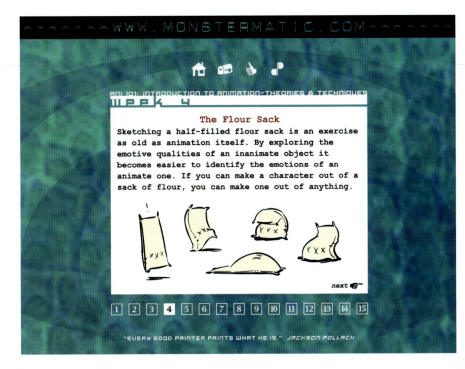

An interactive, online multimedia game can use vector animation to good effect.

MONTE MICHAELIS

With games, there is not only the animation department to consider but also the tech (programming) department. The tech department is where all the game elements are composited and programmed to interact as is required by the various game plays. The tech department essentially builds the game engine into which all the work of the animators must fit and coordinate. This will vary from game to game, so it is difficult to be specific about what this entails. Suffice it to say, games animators will be given specific dimensions and degrees of limitation to work in. The best aspect of games production for the animator is the creation of the cinematic, which is essentially a self-contained short movie which establishes the game characters and provides a back story to the game. Sometimes, cinematics are additional short movies that link game levels. There are fewer restrictions in actual technique imposed on the animator for the cinematics, and, as a result, the enthusiastic filmmaker can have some creative fun. Beyond the cinematic, the remainder of games animation is limited to the animator providing assets that move in specific ways and are slotted into the pre-programmed game engine. Even so, the most mundane of movements can provide interesting challenges for the game animator, where, as always, the core principles of animation such as overlapping action, weight, anticipation, and the successive breaking of joints, for example, can be creatively applied for the benefit of the action.

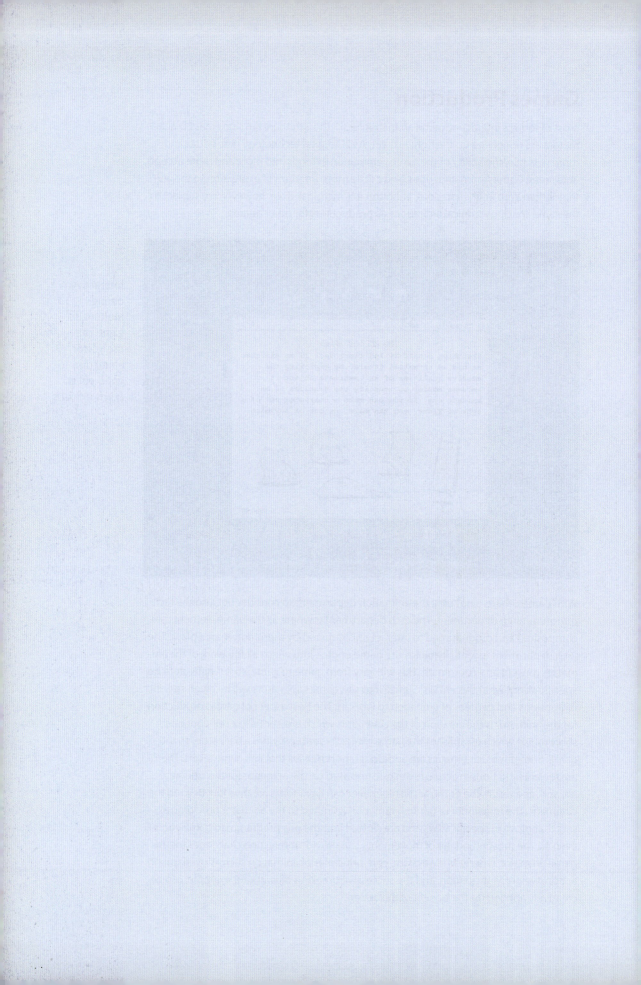

14

The Paperless Animation Studio

My ideal paperless studio on a desktop, with not a pencil or a sheet of animation paper in sight!

The world of animation has experienced a tremendous change in the last decade or so. Not only has the traditional cel approach been almost completely usurped by the relentless and far-reaching 3D revolution, but even this infant, computer-based, mainstream tradition is now threatened by the resurgence of a new and exciting 2D approach, the paperless animation studio!

Time will tell if this new desktop revolution will take hold in the mainstream. But, if recent history is any indicator, more and more individual animators and software manufacturers will be working towards techniques and technology that will improve quality of production while eradicating much of the slog and chore that is commonly associated with animation, particularly 2D animation. The industry is preparing itself for the next stage of its evolution. A new generation of traditionally-styled animators could well emerge who, IF the great teachings of its cel-based predecessors are not neglected, and IF the essential adherence to the need for drawing skill is not overlooked, and IF they could move the content beyond kids' cartoons, may reach new heights with the old tradition that would have been unimaginable just a few years ago.

When the Animator Is Ready, the Software Will Come

The notion of the paperless animation studio is not a new one. It has been talked of for some time now, probably since the first computer arrived on the animation scene. However, until now, the necessary software and hardware have not really been available to make it a plausible reality. Die-hard traditionalists have maintained that paper-based drawing is required to achieve the highest quality of drawing and subtlety of line. One look at the majority of Web animation, where the animator does indeed draw directly into the computer using an electronic drawing pen and tablet, shows that there is no comparison to the fine quality of masterly draftsmanship that was once produced by the late, great Warner and Disney animators. Even the finest of contemporary animators, who earnestly attempt to put all their efforts into working with a paperless drawing of quality, inputting their art directly into the computer, struggle to achieve anything of comparable worth to an original pencil drawing which is traditionally inked-in and then scanned into the computer. Technology has brought great innovation to the tradition of 2D animation, especially in terms of effortless coloring and ease of digital compositing and rendering, but it has so far not solved the problem of improving the drawing capability of a digital production line. Unfortunately, the process of first drawing and then inking paper-based artwork, then scanning it, then adjusting and converting it to a color format within the computer, ready for coloring, is always destined to be a repetitive, laborious process.

In terms of production time and budget, the traditional way is a considerable inconvenience, yet it has always been one that the traditional animator has accepted, as there has been no viable alternative. Even though digital drawing tablets have significantly evolved into at least providing a variable line that can be controlled by pressure of the pen, there really is no substitute for the feeling of pencil on paper or the ability to look directly at drawings, rather than viewing them on a monitor. This is clearly not a natural or comfortable environment for the serious artist-animator to work productively with.

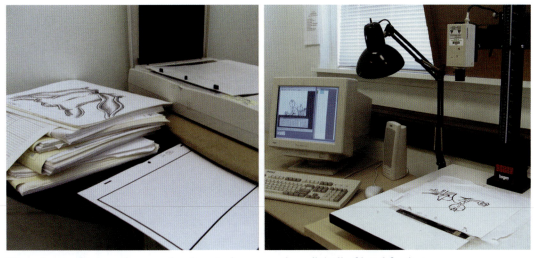

The volume of paper clean-up drawings to be scanned or digitally filmed for just six of the 80 scenes that comprise "Endangered Species" speaks for itself!

Even so, some animators have been prepared to make the leap. Non-traditionalists, studio accountants, producers, and occasionally some directors have been demanding more and more efficient methods in 2D digital animation production, although many will acknowledge that this kind of progress inevitably goes hand in hand with a certain loss of production quality.

It was therefore just a matter of time before a new technology would emerge that might answer everyone's prayer. The industry was ready, it was just a matter of time, and as I finished writing this book in the early summer of 2005, this new technology did appear and it did excite me. Its advent promises a viable revolution away from the old paper-based tradition without any significant loss in drawing quality. Indeed, it seems to extend far beyond the current reach of animators, to enable them to speedily and effortlessly draw in new, innovative, and varied ways. It is perhaps too soon to say that this new 2D revolution will indeed emerge, but certainly the seeds of a new generation of quality animated filmmakers lie within its potential.

The Technology

Two technological elements are required for the advent of the paperless animation studio: a software application that is totally comprehensive in both drawing and production capability and an electronic drawing surface that has all the qualities and capabilities for an artist/animator that echoes the old pencil-on-paper tradition. In terms of some of the technology, this kind of software has to some degree always been there. Excellent applications such as ToonBoom Studio and Cambridge Animation's Animo, for example, have served (and do serve) the industry well and can lay claim to the fact that they do have a paperless studio capability. The problem is not so much in the software, but rather in the hardware that enables the animator to directly input their drawing into the computer without the need for drawing, inking-in, and scanning. I was therefore entirely impressed when I came across software that even

exceeds the existing boundaries of the paperless studio and actively and excitingly integrates itself with the means of producing real drawings into the computer, with similar touch and vision capabilities. The software is Bauhaus Software's Mirage and the drawing hardware is Wacom's Cintiq. Combining these great new innovations has potentially moved the notion of the entirely paperless studio from theory into practice.

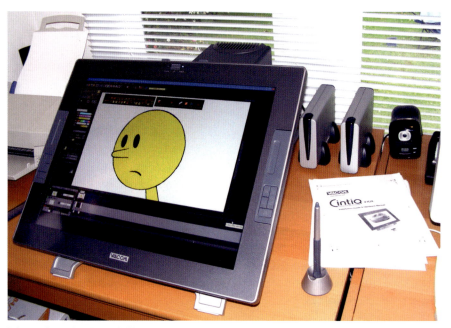

Wacom's sophisticated Cintiq drawing tablet is the biggest hardware advance towards the paperless studio so far.

Bauhaus Software has taken the Cintiq concept one step further by introducing the portable, draw-on-the-screen laptop computer called Nomad, which combines perfectly with their Mirage software.

Mirage

For some time now, I have been searching for 2D animation's holy grail. Digital technology has replaced the world of traditional cel art and yet I have not seen any significant advances in actual 2D digital animation, except in the processes of inking, painting, compositing, and special effects. Certainly huge savings have been made in time and cost, but artistically I have yet to notice any significant creative revolution, except maybe in the latter works of Miyazaki and Chomet. The holy grail, the search for that illusive software that can indeed take the art form of 2D animation beyond Flash or Photoshop imitations of pen, pencil, and paintbrush, and all in a paperless environment, has never emerged to move creativity and aesthetic innovation onward.

The paperless animation studio has been an economic reality for some time, of course, but the truly paperless studio where artists, not technicians, can both conceive and create beyond their wildest dreams has still seemed to elude us. However, I recently chanced across a copy of Mirage. With Mirage, Bauhaus Software has created a program that is economically efficient, digitally versatile, and artistically impressive (see below) and with its new Mirage Studio Pro, Bauhaus takes the capability of paperless filmmaking even further. Coupled with a Cintiq electronic drawing screen, I do believe that the truly paperless studio has at last arrived, and not a moment too soon!

NOTE

In writing so enthusiastically about Mirage and Cintiq, I must be clear that I have absolutely no financial incentive for doing so. I rave on simply because, in my 30 years of award-winning animated filmmaking, I have never found a combination of technology that has so excited me. I have yet to extensively work with these products to discover the full range of their capability. But, so far, I can see nothing but good things coming from them. Indeed, I truly believe that we are on the edge of a new revolution in production, a true 2D production revival, if animators can adopt these advanced with a mission to exceed the finest accomplishments of the great traditional that has led us to this moment in our history. I only wish I had these tools when I began my own "Endangered Species" adventure!

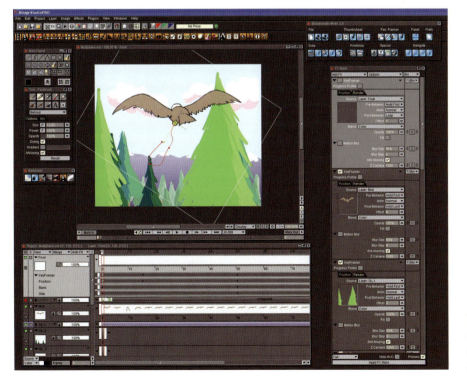

The Mirage palettes, drawing space, and controls.

Perhaps now, aesthetically driven 2D animators can reclaim much of the ground lost to other digital disciplines. I have no expectation that 2D animation will ever replace 3D. However, armed with a tool such as Mirage, the 2D animators of the future now have the potential to advance the art form of 2D animation far beyond the flat-colored, cartoon world that it has always been identified with. Not only can time and money be saved in this paperless dream, but 2D animation artists, perhaps for the very first time, are now able to express themselves in digital ways that were never possible in the good old days of paper and cel.

Even so, animators of the future cannot be complacent and neglect the essential need to first draw, and to draw well, before ever facing their computers. Neither should they ignore the timeless principles of movement that the great paper-based masters of the past have bestowed upon us. However, with those necessary skills firmly secured under their belts, there is no reason why future Mirage animators should not be able to restore the respect and the integrity that the wonderful tradition of 2D animation so richly deserves.

Cintiq

If I had been told a year ago that I would be embracing an electronic way of pursuing animated excellence, I would have laughed. I have always been reasonably certain that the assertion by many that one day 2D animators will not need their traditional drawing tools was "pie in the sky" thinking. The Wacom drawing tablets, as well as those of their competitors, did little to make me doubt my assertion. It is indeed wonderful to control what is on the screen using something that is more natural for an artist to hold than the standard mouse but I could never seem to find the control that a real pencil, on real paper, offered.

When I picked up my first Cintiq drawing pen, I viewed the whole exercise with a great deal of skepticism. This skepticism was quickly dispelled! The drawing surface of the Cintiq is large and comfortable, although it still admittedly has nowhere near the feel of a real paper texture. The pen is not a pencil, that is certain too, but it does feel comfortable and it does enable you to move and draw in a way that feels entirely natural and controllable. The beauty of the large, flat-screen drawing area is that it tilts up and down and rotates, ensuring maximum drawing comfort (similar to a traditional animator's light box with rotating disk).

The pen controls can be adjusted to ensure precise and synchronized contact between where the animator observes the pen tip and what is being drawn. One drawback is that when the entire thing is rotated through 90 to180 degrees, this precise alignment separates exponentially as the viewpoint of the observer and what is being observed changes. Even so, a little adjustment to the hand-eye coordination compensates for any physical misalignment that this can present.

The real benefit from the Cintiq comes when suitable software is combined with it. The cover artwork of this book was created entirely using Cintiq and Mirage. The pencil drawing that takes up 25 percent of the main cover image is not in fact pencil drawing at all, but simulated pencil drawing that was possible with the technology being used. I started with a black-line, cleaned-up image of the posed character, then produced a "pencil" version, a vector-like colored version and a watercolor/illustrated version, using the Cintiq pen and the Mirage tools. I was extremely impressed by this and surprised that, in all, it only took an hour or two to achieve. I certainly didn't miss the notion of pen-

cil drawing, then inking-in the necessary paper levels, then scanning them into the computer, and then coloring and compositing them in a digital program.

I can see absolutely no reason at all why the skills exhibited in this cover art, or any other of an illustrative, drawn, or painterly appearance, cannot be replicated in an animated sequence or production. This surely has to give hope and inspiration to innovative 2D filmmakers who are seeking new techniques and possibilities with their work. Cintiq is certainly a huge asset to Mirage animators. The regular digital drawing tablets enable the user to make the most of the software's extensive and almost all-encompassing capabilities, but the Cintiq makes it a dream to work with!

The Importance of Drawing

Even though I do believe we have wonderful paperless technologies to move 2D animation production onward, it can never be stated strongly enough, or often enough, that truly accomplished 2D animation can only be achieved through drawing excellence. Consequently, in talking about the paperless animation studio, we are not talking about the end of the need to draw. Technology that enables to animator to draw directly into a computer is only of any use at all if that animator is actually capable of drawing well on paper in the first place! Regardless of any miracles of technology laid before us, it is still true to say that the best technology any animator has at their disposal is the humble pencil! Consequently, before any animator can even approach any software, they must have first developed their artistic capabilities through constant practice and sketchbook upon sketchbook of drawing assignments. Even 3D animators will find their reward through the benefits of drawing practice.

Animators will always need the ability to draw, no matter what technological advances make the process easier or faster.

Animators need to understand how objects look from all angles when they are animating dimensionally. Drawing from numerous viewpoints is really the only way of inherently achieving this kind of understanding.

The notion of a truly paperless animation studio is a misnomer, as, somewhere, at some stage, sufficient drawing ability has to be acquired by the animator to take advantage of any software's capability. That said, an entirely paperless production line is very much a reality, as long as that drawing aspect of an animator's education is never neglected. Indeed, drawing, taught and learned correctly, need never be a boring exercise of repetition or familiarity. It can be a stimulating and rewarding pursuit that, in so many ways, can benefit any animator or any artist in the animation field. Drawing not only cultivates strong hand-eye coordination but it also brings an understanding and a greater awareness of what is being seen in the world around us. It can add a three-dimensional appreciation of things we are attempting to animate, as well as be a means by which the animator's vision can be brought to life and then shared with others. Remember, a picture is worth a thousand words! Undeniably, for the accomplished 2D animator, a skill in drawing can bring a certain physical and artistic control that will enable him or her to make the fullest use of the amazing technology that is literally at their fingertips. Software in the hands of such an accomplished artist will theoretically be able take the world of animation into new and previously unapproachable realms, and may it always prove to be so.

2D or not 2D?

It is possibly too early to say whether paperless production line is a great idea ready to be implemented, or if it is a challenge that the 2D animation world is not courageous enough, or artistically educated enough, to take advantage of. One would hope that when acquiring the not-entirely-inexpensive technology

Personally, I think there is nothing more inspiring, or even terrifying, than a blank sheet of animation paper just waiting to be drawn upon!

to attempt it, studios will also invest generously in providing resources, such as drawing classes, for all the animators they intend on using it. It is so easy to buy short-cut software that both speeds up the filmmaking process and reduces production costs at the expense of artistic expertise and dexterity. Investors are reminded that in the early days of animation, the studios that went for short-term benefits were the ones that lost out in the long-term. However, studios that had an eye for quality and an instinct for long-term reward (like the early Disney and Warner Brothers organizations) were the ones to survive and flourish in a competitive world.

The paperless animation studio of the future can be either a short-cut to oblivion or else a longer, more lucrative, quest to the summit of greater accomplishment and reward. Individual animators too, competent in the technology of today and of the future, will find the journey so much more employable and rewarding if they can add to their skills a capability for pencil drawing too. Such an holistic approach, combined with the qualities of imagination, innovation, and great storytelling, will bring to traditional 2D animation the potential of a revival, and maybe even a revolution, that all the great, die-hard traditionalists (including me) have prayed for, for so long.

3D Overview

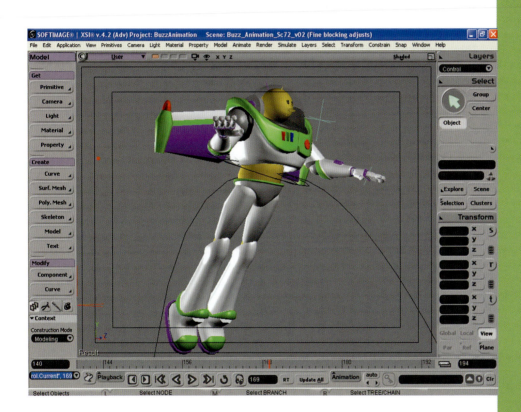

*Just as this character suggests, my
experience in 3D animation was more
a leap of faith, rather than a conscious
understanding of what I was doing. Luckily,
I did eventually land on my feet, and safely!*

I freely admit that my experience in 3D is limited, specifically to just the 3D material in "Endangered Species." I have always been extremely critical of authors who write how-to books without any personal knowledge or practical experience of the things they are writing about. However, in creating "Endangered Species," I had to jump into the deep end of the 3D swimming pool. I was very surprised when some of my 3D-oriented faculty colleagues said they were impressed with what I had created, especially in view of the very limited tutelage they had given me with the software. However, one colleague said he was not actually surprised, as I had already learned the "hard stuff," the principles of animation. It was just a question of learning the appropriate buttons to push on the software to make it all happen. I found the whole process of actually moving a 3D character model extremely exciting and rewarding, as there is nothing more immediate and rewarding as making quick changes to the action and watching them materialize in the blink of an eye.

The instant feedback of 3D software paves the way for so much more experimentation and discovery than is ever possible with 2D animation. Even so, I am sure that the seasoned professionals amongst my readers here will not find too much that is new or unusual about what I have to say. I believe, nevertheless, that sharing my experiences of this brief exploration of 3D will be valuable for the young guns of computer animation, for there is so much that an old dog learning new tricks can say about how things can be moved and how they can be moved well, whatever the environment.

A Word About Software

The majority of the illustrations appearing in this section are created using Softimage XSI, which I also used for the 3D sequences in "Endangered Species." This is not a specific recommendation for something you should rush out and purchase. Software is just another tool that the true animator has at their disposal anyway; it is not the holy grail of animated mastery. What you bring to the animation software is what makes great movement, not the other way round.

The achievements of Max and Maya, like XSI and indeed any other animation program, still remain inherently in the skills of the animator, not the software!

If I am to show a little software bias, I can only suggest that at the low cost end of the spectrum I cannot be more impressed with the capabilities of Animation Master. Although this is another 3D program that I have absolutely no personal experience of whatsoever, it seems to do what all the other high-cost programs can do, but at a fraction of the cost! What particularly impresses me about this program is its

manual. Unlike all the other software manuals, this one actually speaks to you with the soul of an animator, not a techie. It is a perfect starting place for the aspiring young animator who, for relatively little cost, can one day make their Hollywood dreams come true.

Animation Master, the stuff dreams are made of?

In all honesty, most 3D software applications have their individual strengths and weaknesses and on balance the very best of these are pretty much comparable. It is my strong recommendation that you research all the available programs and purchase the one that reflects the depths of your pockets, creative requirements, and career objectives.

The Importance of Drawing

One huge misconception among the uninitiated of the industry is that software can make anyone a 3D animator. In reality, this is far from the truth. Software does indeed enable objects to be moved in space and it offers a fair degree of control in terms of how fast, how far, and how fluidly those objects can move. However, real animation—the kind of character animation that brings inanimate objects to life with personality and enchanting performance—will always need more than just software. It requires a talent for observation, a capability of understanding what is being observed, and the skill to translate what is being observed and understood into a living, breathing character. Observation and understanding come from looking at life and translating that into recognizable poses and caricatures in action. This can only be achieved through a practice of drawing.

The simple initial character sketch for the "Endangered Species" 3D character.

Early concept sketch for "Endangered Species."

It would be impossible to create this kind of structured complexity without first having an intrinsic understanding of how the human form works. Such an understanding can only be acquired through a comprehensive application of drawn human anatomy. MODEL BY ROYAL WINCHESTER

Drawing is a reflective, learning process that trains the eye to see, the mind to understand, and the hand to convey what is being seen and understood into a tangible reality. It is not so much the tools that create the understanding but more the thinking and experience within the individual who is using those tools. Consequently, software will not make the 3D animator, just as the pencil alone will not do the same thing for a 2D approach. Both software and pencils are fundamentally essential tools in the process but they are not the process in itself. It requires an artist, or a true animator, to use both adeptly to communicate their vision, no more, no less. That said however, the use of a humble pencil in drawing can be an important stage of learning for the modeler and 3D animator.

The Disney animators on "Bambi" spent hours and hours in the studio, creating drawn studies of deer, old and young, before they created the first animated drawing for the movie. They recognized that before they could animate anything, they needed to fully understand how their subject moved and what in its physical structure enabled it to move the way it did. Consequently, "Bambi" became a masterwork in animation that could never have been achieved without all the research and the enormous pencil mileage that went into it before they even started the animation process.

Why, therefore, should the 3D animation process be any different? It is true that most 3D characters created so far are warriors, aliens or other fantasy creatures that have no existence in the real world. However, most of them have arms and legs and therefore some extensive drawn studies of the human form (or animal form, it they are creature-like) will bring great rewards in their creation (see the figure above, left). Even if the creature has six legs, it is surely possible its skeletal make-up to be an amalgam of real creatures, perhaps part horse, part insect, and part chameleon. In his excellent book, "The Animator's Survival Kit" (Faber and Faber/ISBN 0-571-20228-4), master animator Richard Williams and late colleague Abe Levito suggest through drawings how the front and back leg movements of a horse can be likened to that of a man and an

This excellent anatomical study of a bullfrog is ideal reference for a modeler who is creating a similar 3D creature, or is even creating an alien life form that bears similar bodily characteristics to a bullfrog! CHARLES WOOD

ostrich, respectively. It is only by studying and drawing figures and objects from life that an animator can fully understand their subject matter. From this understanding comes an ability to create and move things much more skillfully, whatever the form of animation is to be attempted. Therefore, let it never be denied, that the greatest piece of technology any animator can have at their disposal is the humble pencil!

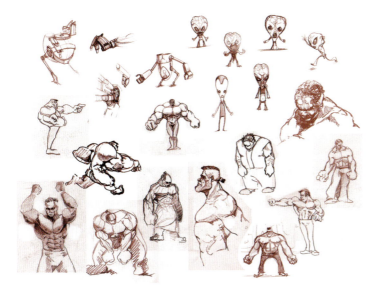

An initial sheet of character concepts. ROYAL WINCHESTER

All this said, it has to be acknowledged that 3D animated filmmaking does go through far more computer-based, technology-dependent production needs than traditional animation. Generic stages such as development, pre-production, production, and completion are basically identical to all filmmaking objectives, but certain processes that make up many 3D production approaches can be very different. Let us therefore consider some of these specific processes here, although I stress they are not presented by a tried and tested master of the medium. Instead, they are presented more humbly, from the perspective of an experienced 2D stalwart who has approached 3D animation for the very first time, and survived! I recommend "Inspired 3D Short Film Production" by Jeremy Cantor and Pepe Valencia (Course Technology PTR, ISBN 1592001173) as a comprehensive, even inspirational, overview of all aspects of 3D production.

Cartesian Space

Unlike 2D animation, the basic foundation of all 3D animated design and movement is math. Every point of a character—the internal skeleton, the surface skin, or its flowing item of clothing—is defined by a particular point in space. In 3D animation, that space is known as Cartesian space. Cartesian space is the virtual world in the computer that is measured along three coordinates, known as the x-, y- and z-axes. The x-axis measures distances from left to right, the y-axis measures distances up and down, and the z-axis measures distances that are near and far (below left).

The x-, y- and z-axes in Cartesian space represent the three dimensions.

This point in space is at x=2, y=0, and z=0.

If a point is located exactly at the center of Cartesian space (also called ground zero) then it will have coordinates of x=0, y=0, and z=0. However, if that point moves to the right by two units it will have a coordinate of x=2, y=0, and z=0 (above right).

If it moves to the left by two units from ground zero, it will have a coordinate value of x=-2, y=0, and z=0. Alternatively, if this point moves up two units, back two units, and to the left by one unit from the center, it will have a coordinate of x=-1, y=2, and z=-2 (below).

This point in space is at x=-1, y=2, and z=-2.

With modern 3D animation programs, it is not entirely necessary to animate the actual points numerically, as the majority of transforming (moving) points, or objects, within Cartesian space is achieved by dragging and clicking. However, the principle of locating points in Cartesian space needs to be understood if 3D animation is to be attempted, for quite often the modeler, at least, needs to be able to measure space through comparisons and duplications.

Character Design

Undoubtedly, the character design stage probably has the biggest drawing require-
ment of all. If a character is to be animated, a representation needs to be made so it
can be created in a digital 3D model form. Consequently, that imaginary character has
to be drawn (and perhaps colored) from all angles, so every aspect and viewpoint can
be defined and understood. The kind of model sheets that are created for 2D anima-
tion—numerous views of the character from every conceivable angle—are probably
too elaborate for a 3D character design sheet. A 3D design sheet should show the
character from front, side, behind, and perhaps from above or below too. That alone
should give sufficient information about the character in question to be built in 3D
form (known as a model) inside the computer. These character sketches have to be ac-
curate and consistent with each other in terms of size, shape, and volume, if they are to
be truly representative from all angles.

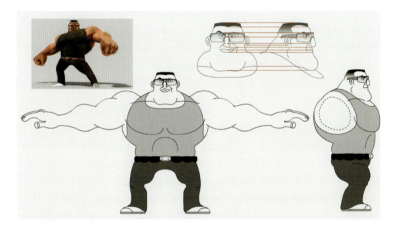

The final design sheet
for Royal Winchester's
character model (see inset).
ROYAL WINCHESTER

An even better way of achieving an entirely comprehensive design for a
3D character is to build a maquette of that character, which can then be
modeled conventionally or digitized directly into the computer using a
three-dimensional scanner.

The model can be created in clay, ceramics, plasticine, or Sculpy. As long
as the model is solidly 3D and can be picked up and moved and viewed
from all the angles without damage, it will work successfully as a use-
able maquette. Higher budget productions can even afford to produce
a three-dimensional laser scan of the maquette, which saves time at the
modeling stage and feeds all the basic shape coordinates of the model
into the computer automatically. This can often save a great deal of time,
although it's not an absolutely perfect solution—some degree of re-
touching is usually necessary.

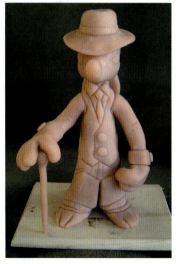

Alternatively, the 3D character model can be produced by the more
time-consuming, yet often more reliable, method of actually measuring
the maquette in every conceivable way and then extruding (pulling out
or shaping) the required dimensions from a primitive geometric design
in the modeling program. One final design option is that photographs
can be made of the maquette from the front, side, and top viewpoints,
which can subsequently be imported into the modeling program and
matched for shape and dimension.

Student animator Rey Reyes
created this dapper maquette as
part of his final 2D graduation
project, although it would
clearly work perfectly for a 3D
assignment also. REY REYES

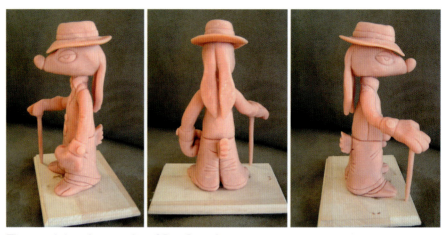

The remaining three angles of Rey Reyes' maquette.

Whatever method is used, the ultimate objective is to create a three-dimensional representation of the drawn character design that the software will recognize and enable you to manipulate it in terms of time and Cartesian space.

Polygons

Modeling is the process of sculpting a three-dimensional representation of an original character design in Cartesian space. As already suggested, the model is composed

A very basic low-poly model.

of points that define the limitations of the surfaces that make up the model. These surfaces are defined as polygons and are established by joining three or more points together. The more points or polygons there are in the character, the more complex and more complicated that character is to move and transform (manipulate), and the larger the file size is. Consequently, characters that are designed for game or Web animation (which inherently require minimal data files sizes so that they can be up and downloaded fast on minimal bandwidths) have to be constructed with as few polygons as possible to define their shape. Such characters are known as low-poly models (left and below).

Low-poly models don't have to be boring or predictable! ROYAL WINCHESTER

On the other hand, characters created for movies (which can have far larger file sizes, as they are not interactive and can be rendered over larger periods of time prior to ultimately being projected on film) require infinitely more polygons to make up their shape if they are to appear rich, natural, and entirely convincing on a big screen.

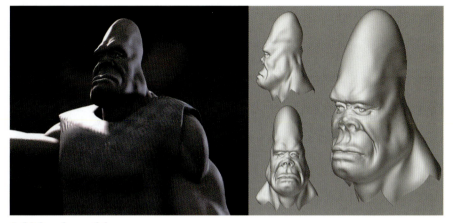

A high-poly model. ROYAL WINCHESTER

Before you can create a 3D character, you need to know the medium the animation is to be produced in and therefore have some parameters on the file size limitations you are dealing with.

Primitives

The actual modeling of characters, in most cases, will be achieved through an integration and/or modification of a series of basic geometric forms. These basic geometric shapes—two-dimensional arc, circle, spiral, and square shapes, and three-dimensional cone, cube, cylinder, disc, grid, sphere, and torus (donut) shapes—are known as "primitives."

Four common primitives used by a 3D modeler: a cube, a sphere, a cone, and a cylinder.

A combination or adaptation of these essential geometric shapes can create any 3D model imaginable, whether it is a vast intergalactic spaceship; a soft, cuddly human baby; or a creepy, crawly insect (see next page). Primitives appear mainly as wireframes when they are initially imported or created (meaning that they are not seen as solid objects, but as forms that are made up of a single grid of lines that define their shape and dimension).

Spherical primitives quickly turned into the bug maquette.

Highlight particular points or polygons within the primitive and extrude them (pull them out) one by one (or group by group) to create the approximate shape of the required character being built (left).

With a broad, approximate shape identified, it is then possible to go into specific areas, add or subtract points and/or polygons, and further manipulate that shape until a more precise and final version of the character is obtained (below).

Depending on how high or low the polygon value of the model is required, this process can go on indefinitely, until the desired character model shape is accomplished.

Select the surface to deform and locate an area to extrude.

Areas can be extruded and then deformed more to get the desired shape.

Character Modeling

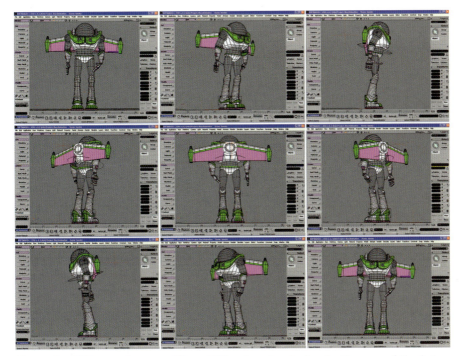

The major difference between 2D and 3D animation is that, in the case of the latter, you have to work (and think) using all viewpoints and not just one.

With 2D character design, it is so easy to cheat. Drawings can be distorted and, as long as there is a consistency of look and color from drawing to drawing, it is quite possible that the viewer will never notice subtle variations in size, proportion, and shape. However, with 3D animation, a character model has to remain consistent in all directions: front, side, back, above, and even below on occasions. Therefore, in building a 3D character, you must repeatedly check that everything appears plausible and consistent from every possible viewpoint. This is the real challenge for a 3D modeler who is sometimes asked to work from just a single viewpoint, such as a 2D illustration, especially in the advertising arena where characters are often an adaptation of a corporate character that has appeared on the product's packaging for years.

To view the 3D model from all angles, use the three viewpoints (front, side, and top) that most 3D animation software provides (below).

A simple camera rotation around a basic character pose.

Generally, all three viewpoints, plus a fourth (called "camera view" in XSI, for example), are visible onscreen (see Figure 15.23). However, it is possible to zoom any one of these viewpoints up to full screen, if greater detail is required and to rotate the character in the camera view.

The four viewpoints in XSI.

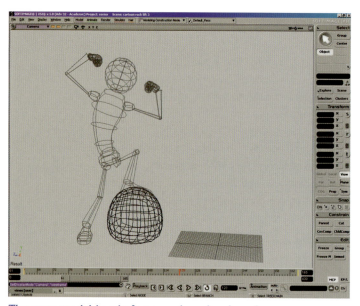

The same model in wireframe and rendered mode.

Characters are initially in a wireframe mode (a see-through frame of polygons and individual points) but you can also view the model in a number of other ways. The most likely of these is Shaded (XSI) mode because it can be extremely confusing to look at a complex model and differentiate between all the polygon lines and points, especially when attempting to define what lines and points are in the front of the character and what are in the back.

To get around this, it is actually possible to have a view that removes hidden lines while in wireframe mode. Any lines that are concealed by the front surfaces are hidden from view, even when the character model is rotated. In comparison, the shaded (or rendered) mode, removes the wireframe view entirely and provides instead a roughly smoothed surface view of the character (left). This enables the modeler to see more readily how a low-quality rendered model of the character might look from various viewpoints, or how the surfaces will react with different angles of light cast on them. There are other modes of the model available as you build it, but most modelers just use the wireframe and shaded functions for speed and efficiency. Always remember though, that the more detailed your view, the longer it will take to render onscreen.

Modeling to Suit Story Requirements

Invariably, films require that the character (or characters) be seen from a number of different angles and from a number of different distances, as shown below. By studying the storyboard and assessing the requirements of the actual film, you may be able to save a lot of unnecessary work by selectively modeling.

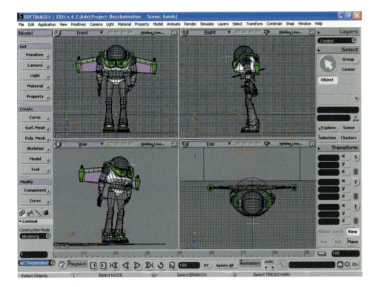

The three views of my Buzz-look-alike (front, right, and top) plus the "camera view" in the bottom left window.

If parts of the character will never be seen by the audience, then those parts of the character model need never be worked on in any particular detail. For example, it could be that only a character's face will ever be seen in close-up yet the back of the head will only be seen in a wide shot. This means you can economize your work by paying more detailed attention to the face modeling and far less to the back of the head.

In theory, if a suited character's visor is down, it may not be so essential to model the face inside.

Similarly, if a character's hand is seen in close-up shot at one point in the film but the rest of the time it is seen in only wide shots, then a separate, more detailed, model of the hand and arm can be produced just for the close-up shot. A less detailed hand can then be used with the wider view shots in the other scenes.

In "Endangered Species," the 3D character's hands are never seen in close-up, so the modeling details could be kept to a minimum.

Rigging and Weighting

A finished character model is, in essence, an elaborate and hollow shell. By itself, it cannot move, bend, or twist, because it has no joints, bones, flesh, muscles, or skin like a real person. However, to make it animatable, it needs to be rigged and weighted. Rigging is the placing of a jointed skeleton or framework within the model so it can be deformed (bent or moved) in specific ways.

The skeleton design and rigging must be adequate for the animator's needs, as indicated here.

The best rigging requires developing a close awareness of the storyboard requirements for that character, as well as (ideally) discovering the requirements of the animator who will be working with that character to make it move effectively. This way, a solution to the rigging will need to be achieved that can enable the animator to create just the right amount of movement and believable flexibility in that character. The skeleton rigged within the character must provide all the essential joint movements that the animator will need. Joints located in the neck, shoulders, elbows, wrists, hips, knees, and ankles are pretty obvious. However, less obvious are the number of bend, pivot, and rotation points that the spine or pelvis will require.

This simple elbow arrangement is more than adequate for the animation requirements of the character.

The jaws may also have to move the mouth open and closed, unless the mouth can be projected onto a fixed face afterwards, to simulate talking. A great deal will depend on the framing and closeness of shots requiring mouth movements, however, or whether or not dialogue will actually be needed in the piece at all. If a character's hands are seen in close-up too, it may be necessary to have separate finger joints inserted at the appropriate places to make them totally flexible and believable in that close-up shot.

The typical skeletal arrangement inside a basic 3D hand.

The real challenges arise when the surface of a model deforms around a particular joint action. For example, a model's arm may look perfectly formed when straight but as it bends at the elbow or wrist, terrible creases may appear on the skin or sleeve's surface, making the whole thing look totally unrealistic and unacceptable. To avoid this, you'll have to re-design the polygon arrangement around the joint area so that it looks more natural when bending.

Forward and Inverse Kinematics

There are actually two ways a 3D animator can approach the movement of a character: forward or inverse kinematics. Forward kinematics (FK) is a way of moving an object within a character through a bone by bone (or joint by joint) transformation process. For example, if the character's arm is to be raised up straight and then the hand dropped, you might first move the upper arm bone, then the lower arm bone, and then the bones of the hand to create the pointing action.

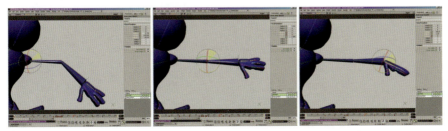

In forward kinematics, the body transforms one bone or joint at a time.

On the other hand, in inverse kinematics (IK), the character moves more like a puppet—the hand moves and the rest of the bones in the arm automatically move in unison, as if strung together.

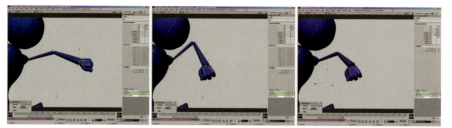

With inverse kinematics, the hand is pulled in and the arm moves in unison with it.

Each method has advantages and disadvantages. With forward kinematics, the movements can be more subtle and sophisticated with the careful transformation of individual bones and joints. Inverse kinematics is a much faster process of creating movement but lacks refined and sophisticated motion. Ultimately, it will depend on taste, schedule, and budget.

Creating the Bone Hierarchy

Even if animating in IK, the model must first be rigged to accommodate a FK (forward kinematics) capability, and then a hierarchy of bones has to be established. To do this, the modeler defines for the animator the degrees of importance that link the various bones and joints in a particular part of the character's skeleton. For example, with a regular arm model, the first bone in the hierarchy would most likely be the upper arm. The next in the hierarchy would be the lower arm, connected to the upper arm by an elbow joint, then a wrist joint, which is connected to the hand bones, and then the various sequential bones and joint connections that make up each of the fingers.

With a hierarchy defined in this way, if one part of the hand is lifted in a forward kinematics action, all the other objects (bones and joints) connected to it in the hierarchy chain will move accordingly.

Using the Schematic window in XSI it is very easy to identify and quickly highlight the hand, before attempting any movement.

Without a hierarchy chain, the upper arm would move on its own, leaving the other bones and joints behind, unattached.

If you do not create a skeletal hierarchy, body parts may not be connected—not very realistic!

Adding Control Points

In inverse kinematics, control points are added toward the end of the hierarchy to enable the entire arm, moved with it. For example, when moving an entire arm, it will require that the control point be placed in the wrist, as indicated below. This is akin to a puppeteer having a string attached to the wrist that lifts the entire arm section.

Control points enable whole body parts to move with inverse kinematics.

Continuing with this analogy of a puppet on a string, when the animator selects the wrist control point and moves it, all the bones and joints in the arm linked to that hierarchy will move too. A second control point (string) will be necessary at the end of the pointing finger, or the hand and fingers will need to be animated with forward kinematics once the wrist control point action has been locked in.

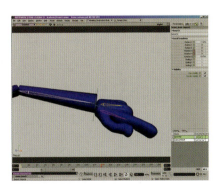

The fingers of the hand would have to be animated using forward kinematics once the arm has been lifted using inverse kinematics.

Manipulators and Nulls

Two additional control objects that the modeler can provide for an animator are a manipulator and a null. A manipulator is essentially a control object that allows a collection of objects (body parts) within the model to be selected as one unit. With these objects selected as a group, they can be scaled, distorted, and moved together in scale. This is valuable if those parts of the object suddenly need to shrink, stretch, or generally deform in proportion with each other while the rest of the model remains the same.

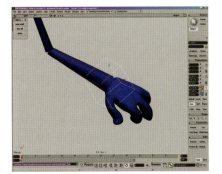

A manipulator is a control point which enables a collection of objects to be selected as a unit.

A null is a control object that is positioned outside of the model but affects selected objects within the model. For example, a null is used to control the model's eye movements. A null point would be located somewhere in front of the character's face and moved to affect the direction of the pupils of the eyes. The pupils of the eyes will move to watch the null, providing a perfect means of giving a specific direction (and change of direction) to the character's look.

A null controls the direction of the eyes by virtue of its position relative to the character.

Weighting

It is one thing to have joints that move within the character model but quite another thing to have them move naturally. For example, the knee or the elbow joint for a human being can bend freely one way but not the other. To simulate this limitation in

a modeled character, the joint has to be weighted so it can only move in the required way and to the required amount. Weighting is a process of applying limitations, or restrictions, to the movement of specific joints so that they have a natural and logical feel to them when moved by the animator. Weighting can add or eliminate backward, forward, and sideway movements; restrict rotation; and apply tension to a joint movement, so it moves very much like the human body. Without such weighting, a joint will bend and rotate unnaturally, which could of course make nonsense of a character's natural movement.

A simple, rotatable elbow joint.

Lighting and Texturing

The last significant aspects of the modeling process are lighting and texturing. In modeling, lighting and texturing define the nature of the surface of a character's skin, clothes, other props, specifically the transparency, reflectiveness, and luminance (i.e., the way that light reacts on the model's surface). This also has to reflect the nature of the material that the model is made up of.

Adjusting the surface qualities of a character. For example, the texture of the character's skin will respond far differently to light than

The arm in front has no texture added, while the arm in back has additional detail and realism. ROYAL WINCHESTER

the texture of its clothing. Both will obviously have their own reflective qualities when light hits them but this has to be defined by the modeler. Most textures are assigned to the surface of a character to suggest textured definition, so the surface does not have to be modeled in infinite detail. Skin, for example, is never a flat, uniform color as often in the 2D world. The surface of most people's skin is actually a combination of varying pigments; rough and smooth areas; clean or dirty; and smooth or hairy. It can also have pock-marks, scratches, zits, or other assorted blemishes.

Therefore, rather than trying to model these extremely subtle textural changes on the surface to characterize the character's skin, it is preferable to create a texture surface patch using a separate digital paint program and then map (or paste) that texture onto the surface of the model's features. The same thing can be done with clothing textures, prop textures (such as paper, wood and metal) and anything else that offers an overall complexity that would make modeling it a nightmare.

Copyright-free textures can be found on the Internet, including www.grsites.com / textures, which is said to be the world's largest.

Selection of images that are part of the endless universe of textures that can be captured and re-used ad infinitum.

Texture painting (the creation of surface textures in a separate paint program) and texture mapping (the projection of the texture onto the model's surface) is relatively more simple and economic than modeling the same thing, hence its attractiveness in 3D modeling. The use of painted textures, as opposed to modeled textures, is especially important in 3D animation that has built-in file size limitations, such as with games animation. Remember that everything modeled requires a certain number of polygons to create it; the more detailed the modeling, the more polygons there are. Therefore, as previously suggested, character models for game productions tend to have significantly reduced polygons but an increased dependence on texture mapping to create the realistic surface look that a character requires. This is where creative texture mapping really comes into it own.

To achieve all this successfully, the entire surface of the model is unwrapped and stretched out like an animal skin, ready for painting.

The unwrapped surface of a character model stretched out for painting. ROYAL WINCHESTER

The unwrapping process is essentially a procedure where the surface polygons of the model are skinned away, piece by connected piece, from its surface and then worked upon as if it were flat, 2D art.

The flattened polygons painted with a suitable surface texture that takes into account the elements of the character's face and clothing. ROYAL WINCHESTER

When the unwrapped surface painting is complete, the skin is wrapped back onto the model, giving a much more realistic surface texture than if it were colored using flat paints. With clever painting and texturing, elements in the model that are not actually created by the modeling, such as creases and blemishes in the skin, give it far more detail and definition than the surface actually contains.

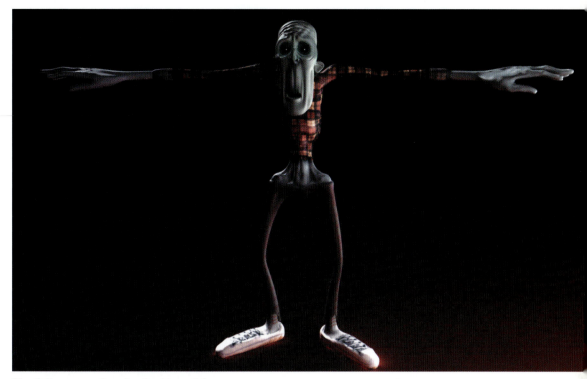

The fully textured and painted model. ROYAL WINCHESTER

As long as the unwrapped connecting polygons can be identified one to another in specific ways, the texturing artist can easily paint them so that they fit neatly back together again when returned to the model. Most 3D animation programs offer this capability, as long as the skinned surface is first unwrapped and re-applied properly by the artist.

An unwrapped and re-wrapped skin. ROYAL WINCHESTER

Environmental Modeling

Wireframe and rendered version of a stylized environmental design, with textures, when seen from the air. KAMAL SIEGEL

Environmental modeling is different to character modeling in the sense that most environmental models do not normally move the way that characters do. They instead form a solid, three-dimensional, realistic-looking location in which the main characters can move. Environmental models are more usually of an interior or exterior nature, terrestrial or cosmic. They simulate the three-dimensional world that the characters exist in and therefore, in live action terms, are more related to the film sets than the actors in them. There are times these environments can be animated, of course, such as tornados, volcanoes, and other naturalistic effects.

The shaded version of the environment, including character. PATRICK CONNELE

Again, a detailed scrutiny of the requirements of the production storyboard will reveal where effort and economies can be made with regards the environmental design. To model even a simple room—with basic furniture, plain curtains, and other domestic props—can still be a huge task, especially if many things within the room need to be modeled individually because they will be picked up by characters. However, if the environmental designer knows ahead of time that only a small part of the room will be featured in close-up and that everything else will be just part of a dimly lit background, then they can get away with working in detail for just the areas that will be closely visible. Other areas can be blocked in with basic surface textures or three-dimensionally painted 2D artwork that matches the modeled element. This clearly is a much faster and more economic approach to take from a budgetary point of view.

A beautiful model prop, located on a close-up desktop surface, illustrating the excellent realism that can be achieved when using 3D textures and lighting effects to their maximum capability. BRIAN MISHLER

The same economies should be considered for exterior environments. A vast landscape with rolling hills, distant mountains, a running stream, and fences around fields would be a huge undertaking if it were all modeled individually. However, if animated action only appears in the foreground (for example, with a character opening a gate and entering a field), the rest of the scene can be composited texture maps, painted artwork, and maybe even modified photographic material that simulates the three-dimensional look. The audience will never notice what is real 3D modeling and what is simulated 3D modeling, if it is all done well enough. As long as the camera does not move in or out during the shot, or as long as the camera does not rotate three-dimensionally around the scene to another angle, the subtle blending of modeling and image mapping is a perfect solution when time and money are a factor. (And even when it's not, this technique could also be aesthetically preferable!)

"Endangered Species"

I do freely admit to the fact that although I am fascinated by 3D animation and wish that it had emerged earlier in my career so I could have had a longer run at it, modeling, rigging, and weighting are of no particular interest to me at all. I totally respect and admire those who enjoy, and indeed prefer, to do this aspect of the creative 3D animation production process. However, for me, the challenge of animated movement is the only thing that makes me get up in the mornings, on a creative level at least! I therefore assigned two of my most talented students, Moises Torres and Ian Walker, to model, rig, and weight the Buzz Lightyear look-alike character I used in "Endangered Species." Needless to say, I was delighted with the result.

I cannot, of course, explain how they did what they did! Much of modern digital technology still remains a great mystery to me. However, I consider this as nothing to be ashamed of as, in many aspects of the 3D animation industry, the talented artists of the modeling and the animation departments of a major studio rarely reciprocate their skills, although they do of course consult with one another as to what is required when the modeling stage is undertaken. (Students applying for specific jobs in a 3D studio should bear this in mind when preparing their presentation showreel or portfolio.)

With "Endangered Species," they did have the advantage of the original Buzz for inspiration and I had countless drawings of my yellow man character who would inhabit the suit, so there was really very little for me to involve myself in during this process. The animation action was set by the original film material as well, so I didn't even need to explain much about how I wanted the model rigged and weighted; it was relatively easy for them to come up with a synthesis of all these things that would represent that unique moment in animation when 3D at last came of age from a character animation point of view, and "Toy Story" changed the face of the industry forever.

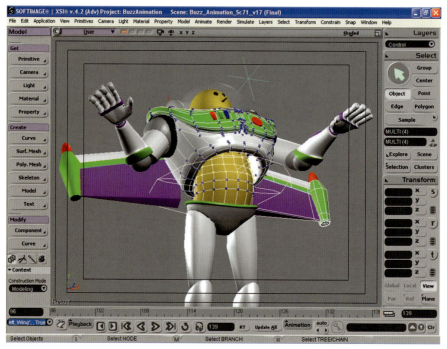

"To 3D and beyond!"

Creating 3D Movement

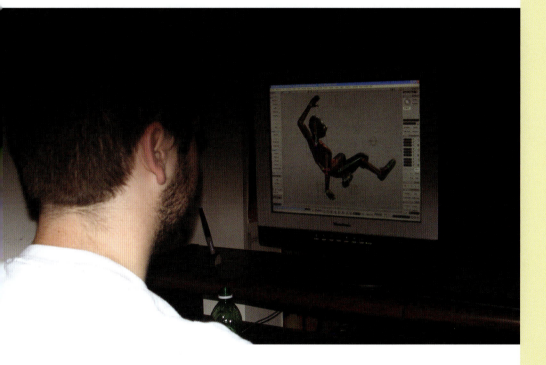

Successful 3D animation is all about observing, analyzing, attempting, assessing, and adjusting, repeatedly.

With the models successfully built, it is time to begin the animation, which takes place in four distinct stages: blocking out the action, creation of key poses, inbetweens (or tweens) are put in, and last, the fine tuning is added.

Blocking Out

Blocking out is essentially the setting of a static character (or characters, if there is more than one) in all the key locations it is required to be positioned in throughout the entire length of the action. For example, if a character is walking forward, you will position the static character in all the key step positions it will need to cover throughout the scene.

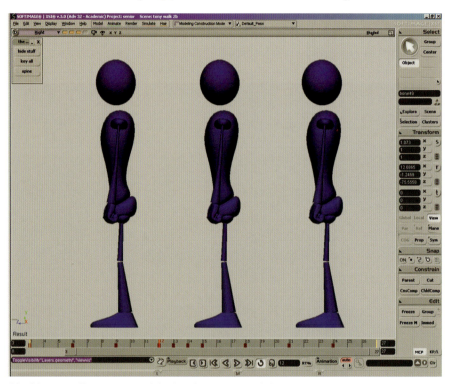

Blocking a walk sequence with the character model.

When played back, it will look like the character is sliding through the shot at the speed it will be in the final action, since the body is not actually animated at this stage. This effectively (and economically) tests the timing and the staging of the proposed shot before the actual hard work of animating begins.

Key Poses

With all the movement blocked out, it is time for the key poses of action to be added. If the character moving forward was blocked out at all the key step points, you will now quite easily be able to position the arms and legs to correspond with those step points to get an approximate look at the final walk. There won't actually be any bodily movement beyond the right leg, left arm forward/left leg, right arm forward positions assigned at this time, but a greater sense of how well it is working, or not, will be possible. It might also be desirable to put all the passing positions in at this stage too, so a more fluid sense of the walk's characteristics will be appreciated.

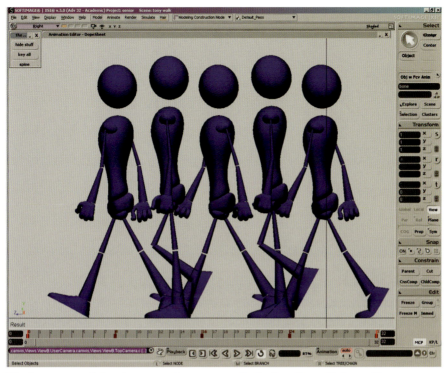

The key poses of the character give a sense of whether the walk is working on not.

It should never be forgotten that the most important factor of creating key positions in any action is that the poses are dynamic and well silhouetted. Art Babbitt, one of the legendary Disney 2D animators, used to say to me that you create a pose and then push it as far as you can. Once you have pushed it as far as you dare, double it! Don't be timid in striking the most dynamic pose that a character's design will allow. The reality of 3D animation is that an action may well be viewed from a number of different camera angles throughout the film. Therefore, key poses need to be evaluated from all perspectives to ensure they are well-blocked and well-silhouetted (see the following two figures).

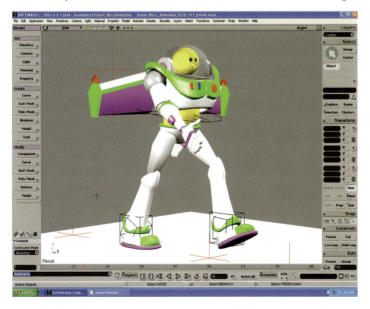

The character is badly silhouetted, with arm definitions obscured by the bulk of the body from this camera angle.

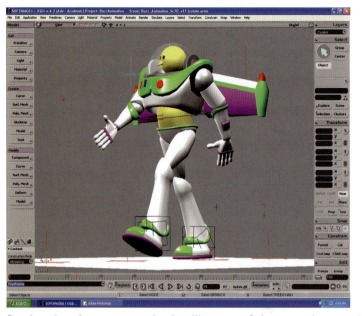

By changing the camera angle, the silhouette of the same character is so much better defined because both arms are clearly visible.

Consequently, you should always check out your key poses from every viewpoint before finally arriving at an ultimate decision, whether or not you have the flexibility to change them in the final version or not. The more dynamic the pose is and the better the camera angle, the better chance the animation has of striking the right note. Therefore, wherever possible, test your action by viewing it from several camera angles.

Inbetweens

This is the point where 3D animation definitely has a significant advantage over traditional 2D animation! With major key poses in position, it is a relatively easy proposition to let the computer do the drudgery of adding the inbetweens.

However, as a computer program thinks entirely logically, it is almost certain that the inbetweens it creates will not be as natural or as smooth as they would be with a hand-crafted approach (next page, top). As I've mentioned in other chapters, all actions in life are expressed as movements on arcs, and this is not the way a software-controlled process generally operates. Computer inbetweening is logical—straight and even—unless guided otherwise. Instead of letting the computer make the inbetweening decisions on its own, you have to push the inbetweens out of an inherent logical pattern and into the more aesthetic motion. The better the placement of the breakdown positions and major inbetweens, the better the motion, though even some final inbetween positions should be adjusted too, so no paths of action are perfectly straight or predictable.

Additionally, the timing of inbetweens should also be adjusted so that their placements are not always even. Most software has f-curve functions to create slow-ins and slow-outs in the animation (addressed in more detail later in this chapter).

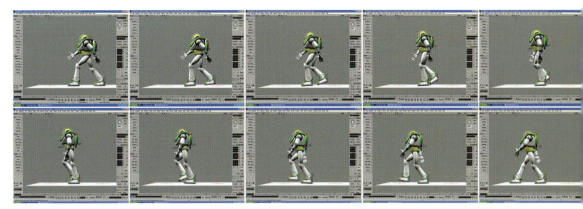

The computer can quickly generate the inbetweens, but some human finessing will still be required.

Fine Tuning

With all the basic inbetweens in and the action viewed fully for the first time, you now make fine tuning adjustments. One of the most common failings of 3D animation is that a rookie animator will key every one of the various body poses on the same frames and inbetween them pose to pose.

Consequently, the end result is that everything is even, predictable, and moving at the same speeds and at the same timing (see figure at left, below). In life, nothing ever moves this way. Not only do the major actions in a scene, such as a walking motion, need to be finessed (on right, below) but additional actions within the main movement, such as arm motion, head bobbing, or other overlapping action, should not be regulated by the same key positions that the initial walk key frames are governed by.

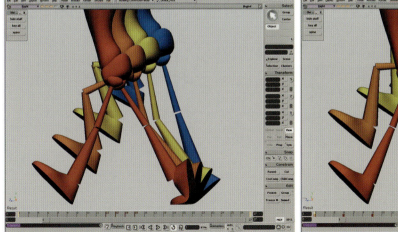

The computer inbetweens the free foot descending to the hit position in a straight line, something that never happens in reality.

By restructuring the inbetweens, the animator can make the free foot descend on a more realistic arc.

The real beauty of 3D animation, or the beauty of a well-created character model, is that all the body parts can be moved independently of each other and on different key settings. Even if the legs are doing one thing on one set of keys, the rest of the body does not have to operate on those same key positions. (There is nothing worse in animation than seeing everything moving on the same key poses, giving it all that floating, underwater slow-motion movement that often gives 3D animation, in particular, the label of "soulless.") Similarly, the breakdown or passing positions for varying actions within an entire movement do not have to be positioned using the same timing, even if they relate to the same key frame poses. The arms, head, and legs, for example, can have differently positioned breakdown poses if that floating look is to be avoided. This is all part of the subtle fine tuning and finessing that you can apply to your work before it is complete.

"Pose to Pose" Animation vs. "Layered Animation"

Pose-to-pose animation is comparable to 2D regular key animation; you create a series of key frame positions, which are assigned frame locations on the action timeline (digital equivalent of the 2D dope sheet) and are inbetweened by the computer. We have already discussed the dangers of this approach in terms of predictable, sterile, all-the-same movement, but its advantages are that it is fast and, in many cases, still the best approach to deal with most challenges.

Layered animation, on the other hand, is comparable to 2D straight-ahead animation; you work different parts of the character's body using different key frames and different timings between them. In other words, if the first major body action (say, the legs and body action) is successfully completed on a specific set of key frames, the secondary action (say, the arms) within the scene might be completed on an entirely separate set of key frames, while further refinements to the head and facial expressions may be created using other key frames.

The advantage of the layered approach to animation is that not everything is dependent on the same key frames (as with pose-to-pose) and the layered (overlapping) key placements bring a more fluid naturalness to the movement. The big disadvantage of layered animation is that it takes far longer to complete than pose-to-pose animation.

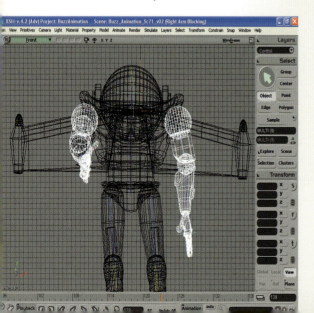

The beauty of 3D animation is that it is so easy to select separate parts of the body (the arms in this case) and animate them independently.

Timing, Timelines, and F-Curves

Outside of correct pose positioning, the creative use of timing in animation is funda-
mentally important. An understanding of timing really only comes with trial and error
or experience . Experience is essentially knowledge acquired through previous fail-
ures, and it teaches us that even though the keys are the most dynamic and well-posi-
tioned poses possible, bad timing can greatly destroy their impact and effectiveness.
The secret of timing is in knowing that nothing in life ever moves evenly or mechani-
cally, except for the most predictable of mechanical devices, of course. Additionally, it
should be recognized that a finely-timed hold in the action can be as effective as all-
action and all-moving animation! (Although a literal hold of a frame in 3D animation
should be avoided at all costs, as it renders the scene lifeless suddenly; a very subtle,
finely moving pose will work much better.) You control animation timing by correctly
placing key poses on the timeline and using f-curves to control the subtle nature of the
inbetweens.

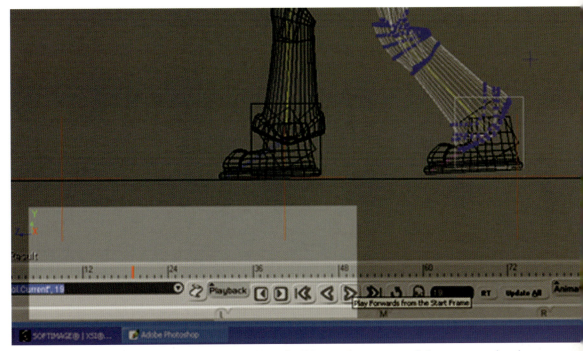

In XSI, the key pose placement on the timeline is as flexible as other aspects of the program, thereby
giving even more opportunity to change the timing of any moving sequence.

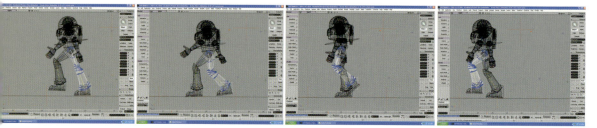

In this walk action, I deliberately dropped the body height just after the hit position, then pushed it up higher on the passing position, to give the character a more dynamic motion.

The timeline is effectively a linear map of all the frames of film contained in a film (made at 24 fps, 25 fps, 30 fps, or whatever film speed is required) that enables you to assign a pose to a specific frame in the sequence. Key placement broadly defines the timing from pose to pose, although the beauty of 3D is that if the timing between keys is too fast or too slow, it is a relatively easy to adjust them. Once the key frames are set, the f-curves enable the inbetweens between the two frames to be modified, specifically to give a more slow-out or slow-in nature to the motion.

The f-curve is a graph that links any two key frame points along a timeline. For a simple, even movement (as shown in the figure on the left, below), the graph between two key points appears as a straight line. If you change the shape of that line between the two key points into a specific curve, it will change the timing and the nature of the movement between them accordingly, giving it either a slowing-in or slowing-out quality. (For more on the concepts and benefits of slowing-in and slowing-out, see Chapter 8, "Principles of Animation.")

The f-curve tool is one of the most important elements of your toolkit, as it allows you to very simply and easily control the action from key pose to key pose.

The f-curve illustration of even inbetweens, generally boring and predictable movement, is straight lines between key poses!

A smooth and graduated f-curve line results in the same qualities in a character's movement.

Constant Testing

Animation is a process of imitative movement and it is only through constantly testing and evaluating movement, based on real-life observation, that the success or failure of an action can be judged or improved. It is far easier and faster to do this in 3D animation than in 2D. Most 3D software provides an instant, real-time playback of the action, without even needing to render out the final sequence. Do not neglect using this invaluable facility to the full. It also provides a wonderful (and instant) learning process that rapidly aids the experience of a developing 3D animator, where even the slightest of changes in the key poses and f-curve settings can result in a significantly different action.

Through this trial and error process, you can test more options for character movement than any 2D animator can in the equivalent amount of time. The looping facility that most software provides is an additional way to learn what is going on with the action in development. With looping, the same action plays back automatically, over and over again, allowing you to study it and identify the strengths and weaknesses of the action. The 3D camera viewpoint can also be easily changed in a matter of seconds.

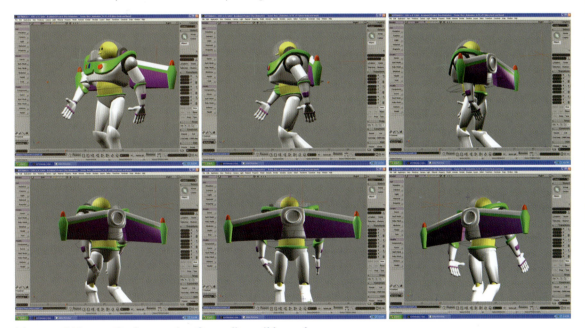

It's a good idea to check an action from all possible angles.

3D movement can be studied and modified in its entirety, and not from just one single viewpoint as it has to be with 2D. Similarly, the same action can be instantly reviewed in anything from a wide shot to an extreme close-up shot, a very valuable aid if preciseness in detail is required, or if the camera is to move in or out of a shot in the final version.

Perhaps these instant learning techniques have enabled 3D animation to evolve far faster than did 2D? Compared with the earliest stumblings of 3D animation in the 1980s, the films being produced today are light years ahead of what was produced by 2D animators in the same emergent timescale. This has to be because of the instant feedback nature of the medium, where a significant change of action can take place almost immediately. 2D animation, on the other hand, requires days, even weeks, to entirely change a movement once it is established.

Traditional Principles of Movement

With all that said, it must always be repeated that it is know-how—not software—that makes an animator. Even in the early days of 3D animation, when John Lasseter (the guiding light of Pixar animation) presented his computer-created film "The Adventures of André and Wally B" at Siggraph 84, he confirmed to his audience that what made his 3D animation different from all the rest was that he used basic animation principles that he had learned when he was a traditional animator. He added that he was surprised at how few people in the computer animation community were aware of these principles.

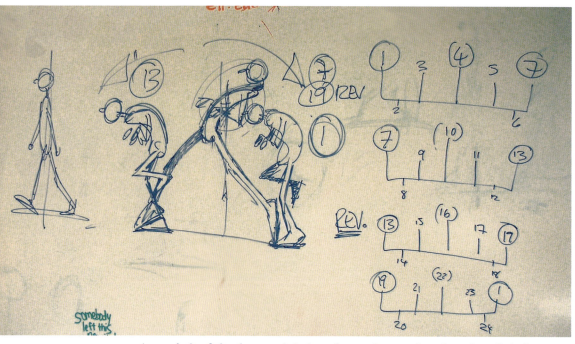

An analysis of the shape and timing of an action can be a huge benefit before you commit your proposed movement to a computer.

Although I didn't know it at the time, my own 2D animation book, "The Animator's Workbook" (Watson-Guptill/ISBN 0-8230-0229-2), published in 1986, was a very successful book because 3D animators were buying it to learn the core principles of animation. Here, almost 20 years later, there is still a steady demand for it, which totally amazes me. It can only be because the principles I highlighted then (derived from the decades of experience and teaching from the grand old masters of animation before me) are universal truths that have worked, do work, and will always work for every kind of animated movement. Consequently, it cannot be stressed enough to 3D students: it is not the software that makes the animator—it is their knowledge and application of the key principles of movement.

Character Motivation

There was recently a discussion on an awn.com Web forum where a young wan-nabe animator asked for information on the drawings required to make a nose sniff. This led to a wider discussion among the more senior animators, who tried to ex-plain to him that there are no instant formulas in animated movement; first he had to ask himself just WHY the character is sniffing in the first place. Is the character sick? Is the character sad, or even on the verge of crying? Or alternatively, maybe the character is sniffing because he's been swimming and has some water left in his nose. There are a number of motivations that might lead to a single sniff and each one of them will require a different approach to the animation. All movements and actions assigned to a character are the result of its inherent thought processes. In creating such a thinking character, you give life to its personality by connecting its actions with a thought process.

The final 3D model for "Endangered Species" compared to an initial storyboard concept drawing.

Walt Disney once said that in most instances, the driving force behind a character's ac-tion is the mood, the personality, or the attitude of that character, or indeed all three. He added that with character animation, the mind is the pilot; it thinks of things before the body actually does them. Perhaps there is no better way of explain-ing things than this and therefore animators of all persuasions will do well to keep it in mind whenever they begin to animate a character of any importance.

"I think, therefore I animate!"

The Value of Caricature vs. Motion Capture

With the advent of mo-cap (motion capture) and rotoscoping (tracing from live action film), it is very tempting for the modern animator to take live-action footage and replicate it exactly using a 3D animation character model. As with rotoscoping 2D animation, mo-cap is not a solution for true, quality 3D animation. The essence of movement, at its highest character animation level of expression, is more about seeing reality and caricaturing it. Live-action footage needs that extra, almost indefinable, ingredient that the experienced animator can bring to it, to give it life and believability as an animation. Mo-cap action is definitely quick and convenient in some ways, but it is hardly convincing unless the movement is pushed beyond itself to create reality.

Studying the original footage and caricaturing the essential key poses results in far better animation than mo-cap. PATRICK CONNELE

Using live-action footage for a 3D animated dance sequence. PATRICK CONNELE

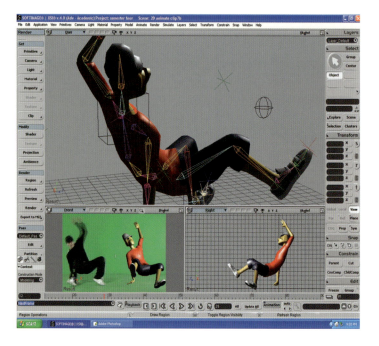

Key positions must be extended beyond reality and the timing has to be modified to create acceptably real action in animation, as weird as that may seem. As suggested, any action a character makes will also be dependent on their internal motivation too, or else the intrinsic personality will not entirely come through. Animators always have to ask themselves important questions before they attempt caricature. Is the character angry? Nervous? Aggressive? Clumsy? What is the character's mood, emotion, motivation? All these factors will affect the way a movement is attempted, if the pitfalls of simply replicating live action are to be avoided.

Sliders and Lip Sync

Another valuable tool in 3D animation is the slider. Sliders are essentially manipulators that enable you to make repeated movements or timings. A slider is often literally that—a moveable line tool that increases or decreases a particular action. For example, sliders are often very well suited to lip sync. The animator (or more likely the modeler) will create a series of independent mouth movements, open to shut, wide to narrow, smiling or scowling, etc, that are assigned to separate slider tools.

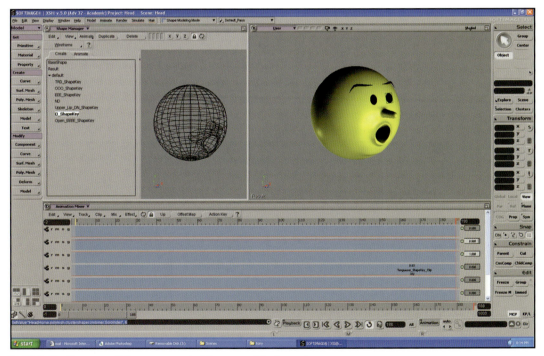

In XSI, the lip sync sliders are created in a graphic format.

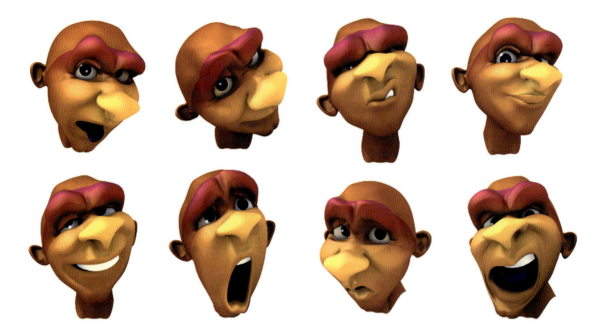

Good animated lip sync often demands a dramatic range of positions that can easily by transitioned to and from with well-created sliders. ROYAL WINCHESTER

By adjusting the slider, the mouth can be opened and closed, widened and narrowed, distorted to smile or even to scowl, accordingly. Similarly, sliders can be attached to eyes, noses, and anything that requires independent, repeatable actions such as muscles and bouncy bellies!

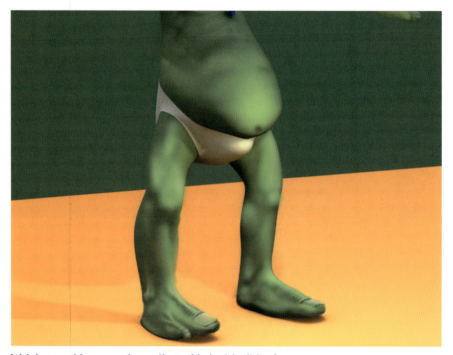

Weighty problems can be easily tackled with sliders! ROYAL WINCHESTER

A whole range of physical expressions beyond the mouth may be manipulated by sliders. However, in the case of lip sync, where the whole series of mouth positions (often referred to as "phonemes") are connected to sliders, the shape of the mouth can be altered by the simple click and drag of a mouse. These shapes are assigned to key frames in accordance with the phonetic breakdown of the track at that point in time. To quickly create the correct phoneme, you move the sliders to achieve the appropriate mouth shape.

This mouth shape is then keyframed. The next mouth position is created with sliders and subsequently saved, and so on until the entire dialogue sequence is built up.

The basic phonemes that will cover most lip sync requirements are, A, E, I, O, U, OO, B, T, L, S, Th, M, and F. One slider may cover a number of these shapes, but often several will be required. For example, at one end of the slider the mouth extreme could be totally closed (M) while at the other end it could be as wide open as possible (O).

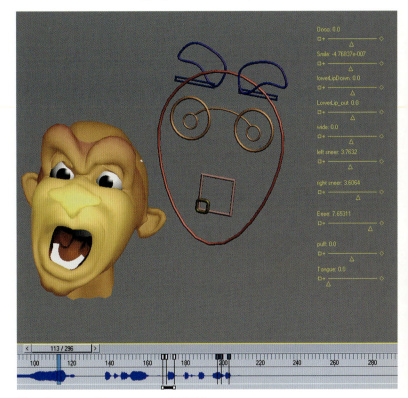

The phoneme slider system of 3D Max. ROYAL WINCHESTER

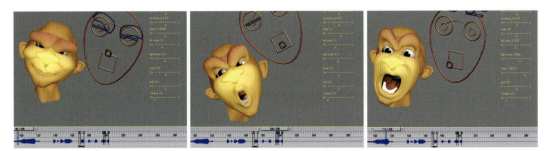

Sliders provide a considerable range of mouth and facial positions. ROYAL WINCHESTER

A position midway inbetween could be used for a U or an E, depending on the way it is constructed. Other mouth positions could be set-up on other sliders, controlling different shapes, until the full vocabulary of phonemes is achieved. In terms of audio phonetic breakdowns, an audio program like Magpie Pro will enable you to analyze the sounds and assign specific phonemes to them, as well as export these selected mouth settings into the 3D program requiring them.

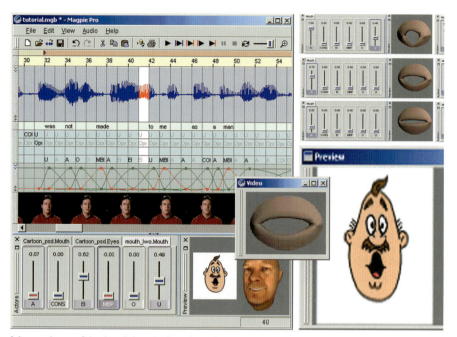

I have always felt that Magpie Pro (by Third Wish Software and Animation) is one of the best-kept secrets in the lip sync industry.

"Endangered Species"

The following is a brief explanation of the approach I took when animating the first two of the 3D sections in "Endangered Species." I do this not so much as an experienced 3D animator who is a recognized authority on the subject, but more as a 2D animator who was approaching 3D animation, wide-eyed, for the first time. Consequently, some of the methods I took were perhaps not entirely conventional. Others were perhaps very much so. However, all I can say in defense of my approach is that I ultimately ended up with animation I had totally intended from the outset and arrived there in reasonable time and without undue mishap, so I must have done something right!

Although the accompanying CD-ROM contains a more detailed review of how the entire sequence was made, this section focuses on scenes 70 and 71.

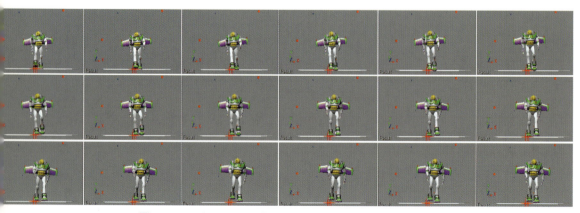

The progressive stages of a successful walk sequence.

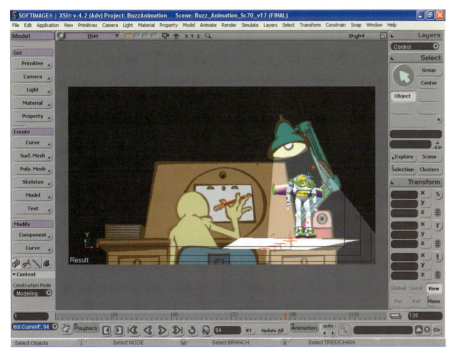

Digital technology can combine two different disciplines of animation in wonderful ways!

Scene 70

The challenge of all the 3D scenes was the fact that there were no modeled backgrounds to create. Since the character was to be composited into a 2D vector environment, created in ToonBoom Studio, I had to create the 3D character with a transparent alpha background and save it in a Targa (TGA) format.

I was able to use the back-projected rotoscope function in XSI to define the 2D background, which gave me an almost perfect location on the 2D background layout integrated in the scene. This achieved, I approached the challenge of the character animation through a number of stages, saving each one as a successive version. This process is pretty much standard for all kinds of 3D animation.

v-01: Blocking In

This is the first necessary set-up stage in all 3D animation. With the character model scaled down and positioned where it needed to be within the 2D layout, I simply moved it to the key poses that represented respective stride positions within the walk that would take it towards the edge of the desk. To do this, I transformed the legs to a left leg forward/right leg back and a right leg forward/left leg back throughout all the key poses.

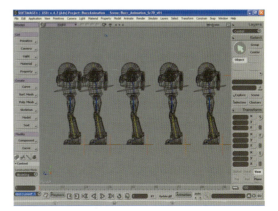

At the initial blocking-in stage there is no movement, just the same static character being positioned throughout the action.

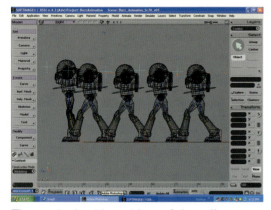

The required stride positions of the walk.

This gave me approximate shape, timings, and stride lengths that would be the foundation for the rest of the walk sequence. In terms of checking, I primarily viewed all this from the side viewpoint, as that position most clearly silhouetted the intended walk action. Of course, I did check the action from the camera view too, to assess how the final position would look from the final angle.

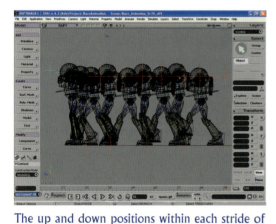

The up and down positions within each stride of the walk.

v-02: Add the Ups on Each Passing Position

With the basic stride foundations of the walk laid down, I introduced a little up and down action by putting in the correct passing positions. This way, when playing this action back over and over again, I began to get a feel for the energy the walk would have.

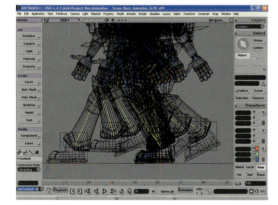

The blocked leg and feet positions of one stride.

v-03: Foot Adjusts

With a generic up and down walk established, I applied a more natural movement to the feet. This entailed having the free foot pointing a little more downward, toward its last contact position as it is lifted from the ground at the back, then bent more up and forward as it is about to reach its ground hit position at the front.

These changes ensured a little more fluidity to the ankle movements which, if not immediately obvious to the audience, does nevertheless have a smoother subliminal effect, creating a more natural feel for the entire walk.

v-04: Increased Up on Passing Position

With the foot adjustments in place, I felt the action needed a little more up and down on it, so I increased the heights of the passing positions. I moved the body as high as it would go, while keeping the feet in contact with the ground. I also angled the body slightly forward, to give it a sense of more velocity from the back leg drive.

The body position had to move forward of center to highlight the character's personality of the walk.

v-05: Foot Tidy Up

With the body even higher on the passing positions, I had to adjust the feet to reflect the slight change of angles, particularly in the legs, edging the foot forward and higher before the hit.

The refined foot positions that give a more natural flow to the action.

v-06: Side-to-Side Sway

Many animated walks are missing a crucial part of the motion. As well as moving the torso forward and back and up and down on each walk stride, it is necessary to add a significant side-to-side sway. Remember, when a moving body is reasonably balanced, the body's center of gravity needs to be somewhere over the contact foot whenever possible. If the body is mid-stride, of course, the center of gravity's weight has to be distributed somewhere between both contact feet.

If the body is deliberately out of balance, as in a jump, or a dive, or a trip, the body should be ahead of the foot action, along the line of the action's trajectory.

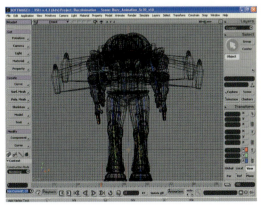

Increasing the side-to-side sway increases the natural swagger of the walk.

Keep the center of gravity of the body generally over the contact part of the foot. If it is either inside or outside the point of contact with the floor, the action will not appear convincing.

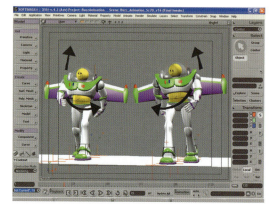

To emphasize the body twist, I rotated the shoulders forward and upward.

Bending the arms at the main joints to begin to create their flexibility.

Adding more flexibility to the wrists and fingers.

v-07: Rotation on Body

Another much-neglected refinement in walking actions is spine and torso rotation. Walking is not just a question of moving one arm ahead of each other, in opposition to each leg moving in front of each other. When an arm moves forward on a stride, so does the shoulder to some extent, resulting in a slight rotation of the spine in that same direction.

Such subtle changes are far easier to do in 3D animation than it is in 2D, of course. Traditional animation would require that all the keys and inbetweens be re-drawn with each action modification!

v-08: Blocked-In Arm Action

With the body and the leg positions pretty much complete, I now began to work on the arm actions.

I began to add just a little flexibility to the elbow and wrist joints, to feel out how I wanted a more natural arm movement to appear.

v-09: Left Arm Bend

Having tentatively felt my way towards the general arm movement I required, I began to mold the action closer to the way I felt it should be. I chose to work on just the left arm first and increased the bend on the elbow joint.

This accomplished, I began to focus on the left side wrist and hand action a little more. I put a slight drag back on the hand from the wrist joint as the arm moved forward and then a delay on the wrist and hand bending back as the arm moved backward again. I then encouraged this overlapping action effect by putting a similar dragging back action to the fingers of the hand, a very subtle whiplash action for the entire left arm. This created a more natural movement entirely.

v-10: Increased Body Action and Start Head Turn

I now reviewed, as objectively as I could, the overall walk action to see if it needed any further adjustments. I eventually decided to add a head turn that would imply that the approaching 3D character was looking at the sleeping 2D animator at the desk.

I gave the head a more natural turn throughout the action.

v-11: Right Arm to Match Left

With everything now working fine, it was now simply a matter of adjusting the character's right arm movements to match those of the left.

Matching the right arm's action to the left arm.

v-12: Lighting Adjust and Final Render

With the action complete, I had to adjust the lighting to reflect the light sources that were implied by the 2D world. In this scene, the desk lamp is the major source of illumination. Therefore, this had to be a significant factor in setting up the lights on the 3D character. When I successfully created this lighting hot spot, I noticed that, as the character moved forward on the desk, away from the light, it became silhouetted by the lack of light in this area. Consequently, I had to add additional light here to ensure that the character could be clearly seen at the end of the scene. The intensity of this light was significantly less than the light I was required to apply at the beginning. With this all successfully achieved, I was at last able to combine the 2D and 3D animation.

The lighting is adjusted before attempting the final composite with the 2D animation; for reference purposes the 2D material is shown here.

Scene 71

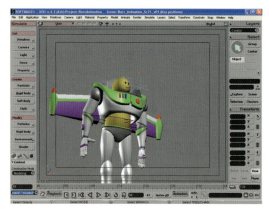

The anticipation moment before the dive.

As with the original "Toy Story" sequence, this angled mid-shot scene was a long anticipation action for the dive that is to follow.

Picking up from the character's positioning in the last frame of the previous scene, I set my camera view up to somewhat match the original "Toy Story" framing and began to build up the required action through a series of different versions.

The blocked-out main positions.

v-01: Blocking Out Positions

Again, the first step in any action is to block out the movement roughly. In this scene, there is not a lot of broad movement but a number of subtle moves that all collectively add up to the basic preparation pose for the dive in the next scene. Consequently, I blocked-out the main positions to reflect the original Buzz Lightyear action, but not closely to suggest that I was just aping it mindlessly.

Note the little anticipation on the arm as it moves back prior to the big move up and forward.

v-02: Right Arm Blocking Out

With the basic movement established, I worked on the arm movements. Again, I simply blocked-out one arm (the right) to achieve the kind of broad movement I was seeking.

v-03: Body Adjust

With the right arm blocked-out, I adjusted the body to accommodate the movements it was implying. Often, it can be OK to move a limb completely independently of a body. However, on this occasion, I needed flowing symmetry of action throughout the entire body movement.

On the third key position (second from the left), the hips stay down, as on the second position, but the body is beginning to open up from the waist, prior to the whole body rising on the fourth (far left).

v-04: Left Arm Blocking Adjustments

With the body and right arm blocked out and in harmony, I adjusted the left arm to match.

Here, I added a little drag on the hand as the left arm moved upwards.

v-05: Body Adjust

Once both arms were working with the body, I saw I needed some additional adjustment of the body. Animation, especially 3D animation, is always a process of adding and tweaking until everything moves as you want it.

Note the additional backward rotation of the body as the arms reach the high point.

Note the arm is now moving inwards as it rises upwards.

Adding further flexibility to the wrist.

Adding drag to the hand encourages further flexibility in its movement.

v-06: Right Forearm Adjust

With the broad action of the arms and body in place, I refined the actions. The arms were far too stiff in their existing movements, so I added flexibility by making more extension on the joint movements. I consolidated this process by applying more flexibility and rotation to the elbow joint of the right forearm, in addition to a little more bend and rotation at the shoulder.

v-07: Left Forearm Adjust

With the right arm moving much more naturally, I adjusted the left arm to match its fluidity.

v-08: Hands Adjust

With the body and arms now broadly moving the way I wanted, I applied more overlapping action to the hands by delaying the wrist and finger joint movements.

v-09: Right Hand Fine Tune

With both hand movements broadly blocked out, I then sought to apply a little more subtle individuality to the movements on the hands. I started by adjusting the bend and the rotation of the wrist joint on the right arm, making its hand action more fluid.

v-10: Left Hand Fine Tune

Although I wanted both arms and hands to move with a degree of symmetry, I did nevertheless wish to reflect Nature's way and make the coordination on the hands slightly different. I therefore applied similar adjustments to the left hand as I did to the right hand, although these adjustments were not entirely 'twinned,' as I wanted to ensure that the movement varied slightly from the left.

v-11: Left Fingers Fine Tune

At the beginning of the move, I needed the fingers to clench tight. However, as the arms reached up and out, I wanted them to separate and point outwards from the body.

Adding a little drag to the fingers as the hand rises.

I further adjusted the fingers of the left hand to fit in more with what seemed to be required, adding much more breadth and extension.

Keeping the fingers closed at the beginning of the move, then opening them at the top, offered a much more natural, expressive movement.

v-12: Right Fingers Fine Tune

Now more satisfied with the arm movements, I adjusted the finger movements of the right hand to reflect those of the left.

Here, I got up close and personal with the hands, giving the fingers even more subtle and expressive personality.

Adding drag and rotation to the right hand.

v-13: Left Hand Adjust

When the finger action was complete, the arms and hands actually collided as they approached each other on the way up! I resolved this by first adjusting the left hand's positioning by tweaking the angles and rotations on its major joints. Then, I adjusted the joints of the right hand in a similar fashion to create a more symmetrical feel to both arm movements.

Adding more symmetrical balance to the movement of both arms.

v-14: Balance Hand Actions

All this done, I felt that the hand actions were a little too floppy at the top of their moves. I flattened and extended their outward movement to make them look stronger and more decisive, first adjusting the left hand and then the right.

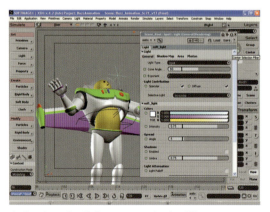

Adjusting the lights to match the 2D environment.

v-15: Lighting Adjust and Final Render

In Conclusion

3D animation has evolved significantly since it first began "way back" in the 80s. What once passed as merely moving graphics now includes full character expression and magical special effects. The transition of knowledge from 2D to 3D is virtually complete and so the horizons that lie before 3D animation are not so much in technique but in content and expression. In my humble opinion, Chris Landreth's Academy Award-winning film "Ryan" not only raised the bar conceptually but underlines the fact that the animator, as filmmaker, should no longer be content to simply create more cartoon films or realistic alien adventures. If any animation, particularly 3D animation, is to evolve, it needs to examine both the inner and outer realms of the human condition, as does all good filmmaking and art in general. "Ryan" offers a challenge for all 3D filmmakers of the future to stretch their perceptions and think outside of the box when it comes to expression and imagination. As 3D technique becomes more sophisticated, so too must its subject matter and ambition. It is not as if Hollywood or the TV networks are the conditioning factors any more. The Web, direct to DVD, and even the games industries are much more tolerant of originality and innovation. It is my greatest hope that 3D animation furthers the search for its own identity and launches itself boldly forward into realms where even 2D animation has feared to tread.

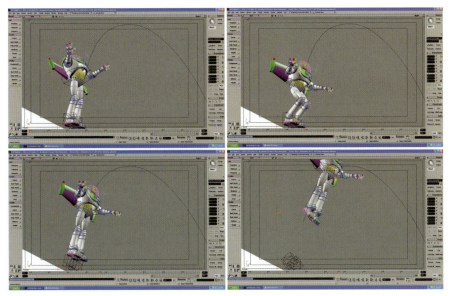

For me, attempting 3D animation has been as much a leap of faith as it has been for my character in "Endangered Species"!

Oh, I Almost Forgot ...

Job-Hunting Advice

Graduate students, as well as serious independent artists, are always asking me about the best way to land their first job in the industry. This is a really serious problem as, in this corporate day and age, the notion of an apprenticeship (and even an internship) is not readily available to most career seekers. Additionally, the current trend for out-sourcing has meant that a great deal of the standard studio work that would normally be completed in the home country (i.e., U.K. or U.S.) is now sent abroad, although the top creative jobs of animator, assistant animator, designers, modelers, and storyboard and layout artists do tend to remain with home-grown productions. Consequently, in an increasingly shrinking workplace (with ever more applicants emerging from schools and colleges of animation, armed with portfolios, showreels, and a great deal of un-reasonable expectations), it is increasingly more difficult for graduates to know just how they might approach studios in the hope of being hired. Of course, it is virtually impossible to offer a perfect master plan that will guarantee a kick-start in the world of animation. However, the following pointers will give some invaluable indications as to what to do (and what not to do) when seeking that very first job.

Showcasing Your Work

Remember, it is extremely important that you take every chance to get your work seen to increase your chances of being hired. The most important step in showcasing your work is to ruthlessly edit the demo pieces to ensure that you grab prospective employ-ers' attention, set yourself apart from the crowd of other applicants, and keep your materials short.

A tightly edited, shrewdly targeted portfolio, as well as a similarly constructed show-reel or Web site, are the major tools for self-promotion as they are immediate and well recognized as the only way to grab the attention.

Drawing Portfolio

Yes, a portfolio of drawings and illustrations is still one of your strongest weapons. To-day, even wannabe 3D animators need evidence of their drawing ability, as studios and employers have learned that the best animators just happen to draw well too, and hav-ing a drawer on the staff (as well as one with a 2D ability, incidentally) is infinitely more beneficial than having someone who just animates in 3D. Progressive and ambitious studios are essentially looking for animator-artists, not just software technicians.

Modern computer animation studios are also becoming aware of the powerful con-ceptual foundation and potential visual comprehension that drawing ability brings to their animators. Consequently, job seekers are strongly encouraged to build a good drawing portfolio to show when pitching for a job. But it must be the right kind of drawing portfolio, with just enough evidence of an understanding of anatomy, form, and dynamic pose.

Employers and personnel managers are tired of seeing the regular large, black portfo-lios, filled with drawings that represent just about every single thing that the applicant has ever done until that moment in time. Remember that you must always make it as

easy as possible for the recruiter to view the work and hopefully offer the job as a result. Portfolios should be scrupulously edited down to show only the very best work, whether it is composed of the obligatory life drawings or samples of design and illustration work that would cover other disciplines than just purely animation.

Edit your portfolio to reflect the job you are applying for. For example, a student seeking their first job as an animator should not show watercolor illustrations or 3D modeling skills. They need to show character sketches, some life drawing examples, and perhaps some key animation poses, especially if they are going for a 2D animation job.

Portfolios of all persuasions should be attractive to look at, neat, clean, and edited to show your very best work. Seasoned Nickelodeon storyboard artist and director John Fountain (who reviews many wannabe portfolios for the studio) prefers to show his portfolio as a standard 11" x 8.5" book, with each page containing his name, phone number and any other information that he deems necessary to establish his professional presence throughout the book.

When attending the 2005 Kalamazoo Animation Festival International, I had occasion to hear John talk of his somewhat scary, yet utterly hilarious, experiences in getting started in the business, as well as some of the weird and wonderful portfolios he has reviewed in his time at the studio. The key thrust of his advice—indeed the advice of all those I have spoken to on the matter—was that you should have a fun and memorable portfolio, one that is not too gimmicky, too difficult to review, or just too overflowing in disorganized and scruffy paperwork! John advises wannabes to be selective in what they show and to tailor the content towards the job or organization that is being sought.

The consensus of opinion in all those I have spoken to on the matter is that, above all else, you must be entirely passionate about your work and what you want to do. Personal neatness and courteousness is another brownie point towards a successful interview.

Showreel

Again, presentation showreels can often be a long and laborious process for prospective employers to endure. Often reviewers lack the time, the patience, or the commitment to consider a marathon of work samples that students may lay before them. Your best work should always be at the very front of the reel. If the prospective employer's attention is grabbed from the get-go, there will be a stronger chance of them watching the rest of the reel. They will certainly not sit through an endless preamble of nondescript work on the promise that the best has been saved till last!

Often, a reviewer will only be prepared to look at the first part of the reel anyway (if you can even get them to see it in the first place!) before deciding whether their time is being wasted or not. Including long and extended introductions, credits, animated graphics, or color bars before your main body of work is both unwise and unproductive, as it proves a time-consuming irritation to the person you are trying to win over. Make sure there are absolutely no offensive editing or video glitches in your presentation. A simple name and phone number at the beginning of the reel is perfectly acceptable, followed by a tight, well-edited presentation of your work, followed perhaps by more credit details (such as name, phone number, address, and Web site if available).

The reel should rarely exceed five minutes in length but if you have only one minute of drop-dead, knockout material to show, then don't pad it out with lesser material to make up to five minutes. Often, a showreel reviewer will have made their minds up about your work in the first 20 seconds or so anyway, so make those first 20 seconds count! Brian Tindall, long-term character technical director at Pixar, relates the story of how he was initially employed because he had a short piece of 3D work on his reel that none of the Pixar technicians could figure out how he did it! Indeed, it grabbed their attention enough to want to meet with him again. Of course, at the subsequent interview he still had to convince them that, apart from his original talent, he was capable of working in a team and fitting into the studio's family-oriented community of artists and technicians. When they were sure he could do that, they hired him. The point was Brian had something unique in his showreel that separated him from the rest of the applicants, something that left a lasting impression in the studio reviewers' minds.

One other key piece of advice that John Fountain offers is that the casing of the showreel, whether it be tape or DVD (a well-authored DVD is much more convenient for employers to review than the rapidly going-out-of-favor tape, incidentally), should always have the name and the contact information on the front with the resume (C.V.) on the back. Similarly, your name and contact details should always be on the actual tape or DVD label too! (The paperwork and the media often get separated in the reviewing process and you have to make it foolproof for the company's hirer to find you if they like what they see but have lost the paperwork.) It is additionally advisable that you double your chances of recognition by placing a folded copy of your contact and resume details inside the box, too, if that is possible, so prospective employers have something to file after reviewing the work if your original, mailed-in paperwork has gone missing.

Web Site

In the past, Web sites have not been a primary tool of presentation, but this is changing rapidly. There is a growing trend for interviewers to want to go to your Web site before even meeting you, to assess your work in an impersonal, relaxed environment. The danger is that an interviewer might cancel the appointment if the material he or she sees is not up to scratch, but such a pre-emptive visit to a candidate's Web site can also be a valuable plus if the material and its presentation is exciting. Indeed, it is known that an employer can be impressed enough with what they see to call a candidate and suggest an interview, quite out of the blue on occasions, if they should stumble across the Web site by accident or recommendation!

These days, no busy studio executive has the time, energy, or inclination to trawl the Web looking for an applicant's work. It will be up to you to charm them into doing so, one way or another. Alternatively, if your portfolio and showreel elements have really caught a potential employer's attention, it will be a bonus if you have a Web site too, where he or she can familiarize themselves with a larger (and perhaps more definitive) body of the your work. Your Web site should have a well-structured design theme that coordinates with your portfolio, showreel, and other materials.

Finding the Jobs

It cannot be stressed enough times that the animation industry is not an easy, lifelong career move. The animation industry, like its film and theatrical counterparts, is entirely transitional and mercurial. You should recognize all this from the get-go and not be disappointed if the times of feast and the times of famine affect your sense of well-being. Animators, like other actors or audience-based performers, have to interview for new jobs on a production-by-production basis. For this reason, you must always have your eyes open and keep your contacts appraised of your interests, goals and experience.

Networking

Even with a well-constructed presentation package, if you don't know anyone or have anywhere to show your work, you'll never get hired! Consequently, it is fundamentally important that you network as much as possible. Networking involves finding out, one way or another, what is going on in the industry, who the major players are, and where the job opportunities can be found. Web sites (such as AWN.com) and "Animation Magazine" will provide many clues, reviews, gossip, and even open commercials of companies and studios that are gearing up for new productions.

To stay ahead of the line, you must know the studios and the productions that are hiring. This may require a nomadic existence, traveling to the work (rather than waiting for it to arrive where you are located). Getting to know other animators and artists in prime studios like DreamWorks, Pixar, Disney, and even the big TV companies like Nickelodeon and the Cartoon Network is a good move too. Offering free assistance to animators, on occasion, will get you known in the business, to a point where, if you prove yourself useful and likeable, existing employees will request to their bosses that you be hired when a position ultimately becomes available.

If you have absolutely no contact or access to professionals in the industry, animation-related conferences and festivals are a perfect place to meet and schmooze with some of them. Quite often, these events are accompanied by job fairs, where newbies can show their portfolios to prospective employers. (But get there early—the lines can be enormous!) Clearly, such events are an absolute must for all serious job seekers who have the determination to get to the places that matter, whatever the cost.

Wannabe 3D animators absolutely should not miss the annual Siggraph event, or E3, wherever they are held, for this is where the computer animation and games industry struts its stuff and seeks out new talent, techniques, and technology that will feed it for the next year at least. For 2D animators, lists of animation-related events and job fairs are available on sites such as AWN.com and craigslist.org.

Recruitment Officers

I have spoken to many industry professionals on this and they all seem to share the same opinion. Although many big studios and organizations hire recruitment officers to allegedly find new talent, it is rare that anyone actually gets a start through them. Officially, you will be required to send your resumes, portfolios, and showreels to them. However, almost all of the first-job scenarios I have heard have come through the "who

you know" situation, not the "what you know." Friends at court, colleague referrals, talent spotters, and word of mouth are always the best way to getting a job for the first time. Sometimes jobs come through recognized and established college contacts with the industry, so choose your college well if you see animation as your chosen career choice (and check their record for student employment beyond graduation!).

All this said, it would be madness for you NOT to send your details to a studio's recruitment personnel in the first instance, because there are always exceptions to the rule (and it only costs a little postage). Even so, being in the right place at the right time is such a common occurrence that it is practically the norm. However, the "right time, right place" effect can never kick-in unless you can recognize and exploit the networking aspect of the profession tenaciously and comprehensively in the first place.

The Reality Check

A great deal of animation personnel are out of work at the same time, all looking for their next job which probably won't even exist in the short-term future. John Fountain always asks, "You may be good enough to get a job, but are you good enough to keep it?" Therefore, plan your exit strategy for the next pitching assault on the industry while you are working, even if you feel secure and comfortable for a while. You just never know when things might take a change for the worse. This is most definitely NOT an industry of permanence—you have to always adapt or die!

The Right Stuff

Persistence, passion, and determination are the strongest qualities a potential animator can possess. Add to this the really illusive quality—genuine talent—and maybe it will not be so tough after all. It has to be said that no one who survives in this industry is ever without talent; those with little or no talent and commitment do not survive. Of course, it is possible for someone to be lucky enough to perhaps get a first job in the industry without underlying talent. However, in the long term, those lacking essential artistic and social skills (remember, animation is a team game and therefore a team ethic is paramount) will eventually be found out and wanting of future, further employment.

Beyond raw talent, there come other qualities of importance, such as vision and originality. You have to be good, but it is infinitely better if you also offer something that no one else offers, while at the same time conforming to basic professional standards. That is clearly hard to demonstrate in seeking a first job, so you need to tailor your presentation with enthusiasm and imagination, even if you are not applying for the position you ultimately want most in the industry. At the same time, always show passion and a willingness to listen and learn concerning anything that is offered, whether it is a job or just good advice on how you can better prepare for an application the next time. However harsh or painful the criticism of your work, you have to take it and grow from it if you are really destined to get into the industry.

The Value of Experience

Get experience wherever you can, for that is probably the most reassuring commodity a job seeker can have in the eyes of a potential employer, outside of raw talent. Sometimes the path to where you want to be is not always the direct route, so be aware and open-minded enough to take any opportunity, even though it may not be where you want to be at that moment in time. The important thing is just to get in the door, even if you are running to get everyone coffee. Work for nothing if necessary, just to get real experience. Employers will be so much more comfortable hiring a person who has shown he or she can do it, however humble or low-key the production or effort involved. Above it all, be persistent, persistent, persistent, and get your work experience from as many people and sources as you can, and as often as you can. To do this you need to become familiar with the key players and workers in the industry, which of course brings us back to networking.

The Value of Familiarity

When you become a recognizable face on the scene, even if you are not actually employed by anyone, there will come a time when someone, somewhere, who likes you will try to give you a break somehow, as long as you have a real talent, prove yourself reliable, and have a good attitude, even under adversity. Become a familiar face that everyone enjoys seeing around. At the same time, make sure also that you don't overstay your welcome, are not seen as just a hanger-on or animation groupie. I've personally found that a smile, a "please" and a "thank you" go a long way to ensuring that you're welcome wherever you go.

Words of Encouragement

When you do get your foot in the door and have a meeting with a potential employer, follow the basic rules of etiquette. Always, but always, be on time for interviews (leave an hour or two earlier than you have to if necessary) and be neat and courteous in your manner. Even if it appears cool to be sloppily and unconventionally dressed, remember that prospective employers look for solid and reliable employees; sometimes casually dressed individuals with a distinctive, unconventional appearance will just not suggest that.

Always only show what you are best at and things that target you for what you most want to do. For example, if you want to be a 3D animator and have no interest or talent for modeling or texturing, get a friend or colleague who is good at these things to create a model you can animate. If, on the other hand, you want to be a modeler or a texturer but are not interested in animation, get a similar friend or colleague to produce some good animation for you from the textured models you have created. This will show your work in the very best light. (Whatever you do, try to avoid animating your own models yourself, if it is not your best strength. A great model, badly animated, is far worse than a great model simply rotated through all angles; people tend to associate bad models with bad animation, even if that is not true.)

Above all else, display a good work ethic when pitching your work and be enthusiastic. Be passionate and sincere about your work and what you hope to offer them. (It is amazing how many job seekers shoot themselves in the foot by being too indifferent, fashionably cool, or simply arrogant or disinterested enough to antagonize the people they are pitching to.) Listen and absorb criticism. Never argue, or become sulky, or show aggression if you don't hear what you want to hear about your work. Absorb and learn, then go away and improve your presentation before the next pitch comes along. (But bear in mind that different studios and recruitment representatives can look for entirely different things in a portfolio, which can be really frustrating!) Carry your portfolio and showreel around with you as much as possible, for you never know when that "right time, right place" opportunity might show up. Technology too offers wonderful opportunity. (The video iPod is a great, compact way of carrying your work around you and showing it, as do most MP3 players!)

Ultimately, as with the inherent process of making animated films, you will only get out of it what you put in—no more, no less. So, it does make sense to perfect and evolve your work presentation material until you arrive fully ready for that ultimate pitch that will finally open the door to your first job in the industry. (Then the fight is to stay in the industry, but that is another story!) Remember always that it is never going to be easy to be a professional animator, especially for women, who are in a huge minority. Yet, despite all the setbacks and all the hardships, animation is still the best occupation in the world, at least as far as I am concerned, so stick with it! It will surely reward you well, as it has (and continues to do so) with me.

Glossary

Glossary

I have attempted to compile a definitive list of the most common terms in the production of contemporary animated films, games, and commercials, in addition to those that have been used traditionally. Many of the terms referred to are not necessarily used in this current publication and there may be omissions, since terminology and procedures differ from individual to individual, studio to studio, and country to country. In addition, this is not a comprehensive list of software-specific terms, as there are so many options available. However, the following is my best effort at the task and I hope readers will find what follows a useful and informative source of reference.

Above the Line Costs Film budget costs that include all expenditure over and above the production costs of the crew, facilities, and regular budget expenditures, such as the producer, director, and principal cast, etc.

Academy Standard 4:3 format screen ratio, used in all TV work and many films.

Acme Most commonly used peg registration system used in 2D animation, comprising of a round central hole and one elongated hole set on either side of it. (Not to be confused with the numerous coyote products featured in the Road Runner cartoons!)

Aerial Image Film process of combining live action with animation (where the animation is filmed conventionally on a rostrum camera, with top lighting—while the live action is simultaneously back projected through the camera lens and onto the film).

Agency/Advertising Agency The organization responsible for a company's advertising strategy, scripted ideas, marketing, and advertising production.

Agent *See* Artist's Rep.

Alpha Channel The fourth channel that digitally accompanies the standard three RGB color channels, allowing for transparency when compositing with other image levels. *See* also RGB.

Analog Tape Recording tape which reproduces sound or picture by a magnetic tape process.

Animatic A filmed storyboard (sometimes final layout drawings in 2D animation) which is synchronized to the soundtrack, prior to animation, so that some idea of how the film will look can be assessed.

Animation Characters Imagined characters that are conceived by a designer and are brought to life by an animator's skill.

Animation Layout Accurate drawing which plots out the size and placement of animated action within a scene, prior to animation. There are conventionally two kinds of layout in a 2D animation production, the background layout and the animation layout.

Animator *See* Key Animator.

Answer Print The final color-graded film print, containing the soundtrack and picture combined.

Anticipation A preemptive action in the opposite direction to the main action, which provides added emphasis or impetus to it.

Arc Curved path of action through which an animated movement travels.

Art Director Artist who is responsible for conceiving the overall visual styling of a film, or the creative lead in games production.

Artist's Rep An agent who presents an artist or animator's work to prospective clients in pursuit of a commission.

Artwork All the created visual material that makes up an animated film.

Assistant Animator Junior (or trainee) animator who assists the key animator in putting in the major inbetweens of a scene. At the highest level, during the golden age of the Disney studio, the assistant animator was the business manager of the key animator in all production work, doing pretty much everything for him or her, other than the creation of key drawings for animation.

Atmos Background sound F/X (effects) that need to be added to the audio track of the film to give the scene a natural sounding atmosphere (e.g., traffic sounds, birds singing, city drone, etc.).

Background Designs *See* Backgrounds.

Background Layout Accurate drawing that depicts everything in a scene that is to appear in the background, prior to the animation or background art being created.

Backgrounds Finished artwork depicting all that does not move in an animation scene, usually to be seen behind the animated action but sometimes in front (then known as foreground), in the form of an overlay level.

Bar Sheet Printed master sheet in traditional 2D animation that enables the director and sound editor to break down the phonetic content (and timings) of an audio track, frame by frame.

Below the Line Costs All budgeted costs, other than those indicated in above the line costs, usually relating to the more general cast, crew, and equipment costs. *See* also Above the Line.

Beta Format of industry standard video tape used for certain broadcast-quality TV production. Also, test software that is freely released for trials prior to that application being sold commercially.

Bi-pack Traditional method of combining live action with animation in the camera.

Bid Budgeting estimate presented to an agency by a production company when pitching for a contract to produce a commercial.

Bit A unit of digital measure to define the amount of information contained in a computer image or file, derived from the terms binary and digit. There are eight bits in a byte. *See* also Byte.

Blank Leader Black, white, or colored filmstrip that an editor adds to the beginning (or sometimes the end) of a filmed scene or sequence to provide intro time when working on an editing bench.

Blue (or Green) Screen Background Method of filming live action that enables the actors to be separated from the background and composited later with another live action, CG, or drawn background. Any strong, even color will serve this purpose, though blue and green are the most prevalent.

Blues Pencil animation drawings created using a blue col-erase pencil.

Boiling The flickering that occurs when a number of animated images containing differing painted textures are filmed in sequence. Boiling also occurs when there is extensive cross-hatching from drawing to drawing, or if the lines of each drawing differ from each other significantly, whether by accident or design. Commonly seen in TV animation such as in "Beavis & Butthead" or "King of the Hill."

Breakdown Drawing The first inbetween drawing that is created by the animator (or assistant animator) between two keys.

Breaking It Down The process where a sound editor or animator produces a frame–by-frame phonetic analysis of an audio track containing dialogue, narration, or song lyrics so the animation may be accurately matched to it. May also include a similar analysis of the beats and main instrumentation found in a music track for the same purpose.

Budget Estimated costs of a production, based upon a known script, visual stylings, and animation approach.

Budgeting (Games) The process of balancing the needs of the designer and the programmer when creating a game engine. Invariably, games are limited to specific data files size, depending upon the platform they are to be played on. If the artwork is too large, there is less room for programming possibilities. If the programming approach is too data-hungry, there is less opportunity for significant artwork and animation.

Burning-in The traditional film process of superimposing a brighter image onto a previously exposed darker one. This was achieved by running a previously exposed scene of film back in the camera and then shooting a second pass of the image (usually white, or a similar bright color, on a black background) to produce a combined, double image. The most basic use of this is to add white titles to a previously untitled film sequence.

Byte A unit of measurement that defines the size of computer data. There are eight bits to a byte, a thousand bytes to a megabyte, and a million bytes to a gigabyte. Just to stretch the mind a little more, there are one billion bytes in a terabyte!

Camera Instruction Sheets *See* Dope Sheets.

Camera Operator Skilled individual who operates a rostrum camera.

Cash Flow Projection of how much, and when, the finances estimated in the budget will need to be accessed throughout the actual production schedule, usually on a week-by-week, sometimes even day-by-day, basis.

Cel Paints Traditional color paints that are applied to the back of cels, once the animation has been traced in line on the front.

Cel Punch Engineered, precision instrument that produces accurate registration holes in animation paper and cel. The Acme punch system is the most commonly used.

Cel Xeroxing Traditional method of copying drawn 2D animation artwork onto cels using a modified photocopying machine.

Cels Sheets of clear acetate onto which the animation drawings are inked, traced or Xeroxed before being painted.

Center of Gravity The inner point within a character where its entire volume, weight and mass are centrally focused.

Character Design The visual representation of a character which is to be animated.

Charts *See* Dope Sheets.

Checker Member of the 2D animation production team who meticulously checks for errors with the animation, background art, and dope sheets, prior to filming or scanning.

Checking The process undertaken by the checker.

Cinemascope (Scope) 2.35:1 film screen ratio that is achieved by using a special anamorphic lens which squeezes the image when filmed and then expands it back to the original dimension when run through an appropriate projector. Scope format is almost exclusively reserved for large-scale, epic movies.

Clean-up Artist The member of an animation team who converts rough animation drawings into finely inked, finished artwork, reflecting the final design style designated for the film, prior to tracing or scanning.

Clean-up The process undertaken by the clean-up artist.

Click Track Guide musical soundtrack, which contains a metronome beat, allowing the animator to time and pace the action prior to the final soundtrack being recorded. As the click track gives the animator a precise timing of the music that will be eventually recorded for the piece, it is extremely important that the beat of the final music is identical to the beat of the click track, otherwise the animation and the music will not be synchronized in the final composite.

Color Designs/Concepts Approved colorings of the various animated characters/elements featured in the film.

Color Gels Colored, transparent cels that were laid over finished animation artwork in traditional 2D animation. Color gels provided a distinct mood change in a scene; for example, a deep blue gel over a scene will give a cold or nighttime feel, yellow will bring a bright/sunlit feel, and red will instill more heated passion or anger, etc.

Color Grading Fine-tuning color adjustments made to the look of a film, once everything has been completed.

Color Model Final color concept of an animated character or object that defines the precise colors to be used when artwork is completed.

Commissioning Editor Individual employed by film or television companies to identify, develop, and then hopefully green light new projects for final production.

Composer Individual responsible for writing and arranging the musical content of the proposed film.

Compositing The procedure of combining various separate filmic elements (e.g., live action with animation, layers of animation with other layers of animation, and special effects, etc.) through a digital or film editing process.

Copy Written text material specifically contained in an advertising script.

Copyright (Rights) Agreement Legal document which enables a filmmaker to work with intellectual property that is not their own.

Copywriter Member of an advertising agency creative team who is responsible for writing a commercial script.

Corporate Sponsorship Finance from a major industrial corporation or business entity that can help finance the production for a film, in exchange for the goodwill, PR, or publicity value that such an association can bring to that company.

Creative Team Members of the advertising agency personnel who are related to the visual and written content of a particular commercial (e.g., art director and copywriter). In a studio setting, the creative team is responsible for developing a proposed project for final production.

Cut Outs Separate pieces of hand-shaped and cut-up animation artwork that is moved under the camera or on the screen, frame by frame, such as in "Monty Python's Flying Circus."

Cut The point in a film where one scene ends and another begins.

Cutting The process undertaken by the editor when assembling all the scenes of a film together.

Cutting Copy A film double-head presentation of the production—meaning the visual action of the production is projected on one strip of film while the soundtrack (mag track) is played on another.

Cycle Animation A process of economizing animation; the same action can be repeated (e.g., a walk or a run action) to get a maximum screen time out of a minimum of moves.

CYMK The subtractive form of color management, used in printing, where all color representation is broken down into varying degrees of cyan, magenta, yellow and black. Using this approach, white is ultimately achieved by subtracting color in each of these elements.

Dailies *See* Rushes.

Dead Zone The first six frames of a scene, where it is said that the human brain cannot detect image or movement.

Design Concept (Concept Art) Images created that define the overall creative look of a film.

Design Stage The phase in the production schedule (at the beginning of the film) when all the design work is undertaken.

Design *See* Design Concept.

Designer Member of the production team who is responsible for the design content of the film.

Development Package A collection of presentation material (script, designs, budget, cash flow, legal documents, etc.) so investors can assess the production from every conceivable angle.

Dialogue All the spoken material in a soundtrack.

Diffusion Filter A filter that is placed over the camera lens to create a soft, diffused look to the scene.

Digital Tape Process which captures audio material digitally (as opposed to the old analog approach).

Director Member of the production team who is responsible for the overall interpretation, styling, performance, and timing of a film.

Dissolve The moment in a film where one scene fades out as another scene fades in.

Distribution Rights An agreement negotiated between a producer and a distributor of a film, where the right to show the film in specific regions of the globe is legally obtained.

Distributor The individual who distributes a film through various markets (cinemas, network TV, cable and satellite TV, retail video, DVD, etc.).

Dope Sheets Pre-printed charts on which the animator can indicate the order of their drawings, the timing of these drawing, the layers for each drawing and the location of the background, as well as other special effects material that will be included in any particular scene.

Double Bounce Style of animated walk where the character's body bounces up and down twice during one step, such as Mickey Mouse's original carefree walk.

Double Take An animated character's exaggerated reaction to an event that he or she has just witnessed.

Double-head The film when picture and soundtrack are projected separately but in sync with one another.

Drawing Board Artist's work surface.

Dub Process of mixing the music, dialogue, and sound F/X onto one soundtrack.

Edit Suite Audio facility where all the visual elements of a film are edited, or dubbed, together.

Edit The process of joining all the scenes of a film together, often in conjunction with the soundtrack.

Editor Creative member of the production team who supervises the edit.

Electric Pencil Sharpener Important and time-saving equipment for a 2D animator.

Establishing Shot A shot at the beginning of a film which sets up the story setting for the audience.

Exposure Sheets (X-Sheets) *See* Dope Sheets.

Exposure Test A test undertaken by the rostrum cameraman to ascertain the correct exposure of a scene (or the special F/X within it).

Extra Charges Costs that are incurred, outside of the original budget, that are brought about as a result of an agency, or client, requesting changes that lie outside of the original script requirements.

F/X Abbreviation for "effects" (visual or sound).

Feature Film Full-length movie most usually shown in a cinema or on TV.

Field Center The central point within a field guide from which all measurements are made. Abbreviated as F.C.

Field Size Area within the animation artwork that the camera will see.

Film Lawyer A legal practitioner who specializes in film work. (Very important!)

Film Optical The traditional process of joining live action with animation, or of adding graphics, titles, dissolves, or visual F/X, to an existing piece of film.

Film Size Defines the specific width of film stock being used (35mm, 16mm, 8mm, Super 8, etc).

Film Stock Defines the nature of film stock being used (color, black and white, film speed, etc.).

Final Shoot Stage of filming where the finished, color animation artwork is shot.

Final Track Stage of recording when the soundtrack is completed and approved.

Fixed Costs Overheads contained in the budget (rent, rates, leases, etc.).

Flipbook A simple process of movement created by drawing small figures in the corner of a book and watching them move as the pages are flipped.

Flipping (Rolling) A technique where a 2D animator can review up to five animation drawings positioned on the pegs of his desktop at once, by interleaving his or her fingers between each drawing and flipping them sequentially as if they were a simple flipbook. Also, a process of reviewing a whole scene of drawings by holding them up in one hand and flicking through them at a constant pace with the other.

Footage Rate Amount of film footage to be completed each week (or even each day) by the animator or assistant animator to meet the schedule.

Footage Length of a film, or sequence, in feet and frames.

Frames Per Second (fps) Rate of speed that the film is projected. For example, 24 fps (cinema and U.S. TV), 25 fps (British TV), or 30 fps for most digital movie media, as well as high quality animation on U.S. TV. Flash animation and streaming for the internet is usually 12 fps.

Frame An individual image contained within a film.

Freeze *See* Hold.

Frosted Cel A diffused sheet of acetate, used in traditional 2D animation, that may be drawn on with regular lead pencils. When this drawing is complete, the frosted cel is then sprayed lightly with lacquer, which turns all undrawn areas transparent, like a regular cel. On frosted cels, a more illustrative, pencil-shaded style of animation could be created. Nowadays, digital programs such as Mirage make this approach so much easier (and less smelly or messy!)

Funny Money Term given to film finance derived from unorthodox sources, such as private investors, who have a personal interest in the nature of the film they are backing, rather than seeing it purely as an investment possibility. (For example, the first-ever British animated feature film was "Animal Farm," a wonderful story by George Orwell that alluded to the horrors of communism. It is rumored that this was backed by the CIA, whose interest was to condemn communism wherever possible.) Alternatively, finance that comes from dubious or illegal sources, such as from money launderers, drug dealers, etc.

Graded Print A double-head film print which has been corrected to match the colors of the original animation artwork.

Graticule (Field Guide) A grid guide that allows the animator to calculate and define the field sizes of various scenes within a film.

Green Light The approval of a project by an investor or distributor.

Green Screen *See* Blue Screen.

Guide Track A preliminary soundtrack that gives the animator an idea of what the final track will be like, especially useful when blocking out animated action before the final audio track is available. (Often used for animatics, when a sequence is being planned out.)

Hand Tracing (Inking) Process where the animation is traced (by brush or pen) onto the cel by an inker.

Hi-Definition (Hi-Def) TV system which uses 1,000 scan lines to provide a picture on the screen, as opposed to 625 lines (in the U.K.) or 525 lines (in the U.S.) *See* also NTSC and PAL.

Highlight An F/X element which creates an illuminated effect on the brightest side of an object or character.

Hit Strong emphasis created in the animated action (usually in synchronization with an important sound or beat in the music).

Hold A moment in the action where an animated character stops moving for a specific number of frames.

Hot Spot Area on the animation artwork which is over-exposed due to uneven lighting on the rostrum camera table or in the scanner.

Image Map A term used in games animation to indicate the background image.

Implied Geometry The process in drawing where objects in the foreground take successive precedence over objects that are further away from them in the background, to create the illusion of scale, form, and perspective. For example, when a character points towards the camera, the nearest part of the forefinger will

take precedence in size and line over the next part of the finger, which will in turn take precedence over the third part of the finger, followed by the various elements of the hand, the forearm, the upper arm, shoulder and body.

Inbetween Drawings Drawings that are positioned between two previously created key or breakdown drawings.

Inbetweener An assistant animator (or an assistant to the assistant animator in larger productions) who produces the minor inbetween drawings.

Inbetweening The process of doing inbetweens.

Independent Filmmaker Filmmaker (usually a producer) who creates a film independent of established film production sources such as TV companies or major Hollywood studios.

Inker Member of the film production team who is responsible for transferring the original animation drawing onto animation cels or individual sheets of paper, prior to scanning.

Inking The process undertaken by an inker.

Key Animator Skilled artist with the ability to bring life to inanimate drawings or images.

Jockey The nickname for someone who is adept at using software.

Key Drawing A major animation drawing, created by a key animator, which represents an extreme position within a movement.

Key Frames Color representations of artwork which indicate the design or positional look of specific scenes within a film.

Lab Film-processing laboratory.

Layout Drawing Detailed sketch which indicates everything that appears in a scene.

Leica Reel Filmed layout drawings that are shown in sync with the approved soundtrack. *See* also Animatic.

Lightbox Backlit work surface used by most members of a 2D animation team.

Line Drawing Pencil animation drawing, prior to the inking and coloring process.

Lip Sync A character's mouth movements that animate in synchronization with the audio track.

Literary Rights Agreement Negotiated legal contract which enables a filmmaker to animate material that is based on an existing book or published story.

Live Action The filming of actors in natural scenery, as opposed to drawn or animated action on painted backgrounds.

Location A place where live action is filmed or an animated scene is set.

Mag Track Soundtrack which is recorded onto 35mm or 16mm magnetic film stock.

Map The background behind any games production action.

Mark-Up The percentage of a budget that represents profit for the filmmaker.

Match Cut An editing device where a character is in a set position at the end of one scene and in the identical position at the start of the next scene, but possibly with a different background. A match cut can work with either a static image or a moving sequence.

Matchline Different colored line, drawn onto an animation drawing, which indicates the limits of the coloring area, to create the illusion that the part is behind an object on the background when it is composited. Alternatively, a line which indicates where a body part on one level matches the rest of the body on another.

Matte An area which blanks-out a specific area on the background or character, so another image or character can be composited into it.

Matte Run An F/X element, used in compositing work, which extends the matting process throughout a scene of animated movement.

Merchandising A means by which extra revenue is obtained from the exploitation of a film, such as toys, games, books, DVDs, and videos, etc.

Mix *See* Dissolve.

Model Sheets Design sheets which depict the size, structure, and dimensions of animated characters when seen from every conceivable angle.

Moviola Machine once used for viewing film during the double-head stage.

Multi-Plane Camera Specially designed camera from the early Disney studio which offered the opportunity to film separate levels of animation at different speeds, creating the illusion of three-dimensional depth.

Mute A film sequence that contains no audio track.

Neg Cutting The traditional process requiring the careful cutting of a film's negative to match the cut arrived at with the double-head version.

Negative Pick-Up Distribution deal which states that the distributor need not pay the film's producer any investment money until final version is completed.

NTSC TV broadcast system used in the U.S. and other selective countries. Because it uses an inferior definition standard of 525 lines, NTSC has been jokingly described as Never Twice the Same Color. *See* also Hi-Definition and PAL.

Optical Track Visual soundtrack stripe that is seen along the edge of a theatrical film print, which enables the audio material to be heard simultaneously as the picture is projected.

Option Agreement Negotiated legal arrangement which allows the filmmaker to purchase the right to develop copyright material for a set period of time, with a view to seeking final production funding for the project.

Overlapping Action Technique used by animators which offers a more fluid look to the action by delaying some of the secondary movement behind that of the main movement.

Packshot The scene usually at the end of a commercial which presents the product a client is advertising.

Painter (Colorist) Member of the film production team who is responsible for painting the animation drawings once they have been transferred onto cel by the inker.

PAL A TV broadcast system used in the U.K. and other countries which provides a 625-line resolution to the picture. *See* also Hi-Definition and NTSC.

Palette The selection of color swatches available within a paint program. The range of colors available is usually severely limited with game or Web productions.

Pan Film action that has the camera traveling across a scene to suggest breadth and movement.

Paper/Cel Rack A studio shelving unit that allows animation paper to be stacked or wet painted cels hung to dry.

Passing Position The midway position between two extreme key/stride positions in an animated walk.

Peg Bar The peg device upon which punched animation paper or cels are placed for consistent registration.

Peg Hole Reinforcements Adhesive paper or plastic reinforcements that are fixed around the punch holes of animation paper or cels, preventing them from tearing.

Peg Holes Specific holes punched into animation paper or cels to aid the precise registration of drawings.

Pencil Test (Line Test) Filmed pencil drawings that test the way the animation is moving.

Percentage Exposure A traditional F/X technique which enables one aspect of the artwork within a scene to be seen as transparent.

Photo-Rotos Full-size photographic prints of live-action footage, printed frame by frame to match the animation field size being used, which enable an animator to register their animation drawings to elements within that live-action footage.

Pilot Film Short taster sequence of finished animation, created specifically to show potential investors what the final proposed film will look like.

Pixel The smallest visual unit in a digital picture when viewed on a TV screen or computer monitor. The images seen on the average TV screen or computer monitor are made up of 72 pixels per inch.

Producer Key member of the production team responsible for ensuring that the film is created on time and on budget, who (within reason) supports the director's vision for the production and who negotiates all distribution (and incidental) deals with outside investors and distributors.

Production Company The organization or studio responsible for the creation of a film.

Production Folders Pre-printed folders containing all the necessary instructions for the animation team to execute the scene.

Production Line The processes involved in the production of a film.

Production Team All the relevant personnel required to create a production.

Programmer The person responsible for creating the interactive game engine that drives any game. Programmers can work on anything from stand-alone game projects for computers and hand-held devices to communal interactive games that are hosted via the Internet.

Projector Equipment required for the projection of all film in cinematic conditions.

Recording Session The event during which a film's soundtrack is recorded.

Reds Pencil animation drawings created using a red col-erase® pencil.

Registration The 2D process of ensuring that each animation drawing is in perfect alignment with the rest. *See* also Peg Bar.

Renderer A member of a 2D animation production team who is responsible for applying textured shading to flat-colored, 2D animation artwork, usually with pencils or wax crayons, to create a more 3D or illustrative look. Or a dedicated piece of hardware used exclusively for rendering out completed 3D animation.

Rendering The work undertaken by a renderer, or the process that comes at the end of 3D animation production.

RGB The additive form of color management used in TV screens and computer monitors, where all color representation is broken down into varying degrees of red, green, and blue. Using this approach, white is ultimately achieved by adding value to each of these three elements.

Rolling A technique where animation drawings are flipped while still on the pegs. *See* Flipping.

Rostrum Camera Specialized vertically mounted film camera that undertakes the shooting of 2D animation artwork.

Rotoprints *See* Photo-Rotos.

Rotoscope Device invented by Max Fleischer for tracing live action movement, frame by frame.

Rotoscoping The process of tracing live action as reference for 2D animated action.

Rough Animation Loosely and speedily drawn 2D animation that allows an animator to rapidly check the proposed action, prior to any detailed and more time-consuming drawing being attempted.

Rushes The initial film print of shot film, often received the day after it has been shot. Called dailies in the U.S.

Safe Titling Area of a full field size within which all titling has to be created. Without it, the text runs the risk of being cut off at the edges or distorted by the outer curvature of the TV screen.

Sales Agent An agent who is able to take a film development package and sell it to established film financiers on behalf of the film's producer, receiving a percentage of the production budget as a fee.

Scene Slate An indication board, filmed at the beginning of a scene, which shows the production, sequence, and scene number of the material being shot.

Scene An individual sequence of visual action which occurs within a film.

Scene Planning The process by which a director plots the sequence of shots which will tell the story. Also, the process of assigning timing and action to the animation by way of a dope sheet or bar sheet.

Schedule An analysis of the timing required for a film production, from beginning to end.

Screenplay (Script) A written description of the story, dialogue, and visual content of the film, written and approved prior to the film's production.

Sequence Collection of scenes that relate a specific phase of the film's storyline.

Shadow An area superimposed onto an animated image to indicate the area farthest from a significant light source.

Shadow Run An F/X element used in compositing work which comprises the required shadowing material for the movement in an entire scene.

Showreel Collection of a filmmaker or animator's previous work, collated on DVD or video tape to show the quality of work that the individual is capable of (in the hope of attracting future work from potential clients).

Slash Animation Old style of animation, in pre-cel days, where the character was animated on the lower level and the background was drawn on an upper level with holes cut in it to allow the action to show through.

Slow-in The process of adding extra inbetween drawings at the end of a movement to ensure that the action decelerates towards the target key.

Slow-out The process of adding extra inbetween drawings at the beginning of a movement to ensure that the action begins slowly then accelerates from the originating key.

Slug *See* Blank Leader.

Sneak Traditional technique of producing a tip-toe style walk with an animated character.

Sound Bench Traditional workplace used by sound editors to produce a phonetic breakdown of an audio track.

Soundtrack All the recorded audio material used in a film.

Sprite Animation The creation of movement using a minimum of pixels, as seen in hand-held games and cell phone graphics.

Stagger Animation technique used to create a trembling, hesitant, or shaking visual effect.

Steinbeck Traditional machine used for viewing film at the double-head stage, utilizing what was once known as a flatbed format. However, with the advent of digital technology, Steinbecks are essentially items of the past.

Sting Short, sharp note or chord in the soundtrack, used to make a dramatic audio emphasis of a moment in the film's action.

Storyboard Visual interpretation of the script, created using a series of interpretive drawings depicting the content of each scene's action.

Storyline Brief written outline of a film's dramatic content.

Studio Overheads Costs relating to the non-creative needs of a production studio (administrative, telephones, electricity, etc.).

Studio Location in which the creative aspects of an animation film's production takes place.

Superimposition (Animation) The process of taking 2D animation drawings off the pegs, to make 2D inbetweening easier.

Superimposition (Film) The process of overlaying an image on top of a previously filmed scene (for example, a title over a product shot in a commercial or a light through a window at night).

Sync (Lip Sync) The alignment of sound and mouth action within a scene.

Synopsis *See* Storyline.

Telecine Facility suite used for the electronic transfer of film imagery to video tape.

TGA A graphic file extension widely used in the graphics industry, originally created by Truvision for their Targa and Vista products.

Theatrical Film Feature length film to be shown in cinema outlets.

Three-Dimensional Animation (3D) Animation using models, puppets, and/or solid objects, but usually that which is created in a computer program.

Tile A small graphic image that can be repeated many times to create a larger image with no appreciable increase in file data size. (For example, a single tile of a tree in sprite-based games animation can be used over and over again to produce a forest with no increase in file size.)

Tile ripping The process of breaking a graphic image down into individual, repeatable tiles so that it can be re-created with minimal file sizes. (Specifically used in handheld game design.)

Tileset The collection of individual tiles that make up an overall game design.

Tiling The process of scanning extra large artwork in sections, then compositing it back together again by overlapping and merging the layers within a computer program such as Photoshop.

Top-lit/Back-lit Shoot The traditional approach to dual shooting of animation intended for live action/animation composited work.

Tracebacks Procedure where non-moving portions of an animation drawing are precisely traced for a required number of times from an originating drawing.

Tracer *See* Inker.

Tracing Down Process of transferring the drawing of a background layout onto a stretched sheet of water-color or cartridge paper, ready for coloring.

Track *See* Soundtrack.

Track Breakdown The process whereby the sound editor analyzes every individual sound on a track, frame by frame.

Transfer The transferring of the soundtrack from the original recording tape to the relevant mag track. *See* also Mag Track.

Treatment Document that outlines the director's concept for the film in the early, pre-development stage.

Triple Bidding Procedure undertaken by many advertising agencies, where three competing production companies are invited to bid on a specific commercial script.

Truck-In (Track-in) Action where the camera moves in on the artwork.

Truck-Out (Track-out) Action where the camera pulls out from the artwork.

TV Cut-Off Area within the field size which represents the outer portion of the artwork which may be cut off when viewed on a TV monitor.

Tweening The process of adding inbetween positions linking two key positions, either by accurately drawing them or by having a computer render them.

Twinning The effect that is achieved when a drawing or character is too symmetrical. This can be particularly apparent in special effects animation where cloud, wave, and smoke shapes are too symmetrical and therefore need to be varied and randomized to make them look more natural.

Two-Dimensional Animation (2D) All animation that is produced on a two-dimensional plane (drawn artwork).

Voice-Over Recorded voice that is heard off-screen.

Voice Talent Actor/actress used for voice-over recordings.

Wedge Test A range of varying exposure tests—produced before a final shoot—where different degrees of exposures are tested until a satisfactory one is reached.

Weight Technique in animation that gives the animated character a real sense of heaviness.

Wide-screen Cinematic screen ratio where a standard Academy format is reduced at the top and bottom to give the picture an extended landscape look.

Wooden A word used by animators to describe a character's action when it lacks weight, energy, or flexibility. Stiff-looking movement.

Zip Pan The technique of extremely fast panning across animation artwork.

Zoom A fast truck-in or truck-out.

Index